After the Photo-Secession

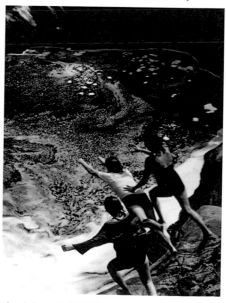

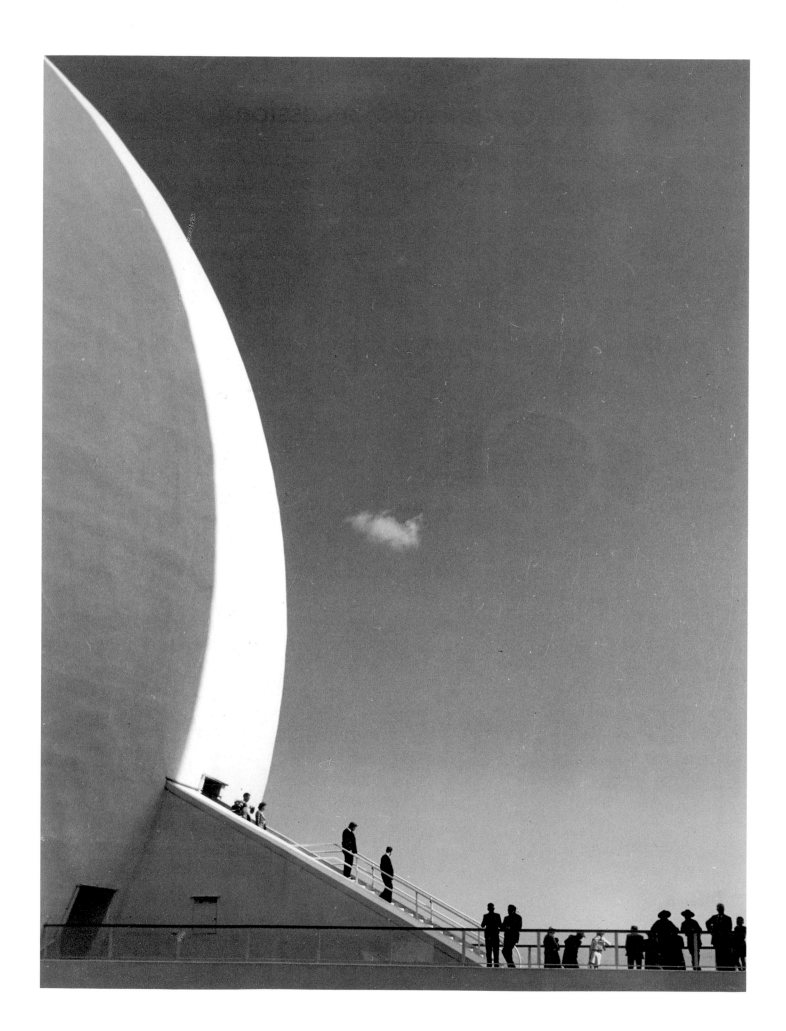

After the Photo-Secession

American Pictorial Photography 1910–1955

Christian A. Peterson

THE MINNEAPOLIS INSTITUTE OF ARTS

IN ASSOCIATION WITH

W. W. NORTON & COMPANY

NEW YORK · LONDON

First Edition

Printed in Italy

Jacket/cover: A. Aubrey Bodine, *Fels Point, Baltimore*. See page 78.
Frontispiece: Arthur Hammond, *Semi-Lunar*. See page 44.

Library of Congress Cataloging-in-Publication Data
Peterson, Christian A.
After the photo-secession : American pictorial photography,
1910–1955 / Christian A. Peterson.
 p. cm.
Includes bibliographical references and index.
1. Photography, Artistic—History. 2. Pictorialism (Photography
movement)—United States. I. Title.
TR653.P48 1997
770'.973'09041—dc21 96-39283
 CIP
ISBN 0-393-04111-5

W. W. Norton & Company, Inc., 500 Fifth Avenue, New York, N.Y. 10110
http://www.wwnorton.com

W. W. Norton & Company Ltd., 10 Coptic Street, London WC1A 1PU

1 2 3 4 5 6 7 8 9 0

This project was supported in part by a grant from the National Endowment for the Arts, a federal agency.

This publication was produced on the occasion of a traveling exhibition organized by The Minneapolis Institute of Arts.

The Minneapolis Institute of Arts, Minneapolis, Minnesota: February 8–May 4, 1997
Worcester Art Museum, Worcester, Massachusetts: August 23–October 19, 1997
Montgomery Museum of Fine Arts, Montgomery, Alabama: November 15, 1997–February 8, 1998
Everson Museum of Art, Syracuse, New York: March 7–April 26, 1998
Georgia Museum of Art, University of Georgia, Athens, Georgia: June 27–August 30, 1998
Portland Museum of Art, Portland, Maine: October 10–December 6, 1998
William Benton Museum of Art, University of Connecticut, Storrs, Connecticut: January 20–March 12, 1999
McNay Art Museum, San Antonio, Texas: August 23–October 17, 1999

Contents

Acknowledgments

This publication and the exhibition it accompanies drew upon the expertise and assistance of many individuals to whom I am grateful.

At The Minneapolis Institute of Arts I thank Evan M. Maurer, Timothy Fiske, and Carroll T. Hartwell for their support of the project; Laura DeBiaso and Lorraine McKenzie for coordinating the tour of the exhibition; Peggy Tolbert for registrarial duties; Gary Mortensen and Robert Fogt for photographic services; Phil Barber, Tom Jance, and the works of art crew for preparing and installing the exhibition; and Kristin Lenaburg for numerous administrative tasks.

To those who lent or donated original photographs for the exhibition, I am especially appreciative: Joseph Bellows, Michael Dawson, Jud and Lisa Dayton, Dayton Art Institute, Jane Bell Edwards, Terry Etherton, Howard Greenberg Gallery, Halsted Gallery, Alfred and Ingrid Lenz Harrison, Wellington Lee, Gladys Leventon, Julia Marshall, Ira Martin, Jr., Lucille and Thomas H. Peterson, Charles B. Phelps III, Photographic Section of the Academy of Science and Art of Pittsburgh, Photographic Society of America, Dennis and Amy Reed, Frederick B. Scheel, Lora and Martin G. Weinstein, Michael and Jane Wilson, John Wintzinger, and James Yarnell.

For information, insights, research assistance, and other materials I express my gratitude to those listed above and James Bastinck, Peter C. Bunnell, Valentino Buttignol, Keith F. Davis, Keith de Lellis, Charli Dunford, Kathleen A. Erwin, Kathleen Ewing, Howard Greenberg, Paul M. Hertzmann, David Holder, Tom Jacobson, Mack Lee, Agnes Limborg, Barbara McCandless, Barbara Head Millstein, Amy Rule, Rachel Stuhlman, Dominique H. Vasseur, Ralph E. Venk, Stephen White, Carla Williams, Deborah Wythe, and Bonnie Yochelson.

I wish to thank the museums who participated in the tour of the exhibition and the National Endowment for the Arts for its financial support of the project.

The task of writing the manuscript was made easier by the constant smiles and encouragement of Melody G. Oquist, devoted companion. Susan C. Jones and Debra Makay expertly and quickly turned my drafts into presentable written form. My appreciation goes to Katy Homans for her inspired design of the publication and to her associate, Gina Webster. And my heartfelt thanks is extended to James Mairs, at W. W. Norton, whose interest in the project made the book you hold in your hands a satisfying reality.

Introduction

American pictorial photography is closely associated with the Photo-Secession, the small cadre of photographers aligned with Alfred Stieglitz at the beginning of the twentieth century. Much has been written about Stieglitz and the Secession, and their shared role in establishing photography as an art is undisputed. But scant attention has been paid to pictorial photography in this country following the brief reign of the Photo-Secession. Most published histories of photography either deny the existence of pictorialism after 1910 or consider the movement derivative and anemic. In truth, neither assessment is correct.

American pictorial photography after the Photo-Secession was a particularly widespread and popular movement. Most cities of any size nurtured one or more camera clubs, with each offering a variety of activities. Frequent exhibitions of pictorial photographs were heavily attended by the general public and a thriving photographic press published numerous monthly magazines and hundreds of books appealing to a broad readership. Rather than becoming moribund, pictorial photography from 1910 to mid-century was decidedly populist, involving a large number of committed practitioners making pictures that were accessible to a wide audience.

Happily, widespread participation and approachable imagery were not synonymous with single-minded, substandard art. On the contrary, American pictorialism after 1910 was multifaceted and artistically adventuresome. Unlike the Photo-Secession photographers and their limited aesthetic stance, many later pictorialists openly embraced modernism and commercialism, in addition to traditional pictorial beauty. Camera clubs and pictorial salons accepted and championed photographs that were abstract, humorous, surreal, picturesque, avant-garde, and campy. Few other photographic movements accommodated such a variety of successful genres.

American pictorial photography after the Photo-Secession richly deserves reexamination. For two generations following 1910, pictorialists dominated the American photographic scene, a fact acknowledged even by their harshest critic, Ansel Adams. Their efforts as well as their numbers are impressive. Only by giving their work serious consideration can we achieve a more complete understanding of American photography as a whole.

After the Photo-Secession

I. The Photo-Secession: Homogeneous and Elitist

Throughout the nineteenth century, photographers used their cameras primarily to capture visual records of the real world. They photographed humans and buildings, mountains, and other largely immobile subjects with an eye toward detail, facts, and verisimilitude. Few camera operators attempted to venture beyond the mere surface appearance of what was before their lens. Although it had a few isolated early proponents, photography as an art did not fully develop until around the turn of the nineteenth century.

At this time some advanced amateur photographers in the United States and Europe began making pictures that proved the artistic status of photography. Calling themselves pictorialists, they banded together in camera clubs, presented exhibitions they called *salons*, and created photographic images that drew inspiration from traditional visual arts.

In this country Alfred Stieglitz (illus. 1) was the leading proponent of photography as an expressive medium. Stieglitz was a well-bred New Yorker who set high standards for the emerging art. As a magazine editor, he often rejected images as "technically perfect, but pictorially rotten." As a gallery director, he created small exhibitions of selective material. And as a photographer, he produced pictures of great sensitivity and individuality.

To further the "cause" of photographic art in this country, Stieglitz formed a fiefdom that both revolved around himself and dominated the small world of pictorialism. At the center of this construct was the Photo-Secession, a group of photographers Stieglitz handpicked for its first exhibition in early 1902. Within a year Stieglitz was publishing *Camera Work*, the self-proclaimed "mouthpiece" of the Photo-Secession and, to this day, the most exquisite photographic periodical ever produced. In addition, Stieglitz gave the Secession a permanent home in late 1905 when he opened the Little Galleries of the Photo-Secession and presented primarily members' work for the next five years.

Stieglitz personally oversaw the operation of the Photo-Secession, *Camera Work*, and the Little Galleries. His strong personality and creative drive made him a true autocrat: He shared power with no one and he was intolerant of dissension. Thanks to his rigid control of the movement, American pictorial photography at the turn of the century was aesthetically homogeneous and politically elitist.

The elitism of the Photo-Secession was evident from its beginnings. The group first appeared as the organizer of an exhibition at New York's National Arts Club in March 1902. But the show, "Ameri-

1. Frank Eugene
Alfred Stieglitz,
photogravure from *Camera Work*, No. 25 (January 1909).
The Minneapolis Institute of Arts, gift of Julia Marshall.

can Pictorial Photography Arranged by the 'Photo-Secession,' " was, in fact, organized exclusively by Stieglitz. He accepted fewer than 165 photographs—an unusually small number for the time—and later declared he had reserved "the right to reject such prints as were not the choicest examples of the subject extant."[1] Early membership in the Secession was so exclusive that some individuals were unaware of their own inclusion. Gertrude Käsebier, for example, had to ask Stieglitz if the presence of her pictures in the 1902 exhibition made her a member. Answering yes, Stieglitz informed her of her status as a founding council member of the Secession. Among the others in this exclusive group were John G. Bullock, William B. Dyer, Frank Eugene, Joseph T. Keiley, Edward Steichen, Eva Watson-Schütze, and Clarence H. White.

The tightly controlled Secession membership consisted mostly of privileged individuals. Photographers could not apply for inclusion in the organization; rather, they were invited to join after their work, writing, or support of creative photography had come to Stieglitz's attention and met his standards. Significant time, energy, and resources were necessary to achieve pictorial success, meaning that few individuals of modest means became Secession members. Some Secessionists (like Gertrude Käsebier) made their living as portrait photographers, a position that brought them into contact with wealthy patrons. Many members were professionals, like Joseph T. Keiley, an attorney. And some, like Stieglitz himself, were independently wealthy and socially well connected.

The Photo-Secession exhibited under strict guidelines for its entire decade-long existence. It showed largely as a unit and only in settings deemed appropriate. Almost immediately after the Secession's 1902 founding, Stieglitz began sending out small loan exhibitions of members' work, often to complement large photographic salons. Borrowers were required to install and catalog these sets as a single unit designated as a "Loan of the Photo-Secession." In addition, the pictures were not to be subjected to a jury or to editing of any kind, retaining Stieglitz's critical selection and the Secession's group identity.

Stieglitz would not send Photo-Secession photographs to undignified venues, and he was especially wary of international expositions. Notice of the 1904 Louisiana Purchase Exposition in St. Louis, for instance, revealed that all photographs—scientific, professional, amateur, and artistic—would be hung together in the fair's liberal-arts building. Stieglitz argued fervently, but unsuccessfully, for the acceptance of pictorial photographs in the fine-arts palace, and the Photo-Secession ended up boycotting the exposition. Stieglitz would not compromise his artistic standards, and many potentially important photographic showcases suffered as a result.

As tangible manifestations of the Photo-Secession, *Camera Work* and the Little Galleries reflected Stieglitz's elitist vision. Only by invitation from the almighty editor/director could a photographer's

2. Cover of *Camera Work*.
The Minneapolis Institute of Arts,
gift of Julia Marshall.

work be included in the magazine or a gallery exhibition. Stieglitz had a singular and clear vision for pictorial photography, and he was largely successful in foisting it upon the photographic world.

Camera Work (illus. 2) excelled all other photographic magazines. Issued quarterly between 1903 and 1917, it featured insightful articles that promoted aesthetics over technique and refined photographic images printed by the rich photogravure process. The magazine's advanced design and limited press run exemplified fine bookmaking. Individual issues often focused on the work of a single photographer, who, upon seeing the finished product, profusely thanked Stieglitz for being enshrined in the pantheon of artistic photography. The editors of competing magazines also regularly praised *Camera Work* for its content and design and readily admitted it was in an exclusive class all its own.

The Little Galleries of the Photo-Secession echoed the refinement of *Camera Work*. Located at 291 Fifth Avenue in New York, the facility was clean, simple, and understated. Photographs were usually presented on large, spacious mounts and hung in a single, horizontal row, in contrast to cluttered exhibition installations elsewhere. This allowed for quiet, contemplative viewing in a setting that seemed almost spiritual. Secessionist Paul B. Haviland recounted: "The minute you gazed into the rooms so fittingly designed, you seemed to breathe a different atmosphere. . . . You sensibly relaxed. You fell into a receptive mood."[2]

Stieglitz exhibited the work of only a limited group of pictorialists at the Little Galleries. A handful of members' and European group exhibitions were mounted but only eight photographers were accorded one- or two-person shows over the twelve-year run of the gallery. During the gallery's early years, when photography was emphasized, the work of Alvin Langdon Coburn, Adolf de Meyer, George H. Seeley, and Edward Steichen prevailed. Not surprisingly, these photographers were also well represented in the pages of *Camera Work*, indicative of Stieglitz's consistent—or, perhaps, homogeneous—view of pictorial photography. Stieglitz honored Steichen, his wunderkind, with an unprecedented four one-person exhibitions at the Little Galleries and with the most illustrations (sixty-eight) in *Camera Work*. When Stieglitz found a photographic talent, he promoted it heavily, to the exclusion of others.

American pictorial photography was exceptionally consistent in look and style. Despite an emphasis on individuality and personal expression, pictorialism operated within well-defined visual boundaries. Stieglitz and the Photo-Secession were creating a whole new class of photographs that had to be easily identified as art. As a consequence, they relied upon a few common affectations to produce a homogeneous aesthetic. This homogeneity was most evident in the dual features of subject matter and image treatment.

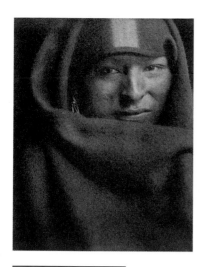

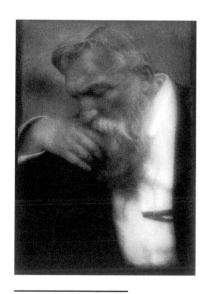

Subjects were limited almost exclusively to portraits, landscapes, and genre scenes. This modest repertoire reflected the influence of academic painting on pictorialism and the desire of photographers to use subjects close at hand. Pictorial portraiture included images of specific individuals and generic portrait studies, in which an unidentified sitter evoked some universal human attributes. Photo-Secessionists continually photographed one another, revealing the group's blatant self-absorption. Landscape photographs were generally romantic, pastoral scenes presented as idyllic escapes from the nation's urban centers. Frequently landscape titles referred to the four seasons. Photo-Secessionists gave a cultural twist to genre scenes: Instead of picturing everyday, working-class environments, Secession members focused on their own more rarified surroundings. As a result, viewers were treated to fashionably dressed subjects, well-appointed interiors, and sophisticated leisure-time activities.

Image treatment was the most codified and important aspect of artistic photography. It was *de rigueur* for pictorial images to be carefully composed, softly focused, and low in tonality. This approach differed dramatically from most utilitarian photographs, which were casually framed, sharply focused, and full in tonal range. Secessionists achieved unusual compositions by cropping off parts of their subjects, allowing large open areas, and by flattening the picture plane: Japonisme was a major influence. Soft-focus effects were universally used to suppress detail and to emphasize mass. Softly focused pictures did not seem of the real world and allowed pictorialists to escape into imagined dreamscapes. And low tonalities helped emphasize the atmospheric qualities pictorialists sought; deep, dark areas and overall low contrast effectively added mystery and uncertainty to Secessionist images.

The photogravures of *Camera Work* vividly illustrate the aesthetic homogeneity of pictorial photography at the turn of the century. The periodical features minor pieces by lesser-known photographers that are virtually interchangeable, but even masterpieces by leading Secessionists are distressingly similar. For example, works by Gertrude Käsebier (illus. 3) and Edward Steichen (illus. 4), two of Stieglitz's champions, repeatedly draw upon the same pictorial conventions. In addition to sharing portrait concerns, many of their accomplished pieces are similar in their use of unconventional framing, soft-focus effects, and low tonalities. On the one hand, the visual consistency of Secessionist photographs produced a unified movement, but on the other, it raised questions of authorship and individual vision. The Photo-Secession was such a homogeneous group that few outsiders could differentiate the work of particular members.

In about 1910 the cohesiveness and prominence of the Photo-Secession began to dissipate. Stieglitz, feeling he had made the case for photography as a fine art, began focusing his attention on modern painting and sculpture. Fewer and fewer photographic illustrations appeared in *Camera Work*.

Significantly, the Little Galleries of the Photo-Secession became known as simply "291," a reference to its Fifth Avenue address and a negation of its original association with photography. During the last seven years of its life, "291" presented photographs only three times. And of these three shows, only one—that of Adolf de Meyer—contained pictorial work.

In late 1910 Stieglitz organized the Photo-Secession's last major museum exhibition, which served as the group's swan song. Comprised of six hundred prints, the "International Exhibition of Pictorial Photography" was presented at the Albright (now Albright-Knox) Art Gallery in Buffalo, New York. Although the exhibition included an "Open Section" (juried by Stieglitz and three of his associates), it was made up largely of photographs by the major American Secessionists and their European counterparts. Clarence H. White's work was installed in a gallery of its own; Steichen and Stieglitz were each represented by more than thirty prints, and numerous other Secessionists showed twenty or more.

Numerous elements of the Buffalo exhibition signaled the demise of the Photo-Secession. For example, the foreword of the exhibition catalog began by stating that the "aim of this exhibition is to *sum up* the development and progress of photography as a means of pictorial expression" [my emphasis]. Stieglitz had been in a reflective mood since the year before, when he organized a Secession exhibition at the National Arts Club, the site of the group's founding. Now, the Buffalo catalog seemed intent upon documenting the Secession's past accomplishments. It contained short biographies of major exhibitors plus the process, negative date, and print date of most photographs; such detailed information was unusual in catalogs of the time and suggested Stieglitz's desire to produce a historical record of the organization. This intent was not lost on those who reviewed the exhibition; in praising it they used such pointed terms as "culmination," "memorial," and "fitting climax." Not surprisingly, the Photo-Secession never exhibited again.

The aftermath of the Buffalo exhibition confirmed the end of an institution. As the organizer of the exhibition, Stieglitz was primarily responsible for the return of borrowed photographs and the payment for pictures sold; characteristically, he was negligent on both counts. More than a year after the exhibition had closed, Gertrude Käsebier and Clarence H. White were both frustrated with Stieglitz's unresponsiveness. In early 1912, they independently tendered their resignations in the Photo-Secession, a group that, in fact, had not met, conferred, or decided upon anything for years.

Without such key players as Käsebier and White, the Secession apparently could not exist. Yet, it might also be said that the Photo-Secession was nothing but Alfred Stieglitz himself. He created it, he ran it, and he eventually killed it. Käsebier, White, and others happily left the remnants of the Photo-Secession to Stieglitz and went on to form other, more democratic groups of photographers. American pictorial photography after about 1910 would not be bound by Stieglitz's elitist and homogeneous views, and the art form and the individual permanently parted company.

II. The Pluralism of Pictorialism

American pictorial photography after the Photo-Secession embraced a wide range of photographic styles. Unlike the uniform and somewhat repetitive appearance of Secessionist work, numerous aesthetic stances fed the later pictorial movement. Between 1910 and about mid-century pictorialism welcomed images of classic beauty, as well as adventuresome pictures incorporating modernism and commercialism. Few movements were as catholic in their taste.

Classic pictorial imagery was prevalent for decades after the breakup of the Photo-Secession. Based to varying degrees on the example of Secession pictures and on the concept of picturesque beauty, this imagery continued to be softly focused and sentimental. It was now simply made by a new and much broader-based group of committed photographers. These pictorialists maintained great self-consciousness about making art, sometimes manipulating their imagery by hand.

Modernist elements began appearing in pictorial photographs in the 1920s, as memory of the Secession faded and the machine age began engulfing American society in general. These pictorial images shed soft-focus effects for a sharper, though not necessarily more realistic, vision. Pictorialism began allowing more contemporary subject matter, such as skyscrapers and automobiles, partially breaking with its tradition of old-world imagery. And more daring visual effects appeared, courtesy of abstraction, surrealism, and the photogram.

Commercialism also found its place in pictorial circles beginning in the 1920s. Along with American consumerism, numerous photographic professions established themselves during this decade. Advertising, illustration, and industrial photography soon infiltrated the ranks of pictorialism by further expanding subject matter and emphasizing high drama. Portrait photography, an older profession, also provided examples of clean, well-lit subjects. Not surprisingly, many professional photographers moonlighted as pictorialists, encouraging a rich, symbiotic relationship between the two fields. Overall, American pictorial photography after the Photo-Secession developed into a hybrid movement.

Traditional Beauty

Traditional aesthetics and picturesque beauty formed the core of many pictorialists' work following 1910. These workers valued simplicity, soft-focus effects, and hand-manipulated imagery, much like their predecessors. They promoted the study of the established arts and continued to proclaim the

self-expressive possibilities of photography. The conservative grounding of pictorialism lived on in their work and in their writing.

Beauty for its own sake was widely worshipped by the traditional pictorialists. It was a concept both vague and widely understood. That is, no one attempted to put definable limits on what was "beautiful," in part because it was assumed that most people knew what was included. Paul L. Anderson, a long-lived pictorialist and author, proclaimed in 1938: "We who are, or claim to be, or want to be, pictorialists, must concern ourselves first of all with beauty."[3] Even at the end of pictorialism's reign, photographers were declaring their commitment to the concept. Adolf Fassbender, another pictorialist of extended influence, wrote in 1952 that pictorial photography was "nothing more or less than the making of beautiful pictures."[4]

The photographic works of Anderson and Fassbender directly reflect their statements. Anderson (illus. 5), who was inspired to begin photographing after seeing issues of *Camera Work* in 1907, carried on the Photo-Secession's sense of refined photographic imagery. Most of his work is simply seen, softly rendered, and flooded with light. Though he worked into the 1950s, Anderson's photographs never incorporated modernist influences. Adolf Fassbender (illus. 6), likewise, remained wedded to the ideals of traditional beauty. He usually photographed landscapes and other everyday subjects with an eye toward old-world picturesqueness. Not surprisingly, Fassbender was a German immigrant, and his sense for natural beauty was deeply ingrained.

The picturesque was closely tied to pictorial beauty. Originally a quality of the fine arts, it came to be associated with popular taste after the middle of the nineteenth century. Traditional pictorialism adhered to populist aesthetics and embraced picturesque qualities. Adolf Fassbender was so enamored with quaint, charming pictures that he virtually equated the words *pictorial, beauty,* and *picturesque.*

For American pictorialists there was no better place to make picturesque pictures than Europe— the Old World itself. There, life was slower, simpler, and safer. Pictorial images made in Europe of quaint structures, costumed villagers, or picturesque landscapes frequently beat out domestic scenes in American competitions and salons. As an example, Frank R. Fraprie's important piece, *Warmth of the Winter Sun* (illus. 7), showing an old villager against a stone wall in Taormina, Sicily, was one of the most widely exhibited photographs in the early 1940s. A number of American pictorialists who were foreign born returned regularly to their native countries, producing substantial bodies of work there. Joseph Petrocelli, of Brooklyn, heavily relied upon his native Italy and North Africa (illus. 8) for imagery, and D. J. Ruzicka (illus. 9), also of New York, frequently photographed in his home country of Czechoslovakia. The European images they produced were invariably romantic and nostalgic, undoubtedly reflecting the makers' emotions, and sometimes contrasted starkly with more modernist work by the same photographers made in this country.

5. Paul L. Anderson
Sunday Morning, 1939.
Halsted Gallery.

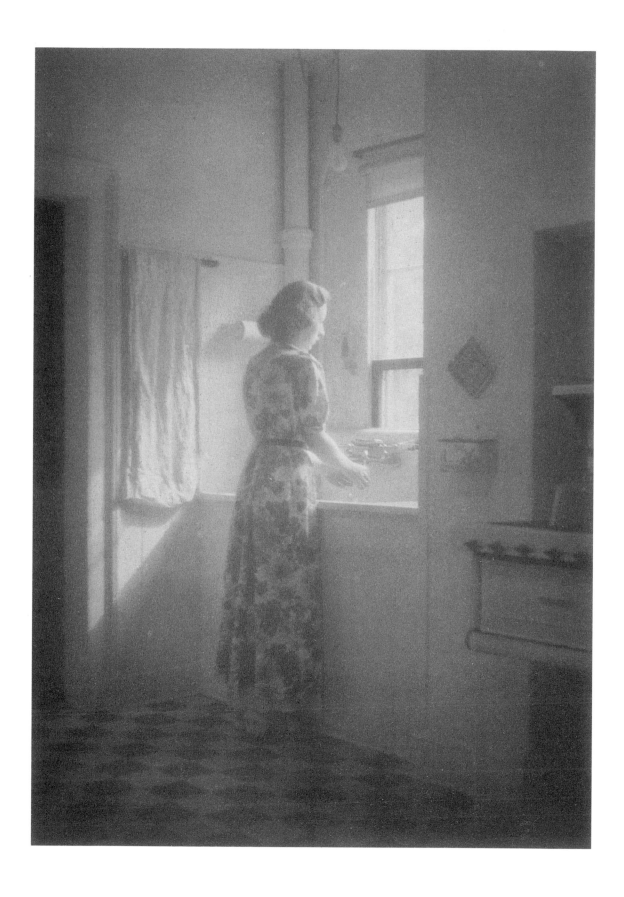

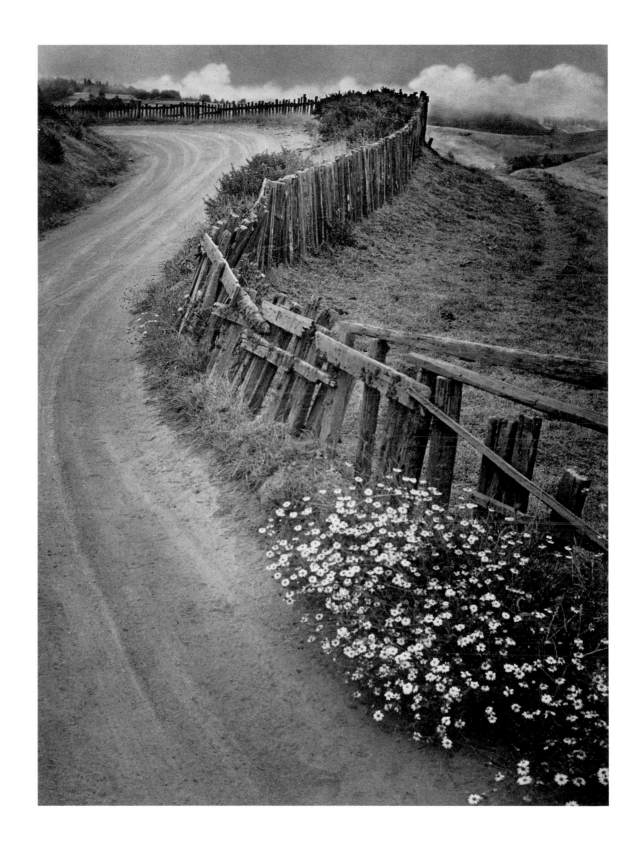

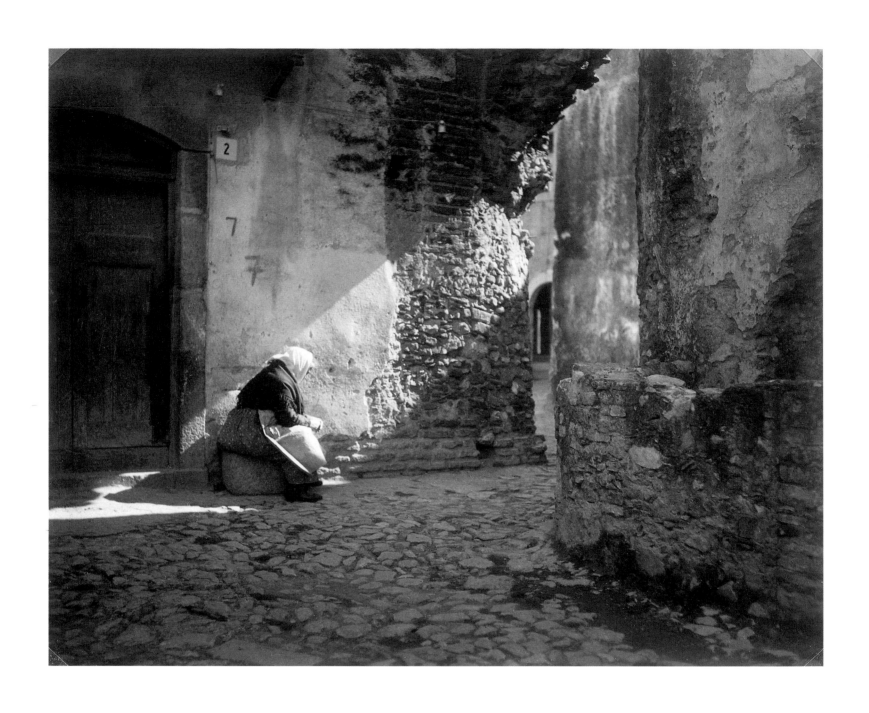

7. Frank R. Fraprie
Warmth of the Winter Sun, 1937.
The Minneapolis Institute of Arts,
Ethel Morrison Van Derlip Fund.

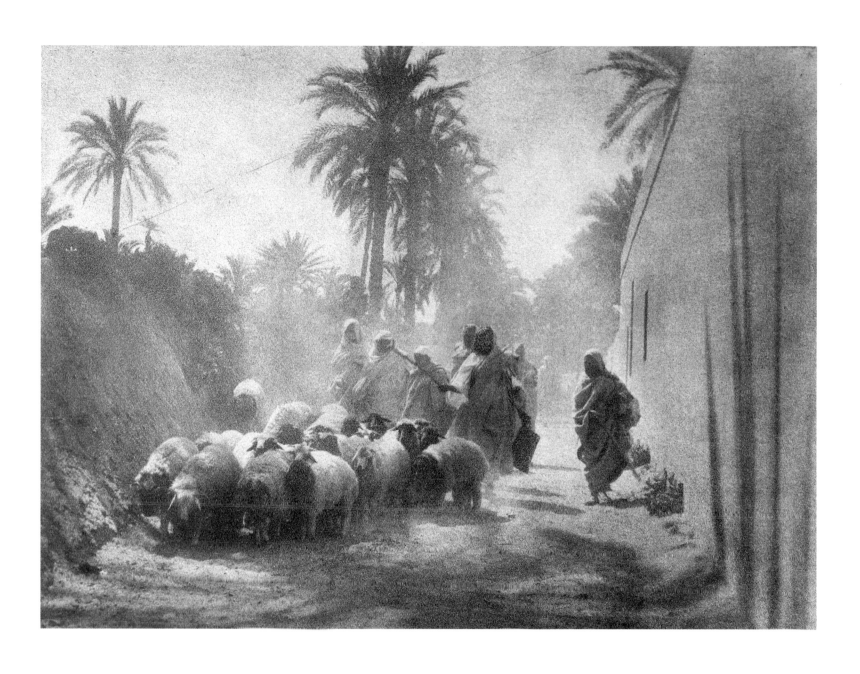

8. Joseph Petrocelli
Pastorale Arabe, 1926.
Photographic Society of America.

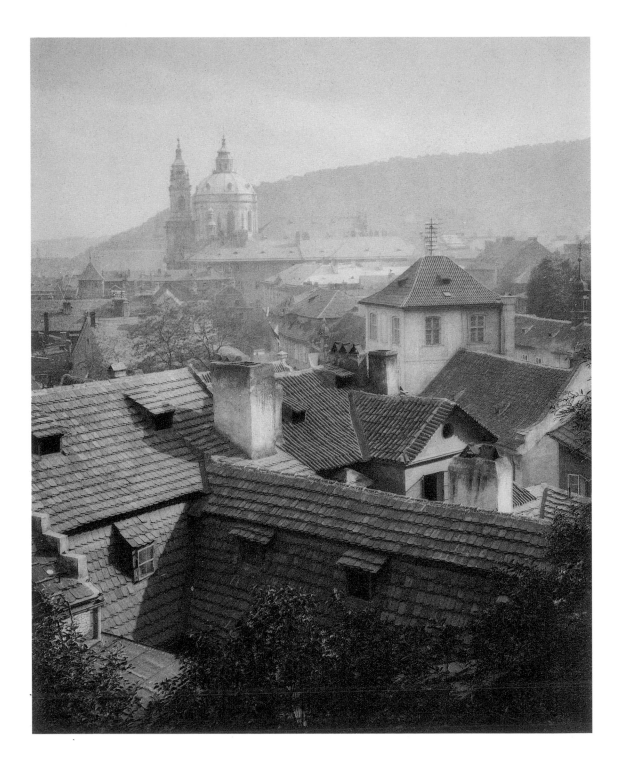

The old-world values of some traditional pictorialists allowed them to essay even religious themes. Pictorialism after 1910 contained a heavy overlay of moral goodness and optimism. Paul L. Anderson included in his understanding of beauty the "beauty of life" and the "beauty of spiritual things." Some pictorialists, however, transcended mere humanism and reenacted specific religious events. Hillary G. Bailey, for instance, created a *tableau vivant* of the Crucifixion (illus. 10) and Harry K. Shigeta made pictorial still photographs on the set of his film on the Passion Play (illus. 11). Such photographs are disorienting for their loaded subject matter and unusual among pictorial images for their specificity.

Soft-focus effects—a defining element of pictorial photography at the turn of the century—continued to be important to pictorialists for some time. Achieved by a variety of means, these effects were prominent into the 1920s. Even in the following decades, however, some pictorialists rendered images that were slightly diffused. The tolerance for soft pictures changed slowly and was variable among pictorialists themselves.

Clarence H. White, the Photo-Secessionist most significant to pictorialism after 1910, was an ardent supporter of soft-focus effects. Interviewed for the 1918 annual report of the recently formed Pictorial Photographers of America, White stated: "I think if pictorial photography were suddenly robbed of the soft focus lens it would be a catastrophe."[5] White and other pictorialists favored the soft-focus lens because it subordinated unwanted details, helped mass light and shadow areas, and produced painterly effects. These factors made for pleasing pictures that both appealed to the spectator's imagination and simulated human vision.

Pictorialists believed that soft-focus effects not only were pleasing but were, in fact, more "natural" than sharply rendered images. They argued that the human eye did not see things needle sharp and photographs so rendered actually hurt viewers' eyes. Pictorialist Paul L. Anderson wrote that "if we are aiming at a work of art I strongly hold that the ideal is a quality of definition approximating that seen by the human eye. The normal human eye possesses chromatic and spherical aberration, and in many cases more or less astigmatism is present as an abnormality, so it is physically impossible for any unaided human being ever to see objects as sharply as does an anastigmat lens."[6] In Anderson's opinion, the normal, sharp-focus lens was made only for utilitarian photographs, while the soft-focus lens was ideal for artistic pictures.

Soft-focus lenses were used most heavily in the 1910s and early 1920s. Among the many available were the Struss pictorial lens, developed and marketed by the Photo-Secessionist Karl F. Struss. In 1917 an ad for the Struss lens claimed that "The Lens of Atmosphere" was now owned by over four hundred pictorialists. That same year the Pictorial Photographers of America devoted their May meeting to the subject of soft-focus lenses, hearing presentations from Struss, two

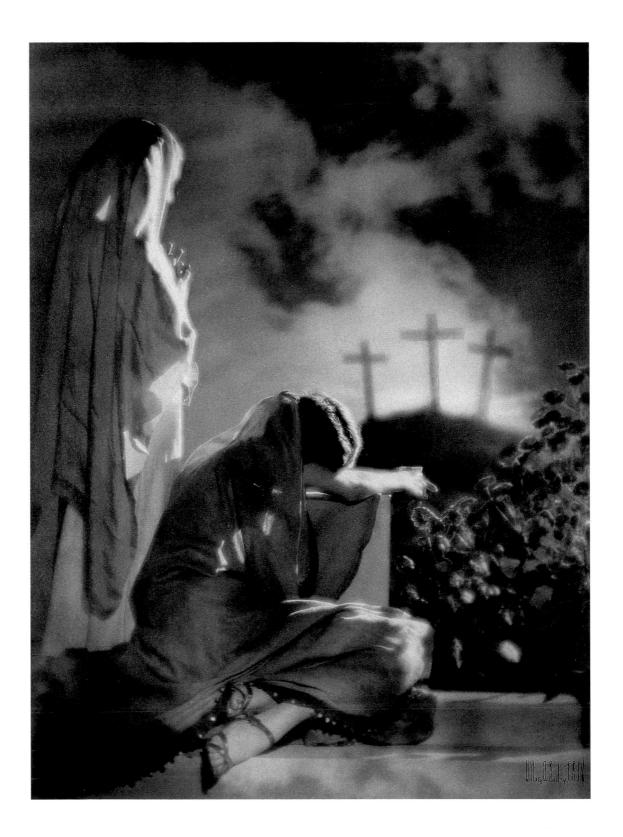

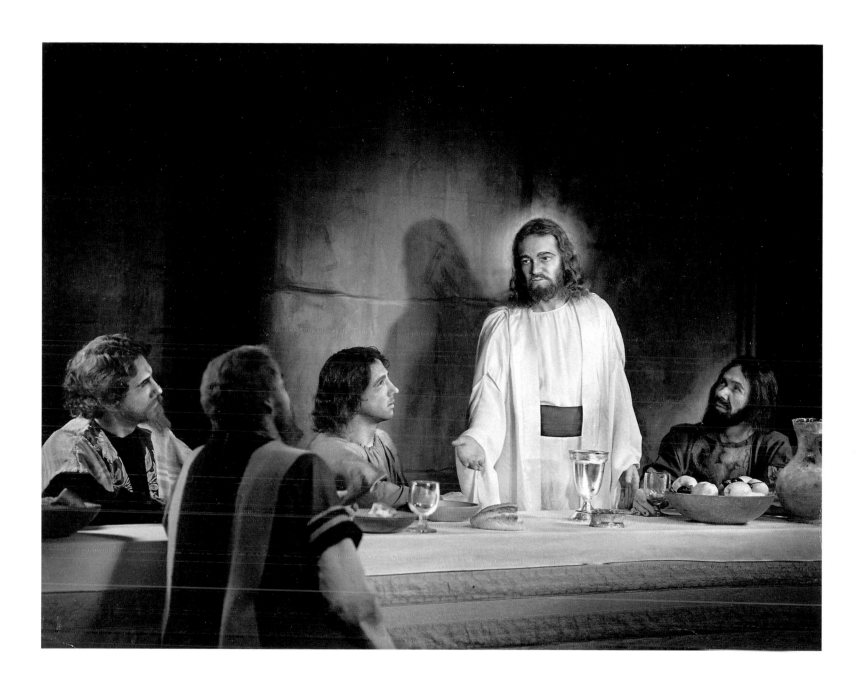

11. Harry K. Shigeta
*The Last Supper from "Zion
Passion Play,"* c. 1947.
The Minneapolis Institute of Arts,
gift of Fred W. and Jane Bell
Edwards.

other manufacturers, as well as member Arthur D. Chapman, who had developed his own lens designs.

Close associates of Clarence H. White formed the core of those who used soft-focus lenses during this period. Prominent among them were Anderson, Chapman, Struss (illus. 12), Edward R. Dickson (illus. 13), and Ira W. Martin. Most of these pictorialists were variously involved in the Clarence H. White School of Photography (begun in 1910), *Platinum Print* (published and edited by Dickson from 1913 to 1917), and the Pictorial Photographers of America (organized in 1916). Their work, along with that of White's, was distinctive for its soft rendition: Outlines melted, highlights glowed, and the viewer's emotions were calmed. Some pictures were so refined visually that they were considered experiments in pure aestheticism. Pictorialists were careful, however, not to confuse controlled softness with mere out-of-focus effect. Out-of-focus pictures lacked good definition and made up the derided "Fuzzy-Wuzzy School," a holdover from turn-of-the-century pictorialism.

Fewer and fewer traditional pictorialists used soft-focus lenses after the 1920s. This was largely a result of the onset of modern times and the untimely death in 1925 of White, a great promoter of the lens. Soft-focus *effects*, however, did not entirely disappear from pictorial imagery. By the 1930s numerous pictorialists began hand-manipulating their photographs, creating diffused images from sharply focused negatives. Traditional pictorialists desired total control over their imagery, which led some of them to hand manipulation. They believed that the negative was merely a means to an end and that only the photographer's imagination limited what could be done. Pictures without handwork were thought to reflect only the factual recordings of the mechanical camera.

Some traditional pictorialists, like Adolf Fassbender and Max Thorek, were European born, emigrating to this country as young adults. Their interest in extensive handwork may be partly attributed to the old-world tradition of handicraft. These photographers were undoubtedly exposed in their youth to unique, finely tooled objects that revealed artistic intentions on the part of the workers who crafted them. Consequently, they saw no reason for not stamping their personalities into their photographic images.

"The photographic Artist," according to Adolf Fassbender, "is a man who has complete control over his medium; a perfect technician who is able to create at will, who can change where light and lens failed, where material was insufficient and value upset."[7] Hand manipulation could rescue faulty negatives and overcome photography's then lack of color and three-dimensionality. Fassbender knew that photographic equipment alone was incapable of capturing the photographer's impressions of a scene. And since the medium was, in his words, "one mistake after another," pictorialists needed the skills to revamp, repair, remake, and recycle their pictures in order to make them artistic.

12. Karl F. Struss
Storm Clouds, 1921.
Collection of Frederick B. Scheel.

13. Edward R. Dickson
Untitled, 1910s.
The Minneapolis Institute of Arts,
Tess E. Armstrong Fund.

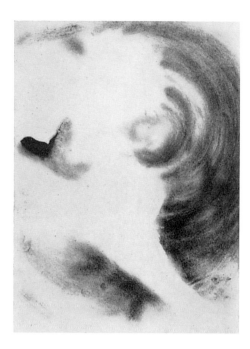

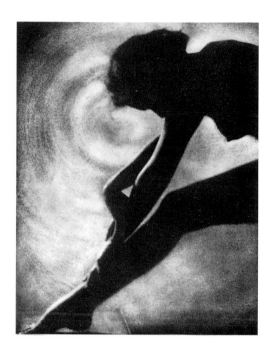

14. Max Thorek
Composition,
contact print from original
negative. Reproduced in *Creative Camera Art.*

15. Max Thorek
Composition,
handwork on back of paper
negative. Reproduced in *Creative Camera Art.*

16. Max Thorek
Composition,
finished print. Reproduced
in *Creative Camera Art.*

The paper negative was the most widely used control process in the 1930s and 1940s. This process generated an enlarged negative on photographic paper that was easier to draw on and alter by hand than the small, original film negative. Intermediary steps included making enlarged film positives, which could also be manipulated. A minimum of five steps was necessary to make a finished print from a paper negative, but some pictorialists claimed to have used up to twelve steps to achieve their desired results. The process allowed dramatic transformations in imagery—from bland, pedestrian images to distinctive, energetic salon prints.

Max Thorek both used and wrote extensively about the paper negative process. In his important book, *Creative Camera Art,* he demonstrated the changes it allowed to his picture *Composition.* Shown first was his initial studio shot of the nude profile, harshly lit, arbitrarily framed, and full of distracting lines (illus 14). Shown next was the back of the paper negative, where Thorek performed confident handwork (illus. 15). Here, he drew in a set of swirling lines and significantly altered the model's anatomy. Seen last was the final photograph (illus. 16), which, in combining the core photographic image with the artist's alterations, obtained a visual coherence completely absent from the original image. Thorek boldly proclaimed that the paper negative "may be heralded as a process affording the pictorialist the greatest latitude for personal expression. It acts as the brush, palette and canvas of the interested worker for with it comes an amazing amount of artistic flexibility."[8]

Prints from paper negatives were usually made on a standard bromide or chloride paper, similar to today's gelatin silver stock. The great advantage of the paper negative was that once all the handwork was applied to the negative, multiple prints could be easily made, without any additional manipulation being necessary. Control processes that required handwork during printing, however, were also used by those pictorialists who felt compelled to alter the photographic image. These included bromoil, gum-bichromate, carbon, kallitype, photogravure, and Fresson.

Prints made by these processes made up a small, but important, minority of the photographs seen in salons and in reproduction. At the 1928 Pittsburgh salon nearly one-fifth of the prints accepted by the jury were bromoils. Paul L. Anderson consistently promoted such handcrafted pictures, printing many of his images in more than one process. His book, *The Technique of Pictorial Photography*, included chapters on eight separate printing methods. From the 1920s through the 1940s photographic monthlies and annuals ran "how-to" articles on a range of manipulative processes.

During this time the bromoil and bromoil transfer processes were most frequently used by pictorialists. These were among the easiest control methods because they began with a regularly printed enlargement. The print was chemically treated to bleach away and physically swell the image area. To restore the picture the photographer then brushed on an oil-based ink, which adhered only to the image area. Successful images required skillful use of the brush, a genuine artist's tool. Bromoil transfers required putting the brush-developed print through a press in contact with another sheet of paper, which became the final print. Among the leaders of bromoil printing were Arthur F. Kales (illus. 17 and 18) of California and A. D. Chaffee of New York.

Performing handwork on photographic images—whether on the negative or actual print—required not only great manual dexterity but significant restraint and responsibility on the part of the photographer as well. Control methods, in fact, were the most abused of all photographic processes, as many novices tried their hand at them without sufficient knowledge and skill. The accomplished users of these methods repeatedly sounded caution. They did not wish to make or see photographs that looked like drawings, etchings, or paintings. "Remember that you are working on a *photograph*," counseled William Mortensen, the flamboyant California pictorialist, "In all alterations, modifications, and additions you must bear this in mind. Your final result must still be completely photographic in appearance."[9] Others agreed that the finished product needed to remain "photographically real," and that success depended on not how much handwork was done, but on how little was done convincingly.

Despite the importance of photographic technique to pictorialists, they remained focused on expressing themselves with the camera. The question of whether photography was an art was continually revisited, with the conclusion usually being that the medium was merely a tool, not a

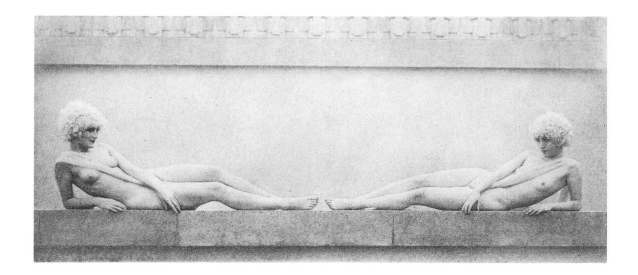

17. Arthur F. Kales
Cameo, c. 1922,
bromoil transfer print. Collection
of Dennis and Amy Reed.

18. Arthur F. Kales
The Forbidden Door, c. 1927,
bromoil transfer print. The Michael
and Jane Wilson Collection.

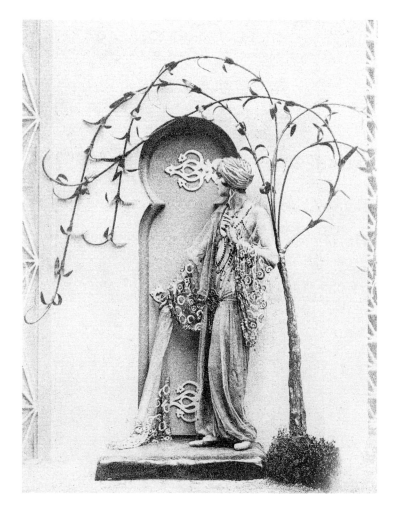

guarantor, of art. Advanced pictorialists reminded their colleagues that equipment and technique were only a means to an end, and should not become an obsession in themselves. Max Thorek, for instance, pointed out that light meters were good servants but bad masters. And William Mortensen went so far as to label technique and creativity as the "monster and madonna," respectively, of photography. The former was "all the mechanically hampering, all the technically frightening, all the mathematically imposing, influences in photography," while the latter was "a symbol of fruitfulness and growth, of life and creative energy."[10] It was universally agreed that technique alone was a hollow entity and that an idea, message, or emotion was necessary for a picture to live. Traditional pictorialists considered the study of the established fine arts as helpful to making creative photographs. "Our photographers need art education," declared Frank R. Fraprie. And instructors at the Clarence H. White School of Photography followed this advice by regularly taking their students to New York art museums. In addition to visiting museums, pictorialists also exposed themselves to the other arts by attending lectures and reading relevant publications.

The photographic press was full of paintings as examples for the creative photographer. In 1922 and 1923 the art and photography critic Sadakichi Hartmann wrote a series of articles for *Camera* on the unique styles and strengths of old masters such as Raphael, Titian, and Michelangelo. And Eleanor Parke Custis's book for photographers, *Composition and Pictures*, reproduced the work of Hals, Da Vinci, Rembrandt, and others; the author pointedly expressed admiration for the lighting effects and compositional features evident in these paintings. Even classical sculpture was suggested as worthy of study; its dependence upon subtle gradations of light was, after all, a characteristic shared with photography.

Camera clubs hosted programs that featured artists and their work. In 1926, for instance, the Newark Camera Club presented an exhibition of paintings by the local Outdoor Sketch Club. Several years later, F. L. Briem, a painter, etcher, and instructor at the Brooklyn Institute of Arts and Sciences, gave his talk, "The Inter-Relation of Fine Art and Photography," to a New York camera club, advising the study of both old masters and modern painters. It was no coincidence that most of the annual photographic salons in this country during the 1930s and 1940s were presented at major city art museums, where the hosting camera club sometimes also met. Furthermore, the museums' directors or curators of art frequently sat on the juries of selection.

Some pictorialists actually had been artists before turning to photography. Foreign-born pictorialists almost invariably had significant art training, which manifested itself in their interest in image manipulation. Hungarian-born Nicholas Ház, for example, studied painting for sixteen years in Europe before becoming a successful pictorialist in this country. He wrote two books on photographic composition, both of which he illustrated with his own line drawings. In 1948, while on a

lecture tour of the United States, he showed more than a dozen of his original paintings at a meeting of the Chicago Area Camera Club Association. American-born Eleanor Parke Custis first established herself as a gouache painter and later excelled at pictorial photography. Her photographic articles and book reproduce both her paintings and her photographs (illus. 19), which were also exhibited together. A careful viewing of her entire ouvre reveals that her photographs sometimes served as direct models for her paintings.

Fine-art references even crept into the marketing of products for pictorialists. Manufacturers exploited the artistic aspirations of pictorialists by selling photographic products as art supplies. In 1944 the Dassonville Company, for instance, advertised its photographic paper as the "rival of the brush and palette for high artistic honors." At about the same time, another company developed a line of "Rembrandt" paper.

Traditional pictorialists concentrated intently upon composition, which they considered a key element to making legitimate art. Deeply concerned with the formal structure of their pictures, they spent an inordinate amount of time and energy maintaining compositional correctness. The number of books and articles that appeared between 1910 and 1950 on photographic composition was rivaled only by literature on technique.

Pictorialists felt they had to know the rules of composition, just as composers must understand the musical scales and poets the rules of grammar. These rules were considered basic to good picture making, almost to the exclusion of other concerns. Composition "is the most important item in photography, or in any other kind of picture making," wrote one author/photographer. "It is not what you say, but how you say it."[11] Pictorialist Adolf Fassbender agreed, stating it was his "strong belief that Composition was, is, and always will be the basis of all good photography."[12]

Fassbender and others detailed the many aspects of good composition for willing readers. They identified, for instance, six types of basic composition and four types of line. The former included the triangle, the circle, the cross, the S-curve, radiated, and steelyard. The main types of compositional lines, each with assigned meanings, were vertical (suggesting dignity and strength), horizontal (repose and quietude), diagonal (action and energy), and curved (danger or gentleness). Pictorialists based most of their compositional decisions on the action of the eye—on, say, where it would "enter" and "leave" a picture.

Good pictorial composition depended upon simplicity. Pictorialists avoided making pictures that were filled with too many objects and too much visual stimulus. Arthur Hammond wrote, "There is no surer or more satisfactory way of making a picture strong and effective than by making it sim-

ple. We can see clearly or can hear distinctly only one thing at a time. We can say only one thing at a time, and a picture, therefore, should tell only one story, deliver only one message or convey only one impression."[13] "Thou shalt not paint two pictures on one canvas" became almost a pictorial mantra. Photographers who embraced traditional beauty had room for only one subject at a time in their pictures. The result? Extremely straightforward compositions.

Pictorialists read extensively about composition, both in early books aimed primarily at artists and in later volumes targeted for photographers. Henry R. Poore's *Pictorial Composition and the Critical Judgement of Pictures*, for instance, provided an academic analysis of paintings and their structure. Arthur Wesley Dow's *Composition*, on the other hand, incorporated progressive ideas on space, and was an important text for Clarence H. White and his followers. Arthur Hammond and Eleanor Parke Custis wrote books specifically for fellow pictorialists. Hammond's *Pictorial Composition in Photography*, which appeared in four editions between 1920 and 1946, was the most comprehensive and easy-to-read text on the subject. Custis's *Composition and Pictures* (1947) grew out of a successful series of magazine articles. It featured reproductions of her accomplished paintings as well as her pictorial photographs (illus. 20), and a detailed discussion, accompanied by numerous diagrams, of dynamic symmetry, an advanced form of mathematical picture analysis.

Such books could easily become what Terence R. Pitts recently termed "aesthetic cookbooks" for the inexperienced pictorialist. Because novice photographers were tempted to follow to the letter the published rules and diagrams of composition, most authors warned against slavish adherence to their words. Eleanor Parke Custis told readers that an image without emotional content that followed every compositional rule would be a lifeless diagram, not an artistic picture: "A diagram can show perfect composition, but no one hangs it on the wall to enjoy for years to come. No one holds a salon of diagrams."[14] Other authors avoided excessive picture analysis, considering it too scientific, and assured readers that good compositions would come to them naturally, after sufficient experience making pictures. Some objected to the word *rule*, preferring less didactic terms like *principle* and *guideline*. A few even suggested that pictorialists versed in the rules of composition could make them secondary to imagination. In reality, however, most traditional pictorialists adhered to compositional predetermination, which continued to strictly define their imagery.

The Influence of Modernism

In the mid-1910s Alfred Stieglitz, Paul Strand, and others insisted that creative photographers pursue the unique aspects of their medium. Shunning the manipulative techniques and escapist attitudes of pictorialists, they established a modern aesthetic for photography. In essence, modern pho-

19. Eleanor Parke Custis
Penguins Three, c. 1939.
The Minneapolis Institute of Arts,
gift of James Yarnell.

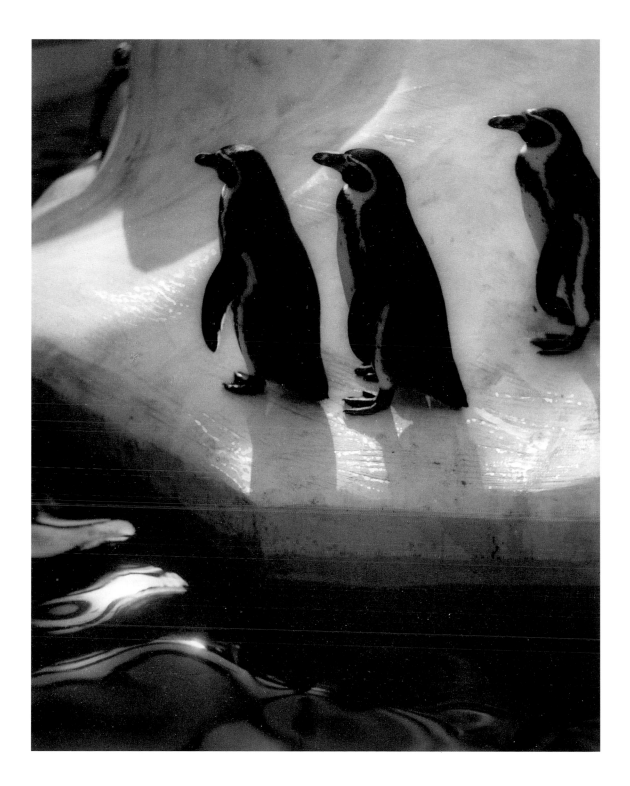

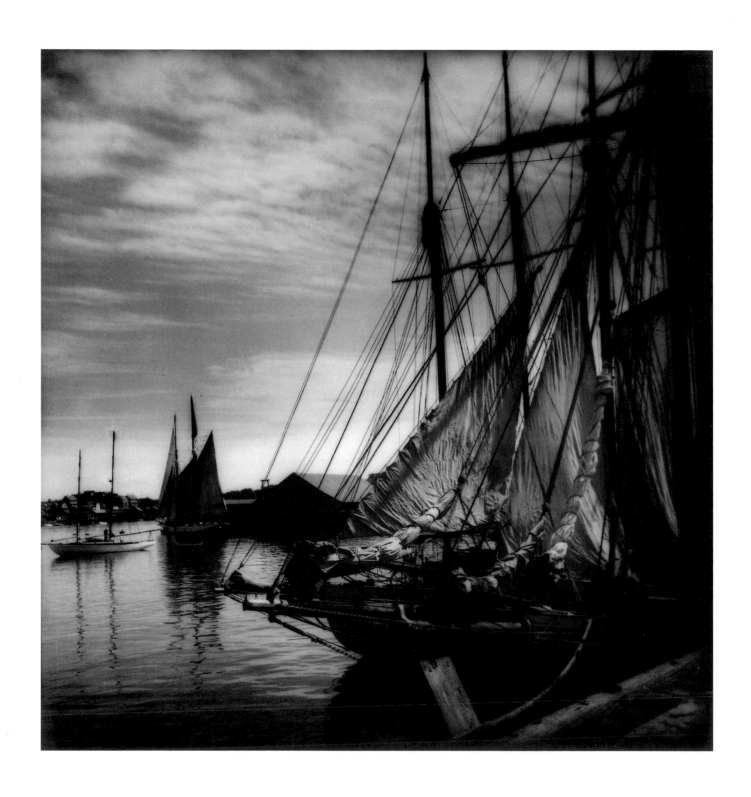

20. Eleanor Parke Custis
Port of Dreams, c. 1936.
The Minneapolis Institute of Arts,
gift of James Yarnell.

tographers made creative pictures of everyday subjects, rendered in sharp focus and a full range of photographic tones. Their images were sometimes abstracted, relating directly to cubism and other avant-garde movements, and always void of common sentiment. Modernist photographs, above all, were unmistakably camera-generated images that showed no darkroom sleight of hand.

Initially, most pictorialists found this work cold, harsh, and objective—mere documentary or record photography. With time, however, their attitudes softened, and by the end of the 1920s many pictorialists began accepting aspects of modernism. Frank Crowninshield, editor of *Vanity Fair*, observed in the 1929 annual of the Pictorial Photographers of America:

In looking over the pages of this annual it will be seen that, more and more, the American photographers are being touched by so called Modernism; by a new-found interest in our stark and skyscraper civilization. More and more they are yielding to the beauty of cubes; to sharply opposed effects of shadow and light; to the Picasso-like quality which we everywhere see reflected in the life about us.

And the inevitable result of this encroachment of modernism has been that the old-time quality of "sentimentality" is very much on the decline in our photographic art. The once popular "storytelling" pictures, the tender landscapes with sheep, the bowls of flowers, the portraits of little children, have had to make way for prints in which a new and almost disordered spirit is evident. The gospel of mass and the age of machinery have certainly been making converts among the American photographers.[15]

By the 1930s modernism had made its mark on the pictorial movement. Many pictorialists admired "purist" photography, acknowledging its strengths and even collecting examples of it. They adopted the practice of previsualizing their pictures, they made straight prints, they emphasized design and full tonalities, they made images packed with movement and drama, and they used experimental processes like photograms and montages. Modernism found a foothold in the organizations, publications, and exhibitions of pictorial photography; it was visible in camera clubs, in magazines and books, and in photographic salons. Often considered antithetical today, pictorialism and modernism were, in fact, not so distinct and separate during their time.

As the machine age dawned, American culture made great advances. The middle class grew rapidly, with the majority of individuals now living in cities rather than rural areas. Technological growth fostered a mass culture. Following the 1925 Exposition des Arts Décoratifs in Paris, the art-deco style swept the country, dominating clothing, furniture, architecture, and graphic design. A national atmosphere of speed and mechanization captivated both pictorialists and modernists.

The miniature camera and the picture press, both new phenomena, profoundly affected pictorial photography. The first mass-marketed 35-mm camera, the Leica, was introduced in Germany in 1925, and by five years later a miniature-camera craze engulfed photographers in the United

States. The ranks of camera clubs swelled with fledgling members intent upon making artistic pictures with their new handheld cameras. Many succeeded. Adolf Fassbender and other traditional pictorialists taught classes on the subject. The 35-mm camera made it easy to obtain bird's-eye and worm's-eye views of subjects, as well as vertical-format pictures. The results were usually inherently more dynamic, dramatic, and disorienting than earlier pictorial imagery.

The picture press, a direct result of the success of the 35-mm camera, also altered pictorialism in the 1930s. News magazines such as *Life* and *Look* quickly earned great popular acclaim. These publications covered topical events and contemporary life, which were now more acceptable as pictorial subjects. Skyscrapers (illus. 21), automobiles, and locomotives (illus. 22) appeared both in the pages of mass-marketed magazines and on the walls of photographic salons. Pictorialists didn't attempt to tell picture stories as did photojournalists of the day, but many of them incorporated the excitement of the times in their images.

The New York World's Fair of 1939 provided an especially rich source of modern subject matter for pictorialists. Celebrating "The World of Tomorrow," it consisted of more than a hundred buildings of art-deco design. At the visual, symbolic, and architectural center of the fair were the Trylon and Perisphere, subjects repeatedly photographed by pictorialists. Arthur Hammond and Adolf Fassbender, for instance, made particularly important pictures of this site. Hammond's *Semi-Lunar* (illus. 23) is flatly rendered and understated, while Fassbender's *Dynamic Symbol* (illus. 24) exudes energy and is marked by visual depth. These images, though both outstanding examples of modern pictorialism, are distinctive, pointing to the pluralism of the movement.

In 1932 Group f.64 was formed, creating an embodiment of the "straight" aesthetic of modern photography. Named after the smallest aperture setting on most lenses, this West Coast association began to promote sharply focused images, as well as prints that were full in tonal range, unmanipulated by hand, and objective in outlook. Ironically, at least half of the original eight members (including Ansel Adams, Imogen Cunningham, and Edward Weston) began their careers as pictorialists, making softly focused, sentimental images early in the twentieth century. During the 1930s Adams wrote several articles for *Camera Craft*, explaining the philosophy of f.64. William Mortensen countered with similar articles on pictorialism. These two waged a battle that was never settled, partly because their differences were not always as significant as they made them out to be. Many pictorialists working in the 1930s were, in fact, using such f.64 methods as previsualization and straight printing techniques.

Previsualization required the photographer to know exactly what the picture would look like before making the exposure. Photographers of Group f.64 believed that pictorialists did not previsualize because so many of them performed handwork on the negative and print. But just because pictorialists

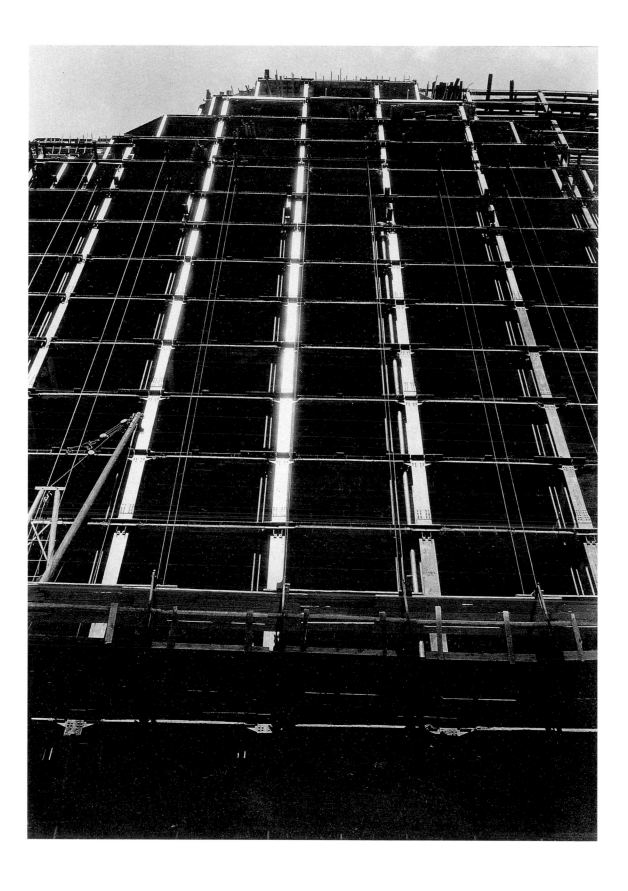

21. Ira W. Martin
Building into the Sky, 1921.
Collection of Ira Martin, Jr.

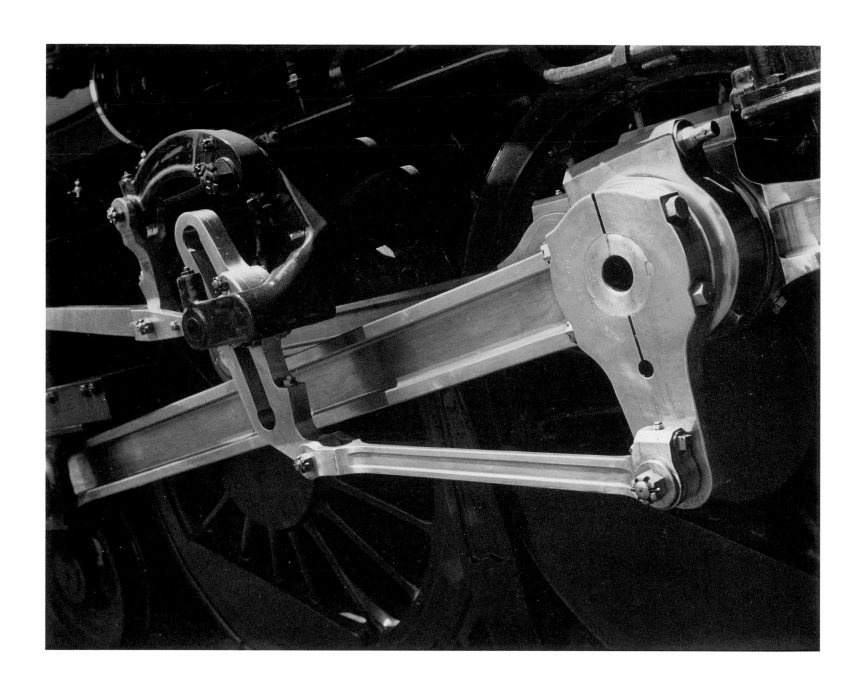

22. Edward Alenius
Stainless Steel, c. 1940.
The Minneapolis Institute of Arts, Ethel
Morrison Van Derlip Fund.

altered their images did not mean they could not envision the outcome when they snapped the camera's shutter. In truth, pictorialists advocated planning, foresight, and anticipation in making pictures. Many of them—especially by the 1930s—made completely straight prints anyway, remaining true to the image as it appeared in their negatives.

Many writers promoted and many pictorialists practiced photographic previsualization. John Wallace Gillies, in his 1923 book *Principles of Pictorial Photography*, stated: "In setting out to make a photograph, it is essential that the worker, in order to insure its power to live, shall premeditate what he is about to do, and not haphazardly photograph that which presents itself. A picture must be created, the photographer must plan it out. Then, if well composed and thought out, it is a real work."[16] Gillies's book was used as a text at the New York Institute of Photography, which had branches in Brooklyn and Chicago, where his message reached hundreds of aspiring pictorialists.

Most pictorialists chose to get as much as possible of their final image in the negative itself, rather than rely heavily upon later handwork. Axel Bahnsen advised that as little as "a few seconds' thought before the 'snap' will save hours of retouching and difficult manipulation after the negative is developed."[17] Pictorialists were well known for their ability to predict when a subject would look best under natural lighting conditions. Upon discovering a scene they wished to photograph, they often returned later to capture it as they had originally envisioned it as a finished image. Adolf Fassbender, who, ironically, was known for manipulating much of his work, touted the importance of predicting what would happen in front of the camera. "I might say that ninety per cent of the pictures that I have made were possible only on account of anticipation," he declared. "It means that we must anticipate a setting, a picture, a happening, before it actually occurs, in order to be ready for it. That may apply even to an ordinary landscape without human interests, without moving objects."[18] Fassbender even discouraged cropping, believing that photographers had failed if they had not seen the whole picture when they initially made it.

Besides previsualizing their images, many pictorialists printed their photographs as sharply as did straight, modernist photographers. In the 1940s Detroit pictorialists generated an interest in making blue-toned prints that were large and shiny-surfaced. This type of work, prevalent in the upper Midwest, was termed "Big, Blue, and Glossy." Pictorialists who made their living as professionals were most likely to produce straight prints for their creative salon work. Among them were A. Aubrey Bodine, newspaper photographer (illus. 25); Fred G. Korth, industrial photographer; and Wellington Lee, portrait photographer (illus. 26). Their professional photographs were invariably straight and unmanipulated, and so were their personal pictures. In some cases, they even submitted to salons the same images they had made on assignment.

Pictorialists didn't wait for the example of Group f.64 to make straight photographs. As early as

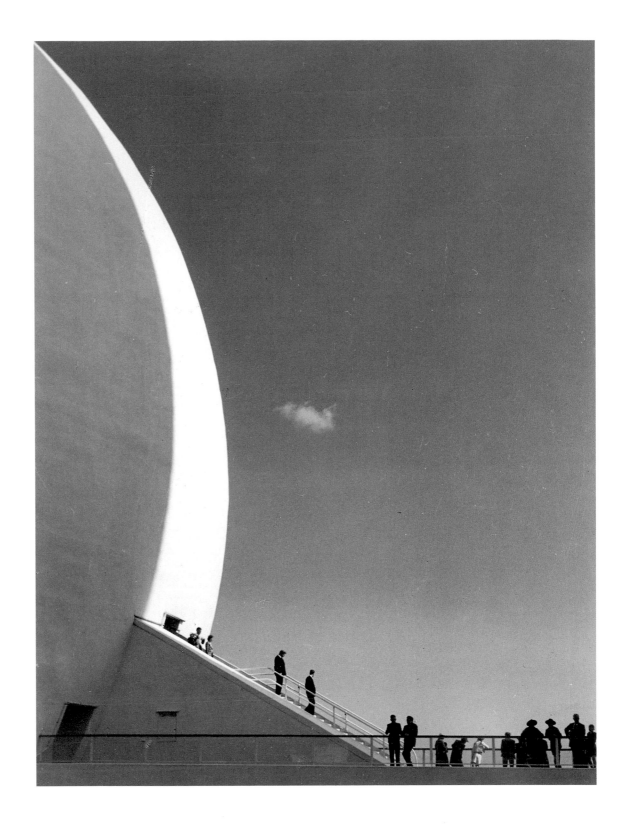

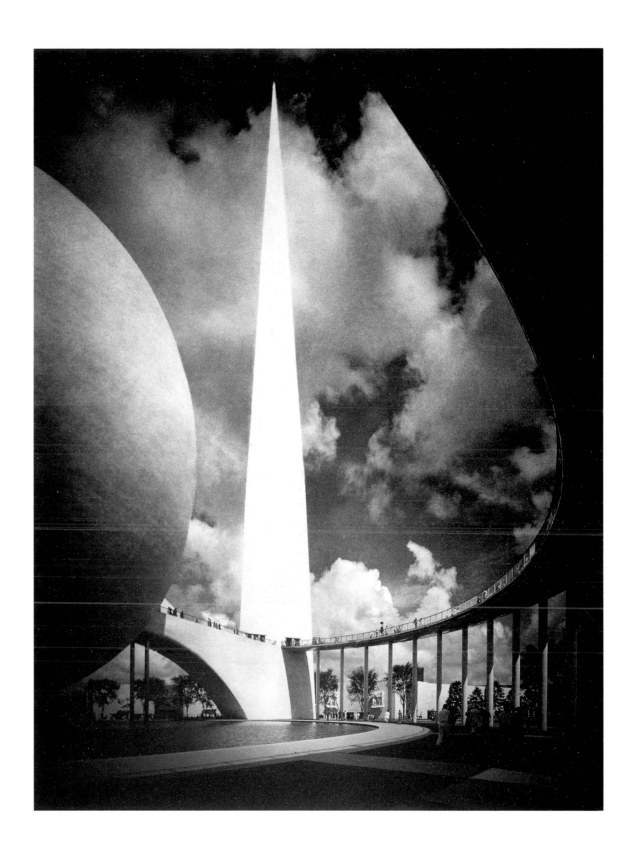

24. Adolf Fassbender
*Dynamic Symbol, New York
World's Fair*, 1939.
The Minneapolis Institute of Arts,
Ethel Morrison Van Derlip Fund.

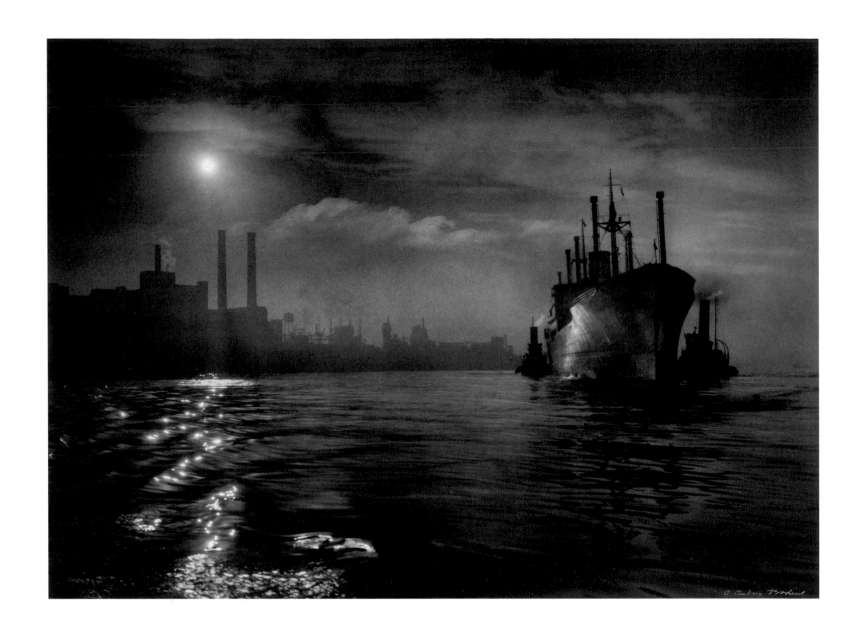

25. A. Aubrey Bodine
Baltimore Harbor, 1940s.
The Minneapolis Institute of Arts,
John R. Van Derlip Fund.

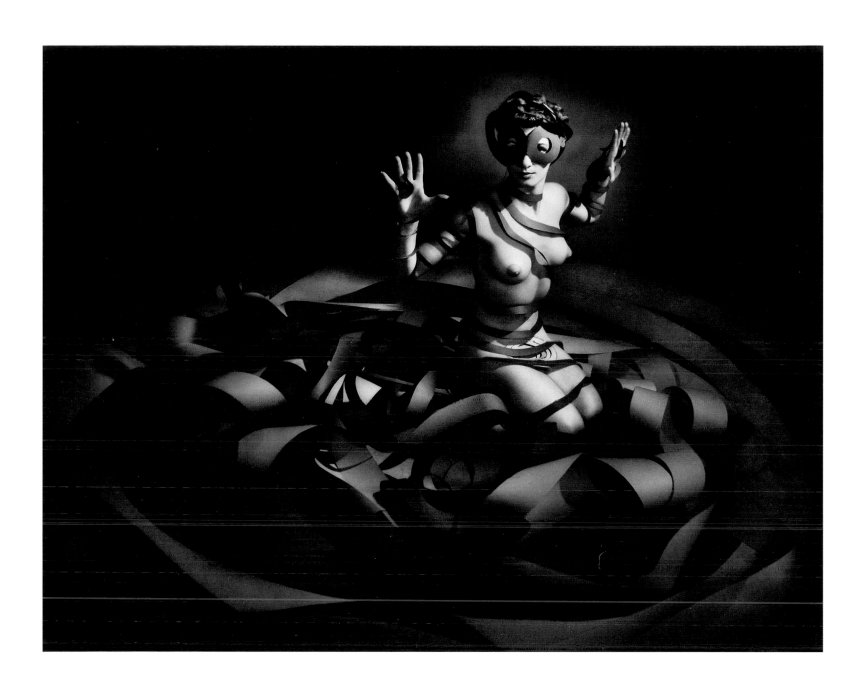

26. Wellington Lee
Girl from Mars, 1955.
The Minneapolis Institute of Arts,
gift of the artist.

1912 Edward R. Dickson, editor of *Platinum Print*, believed that the negative should contain everything the photographer wished to put into the finished print. He disparaged that "to practice the manipulative process is an admission of the paucity of original thought and selection by endeavoring to create, afterwards, that which one failed to secure in the beginning."[19] During the 1910s and 1920s, many pictorialists made straight contact prints from unmanipulated negatives. These small, intimate prints usually were made on platinum paper, a medium that rendered subtle middle tonalities. It was the paper of choice for pictorialists of the Clarence H. White circle, like Arthur D. Chapman (illus. 27), Dickson, and Ira W. Martin.

During the 1930s numerous leading pictorialists maintained an allegiance to straight photography. Hillary G. Bailey (illus. 28) declared, "I am a sincere purist"; Harvey A. Falk (illus. 29) called his photographs "pictorial documentaries"; and Hans Kaden (illus. 30) claimed, "I am a purist at heart." Perhaps most influential was D. J. Ruzicka (illus. 31), a Czech-born New York pictorialist whose own straight work helped instigate the modern-photography movement in his native country.

Ruzicka, whose trademark subject was New York's Pennsylvania Station (illus. 32), prided himself on not having to "work up" his negatives. He believed that good photography depended upon selection, not correction, and that a perfect negative guaranteed a perfect enlargement. "With the arrival of Dr. Ruzicka in 1921 there began a new period in the evolution of photography in Prague," recounted the Czech photographer Jaromír Funke. "Some of the photographers of that time tried to continue in their pre-war styles, and with the resulting flood of bromoil prints the Czech-American Dr. Ruzicka came into sudden collision. For several years he came each summer and exhibited his prints made on common silver bromide paper."[20] As a result of Ruzicka's purist vision, Funke, Jan Lauschmann, Josef Sudek, and a host of other young photographers began making the innovative and avant-garde work for which they are known today.

Back in this country, many American pictorialists began dramatizing their photographs. They included strong, diagonal lines and sharp angles in their images, printed in high-contrast tonalities, and produced large, vertical-format prints. The resulting pictures had high visual impact; some were posterlike, and others loudly screamed their message. To older pictorialists like Paul L. Anderson, who preferred small, delicate prints, these pictures had no place in the photographic salons. But to the majority of the active pictorialists, this was now the way of the pictorial world.

Adolf Fassbender led the charge for high drama in pictorial photography between the world wars. He regularly lectured on "dynamic pictorialism," infused his own work with it, and titled his book *Pictorial Artistry: The Dramatization of the Beautiful in Photography*. His primary goal in photography was still beauty, that indefinable concept, but Fassbender wished to enliven his pictures with elements of modernism. He considered the best work to be a perfect combination of the energy

27. Arthur D. Chapman
Diagonals, 1914,
platinum print. Hallmark Photographic Collection, Hallmark Cards, Inc., Kansas City, Missouri.

28. Hillary G. Bailey
The Last Chord, c. 1935.
The Minneapolis Institute of Arts,
gift of Fred W. and Jane Bell
Edwards.

29. Harvey A. Falk
World of Today, c. 1940.
The Brooklyn Museum,
gift of the artist.

30. Hans Kaden
Path of Light, c. 1943.
Photographic Society of America.

31. D. J. Ruzicka
Heart of Endive, 1932.
Collection of Lora and Martin G.
Weinstein.

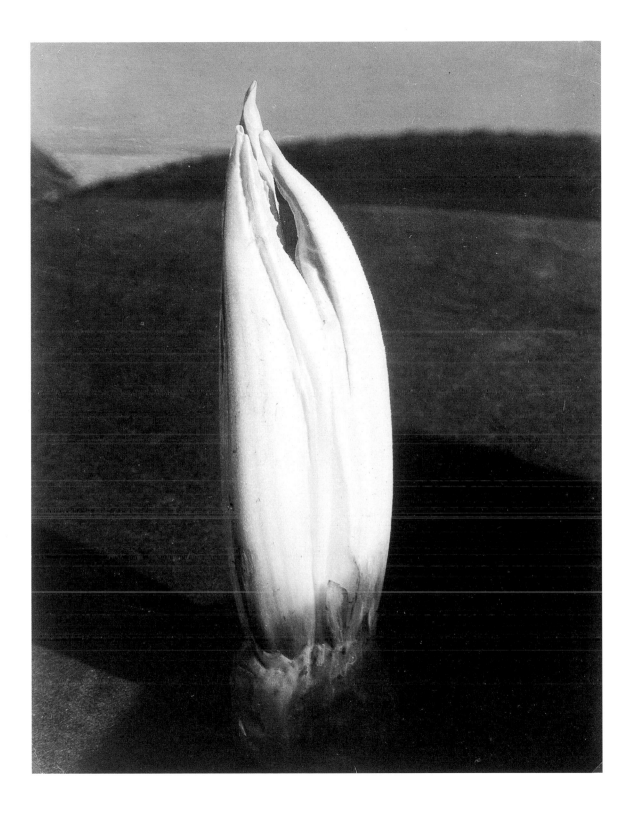

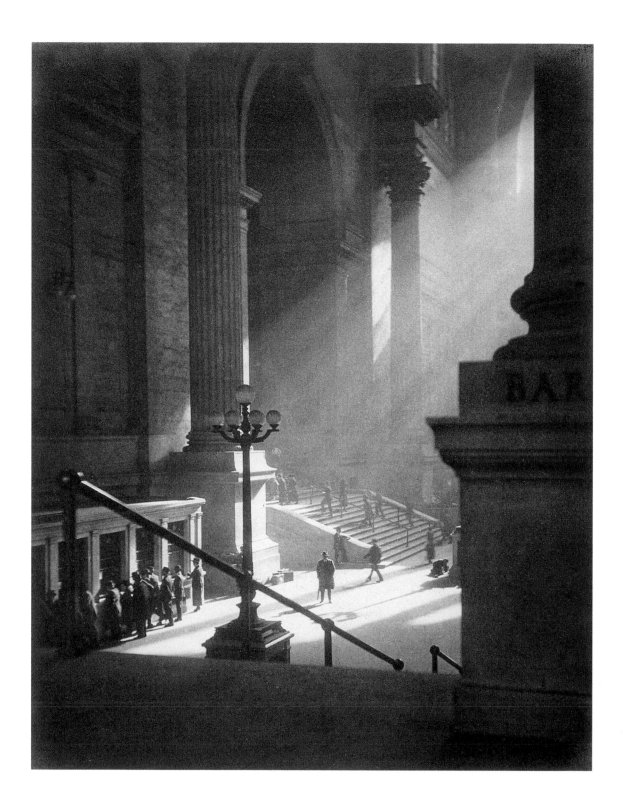

of contemporary life and the beauty of traditional ways. He explained in 1941: "'DYNAMIC' with its opposition to static denotes forceful movements—a powerful motif, while 'PICTORIALISM' usually represents the lyrical and beautiful and can be reverted to as a counterbalance to the former. Therefore, in more practical terms, we can combine these two characteristics to arrive at harmony and the *dramatization of the beautiful*."[21]

Many pictorialists also admired design, another aspect of modernism, incorporating it into their work. To them, the term referred to the abstract construction of a picture, taking into account only line, shape, and mass. This concept relied heavily on Arthur Wesley Dow's earlier teachings, which promoted *notan*, the Japanese emphasis on light and shade, and the analysis of pictures as flat spaces. Dow's student Max Weber, the modern painter, went on to teach these ideas at the Clarence H. White School and to write about them as "space-filling" in *Platinum Print*, the little magazine for pictorialists, during the 1910s.

Platinum Print regularly carried articles on the subject of good design, as did the annuals of the Pictorial Photographers of America and the photographic monthlies. Clarence H. White commented on design in 1918, stating that "the development of modern art, I think, is in the direction of construction; and construction, picture construction, applies to photography as definitely as it applies to painting and other art."[22] A year earlier White made somewhat abstract photographs of boats being built in Maine at an actual construction site—images that remain today his most modernist work (illus. 33). In 1921 Dow himself wrote about the creative possibilities of photography, saying that "he that would paint with light must be first of all a Designer."[23] Over the next decades, pictorialists were encouraged to look at their pictures upside down or through squinted eyes in order to better evaluate the design of the image. As late as 1946, Arthur Hammond, in the last edition of his popular book *Pictorial Composition*, concluded: "The would-be pictorialist must try to cultivate the ability to see pictorially. He must learn to see objects in nature, such as trees, roads, mountains, and so on, not as definite objects, but as shapes, lines and masses that have balance and rhythm and that fill the picture space in a satisfying and agreeable manner."[24]

Japanese-American pictorialists on the West Coast cultivated "space-filling" as a high art during the 1920s and 1930s. With an inborn sense of *notan*, these photographers produced highly refined and understated pictures that were admired at salons throughout the United States and Europe. They frequently photographed nature, the primary subject in traditional Japanese art, rendering it flat, patterned, and asymmetrical. Largely inspired by ukiyo-e woodblock prints, the Japanese pictorialists had little interest in the linear perspective and vanishing points of Western art. The most active centers for these photographers were Seattle, where the camera club published a monthly magazine appropriately named *Notan*, and Los Angeles, where the Japanese Camera

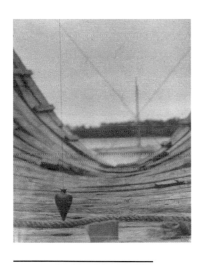

33. Clarence H. White
Ship Construction, Bath, Maine, 1917 (part of triptych). The Museum of Modern Art, New York, gift of Mr. and Mrs. Clarence H. White, Jr.

34. Hiromu Kira
Study, Paperwork, 1927,
Photographic Section of the
Academy of Science and
Art of Pittsburgh.

35. Hiromu Kira
Curves, c. 1930.
The Michael and Jane Wilson
Collection.

Pictorialists of California organized in 1926. The Los Angeles club associated with Edward Weston when he was still a pictorialist, sponsored annual exhibitions, and produced such inspired work that Arthur F. Kales wrote in *Photograms of the Year 1927* that he saw a "Japanese Invasion" of the pictorial world. Hiromu Kira (illus. 34 and 35), Kentaro Nakamura (illus. 36), and Shigemi Uyeda (illus. 37) created singularly important images among the Japanese Americans.

Some pictorialists were so enamored with modernism that they co-opted even its most adventuresome darkroom techniques, such as photomontage, solarization, and the photogram. All the monthly magazines geared toward creative amateurs featured articles on these processes after World War I. *Camera Craft*, for instance, ran a piece in April 1935 by Nicholas Ház that recounted an imaginary conversation with a traditional pictorialist who, after comprehending the work of Man Ray and Moholy-Nagy, recognizes the emotive possibilities of the photogram. *American Photography* published an article titled "Anyone Can Make Photograms," and another periodical claimed that "with the use of photograms we can get entirely away from realism and create a separate world of our own where the end of our imagination is the limit."[25] Pictorialists had always wanted to escape the real world, and they now began considering the subconscious as a place to retreat.

Axel Bahnsen, a European-trained pictorialist, made a handful of images delving into the subconscious and wrote a short article on the subject. Titled "Sur-realism in Photography," the article suggested that those photographers who scoffed at surrealism probably had not tried to understand the movement, a common cause of antagonism against all forms of modern art. Bahnsen explained that successful surrealism did not combine contradictory objects with the intention of baffling viewers. "The pictorialist creating a sur-realist photograph is interested in showing those basic mental images and concepts which are deep in the subconscious," Bahnsen wrote, "and these are shown best by picturing the symbols which we all recognize as the fundamental childhood images upon which we later superimposed layers of more complicated images to express the same idea."[26] Bahnsen's picture *Conscience* (illus. 38), which illustrated the article, combined the easily understood symbols of the hand and the eye, representing the stopping of the mind and self-examination.

Bahnsen made his images by photomontage, a method that, whether performed in the camera or during enlargement, combines images from different sources or settings, creating totally fabricated pictures. Unlike traditional pictorialists, who might seamlessly combine imagery from different negatives—say, a landscape from one and a sky from another—modern pictorialists threw together elements that obviously did not coexist in the real world. William Mortensen, for instance, was well known for concocting images that were both fantastic and horrific (illus. 39). Harry K. Shigeta (illus. 40) also used photomontage extensively in both his personal and his professional work. Writing for

36. Kentaro Nakamura
Evening Wave, c. 1927.
Collection of Dennis and Amy
Reed.

37. Shigemi Uyeda
Reflections on the Oil Ditch, c. 1924.
Collection of Dennis and Amy Reed.

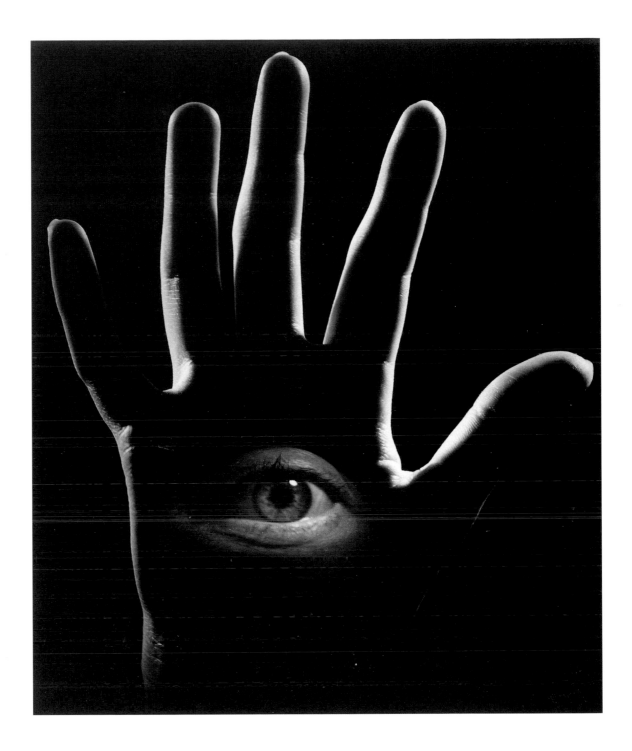

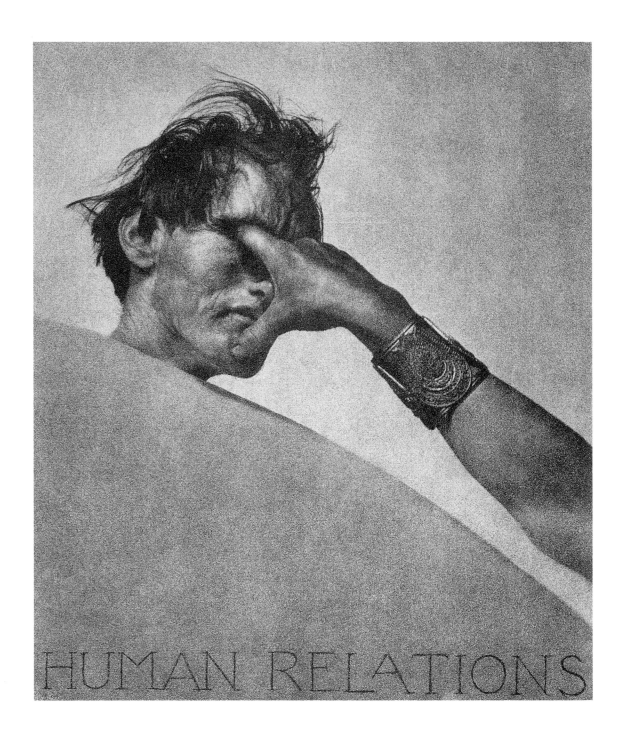

39. William Mortensen
Human Relations, 1932,
bromoil transfer print. The
Minneapolis Institute of Arts,
Christina N. and Swan J. Turnblad
Memorial Fund.

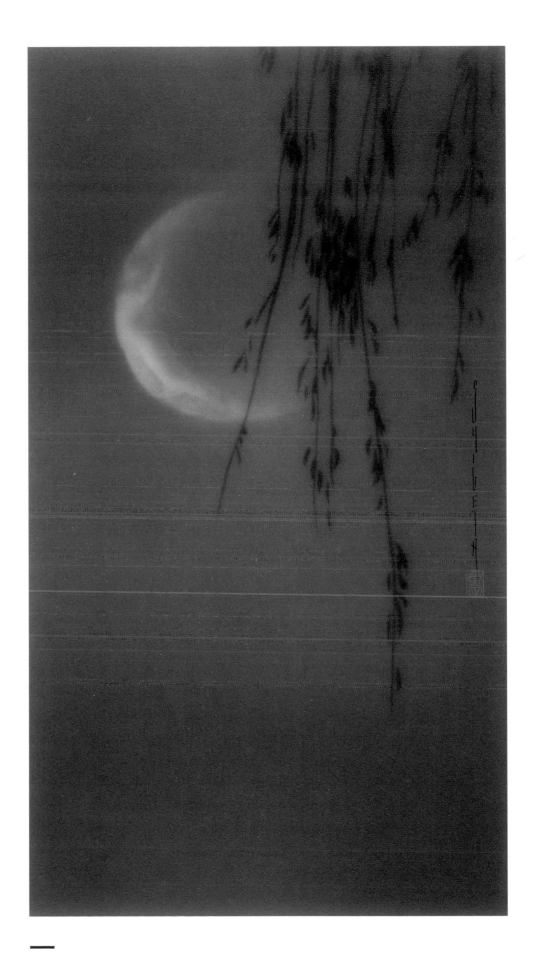

Popular Photography in 1939, he stated: "There are no rules for the selection of the material to be combined into montages, this being one of the most accessible of photographic mediums for highly original and imaginative work. In fact, the photomontage permits the photographer to violate all sorts of accepted notions in order to convey forceful, striking impressions."[27] His salon work often combined classic, female nudes with abstract or solarized designs, making for a sensuous modernism (illus. 41).

American pictorial salons accepted work by Mortensen and Shigeta and also welcomed pictures by photographers who were committed modernists or purists, with no pretensions of being pictorialists. Not only did these individuals submit work to these venues, but they also occasionally helped organize the exhibitions or served on their juries. Beginning in the 1930s, the pictorial movement was surprisingly tolerant and accepting of other forms of photographic expression, an attitude borne out by the content of its exhibitions all around the country.

European modernists found special favor at American salons. Frantisek Drtikol, the leading Czech photographer of abstract nudes, repeatedly sent his work to major salons in this country. He submitted pieces to the salon in Rochester, New York, where local portrait pictorialist Alexander Leventon collected examples of Drtikol's pictures. His photographs were also included in the Third International Invitational Salon of the Camera Club of New York, as was the work of Man Ray. Moholy-Nagy's photographs were accepted by the jury for the first Philadelphia salon of 1932, and the next year the Los Angeles salon showed work by Josef Sudek.

America's leading straight photographers, such as those of Group f.64, also showed their work in pictorial salons. The 1931 Los Angeles salon, for instance, included many glossy bromide prints, a paper pictorialists would have scoffed at only a few years earlier. Represented were Imogen Cunningham and Edward Weston, both now making straight prints, and Weston's son Brett, who was never a pictorialist. Writing in the deluxe catalog for the exhibition, James N. Doolittle acknowledged that the book's reproductions and the salon itself "run the gamut of photographic expression" and noted that the sponsoring Camera Pictorialists of Los Angeles endorsed no particular school, despite the group's name. In 1948 Ansel Adams, a stalwart of photographic purism, accepted an invitation to send his work to the Omaha salon, where it mingled with that of William Mortensen, Max Thorek, and other confirmed pictorialists.

Adams was also among the nonpictorialists who consented to sit on salon juries. Being a judge involved patiently viewing and scoring literally hundreds of submitted photographs, and it also meant having some say in what was hung. The increased diversity of work at pictorial salons undoubtedly was partly a function of more heterogeneous juries. In the 1930s *Life* photographer Margaret Bourke-White helped judge salons in New York and Philadelphia. In the 1940s Adams

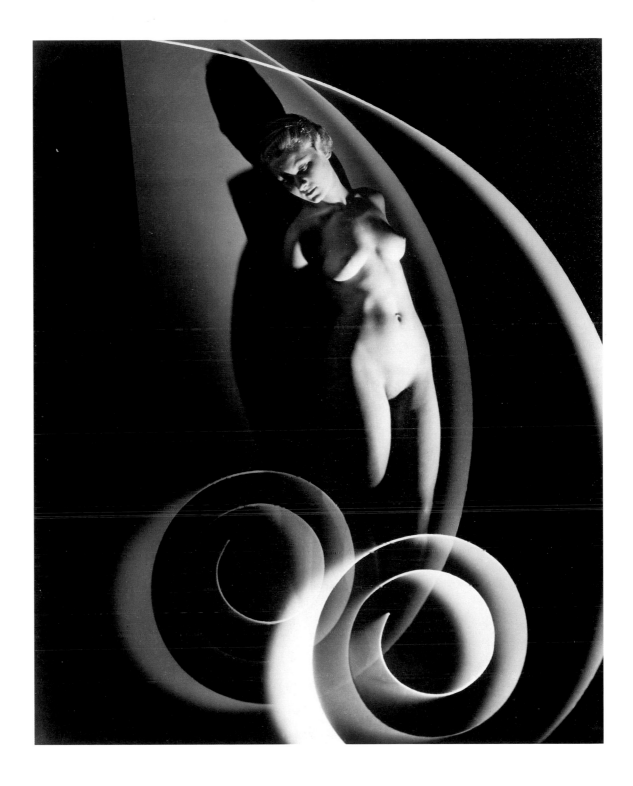

41. Harry K. Shigeta
Curves, A Photographer's Nightmare, 1937.
Collection of Lucille and Thomas H. Peterson.

did the same in Chicago and Sacramento, and Laura Gilpin served on the juries of selection in Omaha, Wichita, and St. Louis.

The American camera clubs that sponsored annual salons where modernists' work was included also presented one-person exhibitions featuring the same individuals. Between 1938 and 1950, numerous clubs showed the photographs of Edward Weston, for example. Among them were the Photographic Society of Philadelphia, Chicago's Fort Dearborn Camera Club, the Newark Camera Club, the Boston Camera Club, and the Camera Club of New York. The Boston club was particularly willing to show nonpictorial work, and did so with one-person exhibitions of Laszlo Moholy-Nagy and Margaret Bourke-White, as well as Weston. Frank R. Fraprie, editor of *American Photography* and an old member of the club, wrote to Alfred Stieglitz about these shows on April 2, 1941, pointing out that they were intentionally "including every scale of photographic thought, from romantic to modernistic." Confirmed modernists made personal appearances at camera clubs as well. Ansel Adams routinely gave talks and demonstrations at clubs around the country and actually spent an entire week with the Detroit Camera Club in the fall of 1941. And Moholy-Nagy presented lectures at least twice, in the late 1930s and early 1940s, to national conventions of the Photographic Society of America, where he promoted new trends in photography and his Chicago school, the New Bauhaus.

The periodicals devoted primarily to pictorialism reported all this activity and also bolstered modernist photography by publishing articles about and by major nonpictorialists, reviewing their new books, and reproducing their work. Some pictorialists regarded as excessive the efforts of the press to treat modernists equitably.

American Photography, the country's leading amateur monthly, gave modernists the most coverage. Despite the relatively conservative views of its long-standing editor, Frank R. Fraprie, himself an ardent pictorialist, the magazine was characterized by progressive ideas and images. The work of Frantisek Drtikol, for instance, began appearing as early as 1924, when two of his images won awards in the magazine's annual competition. During the next decade, the work of Pierre Dubreuil of Belgium, Walter Peterhans of Germany, Josef Sudek of Czechoslovakia, and the international modernist Man Ray was also published. In addition to European modernism, *American Photography* covered nonpictorial advances in this country. In February 1938 Nicholas Ház wrote a respectful lead article on Edward Weston as a purist. In the 1940s three of Weston's books were positively reviewed, and his first serious color work appeared in the magazine's ad pages in 1947. Ansel Adams, also of the f.64 tradition, received similar praise in book reviews and contributed a cover image for the magazine in August 1950. Fraprie celebrated the modernist work of Paul Outerbridge, Jr., in an exhibition review of 1924 and included a major article by Minor White in 1943. Even Alfred Stieglitz, the estranged godfather

42. Edward Weston
Pepper No. 30, 1930.
The Minneapolis Institute of Arts,
bequest of Dorothy Millett Lindeke.

of pictorialism, was favored; *American Photography* reviewed his 1921 exhibition at the Anderson Gallery and published a five-page article on him the year before he died.

Camera Craft, published in San Francisco, gave significant coverage to the West Coast photographers of Group f.64. Edward Weston's first major article, "Photography—Not Pictorial," appeared in 1930, and he later wrote an entire series, one of which featured his image *Pepper No. 30* (illus. 42) as a well-reproduced frontispiece. In 1933 Sigismund Blumann, editor of *Camera Craft*, reviewed the first (and only) Group f.64 exhibition, praising the photographers' intentions and finding in their work a present-day manifestation of the beautiful. Throughout the decade Ansel Adams and William Mortensen produced articles and letters for the magazine that debated the merits of purism and pictorialism, with each side receiving equal time. And Adams also provided numerous cover images.

Other pictorial-oriented magazines also opened their pages to alternative visions. *Camera* reproduced the work of Drtikol and ran a lead article on Weston in 1938, when he received a second Guggenheim grant. *Light and Shade*, published by the Pictorial Photographers of America, printed an open-minded review of Walker Evans's book, *American Photographs*. And the November 1948 issue of the Photographic Society of America's *PSA Journal* featured a major article by Ansel Adams, plus pieces on Roy Stryker's influence on documentary photography and the advanced fashion photographs of Maurice Tabard. Editors of most of the amateur magazines refused to "take sides" and continued to show their readers that accomplished work was being created beyond traditional pictorial lines.

Following their leads, most major pictorialists absorbed this advice and regarded avant-garde, straight, and modern photographers with tolerance and often admiration. They saw value in both individual work and entire movements that went counter to their own, praising and sometimes even collecting nonpictorial work. Adolf Fassbender, who owned books by Henri Cartier-Bresson and Brassaï, frequently advised: "Let us remember [that] new movements are healthy; they lead us to different ideas; they are necessary and stimulate progress."[28] Ansel Adams and Fred R. Archer, the longtime leader of the Camera Pictorialists of Los Angeles, were good friends, frequently corresponding about technical questions. Max Thorek reproduced an image by the Czech modernist Drtikol in his book *Creative Camera Art*. And William Mortensen found significance in German avant-garde photography, dubbing it in 1934 the "Meta-Realist" movement.

Edward Weston garnered particular praise. After working as a pictorialist for several years, he forsook the movement in the early 1920s and subsequently produced highly purist work that was widely admired by pictorialists such as Edward K. Alenius, Boris Dobro, and Harry Shigeta. During his presidency of the Pictorial Photographers of America, Ira W. Martin showed a copy of a new

book, *The Art of Edward Weston*, to a meeting of the organization and wrote to its printer: "Personally, I feel that at this time Edward Weston has taken photography far beyond all other workers."[29] Martin even collected work by Weston, buying a print of *Shell* from his one-person exhibition at the Delphic Studios in 1932. Such attitudes reflected the multifaceted nature of pictorial photography during this period.

The Influence of Commercialism

Before about 1910 pictorialists and professional photographers had very little to do with one another. The financially independent Stieglitz frowned on his Photo-Secessionists earning money with the camera, although a few did. Most pictorialists during this time made every effort to prove that their pictures were fine art and fine art only. They declared their motives to be purely self-expressive and created images that looked like other works of art. Generally, they found utilitarian photographs to be crass and commercial, in an entirely different class of work from their own.

By the second decade of the twentieth century, however, pictorial and professional photography began to overlap. Interestingly, it was the so-called amateurs, the pictorialists, who influenced the so-called professionals, the money-making businesspeople, rather than the other way around. This was a result of many amateurs infiltrating the professional field and the public's increased desire for creative pictures. As the pictorial ranks grew, more and more amateurs tried their hand at making a living with the camera. Having begun making photographs with art in mind, they naturally brought this sensibility to their work-for-hire and happily found customers receptive to more distinctive pictures. By the 1910s the average American had been exposed to well-designed and better-made commercial products across the board. The American Arts and Crafts Movement, spearheaded by Gustav Stickley and his Craftsman furniture, raised design standards throughout society, paving the way for utilitarian photographs of greater beauty as well. Most consumers were no longer satisfied with unimaginative portraits of themselves or their loved ones.

During the 1910s portrait photography improved dramatically. Previously, the average photographic portrait depicted sharply focused subjects stiffly posed against standard studio backdrops; it was merely an objective record of the surface appearance of the sitter. After pictorialists began making portraits with atmosphere and feeling, however, many professionals adopted the same effects. Relaxed poses, natural settings, and soft-focus effects were characteristic of photographic portraits by the 1910s.

The Photographers' Association of America (PAA), the country's national organization of profession-

als, embraced both the look of pictorial imagery and the salon system of pictorialism. Its annual conventions featured Gertrude Käsebier in 1909 and Alfred Stieglitz in 1912, each of whom urged members to make more creative work. At about the same time, Frank R. Fraprie reported that the organization's annual exhibition "was of a remarkably high grade of excellence, and it was apparent that simplicity and careful delineation of character are becoming the ideals of our best professionals."[30] In 1916 Edward Weston, then a young portrait and pictorial photographer from California, spoke to the PAA's national convention on "art principles as applied to photography." By this time the association had already tailored its convention exhibitions after the model of the pictorial salon. A qualified jury judged the pictures on artistic (not utilitarian) merit and then oversaw their tasteful installation.

Pictorial photography influenced professional work outside portraiture as well. After 1910 more and more creative photographs were seen as illustrations and advertisements and in other commercial forms. From 1914 to 1917 Karl F. Struss, the last photographer to join the Photo-Secession, made photographs of home interiors and railroad stations that appeared in such magazines as *Harper's Bazaar*. These pictures revealed Struss's subjective use of the camera and were more than mere visual accompaniment to the text. The little journal *Platinum Print*, in which Struss advertised his services, promoted the use of creative photography for illustration. In 1914 an unidentified author wrote: "The facility of its reproduction, the economic advantage it affords over other arts, its adaptability to personal expression, and its universal and understandable appeal are implements the intelligent users of the camera should employ in helping photography to take its place in the world of illustrative art. For the illustration of stories and poems, there is no reason on earth why a photograph should not be desirable to a publisher."[31] Similarly, the West Coast magazine *Camera Craft* ran a lead article for its amateur readership, "Selling Photographs to Publications," covering applications in literature, poetry, advertising, newspapers, science, and technology. By the end of the decade, Paul L. Anderson observed a significant increase in soft-focus pictures in advertising— an obvious result of pervasive pictorial influences.

Commercialism fully developed in the United States during the 1920s, with the dawn of the machine age. Regional differences declined and business opportunities increased as more and more Americans moved to the city and the automobile became commonplace. After World War I the country shifted from an ethic of production to an ethic of consumption—*mass* consumption. Consumers embraced the new concept of "buy now, pay later," as credit increased and they were able to buy on layaway and installment plans. Business became the national religion of sorts, with corporate heads, like Henry Ford, its prophets. In 1925 President Calvin Coolidge succinctly declared that the business of the American people was business itself.

When mass-marketing came into its own, photography played a key role. The science and psychology of selling products relied heavily upon the photographic image and its ability to persuade potential buyers to become regular customers. Photographs—objective, unaltered, easy to comprehend—were considered the perfect medium for idealizing and dramatizing commercial products. As a result, numerous photographic disciplines developed, seemingly overnight, into major new professions. Advertising, illustrative, editorial, and industrial photography exploded with the growth of commercialism.

Commercial photography during the 1920s and 1930s was largely modernist in appearance. Pictures sported high-contrast tones, dramatic lighting, dynamic compositions, abstract visual elements, and exciting new subject matter. The best commercial photographers exploited these and other artistic effects to give their work more than mere commercial appeal. Successful commercial shots often stood on their own as creative images and appealed to visually sophisticated viewers.

Pictorial photography and commercial photography shared a basic goal: emotional appeal. Both disciplines strove to tap acceptable, common, widespread, and public feelings, albeit for different purposes (one being art, the other commerce). They each favored simplicity, idealization, and rampant optimism. Neither type of photographer wished to disturb viewers or confront them with difficult questions. Descriptions of either form of photography easily apply to the other, as demonstrated by the following characterization of advertising photography: "[It] simplifies and typifies. It does not claim to picture reality as it is but reality as it should be—life and lives worth emulating. It is always photography or drama or discourse with a message—rarely picturing individuals, it shows people only as incarnations of larger social categories. It always assumes that there is progress. It is thoroughly optimistic."[32] Virtually this entire description applies equally well to pictorial photography between the world wars.

The relationship between pictorialism and commercialism during this period was tight and mutually beneficial. Pictorial photographers continued to turn to commercial photography for a living, bringing their creative sense to the profession. Their new and inspired work often led other professionals to make their own commercial assignments more challenging. Pictorialists were somewhat awed by the highly developed technical abilities of many professionals, who usually were happy to share their knowledge at camera-club-sponsored lectures and demonstrations. Each group learned from the other, their work as well as their membership openly intermingling.

Pictorial photography infused new blood into professional photography in the 1920s. At the beginning of the decade, demand was high for pictorial images for illustration and advertising, and the prices paid for such pictures reflected their value. The West Coast monthly *Camera Craft* closely followed this development and the changes it wrought: "Let us consider the advertising picture of

today and of 'yesterday.' There was a baldness in yesterday's work which is growing rarer today. There are two ways of advertising an article by picture. The older way is by a representation of the article itself, and let it go at that. The newer way is to show the article, and to suggest the uses to which it may be put. Here the pictorial element is introduced. The one picture appeals to the imagination and is more likely to be remembered because it is interesting; the other, failing to interest, is quickly forgotten."[33] *Camera Craft* considered its target audience commercial photographers, as well as pictorialists. In October 1924 the magazine editorialized in the article "The Amateur and the Professional," observing that pictorial salons were accepting work from photographers who managed portrait galleries and commercial businesses, all of whom were seeking to give their prints "pictorial value." At the same time it devoted regular columns to such organizations as the Photographers' Associations of America, California, and the Pacific Northwest. The magazine reported on a national convention speech to the Pacific Northwest group by the Canadian photographer John Vanderpant titled "Pictorial Photography"; it was no coincidence that Vanderpant was both a practicing professional and an accomplished pictorialist.

In 1922 California pictorialist Arthur F. Kales began writing a regular report on photography in the western United States for the English annual *Photograms of the Year*. He frequently touched on the relationship between pictorial and professional photographers, noting in 1925, for instance, that six of the most prominent salon exhibitors from Los Angeles, where he lived, were now working professionally. Three years later Kales praised the creative work of these photographers: "With hardly an exception the best work being done today comes from the hands of men who pursue photography as a profession. The Studios of Hollywood have claimed some of our best workers and others have gone in for portraiture and commercial illustration."[34] Among them was Fred R. Archer, who headed the titles department at Universal Pictures and belonged, along with Kales, to the Camera Pictorialists of Los Angeles. Archer made most of his pictorial images on the sets of the films on which he worked, producing pictures like *An Illustration for the Arabian Nights* (illus. 43). Divorced from reality and highly fabricated, the picture satisfied both commercial and pictorial standards.

In 1929 Leonard A. Williams's book *Illustrative Photography in Advertising* was published. Richly illustrated with photographs and magazine ads, it included work by Baron Adolf de Meyer, Lejaren à Hiller, and others, many in the art-deco style. The book, which frequently used the term "pictorial publicity photography," addressed various subjects—equipment, the studio, color, and typography—but the emphasis was on aesthetics. Its first three chapters dealt with composition, a concept at the core of pictorial photography. "We find that composition, meaning good taste in arrangement of things, is the thing that is needed," Williams wrote. "Every writer of advertisements or short stories lives up to the rule—Have a single character, a single event, and a single emotion. Now, the illustra-

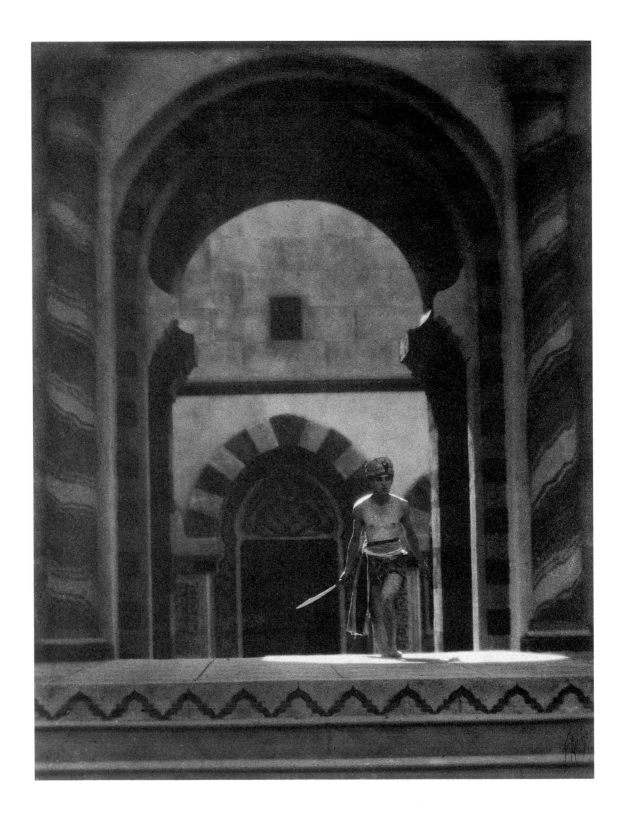

43. Fred R. Archer
An Illustration for the Arabian Nights, c. 1924.
Photographic Society of America.

tor, or pictorial publicity photographer, must have rules similar to the writer. His rule is—Every picture must have a border line known as the frame; within that frame a center of interest must be placed at what is known as the aesthetic center or A.C. point. Some call it the talking point."[35] Simplicity was paramount for Williams, as it was for all traditional pictorialists, and pictures made according to his method found favor among both advertising representatives and salon judges.

The Great Depression of the 1930s affected every profession and pastime, including professional and pictorial photography. Financial restraints curbed photographic activity nationwide. Obviously, fewer businesses had the money to advertise, and fewer hobbyists could afford to buy materials. But both forms of photography played on escapist attitudes. Whether it was the average consumer who was still encouraged to buy or the devoted amateur who made his own pictures, forgetting about everyday conditions was a large part of the appeal of their respective activities. During these difficult economic times, professional and pictorial photography came closer together because they shared a goal—to provide an escape from reality.

Portrait photographers showed particular interest in pictorial effects during the depression. Those who successfully sent pictures to photographic salons became known in their communities as artists working not primarily for money but for their love of the medium. This increased their local reputation and, ironically, allowed them to charge more for their commissioned work. In March 1931 Louis Fabian Bachrach, the founder of a national chain of portrait studios still in existence today, wrote an article titled "Pictorial Interest in Portraiture" for *American Photography*. He stated that every portrait should have a significant amount of "pictorial interest," an element involving the suppression of detail, simple composition, controlled lighting, and a supporting background. Bachrach had faith in the public's increased interest in artistry over technique in photographic portraiture. A few years later the renowned New York portrait photographer Pirie MacDonald joined with pictorialists Adolf Fassbender, D. J. Ruzicka, and a few others to found the Oval Table Society, a group dedicated to promoting pictorial salons. MacDonald, known as the "Photographer of Men," had long supported artistic photography, joining the progressive Camera Club of New York early in the century and contributing an image to its quarterly, *Camera Notes*. He occasionally showed his work to meetings of the Pictorial Photographers of America and spoke to them in 1920 about the "pictorial side of professional photography." Alexander Leventon, of Rochester, New York, was among the other photographers of the time who combined pictorial and portrait concerns (illus. 44 and 45).

Monthly magazines continued to cover both professional and pictorial photography, sometimes disagreeing about which was most influential. In the early 1930s, Herbert Brennon wrote a four-part series on contemporary commercial photography for *Camera Craft*, stating at one point that

"a commercial print nowadays is almost pictorial. The appeal is built into every feature of it."[36] A few years later, Fred G. Korth (illus. 46), a leading industrial photographer, claimed that "many old-fashioned rules of composition have been thrown over board. Today's amateur pictorialists are imitating the best professionals whose work they can study in each issue of *Vanity Fair, Harper's Bazaar, Fortune, Technology Review* and a lot of other publications."[37] Margaret Bourke-White, also known for her industrial photographs for *Life* magazine, was among those contributing to such periodicals. In 1936 the Photographic Society of America (PSA) chose a Bourke-White image of the George Washington Bridge as the only reproduction in the prospectus for its new publication, the *PSA Journal*. Although the PSA was a bastion of pictorialism, it obviously admired graphically modernist work—further proof of the crossover between pictorialists and professionals.

Some magazines in the 1940s seemed particularly intent upon encouraging their amateur readers to enter the professional field. *Camera Craft* pointed out that it made more economic sense to "peddle" one's pictures to advertisers, who paid the maker to use them, than to send them to the pictorial salons, which required an entrance fee from the pictorialist. *American Photography* featured a 1942 article titled "Pictorial Pictures Sell!," which advised pictorialists to print their successful salon images on glossy paper and to use a marketing guide that listed the particular interests of magazines. In the late 1940s, the Baltimore-based magazine *Camera* deluged its amateur readership with information on commercial photography. It began with a nearly year-long series on various forms of professional work, including architectural, industrial, catalog, fashion, mural, and legal photography. In 1948 it ran at least two articles on how to shoot magazine covers, and the next year another series—"Super Shots in Industry"—reproduced and analyzed individual pictures. The magazine also featured a ten-page listing of nearly two hundred publications that purchased photographs for illustration and editorial use. Such resources reinforced the idea that the line between art and commerce had been erased.

A. Aubrey Bodine, a renowned Baltimore pictorialist and newspaper photographer, was a contributing editor to *Camera* at this time. Bodine (illus. 47) was one of many photographers who wore two hats, both making his living with the camera and using it for personal pleasure. He felt that his involvement with pictorialists benefited his work-for-hire because it constantly challenged his artistic standards. "Competition with amateurs keeps me on my toes and helps me to keep my newspaper work up to snuff," he stated. "I will say without hesitation that if it were not for my salon work I would not put half as much effort into each assignment. Salons are a goal I enjoy shooting at."[38] Many of the very images Bodine made on assignment for the *Baltimore Sunday Sun* were accepted at pictorial salons, a circumstance that vividly illustrated the marriage of utilitarian and creative photography.

46. Fred G. Korth
Galvanized Sheets, c. 1948.
The Minneapolis Institute of Arts,
gift of Lora and Martin G.
Weinstein.

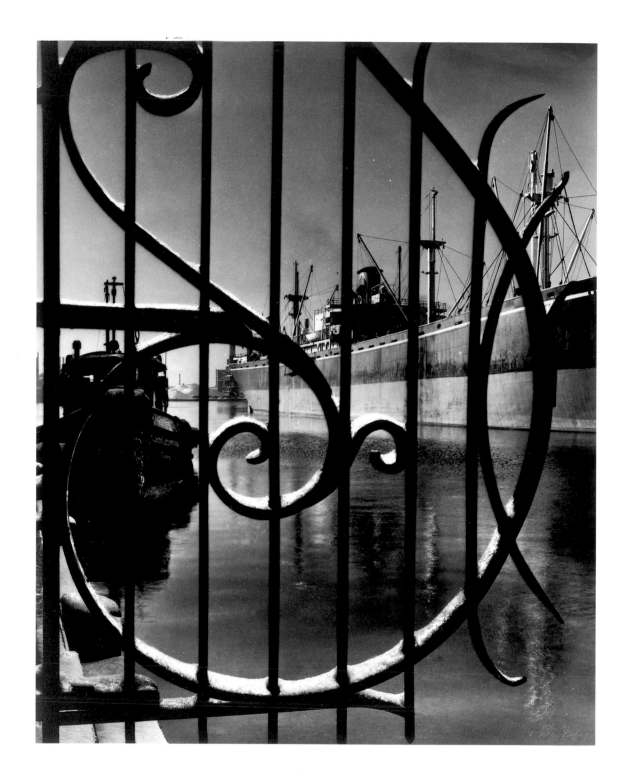

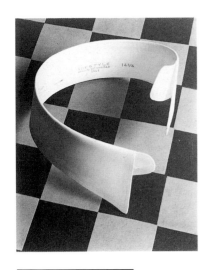

Other photographers joined Bodine in successfully sending prints of their commercial work to picto-rial salons around the country at this time. For example, *Ide Collar* (illus. 48) by Paul Outerbridge, Jr., appeared in the first salon of the Pictorial Photographers of America in 1923, retitled *An Adver-tisement.* William Rittase (illus. 49), of Philadelphia, sent a picture he originally made for the cover of a small magazine to salons in London, Pittsburgh, and Los Angeles. "The pictures which I send to the salons are picked from the day's work," Rittase declared. "To me, my commercialism is my pic-torialism. They are inseparable."[39] In the 1940s Paul Linwood Gittings, a leading portrait photogra-pher, saw his work accepted at salons in St. Louis, Baltimore, and Cincinnati and repeatedly served on the jury of the Houston salon of photography. For most pictorialists, their work and that of their professional counterparts were, indeed, increasingly inseparable.

The general pictorial salons sometimes included special sections for this material, and occasional-ly entire salons were devoted to commercial work. In 1933 the first Detroit International Salon of Industrial Photography was presented—at the same time and in the same building as the city's sec-ond pictorial salon; the joint exhibitions drew 30,000 viewers to the Detroit Institute of Arts. Seven years later, the Photographic Society of America announced a series of industrial salons that would "interest photographers in artistic representation of the spirit and scope of modern industry." Pictori-alists D. J. Ruzicka and Edward K. Alenius were two of the three judges of the First Petroleum Indus-try Photographic Salon, and the prints were "selected in accordance with the highest pictorial stan-dards."[40] When the San Diego salon featured a commercial section in 1935, most of the medal winners turned out to be pictorialists who made their living as professionals. Likewise, the Wisconsin Centennial International Salon of Photographic Art, held in 1948, included industrial work by such photographers as Bodine (illus. 50), M. M. Deaderick, Jean Elwell, and Dorothy Pratte, all known for their pictorial accomplishments.

The mergence of artistic photography and business concerns also was evident in magazine adver-tisements for photographic materials. Manufacturers such as Kodak appealed directly to the salon aspirations of pictorialists and obtained endorsements from leading figures in the field. Its ads often pictured individuals admiring salon installations or the backs of prints bearing numerous exhibition stickers, implying that similar success awaited those who used Kodak's products. A 1941 advertise-ment for a paper manufacturer declared, "Every salon exhibitor—veteran or beginner—seeks per-fection. Perhaps that is why so many outstanding prints hung in every salon are made upon Defender Velour Black."

Leading pictorialists allowed manufacturers to use their names, portraits, and images to sell cam-eras, exposure meters, papers, chemicals, and nearly every other photographic product. The snow photographer Gustav Anderson (illus. 51), for instance, endorsed Kodabromide paper and

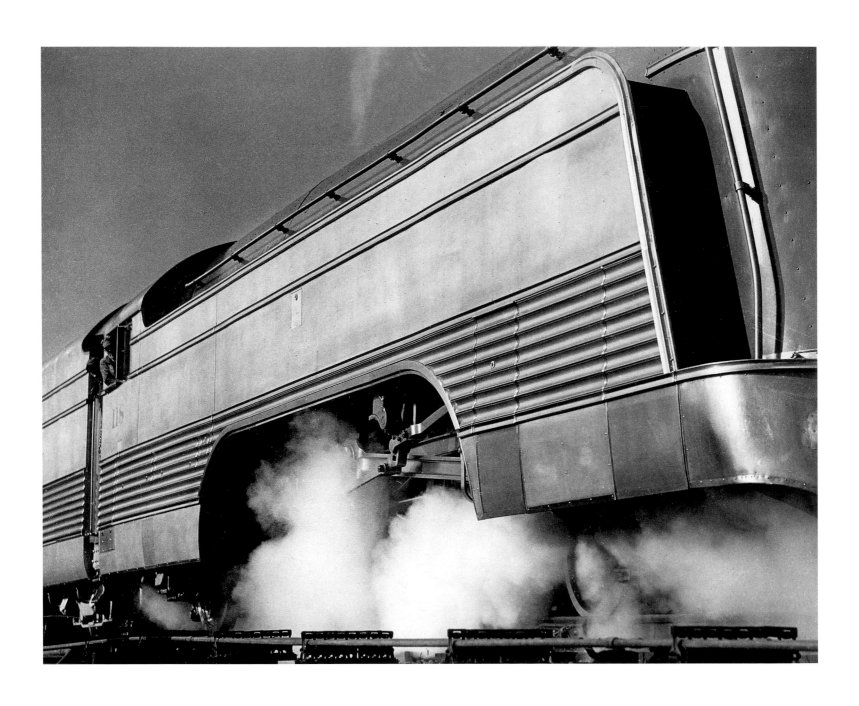

49. William Rittase
Untitled, 1930s.
Private collection.

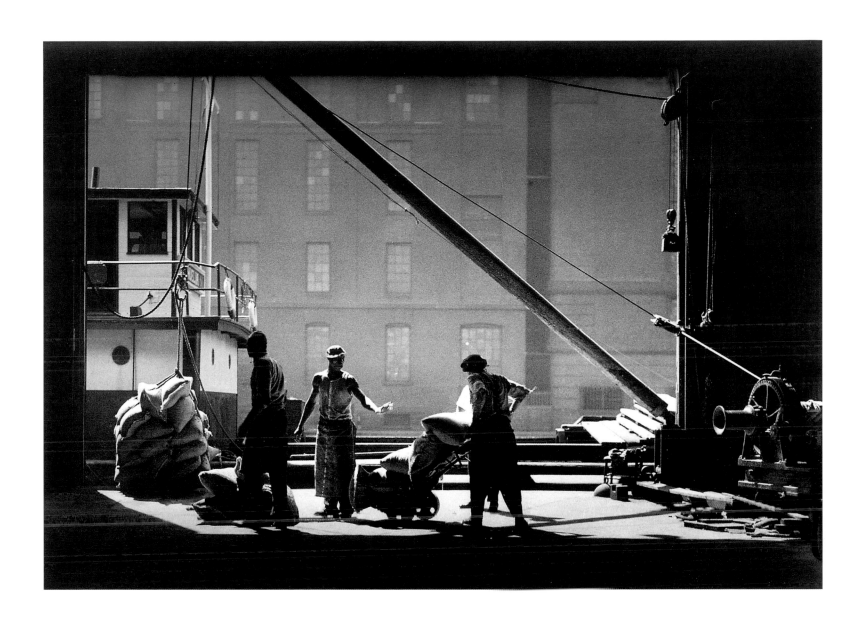

50. A. Aubrey Bodine
Dock Workers, Pratt Street, 1925.
The Minneapolis Institute of Arts,
Tess E. Armstrong Fund.

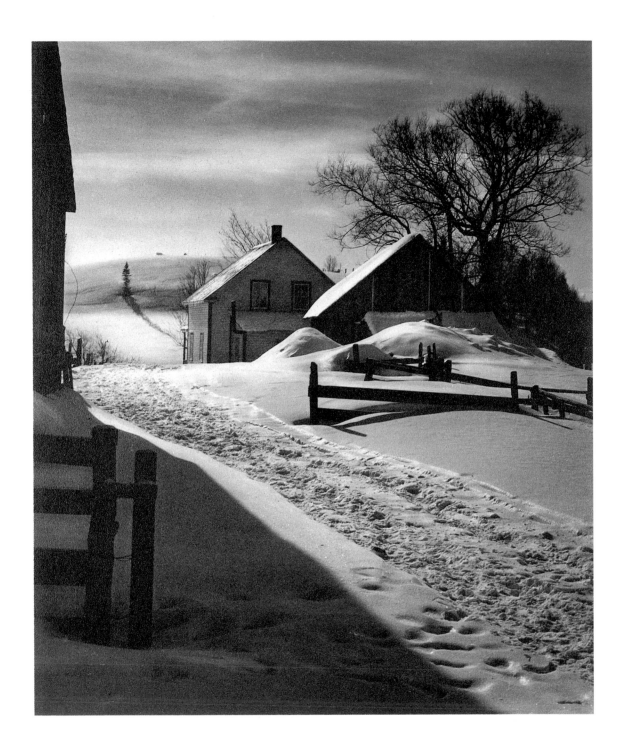

51. Gustav Anderson
Winter Eve, 1938.
Photographic Society of America.

General Electric light meters. Eleanor Parke Custis let the DuPont company reproduce one of her images in ads for their photographic paper. And Adolf Fassbender endorsed such products as the Weston exposure meter, modestly explaining that, despite his great experience at judging light, unusual circumstances sometimes required him to rely on a meter. The Folmer Graflex Corporation of Rochester, New York, proudly ran full-page ads in 1938 picturing eleven leading American photographers—including pictorialists Frank F. Fraprie, Forman G. Hanna (illus. 53), Fred P. Peel, and Max Thorek—who used their cameras.

Some pictorialists even went into business for themselves. Aware of the large market for photographic materials, William Dassonville, William E. Mortensen, and Karl F. Struss (all, coincidentally, Californians) produced products to which they attached their own names. In 1924 Dassonville (illus. 54) established a company to manufacture his rich Charcoal Black paper, a favorite with discerning pictorialists for decades. Mortensen's name appeared on studio lights, texture screens, and other equipment geared to the many amateurs and professionals who studied at his school from the 1930s to the 1950s. And Struss was responsible for the Struss Pictorial Lens, a soft-focus lens popular among both still photographers and cinematographers during the 1910s. The plurality of pictorial photography in the post-Secession era allowed pictorialists to make money and professionals to make art.

The Clarence H. White School of Photography and the Pictorial Photographers of America

Traditional beauty, modernism, and commercialism were the main ingredients that made pictorialism a photographic hybrid after 1910. Photographers mixed together these elements, working alone in their darkrooms or communally at their local camera clubs. But perhaps the most hospitable places for cooking up unique pictorial recipes were the Clarence H. White School of Photography and the Pictorial Photographers of America. Both institutions were based in New York and followed the lead of Clarence H. White until his untimely death in 1925. For a decade and a half, White served as master chef to the rich stew that was pictorial photography.

White was a gentle midwesterner who moved from Ohio to New York City in 1906. His photographic career was the perfect metaphor for the new pictorialism: a sensitive, artistic photographer taking up the mantle of commercial photography. White established his creative reputation early in the twentieth century by making evocative, softly focused figure studies in the rural Midwest, usually using family members as subjects (illus. 52). Stieglitz included him as a founding member of the Photo-Secession and presented many of his images as exquisite photogravures in *Camera Work*.

52. Clarence H. White
Morning,
photogravure from *Camera Work*, No. 23 (July 1908). The Minneapolis Institute of Arts, gift of Julia Marshall.

53. Forman G. Hanna
Grand Canyon, 1920s.
The Minneapolis Institute of Arts,
gift of Terry Etherton.

54. William E. Dassonville
Beach Grass, c. 1920.
The Minneapolis Institute of Arts,
gift of funds from Jud and
Lisa Dayton.

In 1904, however, White began working as an itinerant portrait photographer. And upon moving to New York two years later, he landed teaching positions at Teachers College of Columbia University and the Brooklyn Institute of Arts and Sciences. By the time he began running his own summer school in 1910, he was committed to combining the utilitarian aspects of professional photography with the artistry of pictorial photography. A few years later, he stated, "I believe commercial or professional photography should be pictorial. Pictorial photography is simply a name applied to photography that really has or should have construction and expression."[41] For White, the two fields were anything but mutually exclusive.

In 1910 White acquired an old house on a Maine island, took out an advertisement in *Camera Work*, and began teaching his personal brand of practical photography to a small contingent of students. The school was close to the summer home of pictorial photographer F. Holland Day, who regularly critiqued student work. Gertrude Käsebier, a former Photo-Secessionist, also visited to show her work, providing another high-art influence on the students. Marie Riggins, an early student, later recalled the school's emphasis on the lighting conditions typical of White's own most accomplished pictorial work. "Our day began with the impressionistic morning light," she wrote. "We were encouraged to be out and at work by five or six in the morning in order to photograph the early mists, to seek forms meeting in diffused light."[42] Riggins also pointed out that White spoke most frequently on composition and design, his master topics, and that most of the students were deeply interested in making salon prints. Many years later, Paul L. Anderson, one of the early instructors at the school, observed that, as a teacher, White "leaned almost exclusively toward pure aestheticism."[43]

In 1914 the Clarence H. White School was established in New York as a full-time institution. Technique and vocational preparation became more important, but artistic training remained essential to the curriculum. The painter Max Weber, for instance, taught art history for many years, taking his classes to museums to study both original paintings and decorative-arts objects. Standing in front of a Rembrandt oil or a Chinese rug, Weber would point out the importance of its design and its composition, encouraging the students to think abstractly. Paul L. Anderson, an accomplished pictorialist in his own right, taught technique but emphasized such manipulative processes as gum-bichromate, carbon, oil, bromoil, and photogravure and suggested that professionals who used creative printing processes easily added an aesthetic look to their work-for-hire. According to a 1919 White School brochure, this approach was exactly what many working photographers wanted. In this promotional piece, a leading professional was quoted as asking, "Why not help us make our work an art product so that we can honestly add to our name 'Art Photographer'?"[44]

The White School occupied various locations in Manhattan during its thirty-two-year existence. It stayed the longest, from 1920 to 1940, at 460 West 144th Street, where White and his successors

continued to integrate creative ideas with professional responsibilities. In 1921 White observed that magazines and newspapers were increasingly reproducing soft-focus work in their editorial and advertising pages. Among the guest lecturers at the school were photographers Paul Strand, Edward Steichen, and Alfred Stieglitz, who spoke on the "education of the photographer." Addressing the business of printing and publishing were Heyworth Campbell of Condé Nast, an art director from the J. Walter Thompson advertising agency, and editors from *Munsey's Magazine* and *Woman's Home Companion*.

Former White students were so proud of both their mentor and their subsequent accomplishments that they had formed an alumni association by 1920. The association published an irregular bulletin and two annuals, titled *Camera Pictures*, which are valuable records of their activities. As an example, the December 1920 bulletin detailed the publishing, exhibition, and other artistic pursuits of about twenty alumni. Among them were Laura Gilpin (illus. 55), who was on the board of a Colorado Springs art colony; Clara E. Sipprell (illus. 56), who was making a series of photographs for the *Saturday Evening Post*; and Doris Ulmann (illus. 57), who was completing her second book of portraits, printed in photogravure. *Camera Pictures*, which appeared in 1924 and 1925, was a well-designed publication similar in look to the contemporaneous annuals of the Pictorial Photographers of America. Probably designed by Frederic W. Goudy, who taught typography at the White School, they featured reproductions by such former students as Anton Bruehl, Ira W. Martin, Paul Outerbridge, Jr., and Margaret Watkins, all of whom were by then leading American professionals. Not surprisingly, the primary objective of the alumni association was to promote "pictorial photography as a vocation."

After White's death in 1925 at the age of only fifty-four, his wife and son maintained the school. Aided by alumni and friends of White, they pursued the founder's original desire to teach creative photography as a vocation. Until it closed in 1942, the school promoted the methods and advantages of combining art and industry in photography. In its last years, its board of advisers included such photographers, art directors, and artists as Ansel Adams, Dr. M. F. Agha, and Max Weber, respectively, as well as typographers, art professors, and motion-picture engineers. One of the school's last course catalogs reproduced a portrait of White and an early statement of his on "training in photography." In it he declared: "The best way to get this training is to attend a school of photography where one gets the fundamentals which are practically the same for all branches of photography—the understanding of the chemical and physical reactions involved in the many processes which are being used and developed, the cultivation of a sense of the beautiful, and an aptitude for composition and design."[45] These three elements were expertly combined at the White School to produce a superb curriculum for artistically aspiring professional photographers.

Numerous photography schools operated around the country, but other than the White School,

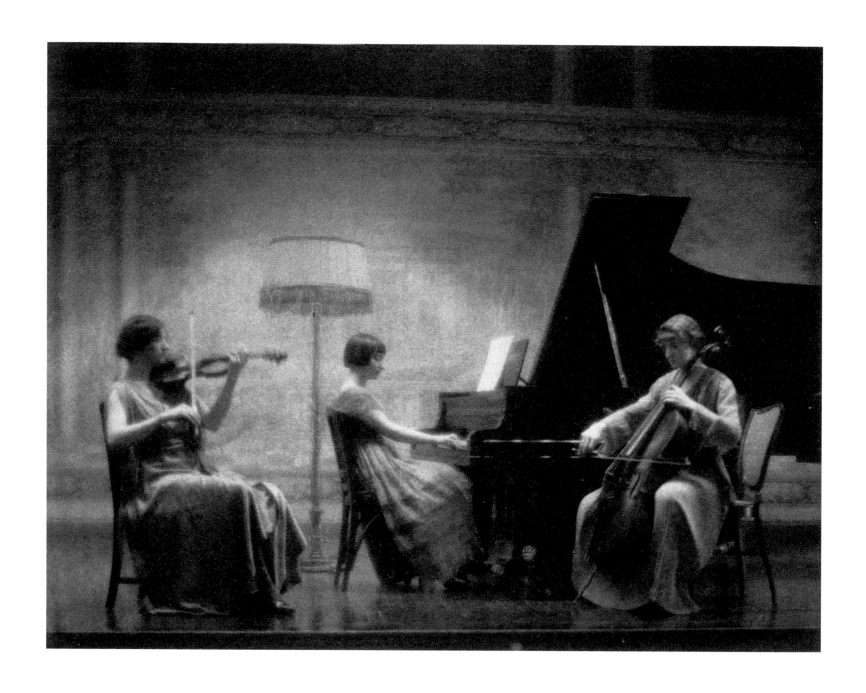

55. Laura Gilpin
The Prelude, 1917.
Laura Gilpin Collection, Amon
Carter Museum, Fort Worth, Texas.

56. Clara E. Sipprell
Old Bottle with Woodbine, 1921.
Amon Carter Museum, Fort Worth,
Texas.

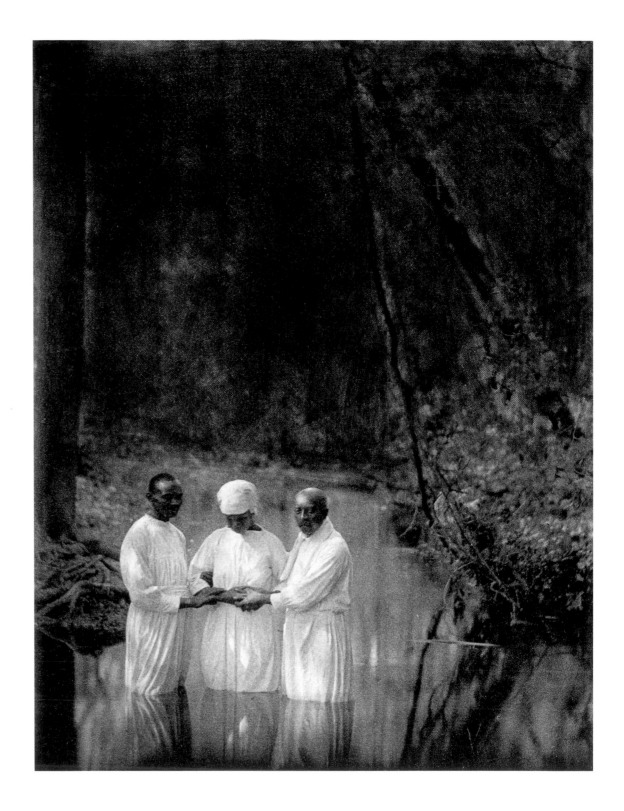

only a few addressed aesthetic issues; most provided only impersonal training for standard commercial work. The schools that did incorporate art were invariably run by individuals—for example, Ben M. Rabinovitch, Adolf Fassbender, and William Mortensen—who themselves made creative images. Rabinovitch (illus. 58) opened the Rabinovitch School and Workshop of Art Photography in 1920 in his own New York studio. In this atelier-like setting, he provided personalized training for both advanced amateurs and creative professionals, sharing his extensive knowledge of different printing techniques. Fassbender, who taught both privately and at a few New York schools, influenced nearly 20,000 individuals during his half century of teaching. Beginning about the time of White's death, he taught manipulative skills to pictorialists and artistic portraiture to professionals, even making an instructional film called *From Scene to Salon*. Mortensen, the best-known California pictorialist, opened the William Mortensen School of Photography in Laguna Beach in 1932 and taught there for thirty years. Mortensen's curriculum, which focused on unique methods of altering primarily figure and portrait images in both black and white and color, appealed to pictorialists and professionals alike.

Shortly after establishing his summer and New York schools, Clarence H. White spearheaded the formation of the Pictorial Photographers of America (PPA). Organized in 1916, with Gertrude Käsebier as the honorary vice-president, the PPA replaced the Photo-Secession as this country's leading organization of pictorialists. True to its name, it initially promoted traditional, soft-focus work, although with a much more populist approach than the Secession. During the 1920s, however, the PPA began embracing other forms of photography and soon was instrumental in bringing a pluralism to pictorialism.

The PPA's interdisciplinary philosophy was confirmed in 1921, when it joined with six other New York arts organizations to open the Art Center. Other participants included the Art Alliance of America, the Art Directors Club, the American Institute of Graphic Arts, the New York Society of Craftsmen, and the Society of Illustrators. This institution, which provided the PPA with a permanent home, represented each organization's specific desire to interact with one another, as well as a general desire to integrate art and industry. PPA president A. D. Chaffee wrote in the group's 1922 annual that the Art Center "is devoted to the development and association of various Arts and Crafts, to interesting the public therein and, particularly, to bringing producer and user together." As advertisers and art directors gained better access to illustrators and photographers, each artist's work was seen more widely, and the public standard of utilitarian art was raised.

At the Art Center and elsewhere, the Pictorial Photographers of America heard knowledgeable speakers discuss the multifaceted nature of both pictorialism and contemporary photography in general. For example, the PPA's 1922 summer conference, held in conjunction with the White sum-

58. Ben M. Rabinovitch
Nude Torso, c. 1929,
photogravure. Howard Greenberg
Gallery.

mer school, now in Canaan, Connecticut, featured a topic titled "What the Photographic Magazine Can Do for the Pictorial Photographer, and What the Pictorial Photographer Can Do for the Photographic Magazine." In 1931 Dr. M. F. Agha, art director of Condé Nast publications, took PPA members to an exhibition of foreign commercial photography and described its achievements. A few years later, the monthly meetings included talks by the Philadelphia professional William Rittase and the New York professional Harold H. Costain, who spoke on "pictorial principles applied to architectural photography." Other speakers included curator Beaumont Newhall and photographers Berenice Abbott, Ansel Adams, Lejaren à Hiller, and Willard D. Morgan, each of whom advocated a personal style of work.

The publications of the Pictorial Photographers of America similarly reflected a catholic attitude toward photography. In the 1920s, the PPA produced five handsome hardbound annuals titled *Pictorial Photography in America*. The first three volumes included mostly photographs of traditional pictorial beauty, but some modernist-inspired images were also reproduced. Prominent among them were Bernard S. Horne's *Design* (illus. 59), which appeared in 1920, and Margaret Watkins's *Domestic Symphony* (illus. 60), in 1922. Both pictures retained the soft-focus effects of early pictorialism but rejected its obsession with accessibility and sentimentality. Horne and Watkins used mundane subjects, emphasized the design of the image, and achieved nearly abstract pictures. Other contributors to the early PPA annuals were individuals who soon became known exclusively for their purist, modernist, or straight photographic work, such as Imogen Cunningham (illus. 61) and Edward Weston (illus. 62).

In 1926 the PPA's annual plunged headlong into the vast turbulent pool of professional photography by featuring an entire section on advertising. It reproduced the work of Anton Bruehl, Paul Outerbridge, Jr., Wynn Richards, Ralph Steiner, Margaret Watkins, and others who had been commissioned by such clients as *Harper's Bazaar*, Macy's department store, and *The New Yorker*. Watkins, a prominent member of the PPA as well as a successful professional, wrote the introduction, acknowledging the influence of such modern artists as Cézanne, Matisse, and Picasso and noting those affected by recent advances in advertising photography.

The new, direct attitude is refreshing. Even the plain businessman, suspicious of "art stuff," perceives that his product is enhanced by fine tone-spacing and the beauty of contrasted textures. And the purchaser, however indifferent to circular rhythms, unconsciously responds to the clarity of statement achieved by stressing the essential form of the article. The art director now realizes that the camera has its own beguiling—and bedeviling—little ways. And the photographer, with more leeway, assumes greater responsibilities. He respects the demands of layout, has some knowledge of reproduction, and appreciates the relation of type-matter and illustrations to the balanced page.

59. Bernard S. Horne
Design, c. 1917.
Collection of Keith de Lellis.

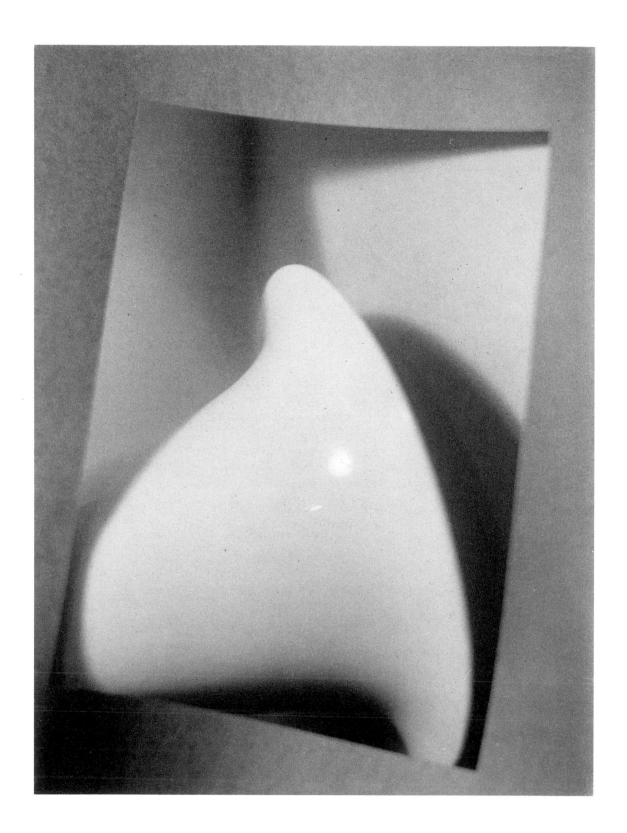

60. Margaret Watkins
Domestic Symphony, 1917.
Amon Carter Museum, Fort Worth,
Texas.

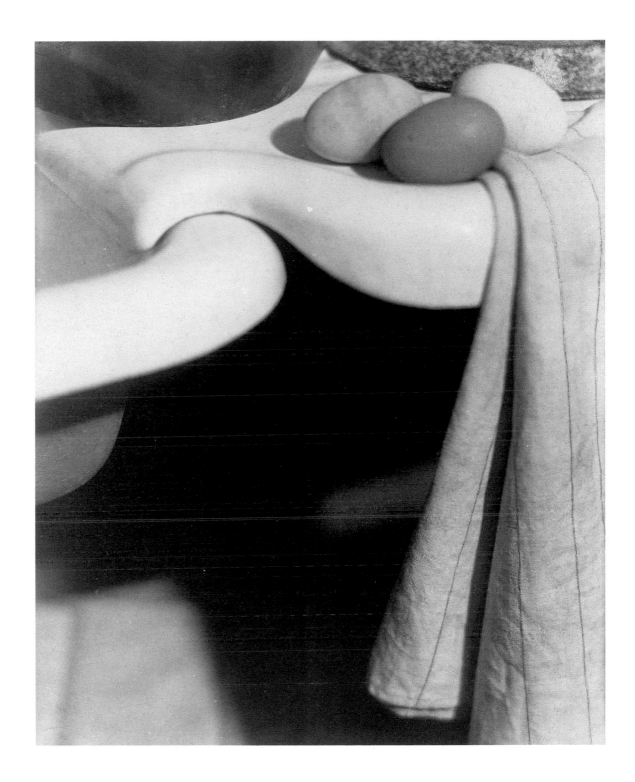

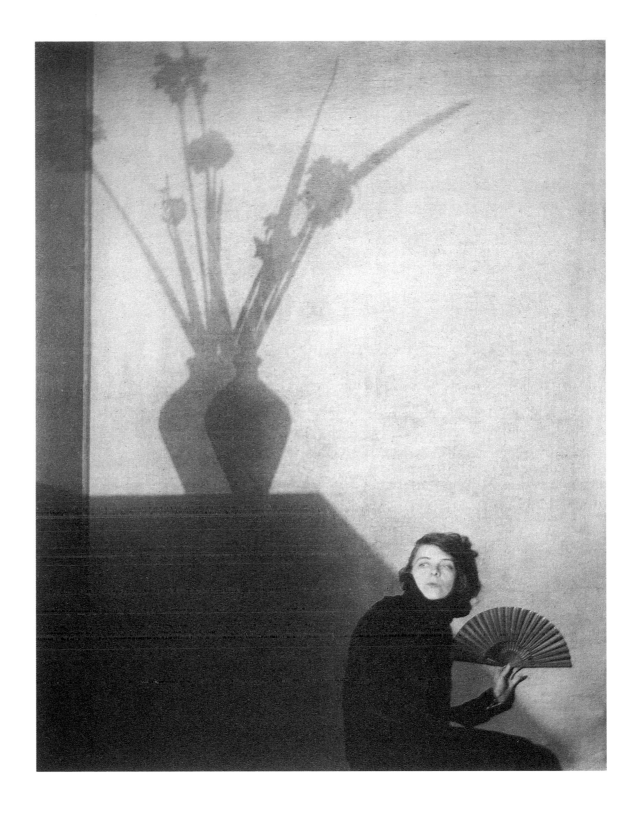

As an innovation we include some photographs which show the new point-of-view toward advertising. Though purely commercial, we feel that they have distinction and beauty which enable them to hold their place beside anything in the so-called pictorial section.[46]

Watkins's remarks imply that she considered pictorial photography the standard by which to judge good commercial work. But with "distinction and beauty," as well as design and drama common to both genres of photography, the difference between them continued to diminish.

In addition to its important annuals, the Pictorial Photographers of America began publishing a regular newsletter called *Light and Shade* in late 1928, shortly after Ira W. Martin became president. It was no coincidence that both Martin and editor Thurman Rotan were professional photographers who worked together at New York's Frick Art Reference Library. Geared to PPA members, *Light and Shade* was not as influential as the five annuals, but it did continue to proclaim the multiple dimensions of pictorial photography after the Photo-Secession.

From the beginning, work by pictorially minded professionals, such as Anton Bruehl, Imogen Cunningham, and Margaret Bourke-White, appeared on the newsletter's covers. The second and third issues contained an unsigned, two-part article in which the author—probably Martin—observed how new pictorialists were abandoning the painterly approach and embracing, instead, the realistic and purist qualities of photography: "This new school sees fit to take photography for what it is, and use to the utmost its inherent assets. The greatest of these is the unconsciously established reputation for honesty in depicting a thing."[47] Throughout the 1930s, *Light and Shade* covered modernism and other trends in photography. An issue largely devoted to the work of Edward Weston quoted numerous laudatory newspaper reviews and his own daybooks. In 1939 PPA president Thomas O. Sheckell spoke forthrightly about the organization: "As a national society of long standing we still want to be able to recognize the varied fields of endeavor in picture making. We want to show to the public all the best in whatever 'school,' if 'schools' the trends might be called. We have no desire to select and represent any one means of expression. They are all interesting to us."[48]

The salons of the Pictorial Photographers of America regularly featured work from various movements. In 1923 its first presentation included submissions by five former Photo-Secessionists, representing the old school, plus photographs by such budding modernists as Imogen Cunningham, Paul Outerbridge, Jr., and Edward Weston. Soon PPA juries included individuals like Anton Bruehl, an established professional photographer, and the precisionist artist Charles Sheeler. In 1937 the PPA began accepting photographs in an array of different classes, such as modern, illustration, architectural, press, science, and natural history. Two years later, it presented its most significant salon, simultaneously celebrating the centennial of photography and the 1939 New York World's

Fair. On view for five months, the PPA's Sixth International Salon of Photography included 530 pictures, nearly four-fifths of which were in the pictorial and modern sections. Its profusely illustrated catalog provided an excellent overview of contemporary photography, including images by more than two hundred pictorialists plus other photographers such as Berenice Abbott, Lewis Hine, Dorothea Lange, Clarence John Laughlin, Laszlo Moholy-Nagy, Barbara Morgan, Eliot Porter, Man Ray, and Edward Weston.

In his catalog foreword, PPA president Ira W. Martin observed how photographers were crossing disciplinary lines:

In the early days of the P.P.A. there was but one kind of photography of interest to the salon public: so-called pictorial photography. Since that time, some of the leading pictorialists have become the leading advertising and illustration photographers, of whom Edward Steichen is an outstanding example. This development is logical and understandable when one recalls that the task of the pictorialist is to make beautiful, dynamic and poetic pictures of everyday subjects. Advertisers and publishers want just such pictures made to order and, usually, in a hurry. A thorough grounding in the fundamentals of pictorial composition enables the photographer to deliver the goods every time—and on time. Speaking commercially, there's money in pictorial photography.[49]

As someone who wore two photographic hats himself, Martin (illus. 63) was by now keenly aware of the dual nature of pictorial photography. He rightly observed that commerce was evident in pictorial photography and art in commercial photography. Pictorialism after the Photo-Secession was a vital mixed bag—and all the richer for its diversity.

III. The Populism of Pictorialism

By 1910 the Arts and Crafts Movement had exposed the general public to significant aesthetic changes. Like its English predecessor, the American version promoted the "simple life" and the combination of beauty and utility. As a result, the look of manufactured products improved, and many people resumed making useful items by hand. Most important, the Arts and Crafts Movement began the popularization of art, encouraging the masses to go to museums, to read about the established arts, and even to try their hand at creating expressive pieces. A progressive American middle class evolved, with artistic aspirations equal to its political goals.

Early-twentieth-century pictorial photography reflected this populist trend. In contrast to the elitist attitudes of Stieglitz and the small membership of the Photo-Secession, democratic ideals and widespread participation characterized the pictorial movement beginning in the 1910s. Photography itself became known as the art of the people. Writers and pictorialists constantly encouraged budding amateurs to make creative pictures with their cameras, believing that every person possessed artistic potential. Women entered the pictorial ranks in droves, helping to further diversify the movement. Because pictorial imagery was accessible, idealized, and escapist, it was popular among the general public, who flocked to countless exhibitions of pictorial photographs.

Individuals around the country participated in pictorial activities in great numbers and with great enthusiasm. Camera clubs and photographic salons, the dual backbone of pictorialism, proliferated rapidly during this period. Hundreds of clubs organized, met regularly, and encouraged their members to keep producing new work. A further stimulus to pictorial output was the international salon, of which many were presented nationwide. Indisputably, pictorial photography dominated the photographic scene in this country from the 1910s to mid-century. Not nearly as widely acclaimed at the time was the work of Alfred Stieglitz, Paul Strand, Walker Evans, and other photographers now considered twentieth-century masters.

The Pictorial Photographers of America made clear the movement's populist goals in its 1917 annual report, issued the year after the organization was founded. It listed eight primary aims:

(a) To stimulate and encourage those engaged and interested in the Art of Photography.

(b) To honor those who have given valued service to the advancement of Photography.

(c) To form centers for intercourse and for exchange of views.

(d) To facilitate the formation of centers where photographs may be always seen and purchased by the public.

(e) To enlist the aid of museums and public libraries in adding photographic prints to their departments.

(f) To stimulate public taste through exhibitions, lectures and publications.

(g) To invite exhibits of foreign work and encourage participation in exhibitions held in foreign countries.

(h) To promote education in this art, so as to raise the standards of Photography in the United States of America.[50]

For the next thirty-five years this organization and countless others worked to encourage the creation and exhibition of accessible images, in the belief that public taste would benefit significantly.

Pictorialism after the Photo-Secession was an inclusive, not an exclusive, movement. Its writers and photographers largely believed that virtually anyone—given sufficient energy and time—could accomplish respectable pictorial images. Aspiring salon exhibitors were told by both critics and their fellow camera-club members that if they worked diligently, they would eventually achieve their own pictorial success.

Pictorialism optimistically decreed everyone a potential artist, a claim based on the belief that everyone possessed natural instincts for beauty. Most individuals simply needed encouragement and technical training in order to physically produce a work of art. Eleanor Parke Custis declared in her book on composition that "the average person has a certain amount of good taste and knows how to arrange things in a pleasing way, whether it be the furniture in his living room, or the objects in his picture."[51] Magazines like *American Photography* and *Camera Craft* were similarly encouraging, running articles such as "Pictorial Photography Made Easy" and "Pictorialism for Beginners," in which amateurs were told that they could probably make artistic photographs from even their existing negatives.

The teacher and photographer Adolf Fassbender was perhaps the ultimate optimist. Fassbender embraced the notion that photography was, indeed, the art of the masses, and he spoke on the subject not only to fellow photographers but also at athletic clubs, high-school conventions, and country clubs. In 1934 he even went on the radio to extol the camera as the easiest tool of visual expression for most people: "How FEW of us can succeed in making beautiful pictures by brush and paint—how few—but how MANY will be able to express their artistic thoughts in pictorial photographs, how many—yes, there is more ART in you, the layman, than you perhaps realize."[52]

Fassbender continually made a personal plea to his listeners to tap the creative drive they had allowed to lie dormant since childhood.

In 1938 a popular general magazine surveyed its readers about their hobbies and found that 47 percent of those responding dabbled in photography. Of course, only a small percentage of this number would have identified themselves as pictorialists, but even this class of most dedicated amateurs did not shy from the term *hobbyist*. Pictorialists reveled in the fun and fascination of amateur photography and happily described their involvement with the medium as a dignified pastime. "With me it has been a hobby, pure and simple," wrote the ambitious Max Thorek, "although I have taken it seriously."[53] Thorek and others were candid about pictorialism being an avocation, although they acknowledged that proficiency in it still required hard work. The right mixture of simple enjoyment and serious effort was considered the best recipe for pictorial success.

Pictorialists who made their living as professionals obviously gained great personal satisfaction and pleasure from also making pictures for camera-club and salon showings, where the atmosphere was decidedly more relaxed than the everyday business world. William Mortensen, who knew both of these worlds intimately, made a point of pitching relaxation to the pictorialists he tried to lure to his Laguna Beach school of photography. A 1941 advertisement for the school described a stay with him as a "Photographic Vacation," specifically mentioning such Southern California amenities as golfing, swimming, boating, surfing, and horseback riding. Pictorial photography without fun was like photojournalism without captions.

The hobbylike aspect of pictorialism led many photographers not only to handcraft their images, but also to build their own equipment. Some designed, constructed, altered, and customized the photographic apparatus they used both out in the field and in their darkrooms. In 1917 *Photo-Miniature* devoted an entire issue to homemade equipment, and the next year *American Photography* introduced a monthly column called "Shop Notes," which offered detailed diagrams on everything from cameras to enlargers. Photographers used such plans either to make unique equipment that was not commercially available or to save money on manufactured products. For economic reasons, homemade equipment was especially popular during the two world wars and the Great Depression. Among those using their creative energies in the machine shop as well as the darkroom were Fred P. Peel, who built a ring light for shadowless images, and Adolf Fassbender, who designed an 8-by-10-inch enlarger with a lens board and negative carrier that were both adjustable for maximum printing control.

While women were less likely to create their own equipment, they gravitated in great numbers to pictorial photography beginning in the 1910s. Inspired by significant social changes, such as their increasing acceptance in the workplace and the right to vote, women began to engage in creative photogra-

phy with the same passion as men. Some women were allowed to join the Photo-Secession—Gertrude Käsebier, most notably—but Stieglitz's paternalistic and sexist attitudes kept him from seriously considering the work of many female camera workers. Clarence H. White, on the other hand, became widely known for the encouragement he gave women photographers at his school. During the 1920s and 1930s, the work of women pictorialists was increasingly apparent in salons and they attained leadership positions in related organizations and banded together to form their own.

The Clarence H. White School of Photography and the Pictorial Photographers of America were bastions of female involvement. This was largely due to White's open-mindedness, his affiliation with Columbia's Teachers College, and his strong interest in home portraiture. White, who frequently photographed his wife and other women, possessed a gentle personality that fostered loyal dedication among his many female students. Women pictorialists who studied with him found professional jobs more easily, made more artistic pictures, and generally pursued photography for much of their lives. In July 1924 White wrote an article for *American Photography* titled "Photography as a Profession for Women," in which he encouraged women both to attend a school such as his and to seriously consider home portraiture, a specialty he believed made the most of their expertise in family matters.

From its inception, the Pictorial Photographers of America welcomed women. Gertrude Käsebier was the organization's first honorary vice-president, and women sat on its executive committee, its nomination committee, and its Council of Forty, with representatives from around the country, such as Francesca Bostwick in Connecticut and Jane Reece (illus. 64) in Ohio. According to the PPA's first annual report, issued in 1917, fully 45 percent of its members were women. President Ira W. Martin paid special attention to their contributions when he wrote a 1929 article on the subject for *Pictorial Photography in America, Volume 5*. In it he noted that women's work was exhibited and reproduced in numbers beyond their quantitative representation among pictorialists. He pointed out that a quarter of the pictures in the PPA's third salon were supplied by women, who made up only about 20 percent of the exhibitors. Women, such as Imogen Cunningham, Clara E. Sipprell, and Doris Ulmann, claimed an even larger part of the PPA's 1929 annual, with 27 percent of the illustrations. Martin believed women excelled at pictorial photography because they had a heightened sense of color, they were good technicians, and they tended to work alone, unimpeded by the group thinking of camera clubs. He concluded his article by saying that the woman pictorialist "continues to be directed by her feminine love for the aesthetic and beautiful, her love for the things that are human and full of vital interest. She does not try for the great unknown of pictures, by using effects and tricks; but rather, with all her good taste and fine judgment, she quietly expresses the phases of beauty she finds around her. It is only natural that we should find in these expressions the subtle things that made a genuine picture."[54]

64. Jane Reece
Interior, with Frank Mannheimer,
Pianist, 1921.
Dayton Art Institute, gift
of the artist.

During the 1930s and 1940s, women organized their own clubs and exhibitions to facilitate and highlight their achievements. Such clubs formed in East Orange, New Jersey; Cleveland, Ohio; Lansing, Michigan; Minneapolis, Minnesota; and elsewhere. In 1937 the Women's University Club of Philadelphia launched a national salon for women pictorialists, which was held for at least three years. The catalog for the Third Annual National Photographic Salon for Women of 1939 listed 110 prints that successfully passed the all-female jury of Eleanor Parke Custis, the world's leading salon exhibitor for three seasons; Peggy Gold, a former student of Adolf Fassbender; and Alice Benedict of Bryn Mawr, Pennsylvania. It proudly stated that 130 women from thirty states and Canada had submitted work to the exhibition, among them Rowena Brownell, Sophie L. Lauffer, and Ethel M. Smith. Other women pictorialists with national reputations at this time were Christine B. Fletcher (illus. 65) of San Francisco and Rowena Fruth (illus. 66) of rural Indiana.

Some women followed their husbands' lead to take up pictorial photography. It was, after all, one way to spend leisure time with their spouses, who were known to disappear into their darkrooms for hours on end. Mary Ramsey Burmeister, writing in the August 1940 issue of *American Photography*, advised, "don't be a darkroom widow," and numerous other articles encouraged women to get interested in the medium. Frequently, wives helped their pictorialist husbands in tasks like modeling and titling prints and some couples fully collaborated in the creative process, jointly signing their work and becoming nationally known as a pair. Among these were David and Eleanor Craig, whose work was prominent in the Pittsburgh salons during the 1930s; Paul K. and Dorothy Pratte of St. Louis, who both earned fellowships from the Photographic Society of America (FPSA); and Barbara and L. Whitney Standish of Boston, who began writing a column for *American Photography* in 1950.

Its educational value was one significant attraction of pictorial photography. Beyond the pleasure of making art, successful pictorialists gained better visual acuity and an overall sense for the beautiful, both of which they could apply to everyday life. Early on, the Pictorial Photographers of America declared their dedication to the "Art of Photography from a standpoint of educational value,"[55] and it is no coincidence that Clarence White first taught photography at Columbia University's Teachers College to students who would someday teach others the utilitarian value of art photography. In 1934 Adolf Fassbender stated that "the hobby has developed into a pursuit of things truly cultural,"[56] implying that pictorialism improved society in general by raising artistic standards. That same year, Edwin C. Buxbaum elaborated on the expansive value of pictorial photography:

When you are concerned with finding beauty in the world to photograph, you will find that you are becoming more appreciative of beauty in everything. You will take more interest in decoration, in architecture, in painting and sculpture and all the other fine arts. Perhaps, you will begin to wonder

65. Christine B. Fletcher
Muscats, c. 1934.
The Minneapolis Institute of Arts,
gift of Lora and Martin G.
Weinstein.

66. Rowena Fruth
Unafraid, n.d.
Collection of John Wintzinger.

about the arrangement of the rooms in your new house that you are building or about the lines of your new car. A complete course in artistic appreciation often results from intensive study of pictorial photography. It makes you enjoy fine things more and increases your appreciation of simple things.[57]

Such benefits accrued to viewers as well as makers of pictorial images, further widening the movement's influence.

Accessibility—imagery that was easily understood by the general public—was basic to the populism of pictorial photography. Photographers generally made traditional pictures that touched upon universal themes. Human interest was paramount, while images of the nude were carefully monitored. Most pictorialists were fiercely patriotic, but their images rarely pictured military scenes or expressed overt political messages. Inherent in the accessibility of pictorial photography was a sense of escapism for photographer and viewer alike, especially during wartime and the Great Depression.

Clearly, pictorial photography was an art for the masses, a sort of technological folk art. Pictorialists sought popular understanding of their images, not high art status for themselves. The New Orleans photographer Wood Whitesell (illus. 67), for instance, set up genre scenes in his causal studio/living space. Writers such as Frank R. Fraprie considered art, by definition, to be populist, declaring that "art to be art must be comprehensible to the common people."[58] And pictorialist Paul L. Anderson believed it was folly to make images for which there was no audience; to do so would subvert the pictorialist's mission of communicating emotion. In 1939 he explained: "The fact remains that if you want your message to get across the footlight, you have to say what people want to hear, and you have to say it in the way they like to hear it, or at least in the way they are accustomed to hear it, the way they can understand."[59]

Pictorialists used universality, among other things, to gain general appeal and understanding. To transform particular subjects into generic exemplars, they suppressed detail and specificity, not photographing events and personalities and removing any sense of time and place. William Mortensen cited Rockwell Kent's contemporary paintings as good examples of images that avoided literal representation, and he suggested that pictorialists attempt the same in their pictures. "In selecting subject material, seek the forms that possess universal appeal, and through the numerous devices available to the camera strive to present a broader concept of the image," Mortensen wrote. "If it is a tree, it should not be a specific species, but rather a symbol of all trees. If it be a head study of an old man, it should bear all the characteristics of age and decrepitude."[60]

In pursuit of accessible imagery, pictorialists frequently made pictures by formula, embracing the tried and true as a means to achieve guaranteed success. They dutifully followed written and spoken rules, regulations, and guidelines on a multitude of topics. When it came to the toning of prints,

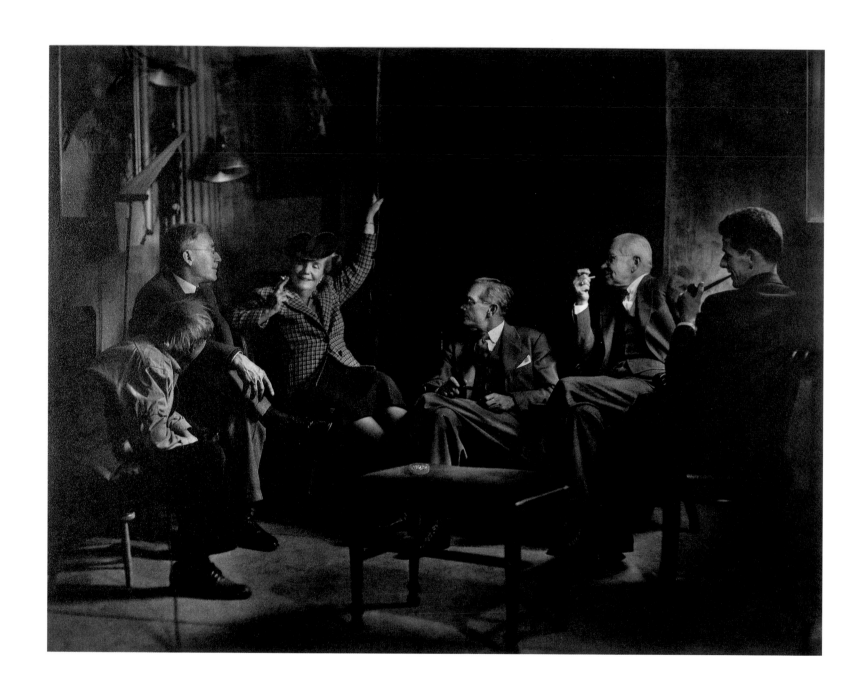

67. Wood Whitesell
Margaret Has the Floor, c. 1946.
Photographic Society of America.

for example, certain colors were acceptable with certain subjects, such as green with summer landscapes and blue with scenes of snow, sky, and water. In 1932 a writer for the *American Annual of Photography* declared: "The making of an artistic picture, like all the arts, is based largely upon definite mechanical laws and principles. By applying these under the guidance of instinct the photographer can create his picture as scientifically as the engineer creates his bridge. Knowledge of these laws and principles is the magic button to success."[61]

Instruction was available to photographers at schools and camera clubs, through correspondence courses, and elsewhere. The teachers usually were accomplished photographers who had received similar instruction from a previous generation and who now passed along their own versions of what was quantifiable in pictorialism. Fred P. Peel, for instance, produced a ten-part instruction course in which he broke down a picture into the intangible (the photograph's story) and the tangible (how it was told). William Mortensen also dissected the elements of pictorial success in his book *The Command to Look*, which he subtitled *A Formula for Picture Success*. Mortensen set forth three problems he felt every picture needed to address: First, get the viewer's attention; second, keep the viewer's interest; and third, achieve the viewer's active participation in the picture, the result of an emotional experience and not simply passive observation. "The formula, if it is to benefit you, must be used and used constantly,"[62] wrote Mortensen. He advised pictorialists to follow the rules religiously because halfhearted adherence brought little reward.

An unwavering allegiance to tradition and classicism ensured the populism of pictorial photography. Like those who administered the painting academies, the leading pictorialists devised their own system of judging and used their past achievements as the standard. Most participants were satisfied with salons including only slight variations of the same pictures for years. Pictorialists like Max Thorek likened pictorialism to classical music, suggesting that it was timeless and enduring. They praised common sense in picture making and disparaged doing something different simply for the sake of being unique. When Paul L. Anderson overheard himself called "old-fashioned," he happily accepted the characterization, assuming it meant he had respect for good composition, a sensitivity to light, a devotion to photographic beauty, and a willingness to work hard. He believed that art changed slowly and that all creative individuals depended heavily upon the accomplishments of those who preceded them. Writing in 1915, Anderson stated that "men make new discoveries, and use the images thus gained for the further modification of their old ones; but no human being has ever created a new image of any sort whatever."[63] Nearly thirty-five years later, as the pictorial movement was coming to a close, Adolf Fassbender echoed Anderson's conservative sentiment when he stated that "pictorial photography is traditional."[64]

The conservative values of the pictorial movement were particularly evident in images of the female

nude. Most pictorialists who photographed the nude worked within strict visual limits, dictated largely by the morals of the time. Those who wrote about this touchy subject compiled lists of things the respectable photographer should avoid.

Propriety in nude photography began by securing appropriate models. Only respectable subjects would do, and most pictorialists relied on friends and the daughters of professional colleagues. P. H. Oelman (illus. 68) hired high-school girls, who were always accompanied by their parents. Very young women were usually used because of their slender bodies and wholesome exuberance. Photographic models had to be ideal in natural form, "a perfect specimen of the race," since pictorialists could not alter their images to the extent that painters and sculptors could. James Pondelicek, a California photographer who made many nudes, also demanded that his subjects be intellectually sound: "The model chosen for this work must be of good breeding, education and intelligence, one who can live her pose and fully understand the photographer's thought. A girl with a perfect figure and no intellect will suggest flesh appeal alone."[65] Pondelicek frequently placed his nudes on sand dunes, an outdoor setting considered natural and safe. Before the 1930s, most pictorialists believed that models photographed indoors were sexually suggestive and at odds with the setting.

Pictorialists considered it essential that the nude be highly idealized, to avoid any hint of impropriety. They achieved this by depersonalizing the model and making her a universal symbol of all women. Successful pictorial nudes emphasized simplicity and abstraction, and if the photographer was knowledgeable about dance and anatomy so much the better. Writers made clear distinctions between images of the naked, whose only place was the hospital, and pictures of the nude, which occupied the hallowed halls of art. To avoid the former, pictorialists were advised to eschew suggestive clothing (such as underwear and stockings), luxury surroundings, bathtubs and showers, self-conscious models, and, especially, smiles and direct eye contact with the camera. "Never have the model look into the lens and smile," wrote Jack Powell. "It practically constitutes an open invitation."[66]

Americans were more conservative than Europeans about nude images in pictorialism, as they were about the unclothed body in art and society in general. Although an annual salon of nude photography was introduced in Paris in 1933, no similar exhibitions occurred on this side of the Atlantic. Undraped subjects were not accepted in the series of camera-club shows that hung in the Kodak building of the 1939 New York World's Fair. In fact, Americans were so reserved about the subject that it took a decision by New York's state supreme court to declare artistic nude photography legal in this country. After the court heard testimony from writers, curators, and photography instructors in a case concerning a class that used nude models, the December 1946 issue of *Camera* magazine reported, "High Court Recognizes Photography of Nude as Art Medium."

Camera and the other large-circulation photographic monthlies were as conservative as pictorialists

68. P. H. Oelman
Pagan, c. 1941.
The Minneapolis Institute of Arts,
gift of the family of Charles B.
Phelps, Jr.

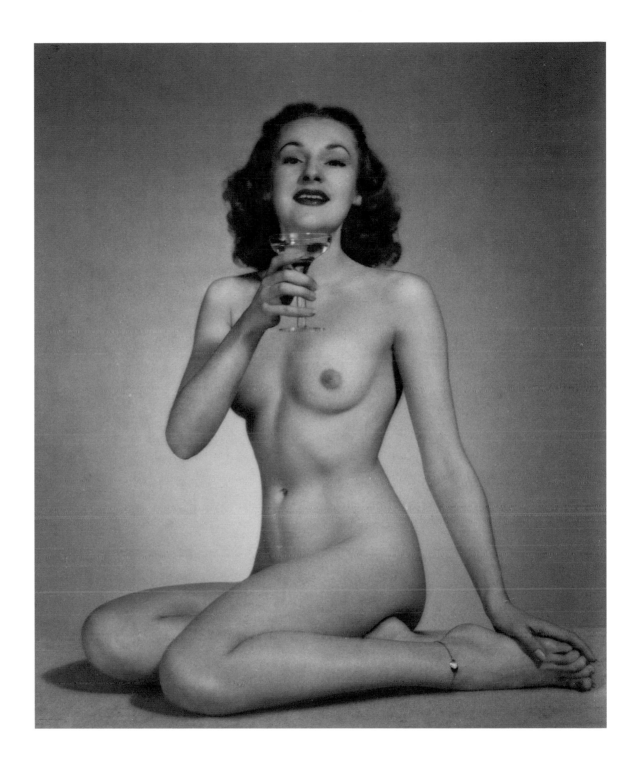

in general. Fearful of alienating readers, they did not reproduce nude images that showed more flesh than was visible in current salons and camera-club competitions. Few magazines displayed nudity during the 1910s and 1920s, and some even banned the subject completely. In 1925 Wilfred A. French, the editor of *Photo Era*, claimed he did not mind being called a prude because he had not seen any nude photographs of sufficient artistic quality to include in the magazine. During the 1930s, however, the quality of nude images improved dramatically, and they became commonplace at salons and in periodicals such as *American Photography*. Nevertheless, pictorial images of the nude continued to be almost exclusively of women and stopped short of any realistic definition in the pubic region.

In 1950 the publishers of *American Photography* issued *Pictorial Figure Photography*, a spiral-bound volume of about sixty reproductions, with Thomas Limborg's *Water Nymph* (illus. 70) on the cover. The publication's text made a concerted effort to justify artistic nude photography by exploring its psychological basis, giving a short history of the subject, explaining methods of lighting and posing, listing a bibliography, and even including a small selection of male nudes. The editor expressed the importance of family values and lamented the controversy that would always surround photographs of the nude. "No other pictorial subject is so fraught with contention and problems as the unclothed human figure," he wrote. "So long as clothing remains a symbol of moral significance and of the deeper object of morals—the preservation of the accepted system of rearing children—photography of the nude will continue to be hotly debated."[67]

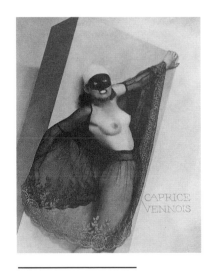

69. William Mortensen
Caprice Vennois, c. 1930. The Minneapolis Institute of Arts, Christina N. and Swan J. Turnblad Memorial Fund.

Pictorial Figure Photography contained experimental nudes by Man Ray and Lionel Wendt as well as images by salon photographers known for their pictorial nudes, such as Buck Hoy (illus. 71) and Max Thorek (illus. 72 and 73). P. H. Oelman of Cincinnati provided more pictures than anyone, with eight reproductions. Oelman was widely respected among pictorialists during the 1930s and 1940s for his pictures of slender, clean-cut women playfully posed against blank interior backgrounds. With beaming faces and a minimum of props, the subjects evoke a strong sense of American optimism. In his effort to offend no one with his nudes, Oelman ended up making pictures that are classic cheesecake.

Pictorialism did have its renegades, however—those who were frankly attracted to the female nude. Most prominent among them was well-known author, teacher, and exhibitor William Mortensen (illus. 69), who aggressively photographed women. He portrayed his nude subjects as sculpture, witch, seductress, old age, and heretic—hardly the normal fare of mainstream pictorialists. On the other hand, he also presented them as Cinderella, youth, and madonna, emphasizing the female form as a sensual object of desire. In 1936 Camera Craft Publishing Company issued the first edition of his book *Monsters and Madonnas*, which contained images both disturbing and pleasing.

70. Thomas Limborg
The Water Nymph, c. 1949.
The Minneapolis Institute of Arts,
gift of Thomas and Agnes Limborg.

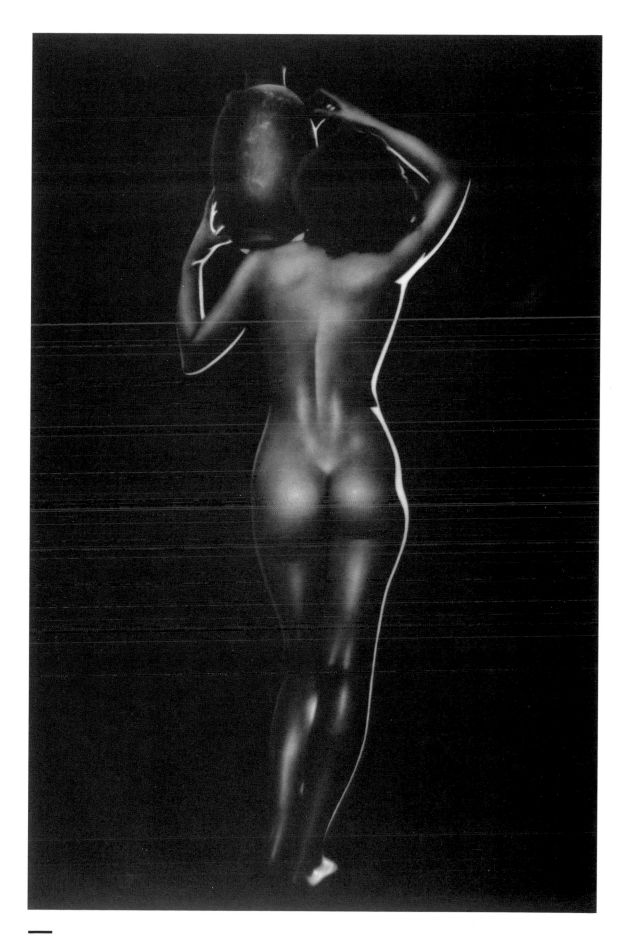

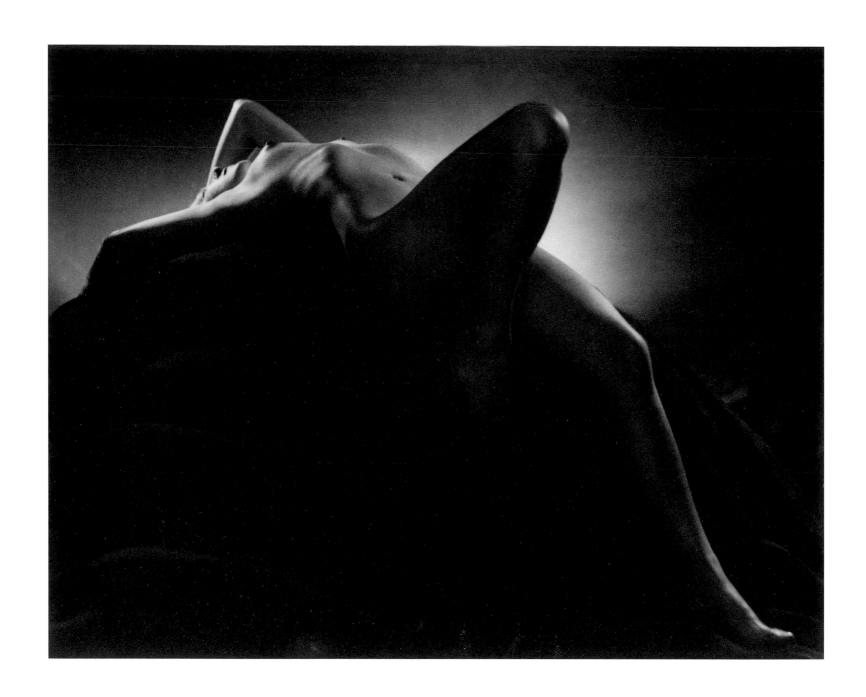

71. Buck Hoy
Dawn, c. 1937.
The Minneapolis Institute of Arts,
gift of Fred W. and Jane Bell
Edwards.

Despair, c. 1936.
Collection of Lucille and Thomas
H. Peterson.

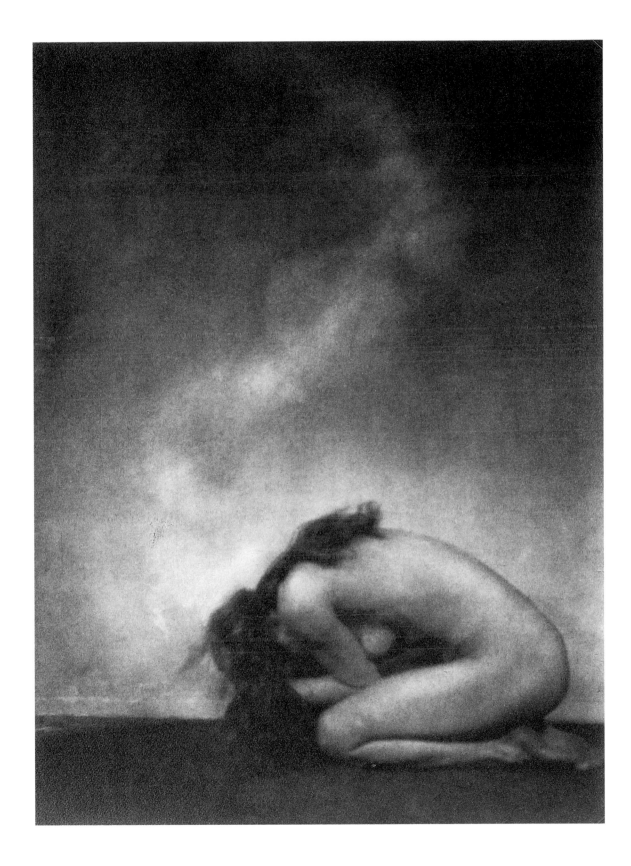

73. Max Thorek
Odalisque, c. 1937.
The Minneapolis Institute of Arts,
Christina N. and Swan J. Turnblad
Memorial Fund.

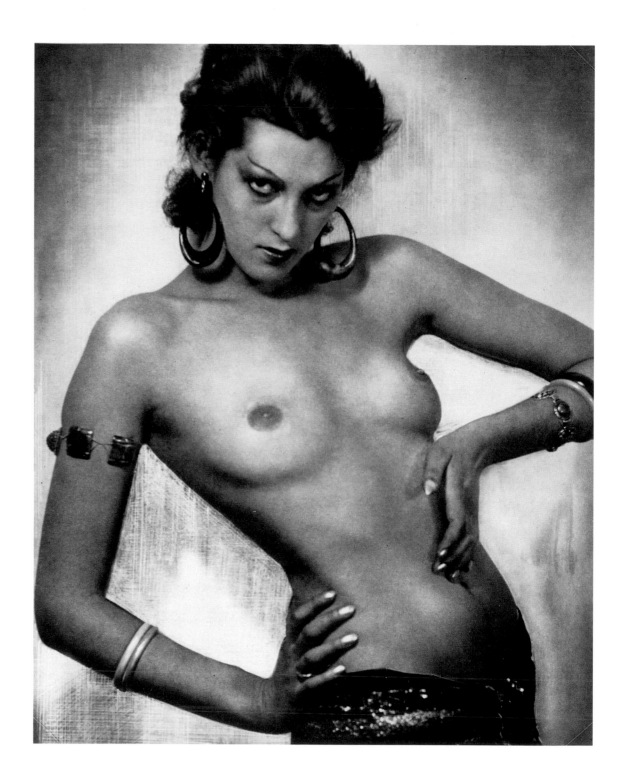

Some subjects appear bound and tortured, but others radiate pure sensual delight. On the book's cover was *Torso* (illus. 74), a depiction of a woman completely naked, her head thrown back and her hair falling below her exposed armpit. Mortensen would have appreciated that this photograph remains one of pictorialism's most erotic images. Writing in *Monsters and Madonnas*, he asserted:

There is, indubitably, an element, a considerable element, of sex in the representation of the nude. There is also an element of sex in almost every work of art that is worth its salt. A work of art that is devoid of this great energizing influence is as epicene and as unpleasant to contemplate as a person similarly bereft. Sex is a force so subtle and profound that it must inevitably influence all activities of life. In art especially, which is so similarly compounded of emotional impulse and creative will, sex is bound to exert a profound influence. When sex may give the theme to a sonnet or a symphony, when to the youth in love the very stars set their courses by sex, it seems scarcely worth the trouble to disclaim sexuality in photographs of the nude (whether they be works of art or not).[68]

Mortensen's provocative and distinctive ideas and images certainly did not represent mainstream, conservative pictorialism. Yet despite, or perhaps because of, them, he was the movement's most popular author and widely admired photographer. Pictorial photographers accepted much of his forthright philosophy, although most of them were reticent about it in public.

Mortensen's interest in sex and the grotesque provided him with an escape from the cramping aspects of realism. Most other pictorialists were similarly uninterested in reality, making escapism the raison d'être of the movement. In their desire to suppress the disagreeable and praise the positive in life, they turned a blind eye on controversy, politics, work or unemployment, poverty, and war. In the half century of pictorialism after the Photo-Secession, there was much to escape: World War I, the roar of the 1920s, the Great Depression, and World War II. Pictorialists pursued a hobby that helped them stick their heads in the sand, so to speak, and that provided a respite from harsh reality.

Pictorial photography attracted scores of professional people because it alleviated work-related pressures. Many doctors and lawyers became pictorialists in order to escape their punishing daily routine. Dr. Max Thorek (illus. 75), for instance, installed a darkroom at his office so he could quickly distract himself from the "gloom, misery, and suffering of human existence" he frequently encountered in the operating room. "This method of recreation affords a very necessary, complete, and congenially pleasant change from the nerve-wracking tasks and the anxiety incident to a busy surgeon's life,"[69] he wrote.

Pictorial imagery was frequently shot indoors and always printed there. Genre scenes, nude studies, portraits, and still lifes were made in the controlled environment of the photographer's studio, often against blank backgrounds that decontextualized the subject. Few pictorialists made landscapes or other pictures that required one to venture out into the world. Escaping into the dark-

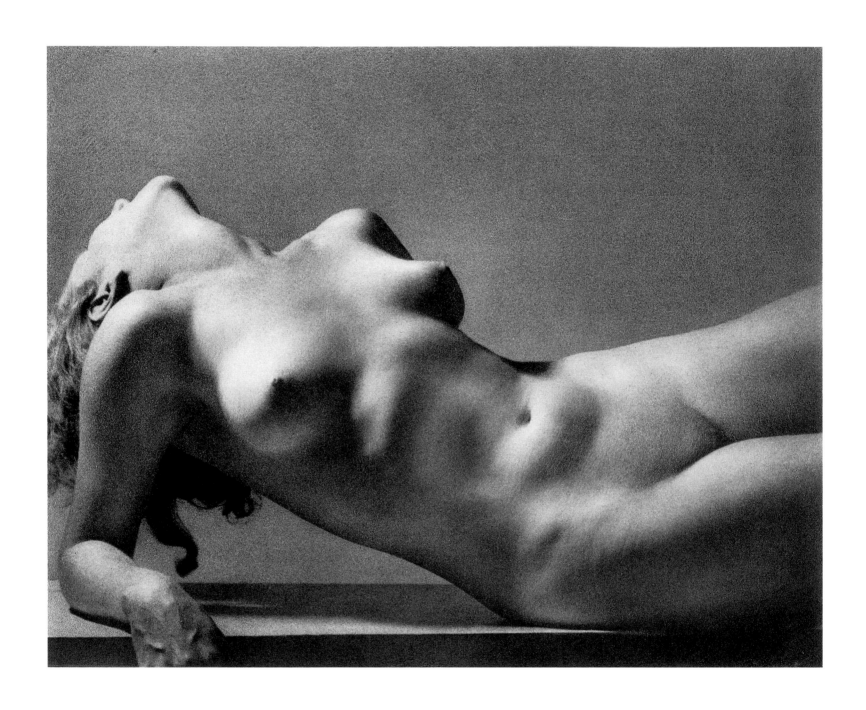

74. William Mortensen
Torso, c. 1935,
bromoil transfer print.
Photographic Society of America.

room, pictorialists spent hours completing their pictures, shut away from family and friends. In both their working conditions and their imagery, they distanced themselves from the minutiae of everyday life.

Neither of the two world wars made a significant impact on American pictorial photography. During both conflicts, all photographers were restricted from working around domestic military installations, but tanks, battleships, and guns were not subjects of much interest to pictorialists anyway. Those who entered the armed forces rarely took along their own photographic equipment, and those who did were inclined to point their cameras at benign subjects, such as quaint examples of European architecture and scenes of old-world village life. Foreign pictorialists found it more difficult to send their work to American salons during World War II, but American pictorialists made up much of the difference. The domestic darkroom became a tranquil refuge that protected photographers from outside forces.

Several important pictorial endeavors coincided with the beginning of World War I and continued throughout the conflict. For example, in 1914 the first Pittsburgh Salon of National Photographic Art was presented, initiating this country's most respected series of pictorial exhibitions and occurring annually for three-quarters of the century. In the fall of the same year, Clarence H. White opened his New York school of photography, after previously teaching only summer courses; as demand for advanced instruction in artistic and commercial photography increased during the war, he moved the school into larger quarters in 1917. The leading periodical of pictorial photography, *Platinum Print*, was first published in late 1913 and continued through most of the war; its eleven well-designed issues celebrated the renewal of pictorialism after the Photo-Secession and prompted the Pictorial Photographers of America to organize. Fittingly, the 1917 demise of *Platinum Print* coincided with the entrance of the United States into the war and the end of available platinum paper in this country.

Few leading pictorialists served in the armed forces during America's year-and-a-half involvement in World War I, perhaps because the pictorial ranks were disproportionately female, and women were not then accepted into the service. The 1918 annual report of the Pictorial Photographers of America reported that only six of its members had military experience in the war, among them Sergeant Arthur D. Chapman. A few years later, Chapman, who had been stationed in France, contributed an image to the organization's annual that did show bombed-out buildings, but its soft-focus effects and artistic framing muted the impact of the subject. While stationed in Europe during the war, Fred R. Archer, soon to be a leading California pictorialist, sent an article to *Camera Craft* in which he described finding himself "surrounded by a desolation a hermit would shun," noting that "the situation really does not harmonize with so pleasant a subject as pictorial photography."[70]

Shortly after the beginning of World War I, editor F. J. Mortimer declared in England's *Photograms*

of the Year, 1915 that pictorialism was "essentially an art of peace." He acknowledged that pictorialists turned their heads from conflict of any kind and noted that pictorial photography in his country was still thriving. Wilbur H. Porterfield, writing in the same publication, suggested to American pictorialists that it was their patriotic duty to maintain the status of the art should European workers be impeded by the war. After the United States entered the conflict, most American photographic magazines ran government appeals for photographic lenses, which were needed for military operations. But the imagery of pictorial photography was not affected.

Economic conditions and the government's isolationist foreign policy in the 1930s only reinforced the escapist desires of American pictorialists. Like society as a whole, they yearned to forget about reality after the stock market crash of 1929. Individual citizens aggressively pursued such new leisure-time activities as playing games, gambling (with what little money they had), and, especially, going to the movies. Making creative photographs was another means of escape, and camera-club membership swelled during this era. Most club members pursued pictorialism as a means to make images that were pleasing to the eye, not disturbing to the mind. They were told to discard the bad and embrace the good. Writing in 1938, Paul L. Anderson advised pictorialists to develop their senses and appreciation "to such a point that you unconsciously see beauty whenever it confronts you, and that you unconsciously ignore ugliness. There is far more ugliness than beauty in the world, and we must learn to overlook the one and see only the other."[71] There was no room in the pictorial movement for sordid pictures; only the beautiful was appreciated.

Pictorialists were more involved with the war effort during the Second World War, but they still shunned harsh imagery of any kind. Just as the 1939 New York World's Fair did not broadcast news of the conflict on-site, pictorialists did not incorporate the war into their imagery. Photographic magazines promoted patriotic activities and covered military uses of photography, but specifically pictorial possibilities in war photography were virtually nonexistent, and so was the desire to make political statements with the camera.

During the early 1940s, few foreign pictorialists contributed to American salons, due to mail restrictions and shortages of money and materials. But many of these salons continued to occur annually, exhibiting mostly the work of U.S. residents, who submitted even more heavily to exhibitions in this country because it was increasingly difficult to send their work abroad. Pictorialists were aware of the questions that some people might have about their escapist activities, but they reassured themselves that the creation and exhibition of pleasant pictures were justifiable necessities. "What of exhibiting in wartime? Is it time wasted from the war effort? Could the materials be used to better advantage in other ways to help speed victory? These questions need little thought to answer," wrote the organizing committee of the 1944 St. Louis salon. "Relaxation is as important as strenu-

ous effort, and morale is as important at home as it is on the war front. While artistic endeavor must surely bend in such arduous times, it need not break."[72]

Others used the same rationale for maintaining camera-club activities. In 1942 Byron H. Chatto addressed the question of club finances during the war, pointing out that fellowship was more important to the life of an organization than was money. "Good fellowship is one wartime essential that need not be rationed," he wrote. "If we are to preserve our sanity in these times of stress we must have moments of relaxation when the war and its problems can be forgotten. What can be better for us than an evening with good friends at the club?"[73]

Despite this escapist reasoning, many camera clubs did directly aid the war effort. The Manhattan Camera Club, for instance, organized a 1941 benefit exhibition and sale that raised money for the British War Relief Society; Adolf Fassbender, Frank R. Fraprie, Arthur Hammond, William Mortensen, D. J. Ruzicka, Max Thorek, and numerous other pictorialists donated photographs. Camera clubs registered their members in a national pool of photographers who stood ready to perform civilian service for the government, and they invariably extended the memberships of those who went into the service. In addition, organizations such as the Central California Council of Camera Clubs issued an invitation to servicemen stationed near any of its affiliates to attend club meetings and use their facilities at no charge.

Pictorialists performed other duties to demonstrate their patriotism. Adolf Fassbender joined the Volunteer Service Photographers, a national group that recruited photographers to take portraits of departing servicemen for their families. The editors of all the photographic monthlies regularly ran free ads and urged readers to buy war bonds; twice Frank R. Fraprie even featured this theme on the cover of *American Photography*. And war bonds were sometimes sold in conjunction with major photographic salons around the country, such as the 1943 Oklahoma salon, where eleven photographers donated their work and $343,000 was raised.[74]

In addition to limiting the international exchange of photographs for exhibition, World War II created other hardships for pictorialists. The government restricted numerous outdoor subjects, and most photographic materials became harder to find and more expensive. Brandishing their patriotism, however, most photographers looked for the silver linings in these dark clouds. Instead of lamenting the shortage of supplies, they vowed to become more efficient, a development that would benefit both them and the national situation. Adolf Fassbender pointed out that most photographers had grown accustomed to using more equipment and supplies than necessary. He firmly believed that simplified technique enhanced photographic work, and that the dozen types of paper, for instance, still available during the war were plenty for any good photographer. Conservation of materials of all kinds, photographic and otherwise, allowed industry to supply more to the war effort.

Pictorialists readily accepted government restrictions on what could be photographed, probably because few of them were interested in such off-limit subjects as waterways, airports, and military bases. From the beginning, pictorialists had promoted and preferred generic material, not specific and identifiable sites. The vast majority of the American countryside was still available to photographers, as was Central Park in New York and most of the nation's other recreational sites (illus. 76). Frank R. Fraprie suggested to those who felt at all hindered to explore the unlimited possibilities of indoor studio work and thereby fine-tune their ability to make portraits, still lifes, and other pictures where control was essential. In addition, he pointed out that every photographer had hundreds of negatives that were never printed or that could bear reprinting.

The avid wish of pictorialists to avoid topical subjects during the war prompted Jack Wright to title an article "'Escape' Photography." Appearing in 1942, it began, "There never has been a time when absorption in the hobby of photography was as enviable and invaluable as it is today. One reason is that there have been few times when the problems confronting mankind bulked as mountainous as they do today, and when some means of mental escape was so important and needed." Wright went on to report that increased worries over the world situation were causing increased ills among the American population, and he suggested that individuals could relieve some of this stress by picking up the camera: "Photography, then, is today affording this valuable escape to tens of thousands."[75]

Difficult domestic and international situations certainly fueled the popularity of pictorial photography, but they were hardly the raisons d'être of the movement. With or without world conflict, escapism was inherent to the movement and the mindset of its practitioners. Pictorialists pictured the world as they wished it to be, not as it really was. They preferred photographic images that could be hung in their homes and complacently enjoyed, not pictures that were disturbing or too realistic. To achieve and perpetuate these goals, they established their own system of international organizations and exhibitions. In the United States, as elsewhere, the camera club and the photographic salon were the citadels of pictorialism, and throngs of devotees passed through their gates.

The Camera Club

Both the popularity and the populism of American pictorialism were evident in the nation's democratically organized and run camera clubs. They promoted camaraderie, on both an intra- and inter-club basis. And beginning in the 1930s, they multiplied in unprecedented numbers. Except in the Deep South, most medium-sized cities boasted at least one club, and large urban areas supported many. Membership in a minimum of one club was considered essential to every pictorialist's development and success.

76. Edward C. Crossett
Cloud Shadows, c. 1941.
Photographic Society of America.

The number of camera clubs nationwide—about fifty to seventy—remained relatively stable during the 1910s and 1920s. The Pictorial Photographers of America served as something of a national camera club during this period, leading the movement with its touring exhibitions and important annuals. In addition, Louis F. Bucher, president of New Jersey's Newark Camera Club, organized the Associated Camera Clubs of America in 1920. Devoted primarily to exchanging exhibitions of members' work, its twenty-two charter clubs were located largely in the Northeast, in the upper Midwest, and on the Pacific Coast.

The number of camera clubs increased tenfold between 1930 and 1940. The *American Annual of Photography* (illus. 77) listed 61 clubs in 1931, 160 in 1935, 302 in 1937, and 532 in 1939. In 1940, after dutifully printing the addresses, officers, and brief activities of more than seven hundred American clubs, the annual found it could no longer devote space to the listing. Lloyd E. Varden claimed that there were actually more than five thousand camera clubs in the United States at this time. Publishing his findings in the November 1940 issue of *American Photography*, he listed nearly forty types of activities and noted that most clubs had twenty-five to fifty members. If Varden's calculations were correct, a quarter of a million individuals were active in the camera-club movement at the time.

An individual club didn't need a large membership in order to succeed. In fact, the Photo Pictorialists of Los Angeles, unlike most other groups, actually limited its membership and became one of the leading clubs in the country. Formed in 1914 with only twelve members—Edward Weston, Fred R. Archer, and Louis Fleckenstein among them—it soon began presenting the important Los Angeles salon. In 1945 Cecil B. Atwater encouraged committed pictorialists living in rural areas by pointing out that it took only two individuals to form a club and claimed he knew of such an arrangement that was "thriving."

There were advantages to numbers, though, and one of them was the income generated by membership dues. Between the world wars, some clubs boasted physical facilities that rivaled those of the professional photographic studio. Some actually purchased their own buildings; Boston members, for example, owned a three-story structure containing a studio, a dressing room, darkrooms, a library, a gallery, a kitchen, and storage area. In the early 1920s, the Chicago Camera Club built its own summer house outside the city on the sand dunes of Lake Michigan—a place for its members to photograph and recreate.

Photographers who lived where no club existed were encouraged to establish one. In 1922 the Associated Camera Clubs of America issued a twenty-four-page pamphlet, *The Camera Club: Its Organization and Management*, which described in detail how to begin a club and provided guidelines about its constitution, plan of management, equipment, membership, fellowship,

77. Cover of the *American Annual of Photography*, 1939. The Minneapolis Institute of Arts.

sociability, and possible activities. The association received 250 requests for this popular pamphlet in the first month of its availability and eventually printed a second edition due to its popularity. The Eastman Kodak Company issued a similar brochure, which met with equal success, and as late as the 1950s the *PSA Journal* serialized a manual on the formation and operation of the ideal camera club.

Most camera clubs accepted pictorialists of any ilk and drew members from throughout the areas they served. The first club to organize in a city usually named itself after its locality, leaving those that subsequently formed to devise more inventive names. In large cities with many camera clubs, councils were formed to coordinate the efforts of all the clubs, encourage camaraderie, and avoid scheduling conflicts. The Metropolitan Camera Club Council, for instance, included about ninety clubs in the New York City area in 1938, and smaller similar organizations functioned in Philadelphia, Washington, D.C., Minneapolis–St. Paul, St. Louis, and San Francisco.

The camera-club movement was so widespread that specialty clubs and even company camera clubs often formed in the larger cities. The popularity of the miniature camera, introduced in this country by Leica, spawned a rash of 35-mm clubs during the 1930s in Baltimore, Boston, Chicago, Cleveland, Los Angeles, Minneapolis–St. Paul, New Orleans, New York, Oakland, Omaha, Princeton, Philadelphia, San Francisco, Washington, D.C., and elsewhere. Perhaps the most specific specialty club was the 1/1,000,000 of a Second Club, of Lansing, Michigan, which was formed in the late 1940s to experiment with high-speed exposures. Camera clubs also organized on college campuses, where established rivalries encouraged fierce competition; their existence led to the publication of *The Collegiate Camera Annual*, beginning in 1940.

Company camera clubs consisted exclusively of employee members. Businesses sponsored them because they boosted staff morale and provided free publicity for the company. With company-provided space and equipment, such clubs enjoyed a great economic advantage over self-supporting clubs, a situation that was especially true in New York City, where rent was high and where more than a dozen such clubs existed by 1941. Among them was the Telephone Camera Club of Manhattan, organized in 1914, as well as groups at Chase Bank, Consolidated Edison, New York Stock Exchange, Western Union, and, boasting 250 members, Metropolitan Life. "When you visit one of these groups you can really watch democracy at work," wrote Emma H. Little in *Popular Photography*. "Prestige among the membership is attained solely by taking good pictures, and you'll find top-ranking officials rubbing elbows and comparing prints with filing clerks. The picture's the thing."[76] Elsewhere in the country, camera clubs formed at telephone companies in Illinois and Indiana, at the Dayton Power and Light Company, and, not surprisingly, at the Eastman Kodak Company, in Rochester, New York.

Pictorialists universally extolled the advantages of club membership for both the individual and the movement as a whole. Max Thorek devoted chapters to the topic in both of his books on pictorial photography. In *Camera Art as a Means of Self-Expression*, he stated:

Once that first, faint spark of interest in photography as a hobby has been struck, one will find that it may best be fanned by the stimulation of contact with other kindred spirits. For that reason, membership in a camera club is essential. The helpful advice and even more helpful criticism of one's fellow members will speed one along the paths of creative camera endeavor at full speed. . . . The interest and encouragement fostered in camera clubs throughout the world has done far more than any single force to raise the level of amateur photography to its present proud eminence. It therefore follows that membership in one's local club is the sine qua non *for the serious amateur. The advantages of such membership can hardly be overemphasized.*[77]

Camera clubs provided a place for pictorialists both to learn new techniques and to share their own expertise. Every club member was considered a source of information and was encouraged not only to attend meetings but also to work up his or her own demonstrations for others. Members of different social classes worked together in a cordial, democratic setting. Individuals checked their professional standing at the door and judged one another only on the basis of photographic skill and artistic accomplishment. Because camera clubs were interested in the work and activities of similar groups, they encouraged visits from out-of-town pictorialists. In 1939, for instance, the Manhattan Camera Club invited fellow enthusiasts who were in the city to see the New York World's Fair to attend its Monday-evening meetings.

The regular meetings of clubs like the Manhattan Camera Club covered every step in the photographic process, from exposing negatives to mounting prints. Demonstrations and lectures were presented on photographic equipment, as well as on how salons were judged. The always popular print-criticism nights provided both a testing ground for individual prints and a forum for the discussion of aesthetics. Generally speaking, however, photographic technique was the most frequent topic at these weekly or monthly gatherings.

Exhibitions were the most visible activity of camera clubs. Every club held an annual members' exhibition, and most presented other shows as well. At these events, individuals could show their best pictures of the year, and the club could promote its strength as a group to the general public. Members' exhibitions often traveled to other camera clubs; for example, in 1930 the Camera Club of New York sent its fifty best prints to Brooklyn, Boston, Akron, and Cleveland. Clubs frequently traded exhibitions with each other or handed over sets of prints to organizations like the Associated Camera Clubs of America, which circulated them throughout the country. This lively exchange of talent was as exciting to the general public as it was to the sponsoring club. "The public, too, is get-

ting picture conscious," wrote John H. Vondell of Amherst, Massachusetts. "A few years ago our local gallery exhibited about one photographic show a year. Now we show about sixteen traveling exhibits during the year. Crowds turn out to visit each show. The newspaper wants a write-up of each exhibit. Neighbors stop me on the street to discuss certain prints in our recent show. The camera club seems to have made the whole community conscious of good photographic work."[78]

As the literature on organizing a camera club indicated, fellowship and sociability were key elements to success. Pictorialists wanted to have fun at their hobby, not spend all their time hunched over trays of photographic chemicals in the darkroom. Most clubs maintained standing committees to organize a regular schedule of social and other special events, such as outings, dinners, and banquets. Club outings, which encouraged photographic activity, were most popular around World War I, when the back-to-nature credo of the Arts and Crafts Movement still held sway. Club members would go en masse to isolated areas to find new subjects and to partake of the fresh air and natural beauty. The California Camera Club, for instance, made annual treks during the 1910s to Yosemite Valley, where one year more than four hundred club and family members camped for nine days. Annual camera-club banquets were social highlights throughout the post-Secession era. In a mood of conviviality and high spirits, members thanked officers, acknowledged leading exhibitors, and generally celebrated their successes. After numerous toasts were given, guests often tucked in to a meal featuring unusual-sounding fare; for example, the menu of the 1940 banquet of the Minneapolis YMCA Camera Club included D-76 cocktail, infra-red ham, candid sweet potatoes, Panchromatic green beans, Kodabrom pineapple, D-52 cheese salad, fine grain bread, Graflex pie-4 × 5, and anti-halation coffee.

Information on the multitude of camera-club activities was readily available to members and aspiring pictorialists alike. All the photographic monthlies ran regular columns devoted to club goings-on, and many clubs published their own newsletters or bulletins, which ranged from mimeographed single sheets to well-designed little booklets. These publications, usually overseen by a full editorial committee, invariably used photographically related names, such as *Close-Up*, *The Developer*, *Foto Flash*, *The Lens*, *Out-of-the-Hypo*, and *The Shutter*. In 1922 *Photo Era* magazine noted that the three leading bulletins were *The View Finder*, of the California Camera Club; *Exposure*, from the Chicago Camera Club; and *The Ground Glass*, published by the Newark Camera Club. By the late 1940s, camera-club bulletins were so prevalent that the Photographic Society of America began an international competition for them, judging them on editorial content and typographic excellence.

The Photographic Salon

The photographic salon, the ultimate showcase for pictorial work, was undoubtedly the most important camera-club-sponsored event. Larger and more comprehensive than the annual members' exhibition, the salon was a highly crafted showing of work by pictorialists of international standing. Leading pictorialists judged entries from around the country and abroad, which usually were exhibited in art museums. Annual catalogs were issued, and the photographic press provided extensive coverage. During the 1930s, the number of American salons surged, reflecting the rage for pictorialism and the competitive spirit of individual workers. Every serious pictorialist aspired to have his or her work included, and the viewing public came in droves to presentations that exemplified the movement's populist approach.

Photographic salons first appeared in Europe during the late 1890s, when the earliest camera clubs presented large juried exhibitions. To suggest the artistic intent of their photographic images, organizers appropriated the term *salon* from the official French exhibitions of academic painting and sculpture. This self-conscious attitude about art continued into the post-Secession era, and the term was common parlance among pictorialists until the middle of the twentieth century. In 1920 *Camera Craft* magazine mused, "What's in a name? A whole lot sometimes. Were we to call an exhibition of lens pictures simply a photographic exhibition, our show would probably fall flat, but let us dub it by the above title; there are hopes . . . To such shows the limousine goeth, and where the limousine goeth the crowd cometh, and we all feel better, even happier; perhaps our collars are whiter and our shoes shine more. Indeed, there is something in a name."[79] Most salon catalogs pointed out that their juries accepted only pictures of artistic expression and reiterated the fact that they awarded no medals, as inclusion in the salon was considered its own reward.

Pictorialists considered it their ultimate goal to have their work included in the best photographic salons around the world. Most of the technical and artistic discussions at camera clubs concerned making pictures of salon quality. Monthly competitions and annual exhibitions served largely as testing grounds for prospective salon prints, and photographic magazines featured articles on how to improve one's chances of acceptance, even speaking of "crashing" the salons. In a chapter titled "Prints for Salons" in his 1938 book, *Print Finishing*, William Mortensen stated, "The great ambition of most photographers and the grand finish of all print finishing is to have one's picture put up on the wall and admired by gasping and incredulous multitudes. Hence, we have salons."[80] Fellow pictorialist John R. Hogan, who was known for his seascapes (illus. 78 and 79), went so far as to state that one could not know for sure if one's prints were good unless they had been accepted by a jury and hung in a salon.

During 1912 and 1913, the last American Photographic Salon traveled to a limited number of primarily midwestern museums, representing the end of the only long-lasting series of salons that

78. John R. Hogan
Crossing the Stream, c. 1938.
The Minneapolis Institute of Arts,
gift of the family of Charles B.
Phelps, Jr.

79. John R. Hogan
The Life Ring, c. 1940.
The Minneapolis Institute of Arts,
gift of the family of Charles B.
Phelps, Jr.

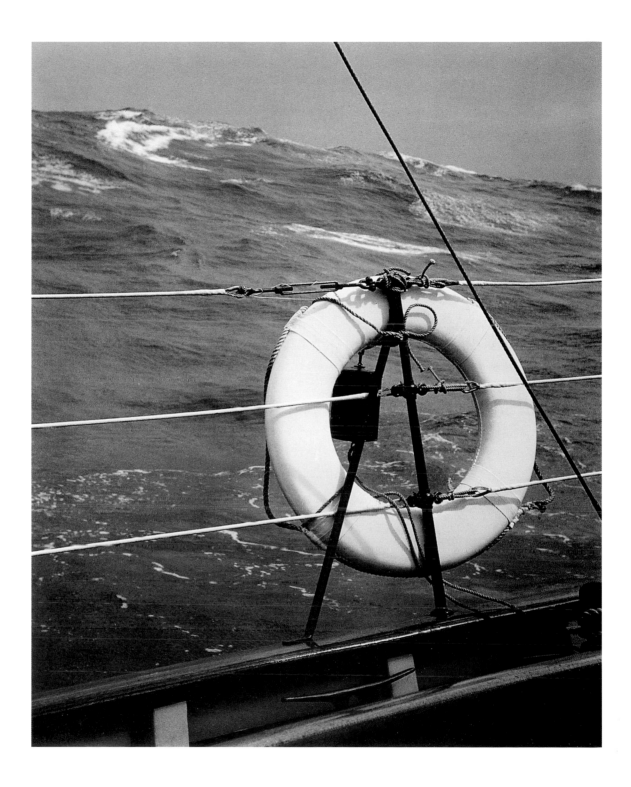

occurred during the Photo-Secession period. The mid-1910s saw the introduction of two new salons, both of which catered to a younger generation of pictorialists and quickly developed into leading exhibitions. For the next quarter century, pictorialists around the country aspired to have their prints accepted at the prestigious Pittsburgh and Los Angeles salons.

The first Pittsburgh Salon of National Photographic Art occurred in January 1914 in the galleries of the Carnegie Institute's Museum of Art. Organized by the Photographic Section of the Academy of Science and Art, it featured work from six East Coast and midwestern camera clubs and eleven individual pictorialists, including Spencer Kellogg, Jr., Wilbur H. Porterfield, and George H. Seeley. Within just a few years, photographic leaders such as Frank R. Fraprie were calling the Pittsburgh show the country's most important exhibition, even "our national salon," on the basis of its consistent quality and the encouragement new exhibitors received. Juries for the Pittsburgh salon maintained high standards and did not accept prints that had previously been exhibited in the United States or that were more than a year old. The salon also gained prestige from its venue, the Carnegie Institute, which often hung the photographs in the same galleries where its nationally renowned annual survey of paintings and sculpture was installed. In about 1920 the salon began conferring special membership status to those pictorialists who regularly submitted high-caliber work to the exhibitions. This recognition, which ranked with serving on the salon's jury, was initially awarded to such leading figures as Charles K. Archer (illus. 80), William E. Macnaughtan, D. J. Ruzicka, Jane Reece, and William Gordon Shields (illus. 81).

In 1918 the Camera Pictorialists of Los Angeles organized its first annual salon, which was hung at the Los Angeles Museum of History, Science, and Art. Louis Fleckenstein, a founding member of the Camera Pictorialists, enthusiastically reviewed it, noting that 58 photographers had contributed nearly 175 pictures and that the show occupied the entire main gallery of the museum, a first in its history. In addition to Fleckenstein, Fred R. Archer, Margrethe Mather, and Edward Weston were among the exhibitors. A sort of western counterpart to Pittsburgh, the Los Angeles salon soon became a highly respected and sought after venue for American and foreign pictorialists. In 1922 the California-based magazine *Camera Craft* reported a marked increase in foreign submissions to the salon, with eleven European countries being represented in its fifth presentation. The Los Angeles salon gained additional visibility among pictorialists in 1931 and 1932, when it published *The Pictorialist*, a limited-edition hardcover book that served as a deluxe catalog for each year's exhibition. Both volumes featured an overview of the salon by club member James N. Doolittle and a hundred full-page reproductions of images from the show. Among the West Coast pictorialists whose work was included were Edward Weston, Karl F. Struss, Edward P. McMurtry (illus. 82), Arthur F. Kales, Imogen Cunningham, and Will Connell (illus. 83), whose abstract lens design graced the cover of both editions. While the Pittsburgh salon continued until 1980, the demise of the Los Angeles salon coincided with that of pictorialism, around mid-century.

80. Charles K. Archer
Bridge Beam Shadows, c. 1927.
Photographic Section of the
Academy of Science and Art of
Pittsburgh.

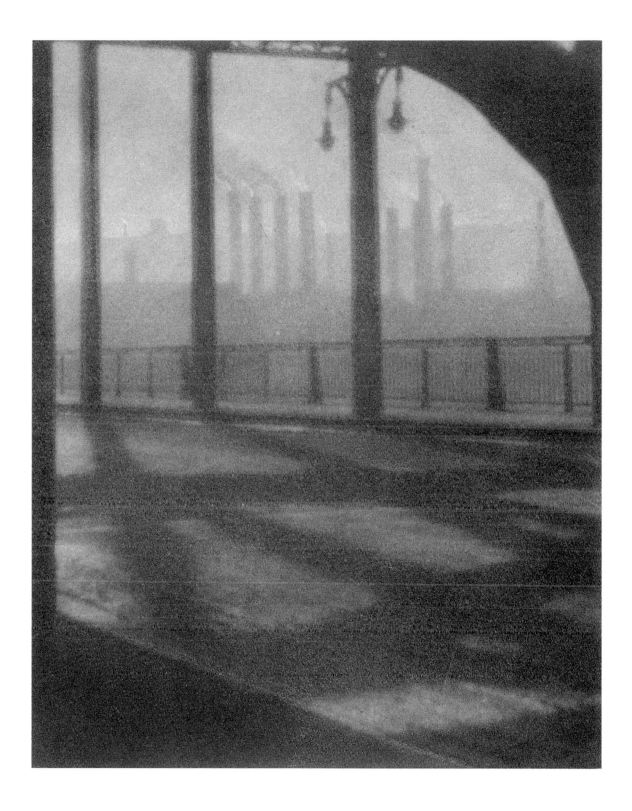

81. William Gordon Shields
An Interior, c. 1920.
Howard Greenberg Gallery.

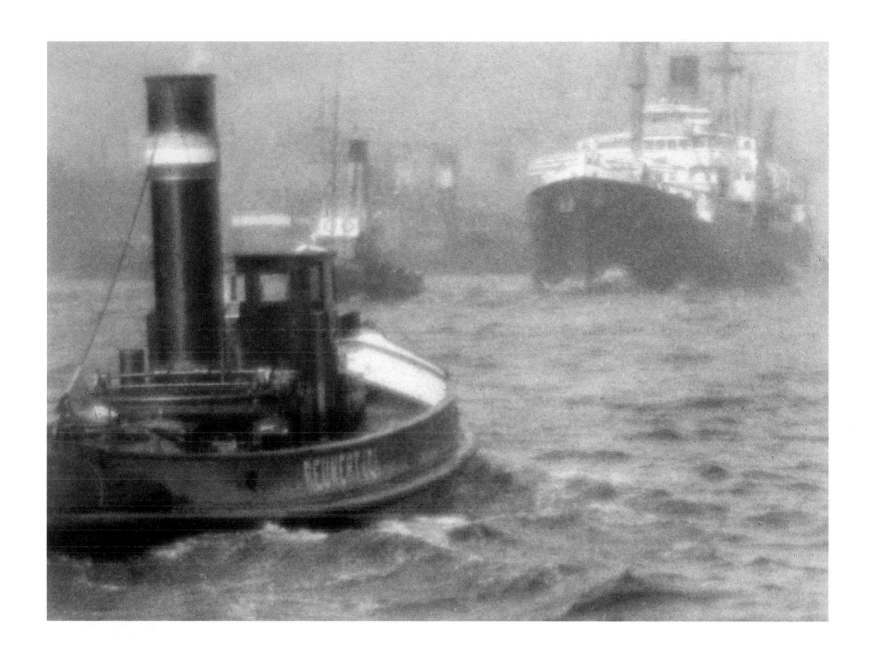

82. Edward P. McMurtry
On the Elbe, c. 1933,
carbo print. The Minneapolis
Institute of Arts, Ethel Morrison Van
Derlip Fund.

83. Will Connell
*Southern California Edison Plant
at Long Beach*, 1932.
Collection of Michael Dawson.

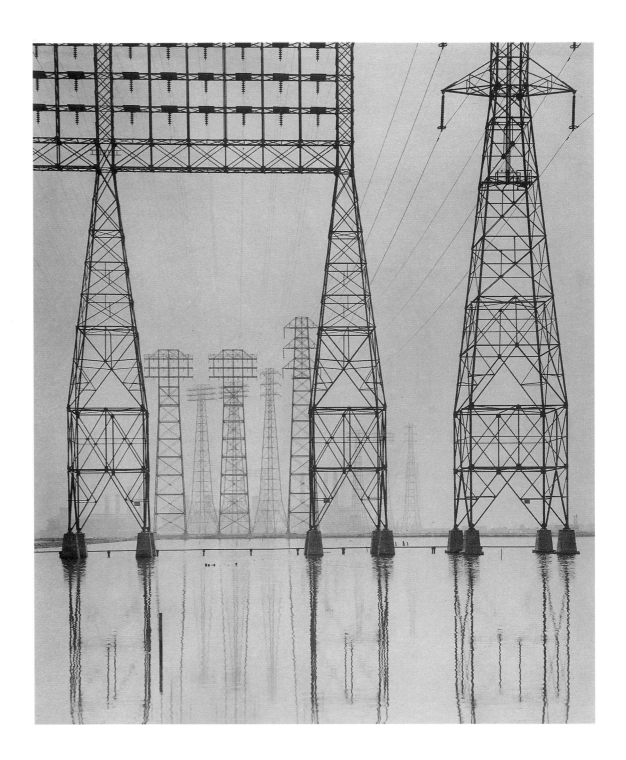

During the 1920s, about ten salons occurred on a regular basis in the United States. In addition to Pittsburgh and Los Angeles, important salon presentations were seen in New York City; Buffalo; Portland, Maine; and San Francisco–Oakland. Salon organizers usually preferred to maintain independent identities for their shows, performing all the work themselves and taking sole credit for the presentation. But beginning in about 1923, the camera clubs of San Francisco and Oakland wisely banded together to organize a single annual salon, which was exhibited at museums in both cities. The only other salon that approached the traveling nature of the Bay Area exhibition was the annual presentation of the Photographic Society of America, which was hung in whatever city the organization's national convention occurred.

During the 1930s the number of salons doubled—from about fifty to around a hundred—worldwide. Every continent except Antarctica was now providing this creative outlet for its active pictorialists; in the United States, at least seventeen cities introduced salons at this time, including Boston, Dayton, Detroit, Des Moines, Lancaster, Memphis, Milwaukee, Minneapolis, Philadelphia, Princeton, Rockford, San Antonio, San Diego, Scranton, Springfield, St. Louis, and Wilmington. Except in the Deep South, where there were few salons until the 1940s, most pictorialists could now enter salons both in their hometown and in other cities within driving distance. Few, however, felt limited to their region's salons, so they freely shipped their work off to shows throughout the country and overseas.

Most American salons operated along similar guidelines, largely initiated by Frank R. Fraprie, the editor of *American Photography*, and the Photographic Society of America. Salon organizers followed strict procedures of announcing the salon, forming a jury, judging the prints, notifying exhibitors, installing the exhibition, and returning the prints. Rules and regulations dictated what pictures were accepted and how they were organized. During the 1930s, salon standards allowed mounts of only 16 by 20 inches, a maximum of four prints per photographer, and nothing hand-colored. Equally important was the setting for the salon; it had to be spacious and dignified, preferably an art museum or gallery. Adolf Fassbender declared in 1936 that if such facilities could not be secured, no salon should be held. Salons that did not adhere to the established guidelines were not highly regarded and rarely made it into Fraprie's influential exhibition listing in the *American Annual of Photography*.

Numerous less-conventional salons occurred as well, many of them of a specialized nature. In New York, salons of pictures made with particular cameras, such as the 35-mm Leica and the square-format Rolleiflex, took place. And in the 1940s nature salons, presenting images that mixed scientific and pictorial concerns, gained popularity. Photographic salons also broke out of the museum setting, turning up at department stores, company lobbies, and even state-fair grounds. These varied interests and venues signaled the continued populism of pictorialism, on the part of both the photog-

raphers and the audience. Pictorialist Axel Bahnsen correctly noted in 1950 that the salon was "a natural manifestation of the cultural status and standards of the public."[81]

Because every pictorialist was free to enter pictures and the general public attended the shows in great numbers, salons reflected the egalitarianism of pictorial photography. In reviewing the first Los Angeles salon of 1918, a writer for *Camera Craft* noted that the exhibition was "open alike to the millionaire and the twenty-five-dollar-a-week clerk, giving either that opportunity the fates may have denied him of otherwise expressing his artistic feeling, a bent that would be entirely neglected without this avenue of expression."[82] Frank R. Fraprie believed that salon juries should look for reasons to keep work *in* rather than *out* of a show, and he found that small, severely judged salons did not show pictorialism at its best. Due to space limitations, however, most salons included only about 10 percent of the work submitted, usually presenting between one hundred and three hundred pictures. This meant that in 1936, when the *American Annual of Photography* counted 27,000 accepted prints among the salons of the year, a staggering quarter million or more photographs had been submitted to salon juries.

These numbers indicate the enthusiasm and productiveness of pictorialists beginning in the 1930s. Many made multiple prints of the same image and submitted them to different salons for five to ten years. They kept detailed personal records of their submissions and rejections and each year anxiously awaited the appearance of the *American Annual of Photography*, which, beginning in 1927, included a "Who's Who in Pictorial Photography." This extensive list gave pictorialists' success numbers for both prints and salons over the last few years. Within a decade, it included the names of more than twelve hundred individuals (with their addresses) from nearly forty countries— a true directory of salon exhibitors. When the annual also began ranking individuals based on the quantity of accepted salon prints, Frank R. Fraprie, its editor, was embarrassed to find himself at the top of the list, with 279 prints in the 1932–1933 season. As the list encouraged pictorialists to send more and more prints to more and more salons, something of a ratings scramble ensued. Over the next twenty years, a handful of pictorialists monopolized the top position, with "superstars" like Max Thorek and Eleanor Parke Custis each capturing it two years in a row. In 1950 Thorek's career total was an astounding 3,973 prints accepted at more than a thousand salons.

Since most salons did not award medals or other prizes, the only tangible indications of salon success for exhibitors were the catalogs and the small identifying stickers that salon committees affixed to the backs of photographs included in their exhibitions (illus. 84). These colorful and often well-designed labels adorn most of the mounts from the period, providing concise exhibition histories of individual pieces. Some photographers believed that the presence of prestigious stickers, such as those from Pittsburgh, could favorably influence the judges at subsequent salons. Others lament-

84. Back of mount for photograph
by Walter S. Meyers, showing
salon and camera-club labels.
The Minneapolis Institute of Arts,
gift of Joseph Bellows.

ed the seeming preference for collecting quantities of stickers over creating quality pictures. Paul L. Anderson asked, "A hundred years from now, will people turn our prints over to feast their eyes on the collection of pasters on the back of the mount?"[83] Some images were so widely exhibited—a few were seen in more than a hundred salons—that their mounts could not accommodate all the stickers they had rightfully earned.

The attendance records of many photographic salons were also formidable, and certainly indicative of the public's interest in creative camera art. The Pittsburgh salons consistently drew about 10,000 people per year, and often 1,500 viewers arrived on its opening day. In 1926 the two-week-long San Francisco salon recorded more than 30,000 visitors. In Rochester, New York, the hosting Memorial Art Gallery set a new record for museum attendance when it presented its 1930 salon, and in Philadelphia the 1932 salon was extended for ten days due to popular demand. The annual New York salon sponsored by the Pictorial Photographers of America generally drew about 20,000 viewers, although many more surely attended its 1939 presentation, which ran for seven months because of the New York World's Fair. It appears, however, that the Toronto salon captured the North American record for attendance, when, according to Frank R. Fraprie, its 1926 presentation attracted 32,000 people per day, reaching a grand total of nearly a million visitors.

Occasionally those attending salons were asked to vote for their favorite photographs, an effective means of further involving the audience and of gauging popular taste. In 1925 the viewers of the Pittsburgh salon chose ten top pictures, among them pieces by Léonard Misonne of Belgium, José Ortiz-Echagüe of Spain, and the Americans Charles K. Archer and A. D. Chaffee. The official judging of photographic salons, however, was a more serious and time-consuming process. During the 1930s, pictorialists hotly debated the qualifications of salon judges. Serving on a jury was a thankless task: long hours spent reviewing—and most often rejecting—huge quantities of prints. But every self-respecting pictorialist aspired to become a sought-after salon judge, which was perhaps the ultimate seal of approval conferred by the pictorial world.

Writers in the photographic press frequently disagreed about whether pictorialists or others should make up the salon jury. Most leading pictorialists agreed that juries should consist solely of those who best knew creative photography, meaning those who practiced it themselves. Adolf Fassbender, for instance, felt it was degrading for pictorialists to have others judge their work because it implied that photographers were incapable of the job. Just as painters would bristle at the thought of photographers sitting in judgment of their work, most pictorialists resented the uninformed opinions of those outside their field. A few pictorialists, on the other hand, preferred artists on photographic juries, believing they were objective critics who brought artistic legitima-

cy to salons. Paul L. Anderson frequently encouraged salon organizers to choose painters, sculptors, and architects as judges, convinced that they knew more about art than most photographers and that they wouldn't be distracted by purely technical considerations. Pictorial photographers ended up dominating but not monopolizing most American salon juries. The jury of the 1921 Oakland salon, for instance, included J. Nilsen Laurvik, the director of San Francisco's Palace of Fine Arts, and Roi Partridge, a printmaker and teacher who happened to be married to Imogen Cunningham. In Minneapolis, Edmund Kopietz, the director of the Minneapolis School of Art, served for years on the jury of the city's annual photographic salon.

Most salon organizers believed three was the ideal number of jury members. An odd number was necessary since judges voted individually on each picture, and five or more individuals usually made an unwieldy group. Photographer William Rittase suggested in 1934 that juries should be composed of one modernist, one conservative, and one "in-between" pictorialist. Some camera clubs chose all three jurors from their own ranks, and others preferred to draw judges entirely from the outside. The Pittsburgh salon relied almost exclusively on nonmembers as judges, believing this arrangement avoided the influence of personality over substance. Group judging at photographic salons reinforced the democratic nature of pictorialism. Instead of a single authoritative voice, multiple outlooks made salon judging an exercise in compromise, with each judge seriously considering the opinions of the other jury members. The one significant exception to this arrangement occurred at the Los Angeles salon; beginning around 1933, one member of the organizing Camera Pictorialists picked the entire show each year. Ironically, judges for this salon found themselves in the position of having to be much more evenhanded and impartial than those who served on a group jury.

Those who sat on a salon jury used the conventional criteria of pictorial photography to judge hundreds of submissions. During the course of the one or two days it usually took to view all the prints, the judges invoked their heightened sense of compositional correctness, photographic technique, and artistic intent. In addition to professional expertise, judges were expected to possess such qualities as worldliness, good taste, and an open mind. "There are certain essential qualifications which a judge of creative camera work must possess," wrote Max Thorek, who was himself an experienced salon judge and who devoted a full chapter to the subject in both of his books on photography. "These are a knowledge of art in general; the special responsibilities and breadth of vision that are summed up in the word culture; a thorough and practical acquaintance with technical photography; good judgment; and above all a sense of fair play and impartiality."[84] Of course, no one could completely suppress personal preferences, and Frank R. Fraprie, another seasoned salon judge, counseled hopeful exhibitors that those who served on juries were only human and that their decisions were not infallible.

Unlike salon judges, members of the general public could freely express their personal likes and dislikes about exhibition pictures. Generally, they simply talked with each other about what they saw on the gallery walls or wrote comments in their catalogs, but occasionally individuals purchased original photographs from the salons, which, because commercial galleries didn't handle photographs, were the primary sources for most people to acquire work. Many pictorialists traded with each other and some built large collections, but outright sales remained modest. Still, the issues of pricing and selling pictures intrigued most salon contributors.

In January 1925 Wilfred A. French, editor of *Photo Era*, indicated that current exhibition committees were disappointed with the low prices most pictorialists placed on their work and suggested that higher prices would help legitimize photography as an art form. "Pictorial workers owe it to their reputation as creative artists as well as to the dignity of pictorial photography as a fine art to regard their productions as comparable to oil paintings—at least the equal of watercolors and etching—and to sell them at comparably high prices," he wrote. "The buying public seems to have a higher regard for an article of merchandise or work of art, the more it costs. Let the pictorial worker remember this."[85] French then asked his readers to write him about their views on pricing photographs, and numerous prominent pictorialists responded.

Most of those whose comments appeared over the next few months in *Photo Era* pointed out that they weren't involved in pictorial photography for the money, since no one could make a living at it anyway. They also suggested that high prices would probably discourage, not boost, sales. Those who had occasionally sold prints were gratified that others were sufficiently interested in their work to buy it (however low the price), but they lamented the difficulty of replacing a sold print with another of equal quality. Clark Blickensderfer (illus. 85) wrote that he charged only ten dollars for his own prints, but he agreed with French that pictures by the master Belgian pictorialist Léonard Misonne were drastically underpriced at fifteen dollars. O. C. Reiter (illus. 86), a key organizer of the Pittsburgh salons, indicated that a fellow pictorialist, whom he didn't name, had been buying photographs for years out of their salons and now possessed an impressive collection.

The Pittsburgh Salon of Photographic Art, as one of the country's leading exhibitions of pictorial work, was an excellent showcase for those interested in buying creative photographs. In 1924 all six of Misonne's beautiful and unique bromoil-transfer prints quickly sold. Francis O. Libby and Rupert S. Lovejoy, both of Portland, Maine, each sold gum prints for twenty-five dollars. And four years later the salon reportedly sold seventy-five photographs. Even during the depression, pictures were bought at Pittsburgh, with the average price in 1931 being just under ten dollars each. Few salons, Pittsburgh included, listed the prices for photographs in their catalogs, probably to avoid

85. Clark Blickensderfer
Lines and Angles, c. 1925.
The Minneapolis Institute of Arts,
Ethel Morrison Van Derlip Fund.

86. O. C. Reiter
The Husbandman, 1919.
Photographic Section of the Academy
of Science and Art of Pittsburgh.

commercial overtones. Normally, prospective customers voiced their interest to a gallery attendant, who then passed the word to the photographer.

In 1932 Byron H. Chatto wrote a short article for the *American Annual of Photography* called "Selling Exhibition Pictures." In it he indicated that connoisseurship had already become an issue with some buyers, who generally wanted to purchase the very print they saw in a salon, not a duplicate made later by the photographer. Thus, the collector was assured of the quality of the piece and also secured the original mount and its affixed exhibition labels. Chatto observed that salon visitors often showed great interest in the pictures marked "sold," closely examining and discussing them. He also made price suggestions: five to ten dollars for bromide and chloride prints, which were easily duplicated, and ten to twenty-five dollars for carbons, bromoils, and other unique prints made by control processes.

The photographic press played a secondary role in facilitating the purchase of pictorial photographs. West Coast editor Sigismund Blumann seemed particularly interested in the general public's acquisition of such images. In 1933, when he was in charge of *Camera Craft*, Blumann offered to supply the prices for particular pictures to anyone who contacted him. Shortly thereafter, when he began publishing *Photo Art Monthly*, he established a Print Service Department, which enabled individuals to contact the makers of the salon prints they wished to purchase. In an ad announcing this service in the first issue of the magazine, he claimed, "There is no educational factor in art so potent as a collection of pictures. There is no greater pleasure than in owning a little salon of your own."[86] At about the same time, *Camera Craft* carried ads in which William Mortensen offered his prints in various formats. Collectors could buy his portfolios of twenty-five small prints for ten dollars (a bargain according to a review in the same magazine), individual portfolio prints for three dollars each, or his full-scale, 11-by-14-inch salon prints for fifteen dollars apiece. Mortensen undoubtedly sold more of his pictures than any other pictorialist during the 1930s and 1940s, thanks to his personal popularity and his marketing skills.

Trading enabled many pictorialists to form major collections of each other's work. Individuals who saw prints they admired either at salons or reproduced in magazines would propose to exchange one of their own for someone else's. The Chicago surgeon Max Thorek built a large collection this way. So did Cecil B. Atwater, an American pictorialist known for his pictures of Mexico; his holdings of work by Gustav Anderson, Eleanor Parke Custis, Arthur Hammond, John R. Hogan, Hans Kaden, P. H. Oelman, Thomas O. Sheckell (illus. 87), and others gave him "daily mental and spiritual nourishment." In 1945 Atwater made available to museums that didn't host their own photography exhibitions half of his collection of 200 top salon prints. Fortunately, a few of these private collections have remained intact. The 160 pictures gathered by Stanley A. Katcher, a lawyer by

87. Thomas O. Sheckell
Springtime on the Jordan, c. 1942.
The Minneapolis Institute of Arts,
Tess E. Armstrong Fund.

day and a pictorialist by night, are held by the University of New Mexico Art Museum in Albuquerque. And Max Thorek gave his collection to Chicago's Museum of Science and Industry in 1935, in celebration of the city's Century of Progress exposition.

Thorek's gift was unusual for the time, and only two other museums created collections of pictorial photographs before mid-century. What is now the National Museum of American History of the Smithsonian Institution apparently began collecting sometime in the 1920s and the Brooklyn Museum commenced its collection around 1940. Both institutions acquired, as well as exhibited, pictorial work because, unlike virtually any other museum, they had staff curators who specialized in photography. New York's Museum of Modern Art appointed Beaumont Newhall as its first curator of photography in 1940, but Newhall, a close ally of the purists Ansel Adams and Edward Weston, had little patience for pictorialism.

By the early 1920s, Dr. A. J. Olmstead was serving as the "custodian" in the department of photography at the Smithsonian Institution in Washington, D.C. *Photograms of the Year 1921* reported that the museum had "issued invitations to some selected photographic artists to contribute examples of their work" and praised the move as "Government recognition of the attainment of high pictorial rank."[87] Although Olmstead was also in charge of the Smithsonian's substantial collection of photographic equipment, he introduced a series of one-person exhibitions in the 1930s. These exhibitions, which continued into the 1950s, encouraged the featured photographers to give a small group of their prints to the Smithsonian's growing permanent collection. Under Olmstead, hundreds of pictorial photographs were acquired, including work by Edward L. Bafford, Jean Elwell, G. G. Granger, George C. Poundstone, Floyd Vail, and a host of others. In 1933 the widow of the Brooklyn pictorialist Joseph Petrocelli gave the Smithsonian eighty-five master prints by her late husband, creating a major archive of his work there.

In 1942 the Brooklyn Museum appointed Herman de Wetter, an associate of both the Photographic Society of America and the Royal Photographic Society, as its curator of photographs. De Wetter had begun working at the museum about a decade earlier, apparently as a photography teacher and photographer. Around 1940 he began soliciting pictorial prints for the start of a permanent collection, sixty-five of which went on view in the fall of 1941. A few years later, he wrote an article for *Popular Photography* proclaiming that the institutional collecting of photographs helped cement the medium's status as an art form. "It was inevitable that photography should take its rightful place among the modern arts, worthy of preservation," he wrote. "Under the direction of the curator, the collection is being gradually acquired and includes only outstanding examples of work."[88] He reported that Brooklyn's collection now numbered about three hundred prints, selected primarily from national salons and camera-club exhibitions. Annual exhibitions from the collection were

staged, and the museum's entire holdings were available for private viewing by appointment. De Wetter also stated that museums from around the country had borrowed from Brooklyn entire exhibitions, which were always enthusiastically received by local audiences. Unfortunately, none of these borrowing institutions proceeded to establish its own holdings of pictorial photographs, leaving the Museum of Science and Industry, the Brooklyn Museum, and the Smithsonian with the only period collections of such work.

IV. The Demise of Pictorial Photography

Pictorialism evolved through various stages during its forty-year life span after the demise of the Photo-Secession. During the 1910s it rebuilt itself under the tolerant and watchful eye of Clarence H. White, who still encouraged creative photographers to make evocative, softly focused pictures. During the 1920s, the Pictorial Photographers of America instilled the movement with populist attitudes and a plurality of photographic styles. Pictorial activity exploded in the 1930s when pictorial imagery reflected the influence of modernism. During the 1940s, the pictorial movement solidified its rules, both visually and organizationally, making it more challenging for practitioners to rise above the mediocre and repetitive. By the 1950s, however, artistic, technological, and social circumstances led to the demise of pictorialism. Numerous writers for the photographic press, the very voice of pictorialism, began to sound its death knell, and criticism from within the movement itself indicated the seriousness of the matter. In January 1952 a contributor to *Metro News*, the combined bulletin for New York's hundred-some camera clubs, assessed the current situation this way.

Pictorial photography has earned a reputation as being old hat, repetitious and redundant; it is certainly true that we see the same old subject matter presented in the same old way in the salons year after year. The pictorialists have earned a reputation for being old fuddy-duddys who imitate each other's work until we become saturated with seeing the same pictures with new names under them year after year. The pictorialists have limited themselves to the "pretty" pictures and there has been a horrible tendency to over-sentimentalize much trite subject matter. The pictorialists have had a narrow viewpoint with their over-emphasis on technique, and the rejection of any picture that did not fit the "rules of composition"! This tendency on the part of the pictorialist to judge all pictures from the narrow viewpoint of a set of man-made compositional rules, and a preconception of what makes a good picture, has been the curse of pictorialism.[89]

Such a grim assessment by one of the movement's own was, indeed, an ominous sign.

During the 1950s, pictorial photography was marginalized by the very institutional support system it had established for itself in its infancy. The salons, photographic magazines, and camera clubs all democratized so successfully during the 1930s that, by mid-century, pictorial work became but one small portion of their interest. For example, the Photographic Society of America (PSA), which had begun as a national organization of pictorialists, eventually regarded pictorialism as only one of six divisions, the others being color, motion pictures, nature, photojournalism, and technical. In March 1951 Jacob Deschin reported in the *New York Times* that the PSA was actively soliciting the involve-

ment of professional and other non-pictorially-oriented photographers and that its exhibits and offi-cers would reflect the new balance. The same year the society designated Edward Weston, an archen-emy of pictorialism for twenty-five years, an honorary fellow (Hon. FPSA), its highest award.

In a way, pictorialism was a victim of its own success. So many photographers practiced it and it encouraged so many different approaches that it lost its own identity. The plurality of styles and interests that strengthened pictorial photography in the 1920s and 1930s ultimately splintered and diluted the movement by the 1950s. Salons included color, candid, nature, press, documentary, and scientific pictures alongside standard pictorial fare. The results were weak exhibitions and a confused public. Aware of this mistake, Adolf Fassbender called for separate shows, declaring that "we cannot cook cabbage and chocolate together and expect a good meal."[90]

Most white Americans were rampantly optimistic during the 1950s, despite the Red-baiting of McCarthyism and continued racial segregation. They elected a war hero, Dwight Eisenhower, as president, had children in record numbers, and enjoyed the fruits of great economic expansion. They began building the interstate highway system; bought large, American-made automobiles; moved to the suburbs; and tuned in to their new television sets. By 1955 more than two-thirds of American households had TVs, captivating boxes that lured many amateur photographers out of their darkrooms. With the United Nations in place and Ike in the White House, the country felt confident, comfortable, and safe. Unlike previous decades, the 1950s offered little reason to escape everyday life. Pictorialism, in turn, lost one of its main reasons for being.

In addition to television, other technological developments severely altered creative amateur pho-tography by mid-century. Amateur movie-making equipment and stereo cameras distracted some photographers from their pictorial work. Camera clubs tried to accommodate these interests, but many saw their ranks depleted as members went off to start clubs devoted exclusively to such concerns. The 35-mm camera also affected the way many pictorialists saw the world and pho-tographed it. Those wielding the miniature camera often spent less time both shooting their film and making their prints, and their indifference showed in terms of less visual foresight and less technical care. The development of affordable color materials for the amateur also discouraged pictorialists from handcrafting their own black-and-white prints. Further proof of pictorialism's demise was the replacement of print exhibitions in museums with slide screenings in auditoriums.

Pictorial photography had made its mark on the motion-picture industry during the 1920s and 1930s, but its influence waned after World War II. Between the wars, the cinema adopted such pictorial effects as soft focus, strong lighting, and good composition. At least one pictorialist—Karl F. Struss in 1917—went to Hollywood to become a cinematographer and never looked back. Numerous other

Southern California pictorialists brought to bear their artistic sensibilities on the film industry. But as motion-picture equipment infiltrated the amateur market, many pictorialists gave up making still pictures to shoot countless reels of home movies. Most photographic monthlies ran cinema columns starting as early as the 1920s, but massive interest did not build until the late 1940s. In 1946 the Photographic Society of America created a motion-picture division and the next year organized its first movie salon. Virtually all the California camera clubs had motion-picture committees, as did clubs as far away as Iowa, where by 1948 the Des Moines Camera Club had become the Des Moines YMCA Movie and Camera Club. Most photographers seduced by amateur movie-making equipment were unable to apply the artistry of traditional pictorial photography to their movies.

The popularity of the 35-mm camera also thwarted the continued vitality of pictorialism. Leicas and similar small-format cameras were introduced into the United States in the mid-1920s, but for the next twenty years most pictorialists favored medium size format cameras. From the beginning, photographers like Paul L. Anderson had objected to the high speed and instantaneous nature of the pictures made with the so-called candid cameras. Some leading pictorialists noted that those who participated in clubs devoted exclusively to making pictures with 35-mm cameras often fixated on technical concerns and multitudinous accessories rather than on artistic matters. In 1941 Anderson flatly stated that "the miniature camera is no instrument for the pictorial worker."[91] Adding to the lure of the 35-mm camera in the mid-1940s was the revival of stereo photography, which seemed to render pictures in three dimensions. The popular Stereo-Realist produced pictures that were grounded in the real world and antithetical to the fantasy and escapism inherent in pictorial images.

Besides fostering inferior pictorial work, the 35-mm camera facilitated the explosion of color photography, a phenomenon that dealt the movement its final blow in the 1950s. Pictorialists resisted making color work for years, initially excluding hand-colored monochromatic prints from their salons. In 1937 Kodak introduced its 35-mm Kodachrome film for still cameras, enabling amateurs to make rich color transparencies, but most pictorialists persisted in making black-and-white photographic prints. Even the subsequent Kodacolor print process initially failed to convert many creative photographers, due to its cost and unreliability. By the mid-1940s, however, pictorialists could no longer resist the seductiveness of color, and they began churning out thousands of tiny 35-mm color slides. All of a sudden, photographic magazines reproduced color prints and carried articles on the subject, salons began accepting slides, and senior pictorialists even tried their hand at it. Adolf Fassbender learned and taught the Tri-Color Carbro process but eventually abandoned it because it was difficult to control. William Mortensen developed his own Metalchrome process, in which the color was added by hand, and produced some particularly painterly portraits. In 1947, when the stalwart Pittsburgh salon accepted color slides for the first time, the floodgates were opened.

Color slides distracted photographers from classic pictorial concerns. Content and expression took a backseat to the issue of color itself. Some, of course, thought that the only colors achieved were unnatural and jarring. And little control or manipulation was possible, because the medium was film instead of paper. Slide makers simply pointed the camera and shot, letting commercial processors develop their film; since no personal darkroom work was necessary, the *craft* of pictorialism disappeared. Exhibitions were now drastically different. Instead of a handsome museum installation of individually made photographic prints, the show was now a lengthy auditorium screening of hundreds of machine-processed slides. In 1957 Adolf Fassbender wrote to the secretary of the Royal Photographic Society that "color has taken the amateurs by storm." He reported that the standards of pictorialism "are being rapidly lowered due to so much color snapshot work. Naturally the color movement is being punched by all manufacturers, as people seem willing to use it regardless of their results."[92] By this time, camera clubs and salons devoted exclusively to color operated in many of the country's largest cities.

Quantity superseded quality when color slides were exhibited. It was much easier to make and submit slides than it was monochrome prints, so the number of submissions and acceptances increased dramatically. Nearly four thousand slides were sent to the 1945 Chicago slide salon, a formidable number for the jury to view and judge. In reality, however, the number of prints sent to salons had also increased noticeably in the 1940s, due to the exhibition rankings in the *American Annual of Photography*. The annual's regular listing of pictorialists and the number of their successful salon pictures encouraged photographers to make more and more prints, often at the expense of quality. The numbers game that developed during the 1940s in the salons stirred skepticism for pictorial exhibitions and contributed to the demise of the entire movement.

As early as 1934, Edwin C. Buxbaum predicted the outbreak of a disease he termed "salonimania," referring to pictorialists' craze for salon exhibiting. He jokingly wrote that its symptoms included a greater interest in acquiring salon labels than in making good pictures ("labelitis") and indicated that among its few cures were an unsympathetic wife and a lack of funds. Most pictorialists kept record books of where and when their prints had been submitted, proudly totaling acceptances of particular pictures. Paul L. Anderson noted that bromide printing papers, similar to the fiber-based photographic papers of today, took less time to expose and develop than earlier processes like platinum and thus enabled pictorialists to essentially mass-produce their pictures. Anderson stated in 1935 that he knew a salon exhibitor who regularly produced thirty-five exhibition prints in a morning. By contrast, he claimed that the old-school pictorialist William E. Macnaughtan (illus. 88) had made only thirty-three finished prints during his entire ten-year exhibition career.

Most pictorialists admitted they were salon addicts: Once they got a taste of glory, there was no holding them back. Magazine editors Franklin I. Jordan and Frank R. Fraprie claimed that salon

88. William E. Macnaughtan
A Connecticut River, 1912,
platinum print. The Minneapolis
Institute of Arts, gift of funds from
Jud and Lisa Dayton.

exhibiting had become a sport and lamented the debasing nature of the game. More and more, photographers were making pictures primarily for exhibition purposes and not as a means of self-expression. Some exhibitors were known to tailor their entries to a specific salon according to the makeup of its jury. Even the salon catalogs quantified their contents by listing the geographical sources of their submissions and acceptances. An anonymous writer for Atlanta's 1950 Dixie International Exhibition of Pictorial Photography wryly noted, "Photography is the only art (if art it is) in which the participant bases his success or failure on a score or percentage."[93]

As numbers became paramount to pictorialism, some leaders withdrew from salons. Even before 1940, Paul L. Anderson stopped exhibiting, as did Adolf Fassbender and D. J. Ruzicka in the next few years. In 1944 Ruzicka stated that "the salons have served a good purpose but in the last few years they have degenerated into a scramble for ratings."[94] After an initial flush of success, some pictorialists dropped out because they couldn't maintain the frantic pace necessary to continue competing. A. Aubrey Bodine became disgusted with the salons by mid-century, believing they were too large and the judges weren't critical enough. A frequent jury member and exhibitor himself, he revealed there was something of an unwritten code among the elite group of pictorialists who judged the salons that made it easier for their work to pass the jury. He subsequently quit both judging and exhibiting on the ever-expanding and seemingly out-of-control salon circuit.

As pictorialists clamored for more and more salon acceptances, salon judges were increasingly criticized for their failures. During the 1940s, numerous articles contained complaints that the current jury system was adding to the stagnation of pictorial photography. Chosen from the pool of frequent exhibitors, a small group of salon "shamans" ruled the pictorial world with their conservative decisions. Because new work was discouraged, young, creative photographers weren't inclined to submit to salons. Even the venerable Frank R. Fraprie despaired in 1944 that he observed in the salons "a false taste" that was being "perpetuated in a growing spiral."[95] Pictorialism was turning into a photographic black hole, a void of its own making.

Conditions of the Baltimore salon in the early 1950s illustrate this deterioration. For several years, the Baltimore Camera Club had presented its annual international salon at the Baltimore Museum of Art, proudly reproducing a picture of the museum's facade on the cover of its catalogs. In 1951, however, the museum denied its galleries to the salon, citing poor attendance the year before and the gutted state of pictorialism in general. Desperate to return to this prestigious facility, the camera club agreed to alterations in its restrictive exhibition rules, and the salon was again scheduled at the museum in 1952.

Primary among the changes was the makeup of the jury, over which the museum took complete control. Instead of a predictable lineup of established salon exhibitors, which in the past usually included

resident pictorialist A. Aubrey Bodine, the museum asked three non-photographers—two artist/teachers and the curator of graphic arts from the Smithsonian Institution—to judge the submissions, an unprecedented move. The camera club also agreed to ease the tight restrictions on print and mount sizes, comprising the universal standard of 16-by-20-inch mounts. Finally, gold medals were to be offered, breaking the established no-prize rule of American photographic salons.

That the authorities at the Baltimore Museum of Art sought to host a salon very different from the embarrassment of a few years before was evident in the 1952 entry form. In it the museum director stated that entries should engage contemporary concerns, communicate ideas and feelings, and avoid both cliché and imitation of the established arts. The form expressed the organizer's primary goal as an attempt to "relieve the general similarity and possible monotony of appearance of the familiar photographic salon—such of which appearance has been attributed to imitative rather than creative expression on the part of exhibitors." It went on to grandiosely state that the salon would try to "settle once and for all whether or not photography is one of the arts or just a skilled craft."

When it opened on May 31, the 1952 Baltimore International Salon of Photography shocked what remained of the pictorial world. The jury had chosen only ninety-four pictures for the exhibition, most of which were decidedly nonpictorial. Up to this point, most salons had democratically included two to three times this many photographs. Even more startling was the look of the successful pictures. Gone, for the most part, were sentimental subjects, soft-focus effects, and generic imagery. Representative of the exhibition was the gold-medal winner, *Mighty Manhattan*, by New York photographer Otto Litzel (illus. 89); it objectively pictured the United Nations, Chrysler, and other New York buildings, and looked like an uninspired publicity photograph. The work of only four established pictorialists—A. Aubrey Bodine and Max Thorek among them—passed the jury.

While a few pictorialists applauded the salon's altered look, most derided what became known as the "Baltimore Experiment." Adolf Fassbender derisively called the jury "ultra-modern," and William Mortensen felt that the museum had sent "horse-breeders to judge a dog show." Numerous articles surveyed the damage the salon had wrought, including one by Mortensen, titled "The Hermits of Baltimore." In it he reproduced only pictures that the jury had rejected (his own among them) and stated that he preferred their company to that of the impersonal, factual pictures that made up the show. Mortensen found little communicative value in the accepted pictures and counseled, "If you find yourself wondering why the winning prints fail to do anything for *you*, I will explain that perversely, hopelessly, they attempt to portray complete, objective reality—the thing itself rather than the significance of the thing. It is as if a man with the ability to speak should elect to talk by pointing, child-like, at objects."[96]

89. Otto Litzel
Mighty Manhattan, c. 1951,
reproduced in catalog for 1952
Baltimore International Salon of
Photography.

Over the next few years, the failure of the 1952 Baltimore salon, a pictorial event in name only, became increasingly apparent. Pictorialists began to reappear on the jury of selection the very next year, soon dominating decision-making again. In about 1955, however, the Baltimore Museum of Art once and for all evicted the exhibition from its galleries, making it necessary for the camera club to find less prestigious accommodations. Soon the presentations were termed *exhibitions*, not *salons*, reflecting the more modest aesthetic stance of the club's members. And slides and color work quickly outstripped the quantity of monochrome prints, the now-antiquated medium of pictorial photography. This situation was repeated simultaneously throughout the United States, as the words *salon* and *pictorial* disappeared from the camera-club lexicon.

The fate of photographic magazines at this time reflected the demise of pictorial photography. Frank R. Fraprie, the editorial backbone of pictorialism, retired from both the monthly *American Photography* and the *American Annual of Photography* at the end of 1949. Succeeding editors redesigned the publications and dramatically altered their content. Both periodicals now featured writing and reproductions by contributors committed to straight, experimental, modernist, and journalistic photography—in other words, the antithesis of pictorialism. George B. Wright, the new editor of *American Photography*, devoted the January 1951 issue to a mid-century review of photography, and its contents reflected the magazine's new direction. Among the contributors of major articles were Beaumont Newhall, who wrote about turn-of-the-century photography; Arthur Siegel, who surveyed documentary work; Sibyl Moholy-Nagy, who reviewed her late husband's avant-garde pictures; and Dody Warren, who wrote on Ansel Adams, Paul Strand, and Edward Weston, the holy triumvirate of purist photography. The one nod to pictorialism was a four-page summary of camera-club activities by L. Whitney and Barbara Standish, but their brief article was a bitter reminder of the magazine's previous total commitment to the subject. *American Photography* and its accompanying annual no longer spoke to creative amateurs, and both ceased publication in 1953, as did the Baltimore-based monthly *Camera*, another pictorial stalwart. Pictorial photography, pictorial salons, and the pictorial press all were history by the mid-1950s.

It was no coincidence that a new photographic magazine, *Aperture*, was launched at this time. Edited by Minor White, it was committed to serious, emotive picture making—that is, to straight artistic and documentary work. The quarterly's founders, including Ansel Adams, Dorothea Lange, and Beaumont Newhall, preached and practiced photography diametrically opposed to the pictorial tradition of the recent past. Their aesthetic soon dominated American photography, gaining visibility at museums, at exhibitions, and in publications. After mid-century, the remnants of pictorialism could not compete with this powerful new passion for artistic camera work.

90. Adolf Fassbender
City, Thy Name Be Blessed, 1934.
The Minneapolis Institute of Arts,
Ethel Morrison Van Derlip Fund.

Although pictorial photography has been moribund since the 1950s, its influence is still evident—in the continued popularity of camera clubs and their slide shows and in the technically sound, compositionally correct, and visually safe images that advanced amateurs produce. These individuals are living the legacy of pictorialism, though they probably are unaware of the movement or its leaders. Although present-day camera-club activity most likely will never achieve the prominence pictorialism once enjoyed, its numbers grow and interest remains high. This phenomenon was optimistically predicted years ago by Adolf Fassbender (illus. 90), who continued to make pictorial images into the 1960s. He believed that pictorialism, by its very nature, was eternal, because it was based on a popular standard of beauty that appealed to the general masses. "There is no solution in trying to eradicate pictorialism for one would then have to destroy idealism, sentiment and all sense of art and beauty," he wrote in 1952. "There will always be pictorialism."[97]

Notes

1. Alfred Stieglitz, "The Photo-Secession at the National Arts Club, New York," *Photograms of the Year 1902*, p. 18.

2. Paul B. Haviland, "The Home of the Golden Disk," *Camera Work*, No. 25 (January 1909), p. 21.

3. Paul L. Anderson, "On Photography as a Fine Art," *American Photography*, May 1938 (Vol. 32), p. 308.

4. Adolf Fassbender (interview), "Pictorialism Today," *American Photography*, February 1952 (Vol. 46), p. 36.

5. Clarence H. White (interviewed by Henry Hoyt Moore), "The Progress of Pictorial Photography," *Annual Report of the Pictorial Photographers of America*, Pictorial Photographers of America, New York, 1918, p. 12.

6. Paul L. Anderson, "When Is a Good Photograph Not a Good Photograph?," *American Photography*, June 1940 (Vol. 34), p. 392.

7. Adolf Fassbender, "Understand: Amateur versus Artist," manuscript, n.d., unpg. Fassbender Foundation, on loan to The Minneapolis Institute of Arts.

8. Max Thorek, *Creative Camera Art*, Fomo Publishing Co., Canton, Ohio, 1937, p. 36.

9. William Mortensen, *Print Finishing*, Camera Craft Publishing Co., San Francisco, 1938, p. 71.

10. William Mortensen, *Monsters and Madonnas*, Camera Craft Publishing Co., San Francisco, 1936, unpg.

11. John Wallace Gillies, *Principles of Pictorial Photography*, Falk Publishing Co., New York, 1923, p. 183.

12. Adolf Fassbender, "Composition," manuscript for lecture to the Federated Camera Clubs of New Jersey, April 21, 1958, p. 3. Fassbender Foundation, on loan to The Minneapolis Institute of Arts.

13. Arthur Hammond, "The Selection of the Subject in Pictorial Photography," *American Photography*, April 1927 (Vol. 21), p. 198.

14. Eleanor Parke Custis, *Composition and Pictures*, American Photographic Publishing Co., Boston, 1947, p. 101.

15. Frank Crowninshield, "Foreword," *Pictorial Photography in America, Volume 5*, Pictorial Photographers of America, New York, 1929, unpg.

16. John Wallace Gillies, *Principles of Pictorial Photography*, Falk Publishing Co., New York, 1923, p. 141.

17. Axel Bahnsen, "A Rational Approach to Pictorial Photography," *Camera*, December 1940 (Vol. 61), p. 40.

18. Adolf Fassbender, "Finding of Pictures," unpublished manuscript, n.d., p. 28. Fassbender Foundation, on loan to The Minneapolis Institute of Arts.

19. Edward R. Dickson, "The Eighth American Photographic Salon," *Photo Era*, February 1912 (Vol. 28), p. 88.

20. Jaromír Funke, "Dr. D. J. Ruzicka ve Fotografie," *Fotografický Obzor*, 1936, (Vol. 44), pp. 171–172.

21. Adolf Fassbender, "Dynamic Pictorialism," *PSA Journal*, July 1941 (Vol. 7), p. 77.

22. Clarence H. White (interviewed by Henry Hoyt Moore), "The Progress of Pictorial Photography," *Annual Report of the Pictorial Photographers of America*, Pictorial Photographers of America, New York, 1918, p. 7.

23. Arthur Wesley Dow, "Painting with Light," *Pictorial Photography in America, 1921*, Pictorial Photographers of America, New York, 1921, p. 5.

24. Arthur Hammond, *Pictorial Composition in Photography*, American Photographic Publishing Co., Boston, 1946 (fourth edition), p. 516.

25. Joseph Foldes, "Photographic Self-Expression," *Camera*, June 1949 (Vol. 71), p. 94.

26. Axel Bahnsen (as told to Paul Howe), "Sur-realism in Photography," *Camera*, March 1941 (Vol. 62), p. 30.

27. Harry K. Shigeta, "Photomontage Tells the Story," *Popular Photography*, October 1939 (Vol. 5), pp. 20–21.

28. Adolf Fassbender, "Pictorialism through the Years," unpublished manuscript, n.d., p. 2. Fassbender Foundation, on loan to the Minneapolis Institute of Arts.

29. Ira W. Martin to Will A. Kistler, November 17, 1932. Edward Weston Archive, Center for Creative Photography, University of Arizona, Tucson.

30. Frank R. Fraprie, "Pictorial Photography in the United States," *Photograms of the Year, 1912*, p. 36.

31. "Spheres of Usefulness," *Platinum Print*, May 1914 (Vol. 1), p. 10.

32. Michael Schudson, *Advertising, the Uneasy Persuasion: Its Dubious Impact on American Society*, Basic Books, New York, 1984, p. 215.

33. Edgar Felloes, "The Pictorial Quality," *Camera Craft*, December 1922 (Vol. 29), p. 28.

34. Arthur F. Kales, "Photography in Western America," *Photograms of the Year, 1928*, p. 13.

35. Leonard A. Williams, *Illustrative Photography in Advertising*, Camera Craft Publishing Co., San Francisco, 1929, pp. 11–12.

36. Herbert Brennon, "The Commercial Photographer Today," *Camera Craft*, December 1931 (Vol. 38), p. 573.

37. Fred G. Korth, "Advantages of a Wide-Angle," *Camera Craft*, March 1936 (Vol. 43), p. 113.

38. A. Aubrey Bodine, quoted in Harold A. Williams, *Bodine: A Legend in His Time*, Bodine and Associates, Baltimore, 1971, p. 44.

39. William Rittase, "Why I Am a Pictorial Photographer," *Photo Era*, December 1930 (Vol. 65), p. 301.

40. "Photographic Society of America Announces First Industrial Picture Salon," *Camera*, May 1940 (Vol. 60), p. 362.

41. Clarence H. White (interviewed by Henry Hoyt Moore), "The Progress of Pictorial Photography," *Annual Report of the Pictorial Photographers of America*, Pictorial Photographers of America, New York, 1918, p. 8.

42. Marie Riggins, "Modern Pictorial Photography and the Measure of Its Art," Ph.D. dissertation, Western Reserve University, Cleveland, 1943, pp. 5–6.

43. Paul L. Anderson, "Some Pictorial History," *American Photography*, April 1935 (Vol. 29), p. 206.

44. *A Professional Course for the Professional Worker in the Clarence H. White School of Photography*, Clarence H. White School of Photography, New York, 1919, p. 3.

45. Clarence H. White, "Training in Photography," *Clarence H. White School of Photography*, New York, c. 1940, p. 4.

46. Margaret Watkins, "Advertising and Photography," *Pictorial Photography in America, Volume 4*, Pictorial Photographers of America, New York, 1926, unpg.

47. [Ira W. Martin], "The New School: Second Part," *Light and Shade*, February 1929 (Vol. 1), p. 8.

48. Thomas O. Sheckell, "A Broad View," *Light and Shade*, March 1939, p. 1.

49. Ira W. Martin, "Foreword," *Sixth International Salon of Photography*, Pictorial Photographers of America, New York, 1939, unpg.

50. *Pictorial Photographers of America* (annual report), Pictorial Photographers of America, New York, 1917, p. 6.

51. Eleanor Parke Custis, *Composition and Pictures*, American Photographic Publishing Co., 1947, Boston, p. 4.

52. Adolf Fassbender, "The Joy of Making Pictures," WOR radio broadcast manuscript, September 9, 1934, p. 4. Fassbender Foundation, on loan to The Minneapolis Institute of Arts.

53. Max Thorek, "Photography as an Avocation," *American Annual of Photography, 1951*, p. 7.

54. Ira W. Martin, "Woman in Photography," *Pictorial Photography in America, Volume 5*, Pictorial Photographers of America, New York, 1929, unpg.

55. Edward R. Dickson, "Pictorial Photographers of America: Its Work and Its Aim," *Photo-Graphic Art*, October 1917 (Vol. 3), p. 18.

56. Adolf Fassbender, "Pictorial Photography," *Photo Art Monthly*, October 1934 (Vol. 2), p. 468.

57. Edwin C. Buxbaum, *Pictorial Photography with the Miniature Camera*, Fomo Publishing Co., Canton, Ohio, 1934, pp. 70–71.

58. Frank R. Fraprie, "Our Seventeenth Annual Competition," *American Photography*, September 1937 (Vol. 31), p. 610.

59. Paul L. Anderson, "The Rationale of Pictorial Composition," *American Annual of Photography, 1939*, p. 8.

60. William Mortensen, "Talking about Photography with Mortensen," *American Photography*, June 1950 (Vol. 44), p. 33.

61. Warwick Barse Miller, "An Outline of Pictorial Photography," *American Annual of Photography, 1932*, p. 200.

62. William Mortensen, *The Command to Look: A Formula for Picture Success*, Camera Craft Publishing Co., San Francisco, 1937, p. 72.

63. Paul L. Anderson, "The Education of the Photographic Artist," *Photo Era*, December 1915 (Vol. 35), p. 269.

64. Adolf Fassbender, "Contemporary Exhibition Photography," *PSA Journal*, June 1951 (Vol. 17), p. 375.

65. James Wallace Pondelicek, "Figure Photography," *American Photography*, June 1922 (Vol. 16), p. 346.

66. Jack Powell, "The Nude in Photography," *PSA Journal*, January1943 (Vol. 9), p. 20.

67. J. C. Bridges, ed., *Pictorial Figure Photography*, American Photographic Publishing Co., Minneapolis, 1950, p. 7.

68. William Mortensen, *Monsters and Madonnas*, Camera Craft Publishing Co., San Francisco, 1936, unpg.

69. Max Thorek, "Why I Am a Pictorial Photographer," *Photo Era*, August 1928 (Vol. 61), p. 63.

70. Fred R. Archer, "How Four Pictures Were Made," *Camera Craft*, February 1919 (Vol. 26), p. 47.

71. Paul L. Anderson, "On Photography as a Fine Art," *American Photography*, May 1938 (Vol. 32), p. 315.

72. "Wartime and the Fourth St. Louis," *Fourth Annual Saint Louis International Salon of Photography*, St. Louis Art Museum, 1944, p. 5.

73. Byron H. Chatto, "The Camera Club in Wartime," *PSA Journal*, October 1942 (Vol. 8), p. 426.

74. "?00,000 for a Photograph," *American Photography*, April 1943 (Vol. 37), p. 11.

75. Jack Wright, "'Escape' Photography," *Camera Craft*, March 1942 (Vol. 49), p. 139.

76. Emma H. Little, "Big Business Sponsors Camera Clubs," *Popular Photography*, April 1941 (Vol. 8), p. 37.

77. Max Thorek, *Camera Art as a Means of Self-Expression*, J. B. Lippincott Co., Philadelphia, 1947, pp. 10–11, 219.

78. John H. Vondell, "I Belong to a Camera Club," *Popular Photography*, October 1938 (Vol. 3), p. 35.

79. "The Photographic Salon," *Camera Craft*, November 1920 (Vol. 27), p. 370.

80. William Mortensen, *Print Finishing*, Camera Craft Publishing Co., San Francisco, 1938, p. 119.

81. Axel Bahnsen, "Axel Bahnsen Says," *American Photography*, September 1950 (Vol. 44), p. 28.

82. George Brookwell, "First International Photographic Salon," *Camera Craft*, April 1918 (Vol. 25), p. 142.

83. Paul L. Anderson, "On Photography as a Fine Art," *American Photography*, May 1938 (Vol. 32), p. 308.

84. Max Thorek, *Creative Camera Art*, Fomo Publishing Co., Canton, Ohio, 1937, p. 127.

85. Wilfred A. French, "Attention—Photo-Pictorialists!," *Photo Era*, January 1925 (Vol. 54), p. 57.

86. "Photo Art Monthly Print Service," *Photo Art Monthly*, November 1933, advertising page.

87 Floyd Vail, "Pictorial Photography in America," *Photograms of the Year 1921*, p. 28.

88. Herman de Wetter, "Photography Joins the Arts," *Popular Photography*, July 1943 (Vol. 13), p. 83.

89. Robert Worth, "Creative or What's in a Name?," *Metro News* (Metropolitan Camera Club Council, New York), January 1952, p. 9.

90. Adolf Fassbender, "Artistry in Photography," *Brooklyn Central* (Central Branch Brooklyn YMCA), May 1, 1936 (Vol. 35), p. 5.

91. Paul L. Anderson, "Modern Trends in Pictorial Photography," *American Annual of Photography, 1941*, p. 28.

92. Adolf Fassbender to L. E. Hallett, September 11, 1957. Fassbender Foundation, on loan to The Minneapolis Institute of Arts.

93. *Third Dixie International Exhibition of Pictorial Photography*, Dixie Camera Club, Atlanta, 1950, unpg.

94. D. J. Ruzicka, quoted in Jack Wright, "PSA Personalities: Dr. D. J. Ruzicka, FPSA," *PSA Journal*, February 1944 (Vol. 10), p. 99.

95. Frank R. Fraprie, "The Editor's Point of View," *American Photography*, August 1944 (Vol. 38), p. 7.

96. William Mortensen, "The Hermits of Baltimore," *Camera*, February 1953 (Vol. 76), p. 88.

97. Adolf Fassbender, "Pictorialism Today," *American Photography*, February 1952 (Vol. 46), p. 54.

Bibliography

This is a selected bibliography of general references on pictorial photography after 1910. Monographic books and articles on or by individual photographers are listed with their biographies.

Album of Pictures. S. D. Warren Co., Boston, 1939.

American Annual of Photography. New York and Boston, 1887–1953.

American Photography. Boston, 1907–1953.

Bailey, Henry Turner. *Photography and Fine Art.* Davis Press, Worcester, Massachusetts, 1918.

Barnes, Lucinda, ed. *A Collective Vision: Clarence H. White and His Students.* University Art Museum, California State University, Long Beach, 1985.

Bucher, Louis F., and R. L. van Oosting. *The Camera Club: Its Organization and Management.* Associated Camera Clubs of America, n.p., 1931 (second edition).

Buxbaum, Edwin C. *Pictorial Photography with the Miniature Camera.* Fomo Publishing Co., Canton, Ohio, 1934.

Camera. Philadelphia and Baltimore, 1897–1953.

Camera Craft. San Francisco, 1900–1942.

Camera Pictures. Clarence H. White School of Photography Alumni Association, New York, 1924, 1925 (two volumes).

Campbell, Heyworth. *Modern Masters of Photography, Series 1: Pictorialists.* Galleon Press, New York, 1937.

Clarence H. White School of Photography. Brochures and catalogs, 1910–1942.

Columbia University Photographic Studies. Columbia University, New York, 1920.

Dé Lardi, Alfred A., ed. *Ships and Water.* David McKay Co., n.p., 1938.

"Directory of Pictorial Photographers." *American Art Annual, 1930* (Vol. 27), pp. 492–503.

Erwin, Kathleen A., and Bonnie Yochelson. *Pictorialism into Modernism: The Clarence H. White School of Photography*. Rizzoli and George Eastman House, New York and Rochester, 1996.

Gillies, John Wallace. *Principles of Pictorial Photography*. Falk Publishing Co., New York, 1923.

Jacobs, Michel. *The Art of Composition: A Simple Application of Dynamic Symmetry*. Doubleday, Doran and Co., New York, 1930.

Light and Shade/Bulletin of the Pictorial Photographers of America. New York, 1928–present.

Mann, Margery. *California Pictorialism*. San Francisco Museum of Modern Art, 1977.

Masterpieces from American Photography. American Photographic Publishing Co., Minneapolis, 1950.

Masterpieces from the American Annual of Photography, 1940–1950. American Photographic Publishing Co., St. Paul, Minnesota, 1950.

May, Robert C. *The Lexington Camera Club, 1936–1972*. University of Kentucky Art Museum, Lexington, 1989.

Oliver, Andrew. *The First Hundred Years: An Historical Portrait of the Toronto Camera Club*. Toronto Camera Club, 1988.

Peterson, Christian A. *Pictorialism in America: The Minneapolis Salon of Photography, 1932–1946*. Minneapolis Institute of Arts, 1983.

————. *Index to the Annuals of the Pictorial Photographers of America*. Minneapolis, 1993.

————. *Index to the American Annual of Photography*. Minneapolis, 1996.

Photo Era. Wolfeboro, New Hampshire, and Boston, 1898–1932.

Pictorial Figure Photography. American Photographic Publishing Co., Minneapolis, 1950.

The Pictorialist. Camera Pictorialists of Los Angeles, 1931, 1932 (two volumes).

Pictorial Photography in America. Pictorial Photographers of America, New York, 1920, 1921, 1922, 1926, 1929 (five volumes).

Platinum Print/Photo-Graphic Art. New York, 1913–1917.

PSA Journal. Photographic Society of America, Philadelphia and Oklahoma City, 1935–present.

Reed, Dennis. *Japanese American Photography in Los Angeles, 1920–1945.* Los Angeles Valley College Art Gallery, 1982.

———. *Japanese Photography in America, 1920–1940.* Japanese American Cultural and Community Center, Los Angeles, 1986.

Riggins, Marie. "Modern Pictorial Photography and the Measure of Its Art." Ph.D. dissertation, Western Reserve University, Cleveland, 1943.

Sixth International Salon of Photography. Pictorial Photographers of America, New York, 1939.

Strong, William M. *Photography for Fun.* Leisure League of America, New York, 1934.

Taylor, Herbert G., ed. *My Best Photograph—And Why.* Dodge Publishing Co., New York, 1937.

Tilney, F. C. "What Pictorialism Is," *Photo-Miniature,* January 1924 (No. 192), entire issue.

———. *The Principles of Photographic Pictorialism.* American Photographic Publishing Co., Boston, 1930.

Towles, Will H. *Towles' Portrait Lightings,* Frank V. Chambers, Philadelphia, 1925.

Ward, Nowell. *Picture Making with Paper Negatives.* American Photographic Publishing Co., Boston, 1938.

Williams, Leonard A. *Illustrative Photography in Advertising.* Camera Craft Publishing Co., San Francisco, 1929.

Wilson, Michael G., and Dennis Reed. *California Pictorialism: Photographs 1900–1940.* J. Paul Getty Museum and Henry E. Huntington Library and Art Gallery, Malibu and San Marino, California, 1994.

Biographies

William A. Alcock
c. 1881–1944

Alcock made and exhibited pictorial photographs for two decades, beginning in the late 1910s. A New Yorker, he associated with numerous photographic organizations, teaching courses and judging pictorial salons. He made his living as an attorney, maintaining an office on Wall Street.

William Alexander Alcock was born around 1881 in Londenderry, Ireland. At the age of twelve, he moved to the United States and in 1902 graduated from New York Law School. For the next thirty years, he was an attorney, specializing in surrogate and real estate law.

Alcock's interest in photography began in the late 1910s, when the photographs in a book about roses inspired him to buy a 5-by-7-inch Graflex camera to document his own garden. In 1918 he attended Clarence H. White's summer school of photography and took classes at the Brooklyn Institute of Arts and Sciences under William H. Zerbe and Sophie L. Lauffer. By the next year, he was teaching in the institute's department of photography, where he served as vice-president from 1922 to 1925.

Beginning in 1919, Alcock exhibited extensively at camera clubs and in photographic salons in Toronto, Montreal, London, Copenhagen, Buffalo, Los Angeles, Portland, Kansas City, and Pittsburgh (the latter as late as 1939). He contributed to the annual members' exhibitions of the Camera Club of New York from the early 1920s to the mid-1930s, and in 1924 he was honored with a one-person exhibition at the Photographic Society of Philadelphia.

During this same period, reproductions of his work and articles he wrote appeared in the photographic press. *American Photography, Camera, Photo Era,* and the first three annuals of the Pictorial Photographers of America contained his pictures. In the early 1920s he contributed articles to the *American Annual of Photography* on the bromoil, carbro, and bromide printing processes. As a result of his frequently serving as a salon judge, in places such as Pittsburgh, Rochester, and Toronto, he also wrote exhibition reviews.

In addition to the Camera Club of New York and the Pictorial Photographers of America, other photographic organizations welcomed Alcock as a member. From 1922 to 1927 he was a master craftsman in the Guild of Photography of Boston's Society of Arts and Crafts. He joined the Newark Camera Club and was an early member of the Photographic Society of America. England's Royal Photographic Society granted him fellowship status (FRPS).

Alcock was popular among his fellow pictorialists and generous to them as well. For instance, he performed pro bono legal services for the Clarence H. White School of Photography. In 1931 Alcock wrote a four-part series of articles for *Camera Craft* titled "Recollections and Personalities," in which he fondly described his friendships with numerous photographers. He was frequently photographed by his pictorial colleagues, including Alexander Leventon, Edward Weston, and D. J. Ruzicka, a particularly close friend and one with whom he traveled to California in 1937.

Alcock's imagery was somewhat eclectic, ranging from urban streets to figure studies. He apparently preferred to print in the manipulative processes of gum bichromate and oil. In the early 1930s, he enthusiastically embraced the miniature camera, lecturing on its use for portraiture to the New York Miniature Camera Club.

Alcock died in a retirement home in Amityville, New York, on December 12, 1944, at age sixty-three.

Gillies, John Wallace. "Concerning One William A. Alcock," *American Photography,* November 1923 (Vol. 17), pp. 668–670.

"William Alcock Funeral Is Held," Brooklyn Daily Eagle, December 14, 1944.

Edward K. Alenius
1892–1950

Alenius practiced pictorial photography from the late 1920s through the 1940s. He championed manipulative printing processes and photographed primarily the environs of New York, where he lived.

Edward K. Alenius was born in Finland on February 9, 1892. He trained there in electrical engineering and in 1923 emigrated to the United States. By 1934 he was an electrical engineer at Bell Telephone Laboratories, where he also supervised the artwork for Bell System instruction manuals.

Alenius was drawn to pictorial photography in his mid-thirties and actively pursued it to the time of his death at age fifty-eight. He initially entered a photography contest at the Bell company in about 1928 and soon taught himself the manipulative processes of bromoil and carbro. He regularly exhibited his work in photographic salons; in the 1934–1935 season he was the world's most prolific exhibitor, with 342 prints in 70 salons. Alenius photographed Central Park and a variety of other New York subjects, most of which he rendered in the typical romantic style of pictorialism. His more modernist image *Stainless Steel* appeared in a 1941 magazine advertisement for Kodak film.

Alenius freely shared his photographic expertise with others. For the December 1934 issue of *American Photography* he wrote an article on the Fresson process, a subject he also taught at the Brooklyn Institute of Arts and Sciences. He lectured and gave demonstrations to numerous camera clubs in the Northeast. In 1939 he led a six-week photographic tour of seven European countries. During the 1930s and 1940s he served as president of the Telephone Camera Club of Manhattan, the Jamaica Camera Club, and the Metropolitan Camera Club Council of New York.

Alenius received photographic honors befitting his stature. In the 1930s his work was featured in one-person exhibitions at the Smithsonian Institution and the Boston Camera Club. He received fellowships from England's Royal Photographic Society (FRPS), in 1936, and the Photographic Society of America (FPSA), in 1940.

In about 1940 Alenius moved from Jamaica, New York, to Basking Ridge, New Jersey. He died in an auto accident there on August 14, 1950.

Alenius, Edward K. "Since You Asked Me about Myself," *Photo Art Monthly,* October 1936 (Vol. 4), pp. 478–486.

"Edward K. Alenius, F.P.S.A. (Fellow)" (obituary), *Photographic Journal,* October 1951, p. 311.

Wright, Jack. "PSA Personalties: Edward K. Alenius, FPSA," *PSA Journal,* January 1944 (Vol. 10), pp. 15, 23.

Gustav Anderson
1897–1974

Anderson was the acknowledged master of snow photography among pictorialists from the mid-1930s through the 1940s. His winter scenes were widely used as illustrations in the popular press. He worked as a photoengraver and lived on Long Island.

———

Gustav Anderson was born in Stockholm, Sweden, on October 17, 1897. He grew up in a country village, where he learned to love winter and to ski competitively. By the age of fourteen, he was working in a photoengraving shop and studying art at night school. He subsequently worked in the Swedish film industry, where he reportedly hand-developed the first Greta Garbo film. After emigrating to the United States in about 1925, he worked for nearly the rest of his life as a photoengraver in New York.

Anderson was known among pictorialists exclusively for his snow photographs. He had made snapshots during his Swedish childhood but didn't begin making artistic photographs until he had been in this country for a decade. In 1934 he took a photography class at the Brooklyn Institute of Arts and Sciences under Adolf Fassbender, who inspired him to look creatively at his favorite subject—the outdoors in winter.

Beginning in 1928, Anderson lived in Amityville, New York, then a largely rural village that provided both numerous subjects and a home base for his photographic skiing adventures. Over the next twenty years, he photographed much of the environs of Amityville, always under a blanket of snow and often at subzero temperatures. He made his best-known photograph, *Winter Eve*, while on a skiing trip to Canada in 1938; this classic example of the accessibility of traditional pictorial images appeared on the cover of the December 25, 1938, issue of the *New York Times Magazine*. Anderson also wrote articles on snow photography that appeared in *Photo Art Monthly* (March 1937), *Camera* (December 1943), and *Popular Photography* (February 1948).

Anderson was a relatively modest salon exhibitor who showed for less than a decade—from the mid-1930s to the early 1940s. But outside the salon system his work was reproduced perhaps more than any other pictorialist during the 1940s and 1950s. Anderson made a concerted effort to market his snow pictures for commercial use and once even tried unsuccessfully to live off the resulting income. A New York picture agency handled his photographs, selling them for editorial, advertising, and promotional purposes. They appeared on such items as Christmas greetings from the Prudential Insurance Company and the covers of specialty magazines like *Revere Patriot*. His pictures also were featured in a large photo mural installed at Amityville's Security National Bank.

In 1972 Anderson and his wife moved to Salt Lake City to be near their only child, Stella. He died of cancer there two years later on November 9.

———

Carlson, Lillian. "Excels in Camera Art," *American Swedish Monthly*, December 1940 (Vol. 34), pp. 14–17, 34.

"Newfoundland: Gustav Anderson Vacationed in the North with a Camera," *U.S. Camera*, November 1941 (Vol. 4), pp. 45–52.

"Obituaries: Gustav Anderson," *Amityville Record*, November 21, 1974, p. 15.

Paul L. Anderson
1880–1956

Anderson was a prolific photographer and author for much of the thirty years following 1910. He consistently photographed in the romantic style and printed in a variety of manipulative processes. His writings were instructive on technical matters and traditional on aesthetic issues.

———

Paul Lewis Anderson was born in Trenton, New Jersey, on October 8, 1880. In 1901 he graduated from Lehigh University with a degree in electrical engineering, a field in which he worked for about ten years.

Anderson, one of the few pictorialists of the post–World War I era to begin photographing seriously during the reign of the Photo-Secession, was inspired to take up photography in 1907, when he saw issues of *Camera Work*, the finely printed quarterly edited by Alfred Stieglitz. For the next forty years, he photographed in a pictorial style based on traditional beauty and Photo-Secession aesthetics.

Anderson produced four discrete bodies of work: portraits, landscapes, still lifes, and architectural views of Smith College. His portraits were of friends and immediate family members, sometimes in genrelike domestic scenes. His landscapes and still lifes were classically composed images that often shimmered with natural sunlight. And his studies of Smith College documented, in a romantic fashion, the site of his two daughters' advanced education. Anderson printed most of his images more than once, in different photographic processes. Prints made in platinum, palladium, gum-bichromate, carbro, bromoil, photogravure, and combinations thereof reveal the interpretive possibilities of these media.

Anderson wrote four books on photography and many articles for the photographic press. From 1911 to the mid-1920s he wrote regularly for *Platinum Print, American Photography, Photo Era, American Annual of Photography*, and *Photograms of the Year*. His books included *Pictorial Landscape-Photography*, an intimate publication on a specific subject, and *The Technique of Pictorial Photography*, a large volume dealing primarily with equipment and processes. In the late 1920s and early 1930s he temporarily abandoned photography to author several novels for young adults. In 1933, however, he reemerged as an advocate of traditional pictorialism, writing for monthly photographic magazines for another decade.

In addition to writing, Anderson taught and operated portrait studios early in his career. After quitting his job with a New York telephone company, he opened his first studio in 1910 in East Orange, New Jersey. During World War I he used Karl Struss's New York studio while Struss was in the service. Anderson became an instructor in 1914 at the Clarence H. White School of Photography and for the next four years taught at both the school's main facility in New York and its summer locations in Maine and Connecticut.

Anderson faded quickly from national prominence among pictorialists during the 1940s. By World War II he was a respected senior pictorialist only at the Orange Camera Club, where he had repeatedly served as president and where he continued to show his prints. He stopped photographing in the early 1950s and died in Orange on September 15, 1956. The University of Arizona's Center for Creative Photography and the George Eastman House hold major collections of his photographs.

———

Anderson, Paul L. *Pictorial Landscape-Photography*, Photo-Era, Wilfred A. French, Boston, 1914.

———. *Pictorial Photography: Its Principles and Practice*, J. B. Lippincott Co., Philadelphia, 1917.

———. *The Fine Art of Photography*, J. B. Lippincott Co., Philadelphia, 1919.

———. *The Technique of Pictorial Photography*, J. B. Lippincott Co., Philadelphia, 1939.

Pitts, Terence R. "Paul Anderson," *The Archive* (Center for Creative Photography, University of Arizona), No. 18 (May 1983), entire issue.

———. *Paul Anderson: Photographs*, Guide Series Number Seven, Center for Creative Photography, University of Arizona, Tucson. 1983. (Contains bibliography.)

Charles K. Archer
1869–1955

Archer produced and exhibited bromoil prints from the 1910s into the early 1940s. He was closely associated with the prestigious Pittsburgh salon, serving as its president for twelve years. For much of his working life he managed the photography department of Carnegie Steel.

Charles K. Archer was born in Bellaire, Ohio, on November 28, 1869. He began working for Pittsburgh's Carnegie Steel Company in 1907 and seven years later organized its department of photography. By the time he retired in 1940, he had produced approximately ten thousand industrial and steel-mill pictures for the company. He was also highly regarded for his seamlessly printed photo murals in the late 1930s.

Archer began making creative photographs by 1912, when a reproduction of one of his images appeared in the *American Annual of Photography*. He joined the Photographic Section of the Academy of Science and Art of Pittsburgh and remained deeply involved with the group for more than two decades. In 1920 he was elected an associate member of the academy's annual salon, and from 1928 to 1940 he served as its president.

Archer's work was widely exhibited and reproduced. During the 1920s and 1930s his pictures appeared in *Camera* and *Photo Era*, as well as the book *Principles of Pictorial Photography*, by John Wallace Gillies. He presented a one-person exhibition of his work in 1927 at the Camera Club of New York. Salons in Chicago, Los Angeles, and Philadelphia, as well as Pittsburgh, regularly accepted his work into the early 1940s. Archer primarily made bromoil prints, employing a manipulative process at which he excelled. He found that photographic paper at least three years old worked best for his imagery, which focused on the Pittsburgh steel mills and idyllic mountain landscapes.

Archer involved himself in the early activities of the Photographic Society of America, serving on its board in the mid-1930s. In 1938 his pictures and endorsements were used in magazine ads for Kodak paper. Upon retiring to Phoenix, Arizona, in 1940 he continued to photograph, concentrating on southwestern Indian life. About eight years later he relocated to Van Nuys, California.

Archer died in Van Nuys on October 11, 1955. Nearly two hundred of his bromoil prints constitute the core of a permanent collection of photographs still owned by the Photographic Section of the Academy of Science and Art of Pittsburgh.

Craig, David R. "Charles K. Archer" (obituary), *PSA Journal*, February 1956 (Vol. 22), p. 46.

"Noted Photographer 'Retires,' " *Camera*, January 1940 (Vol. 60), p. 43.

Fred R. Archer
1889–1963

Fred R. Archer was active in pictorial photography in Southern California from the mid-1910s past mid-century. He was influential as the leader of the important Camera Pictorialists of Los Angeles and as a teacher of professional photographers. His pictorial work included both modernist-inspired and more traditional images.

Archer was born on December 3, 1889, in Atlanta, Georgia. Six months later his family moved to California. His father was a photographer and the proprietor of a photographic-equipment repair shop, where young Fred worked. He received additional photographic training while serving as an aerial photographer in France during World War I.

Archer worked in Southern California's growing film industry for fifteen years, beginning immediately after the war. For the first five years, he was employed by Universal Studios, where he pioneered the use of photographic backgrounds for titles. Subsequently he worked on Cecil B. DeMille's film *King of Kings* and at Warner Brothers, where he made celebrity portraits for three years.

In 1935 Archer left the motion-picture studios to begin teaching. For several years, he was head of the photographic department at what is now the Art Center College of Design in Pasadena. In 1942, however, he established in Los Angeles the Fred Archer School of Photography, which trained portrait photographers; by the end of the decade, the school was housed in seven separate buildings. In 1948 he authored his only book, *Fred Archer on Portraiture*, which he undoubtedly used as a text at the school.

In addition to his vocation, Archer was an avid pictorialist for many years. He began exhibiting in 1914, when one of his creative pieces was included in the prestigious London salon of photography. He continued to send work regularly to salons into the mid-1940s. Archer also assumed a leadership role in the Camera Pictorialists of Los Angeles, the most prominent camera club on the West Coast. In 1914 he was the youngest founding member of the group, and when it disbanded about thirty-five years later he was the only remaining founder. He was the group's designated director for many years and a regular judge for its annual salon.

Archer seems to have produced primarily two bodies of creative photographs. One, containing abstract and design-oriented modernist images, is characterized by the use of mirrors, reflected light, and hard-edge subject matter. The second body of work is solidly pictorial, consisting mainly of figures set on either miniature or full-scale movie sets. In the June 1924 issue of *Camera Craft*, he described how he made *An Illustration for the Arabian Nights*.

Archer remained active throughout the 1950s. He continued to judge photographic salons and received two of the Photographic Society of America's highest awards—an honorary fellowship (Hon. FPSA) and the Stuyvesant Peabody Award. He died on April 27, 1963, in Los Angeles.

Archer, Fred R. "Why I Am a Pictorial Photographer," *Photo Era*, September 1929 (Vol. 63), pp. 117–118.

———. *Fred Archer on Portraiture*, Camera Craft Publishing Co., San Francisco, 1948.

Blumann, Sigismund. "Fred R. Archer: An Artist Who Has Begotten a Controversy," *Camera Craft*, October 1929 (Vol. 36), pp. 455–464.

"Obituaries: Fred Archer, Hon. P.S.A.," *PSA Journal*, June 1963 (Vol. 29), p. 45.

Wright, Jack. "PSA Personalities: Fred R. Archer, FPSA," *PSA Journal*, March 1946 (Vol. 12), pp. 118–119.

Cecil B. Atwater
1886–1981

Atwater was one of New England's most successful pictorialists during the 1940s and 1950s. He traveled extensively, making most of his photographs in Mexico and printing them through paper negatives. He also served the Photographic Society of America in various positions.

Cecil B. Atwater was born on July 26, 1886, in Massillon, Ohio, just west of Canton. He was educated in Boston and New York and spent most of his life in Massachusetts, working as an office manager at the Liberty Mutual Life Insurance Company.

Atwater came to photography as an amateur cinematographer, filming wild game in the United States and Canada. Desiring a more pliable means of artistic expression, he took up pictorial photography by the late 1930s, when he began exhibiting in the salons. His work was widely seen, and in the 1948–1949 season he ranked as the world's most prolific exhibitor, with 238 prints in 85 salons. Traveling for business, he exposed most of his negatives in Mexico and Canada. He frequently used the paper negative process to produce idealized images of Mexican village life and other patently pictorial subjects. In 1948 he wrote *Photographing Mexico*, a guidebook containing reproductions of some of his salon prints.

Around 1941 Atwater joined the Photographic Society of America (PSA), an organization he would actively support over the next twenty-five years. He became a board member, served as chairman of the camera-club division, and wrote articles and edited a column for its journal. In 1947 he received fellowship status in both the Royal Photographic Society (FRPS) and the PSA. During the 1950s and 1960s he went on at least four extensive PSA-sponsored speaking tours, sharing his knowledge and pictures.

Atwater supported pictorialism in other ways as well. In 1940 he served as president of the New England Council of Camera Clubs and three years later held the same position at the Boston Camera Club. He frequently judged photographic salons around the country, performing this duty more than anyone else during the mid-1940s. And he generously loaned to museums his collection of about two hundred prints by fellow pictorialists.

In 1954 Atwater retired from business, but he continued to photograph and lecture for another ten years, making at least two photographic trips to Asia in the early 1960s. He died on December 12, 1981, in Clearwater, Florida, at age ninety-five.

Atwater, Cecil B. *Photographing Mexico*, Camera, Baltimore, 1948.

"Cecil B. Atwater, New England Ace," *Camera*, June 1944 (Vol. 66), pp. 34–35.

Wright, Jack. "PSA Personalities: Cecil B. Atwater, APSA," *PSA Journal*, February 1945 (Vol. 11), pp. 86–87.

Edward L. Bafford
1902–1981

Bafford made pictorial images in both black and white and color from the 1920s until his death. He was a master of the bromoil process, usually making romantic images of rural life and the environs of Baltimore. He spent his entire professional career in the commercial printing industry.

Edward L. Bafford was born on January 16, 1902, and was orphaned three years later. He was raised in Baltimore by his grandmother and was forced by poverty to leave school at age eleven to work in a factory. In 1916 he secured a job at a commercial printer and began his life-long vocation. After working for a few firms, he joined with two partners in 1944 to establish Neolith Colorcraft, Inc., a lithographic printing house from which he retired in 1967.

Bafford received his first camera in 1914 and a few years later made his first important photograph. Taken surreptitiously due to wartime restrictions, it pictured a workman steam-cleaning the wheels of a locomotive. Photographic salons in Rochester and Portland, Maine, quickly accepted the image, and Bafford's long exhibition career was launched. During the 1930s and 1940s, his work was repeatedly shown in salons in Baltimore, Pittsburgh, and Wilmington. Even after the mid-century demise of pictorialism, Bafford continued to submit work to camera-club-sponsored exhibitions for two decades.

Bafford began working with the manipulative bromoil process around 1926 and used it for the rest of his life. This handworked process results in an image that appears pointillistic and painterly, characteristics admired by traditional pictorialists. Bafford frequently made bromoil prints that pictured Baltimore's streets and harbor, as well as the surrounding countryside.

Bafford was active in local and national pictorial organizations. In 1926 he joined the Baltimore Camera Club and over the next fifty-five years served as its president ten times. He was also instrumental in forming the Council of Maryland Camera Clubs. In 1937 he joined the Photographic Society of America, which later gave him fellowship status (FPSA). He also served as chairman for the PSA's 1950 national convention, which was held in Baltimore.

Bafford enjoyed sharing his knowledge with other pictorialists. In 1932 he taught a photographic class over the radio, and three years later he began a weekly series called the "Bafford School of Photography" at the Baltimore Camera Club. He demonstrated the bromoil process to clubs in Akron, in Detroit, and, most frequently, in Baltimore.

In addition to his presence at photographic salons, Bafford also presented numerous one-person exhibitions of his work. He had three solo shows at the Smithsonian Institution in 1950, 1952, and 1956, and one each at the Massachusetts Institute of Technology and the Arts Society of Washington, D.C., in the mid-1950s. In 1963 his work traveled through the Soviet Union with that of A. Aubrey Bodine, Baltimore's best-known pictorialist and a close friend of Bafford's.

Baltimore institutions held Bafford in high esteem. For example, the Baltimore Camera Club named an award in his honor in 1953 and subsequently honored him at numerous surprise banquets. In 1975 the University of Maryland Baltimore County presented a one-person exhibition of his recent color photographs and named its photography collection after him. Most of his work now resides there.

Bafford died on February 5, 1981, in Glen Arm, Maryland.

Beck, Tom. *Edward L. Bafford, 1902–1981: A Life in Photography*, University of Maryland Baltimore County, 1981.

"Obituaries: Edward L. Bafford, FPSA," *PSA Journal*, July 1981 (Vol. 47), p. 35.

Axel Bahnsen
1907–1978

Bahnsen practiced pictorial photography from about 1930 far past mid-century. He spent his adult life running a professional portrait studio in central Ohio. His best pictorial images were mildly suggestive of surrealism.

Axel Bahnsen was born on May 21, 1907, in Auburn, New York. His family moved to Europe four years later but returned to the United States during World War I. After the war, Bahnsen attended school in Switzerland, while his parents lived near Paris. In 1924 he moved to Yellow Springs, Ohio, to attend Antioch College.

He left school two years later, bought a Graflex camera, borrowed money from his father to purchase a studio, and began his photographic career. Business was slow during the Great Depression, but by 1936 he was able to open a portrait studio in nearby Dayton as well. His Yellow Springs studio, however, remained his home base, and he was active there until his death.

Bahnsen was attracted to pictorial photography after seeing a copy of the *American Annual of Photography* in the late 1920s. Within a few years, he was exhibiting in salons throughout the world, submitting more than two hundred prints to sixty-six salons in the 1937–1938 season. In 1942 and 1946 he had one-person exhibitions at the Smithsonian Institution. He was active in the Photographic Society of America, which awarded him a fellowship (FPSA) in 1951.

Bahnsen's most distinctive work incorporates surrealist elements, demonstrating the influence of modernism on some pictorialists. These sharply focused images feature unlikely subjects, combined through composite printing and/or collaging. Though sometimes a bit heavy-handed, they reveal his interest in the subconscious.

Bahnsen took up informal teaching in the late 1940s, welcoming both amateur and professional photographers into his studio and on field trips twice a week for technical and creative guidance. For thirty years, he taught these sessions, which enhanced his influence throughout the Midwest.

After a decade-long hiatus from exhibiting, Bahnsen resumed participation in the mid-1960s. He was still a highly visible pictorialist when he died of a heart attack on April 24, 1978, in Springfield, Ohio.

Bahnsen, Axel. "Sur-realism [*sic*] in Photography," *Camera*, March 1941 (Vol. 62), pp. 30–32.

———. "Axel Bahnsen Says," *American Photography*, September 1950 (Vol. 44), pp. 25–28.

Horvath, Allan L. "Axel Bahnsen, FPSA; Heritage," *PSA Journal*, October 1980 (Vol. 46), pp. 23–27.

Hillary G. Bailey
1894–1988

Bailey was a jack-of-all-trades in photography from the 1920s to 1940s. He took professional portraits, worked for a major photographic manufacturer, and was active as a pictorialist.

Hillary Goodsell Bailey was born on June 5, 1894, in Muncie, Indiana. He attended Depauw University in Greencastle, Indiana, and served in the U.S. Army during World War I.

Bailey's photographic career began in 1922, when he opened a portrait studio in Greencastle, a town about thirty miles west of Indianapolis. Like most advanced portrait photographers of the day, Bailey worked largely with a soft-focus lens, a device he favored until the late 1930s. By the mid-1920s he relocated to Indianapolis and began producing illustrative as well as portrait photographs. In 1936 he closed his studio and went to work for the Agfa Ansco Corporation, a major photographic manufacturer in Binghamton, New York. For the next five years, he was responsible for disseminating information on the company's professional materials and equipment.

From the mid-1920s to the mid-1940s Bailey wrote about professional photography as well as practiced it. He contributed articles on the ethics, business, and technique of portraiture to such magazines as *American Photography*, *Camera*, and the *PSA Journal*. In 1938 his book on portrait photography, *The Story of a Face*, was published. Two years later, the Photographers' Association of America conferred its highest membership category (Honorary Master of Photography) upon him for his service to the field.

Bailey's pictorial activities closely coincided with his professional pursuits. He was exhibiting in salons by 1925 and was active in the Indianapolis Camera Club. He joined the Pictorial Photographers of America in 1929 and a few years later was a charter member of the Photographic Society of America. His best-known pictorial image, *The Last Chord*, was frequently exhibited and reproduced, including in an advertisement for Agfa products; this intentionally serene image shows the hands of Bailey's father, a minister.

In 1943 Bailey left Agfa for a job unrelated to photography at the Coca-Cola Company in Atlanta, but he remained active in the field. He joined the Atlanta Camera Club, edited its newsletter, and continued to make portraits. His Atlanta brochure, *The Story of Your Face* (an obvious nod to his earlier book), encouraged businessmen to use photographic portraits in their printed materials.

Bailey retired in 1962 to Clearwater, Florida, where he died on October 10, 1988.

Bailey, Hillary G. "The Passing of the Soft Focus Lens," *American Photography*, March 1938 (Vol. 32), pp. 194–196.

———. *The Story of a Face*, Camera Craft Publishing Co., San Francisco, 1938.

———. *Indoor Photography*, Ziff-Davis Publishing Co., Chicago, 1940.

Clark Blickensderfer
1882–1962

Blickensderfer made and exhibited pictorial photographs during the 1920s. Based in Denver, he photographed primarily birds and the Colorado landscape. He apparently made his living handling family investments.

Clark Blickensderfer was born on September 17, 1882, in Denver. He earned a degree in civil engineering from Columbia University in New York and then returned to Denver to manage his father's real estate holdings.

Blickensderfer began using the camera as a utilitarian tool in the early 1910s, making a photographic record of his frequent excursions into Colorado's Rocky Mountain National Park. Appropriately, his first published photograph appeared in a 1915 mountaineering annual.

Blickensderfer's pictorial activity was limited to the 1920s. In 1923 he was a founding member and first president of the Denver Camera Club. He also served as a regional vice-president for the New York–based Pictorial Photographers of America, whose annuals included his work. His photographs also were reproduced in *American Photography* and *Photograms of the Year*, and in 1924 he wrote a short article for *Camera Craft* on how he made a particular picture.

In 1923 Blickensderfer began exhibiting his work in pictorial salons. Over the next half-dozen years, his photographs were accepted by juries in London, Toronto, Pittsburgh, San Francisco, Buffalo, New York, Paris, and Los Angeles. During this time, he also presented one-person exhibitions at the California Camera Club, New York's Art Center, the Camera Club of New York, and the Chicago Camera Club. He stopped making black-and-white prints by the end of the decade and turned his attention to large-format color transparencies. He eventually concentrated on 35-mm color slides for the rest of his life.

Blickensderfer's photographs reflect his great love of the outdoors. He took frequent camping trips on which he photographed the splendors of the Colorado Rocky Mountains. His love of birds is evident in his ornithological photography. In addition, he turned his camera on the architecture and lifestyle of southwestern Indians. His extremely high-key and softly focused image *Lines and Angles*, for instance, pictures the entrance to an adobe Western Union station.

Blickensderfer actually showed his work into the early 1930s, when he sent photographs to annual exhibitions of the Colorado Mountain Club, of which he was a charter member. The pictorial world, however, paid little attention to him after this time. He died on January 12, 1962, in Denver.

Blickensderfer, Clark. " 'Winter above Timber Line': How the Picture Was Made," *Camera Craft,* May 1924 (Vol. 31), pp. 233–236.

"'I Will Lay Me Down in Peace': Clark Blickensderfer" (obituary), *Rocky Mountain News*, January 15, 1962, p. 73.

Witthus, Rutherford W. *Blickensderfer: Images of the West*, Cordillera Press, Inc., Boulder, Colorado, 1986.

A. Aubrey Bodine
1906–1970

Bodine was a career photographer for the *Baltimore Sunday Sun* for his entire adult life. From the mid-1920s until his death, he produced dramatic pictures of Baltimore and its environs for the paper. Many of these visually appealing images were also successful in pictorial salons, in which Bodine exhibited for decades.

A. Aubrey Bodine was born on July 21, 1906, in Baltimore, his lifelong home. At the age of fourteen, he became a messenger for the *Baltimore Sun*, where he would spend his entire career. Soon he was making photographs in the paper's advertising department, and in 1941 he was named head of the photography department of the Sunday edition.

Working under a weekly, instead of a daily, deadline allowed Bodine the freedom to make photographs that were universal and lasting, rather than event-oriented and ephemeral. For forty-five years, he captured the look and feel of Baltimore, the Chesapeake Bay, and countless sites throughout Maryland and Virginia. His appealing pictures of the buildings, boats, streets, and people of these areas appeared every week in the pages of the *Sun*, and four books of his accessible images were published.

Pictorialists also admired many of Bodine's professional photographs. Their simple compositions, idealistic outlook, and virtuosic printing technique exemplified key tenets of the pictorial movement. Bodine began exhibiting in salons in 1925, the year he made his beautifully lit and stagelike image *Dock Workers, Pratt Street*. Throughout the 1930s and 1940s, he was a consistent exhibitor as well as a salon judge. In the 1950s he had one-person exhibitions at the Smithsonian Institution and the Baltimore Museum of Art. Like a few other pictorialists, he continued to submit work to the annual exhibitions presented after mid-century. In 1961, for instance, his photographs were included in at least fifty international salons, from Bangkok, Thailand, to Johannesburg, South Africa.

Bodine was equally involved in both amateur and professional organizations. He joined Baltimore camera clubs and was a founding member of the Photographic Society of America, which in 1965 awarded him an honorary fellowship (Hon. FPSA). He was a charter member and fellow of the National Press Photographers Association and was named Newspaper Magazine Photographer of the Year in 1957.

Comfortable with the printed page, Bodine involved himself in publishing. In 1946 he became a contributing editor to *Camera*, a monthly published in Baltimore that, for five years, featured his salon photographs and articles. In 1951 he formed Bodine and Associates, Inc., a firm that co-published his well-printed, oversize picture books and that remained in business after his death.

In 1970, at the age of sixty-four, Bodine fell ill while working in the photo lab of the *Sun*; he died shortly thereafter, on October 28.

Bodine, A. Aubrey. *My Maryland*, Camera Magazine, Baltimore, 1952.

———. *Chesapeake Bay and Tidewater*, Hastings House, New York, 1954.

———. *The Face of Maryland*, Bodine and Associates, Baltimore, 1961.

———. *The Face of Virginia*, Bodine and Associates, Baltimore, 1963.

Ewing, Kathleen M. H. *A. Aubrey Bodine, Baltimore Pictorialist, 1906–1970*, Johns Hopkins University Press, Baltimore, 1985.

Williams, Harold A. *Bodine: A Legend in His Time*, Bodine and Associates, Baltimore, 1971.

Nickolas Boris
1900–1935

Boris worked as a portrait photographer in Ohio. He also made pictorial images of studio-based figure studies during the late 1920s and 1930s. He sent his work to salons throughout the world and died at a young age.

Nickolas Boris was born on September 23, 1900, in Patras, Greece. The adventurous teenager ran away for six months and visited numerous European ports. He returned to Greece and studied art at an academy in Athens, graduating in 1915. After two unsuccessful attempts to enter the United States as a stowaway he finally emigrated to this country in 1917.

While still in his teens, Boris went to work for an architect in Springfield, Ohio, where he was introduced to photography. In 1929 he opened his own photographic studio in Cincinnati (or possibly in nearby Hamilton), specializing in creative portraiture. He associated with local and national professional organizations and remained active until his early death six years later.

Boris experienced his first salon success in 1927, when all three of the pictures he submitted to the London salon were accepted and hung. He continued to exhibit internationally, winning certificates, medals, and diplomas. By the early 1930s, salons were accepting more than a hundred of his prints each year. At the same time, reproductions of his work appeared in such magazines as *American Photography, Camera,* and *Camera Craft*. In 1932 he was designated a fellow of the Royal Photographic Society (FRPS), and two years later he was a charter member of the Photographic Society of America. At the time of his death, he was serving as president of the Photographic Society of Cincinnati.

Boris's creative work took the form of allegorical figure studies that he created in his own studio. Using dance and drama students as models, he made pictures that evoked such themes as music, motherhood, and death. His best-known image is *Bas Relief*, which shows three athletic men in friezelike form against a flat background; Adolf Fassbender and other leading pictorialists collected prints of it.

Boris died after an operation in Cincinnati on November 18, 1935, at the young age of thirty-five.

Blumann, Sigismund. "Nickolas Boris," *Camera Craft*, July 1930 (Vol. 37), pp. 325–330.

———. "Nickolas Boris, F.R.P.S., A Painter Who Adopted and Prefers Photography," *Photo Art Monthly*, August 1934 (Vol. 2), pp. 356–362.

Boris, Nickolas. "Why I Am a Pictorial Photographer," *Photo Era*, November 1930 (Vol. 65), pp. 245–246.

———. "The Camera as a Brush," *Photo Art Monthly*, August 1934 (Vol. 2), pp. 362–366.

LeSage, W. Dovel. "Nickolas Boris, F.R.P.S., My Friend," *Photo Art Monthly*, March 1936 (Vol. 4), pp. 110–122.

Rowena Brownell
1887–1978

Brownell resided in Providence, Rhode Island, making and exhibiting pictorial photographs during the 1930s and early 1940s.

Rowena E. Pierce was born on August 2, 1887. She commenced her art career as a sculptor but switched to photography after marrying Alfred S. Brownell and starting a family. She first submitted her photographs to salons in 1932 and continued to do so for about twelve years. Her most prolific seasons were during the mid-1930s, when she consistently exhibited over 125 prints in more than 50 salons per year. By 1940, when a lead article about her appeared in *Camera Craft*, she was one of this country's best-known exhibitors, sending her work to most of the important foreign and domestic salons, including those in Pittsburgh and Wilmington. She also judged national salons and presented numerous one-person exhibitions of her work, including one at the Brooklyn Institute of Arts and Sciences in 1937.

During the 1930s, Brownell's pictures were reproduced in many monthly magazines and photographic annuals, such as *American Photography, Camera, Camera Craft, Popular Photography,* and the *PSA Journal*. At the same time, the English annual *Photograms of the Year* and the *American Annual of Photography* also included her pictures. For the latter, she wrote her only known article—a 1946 contribution that explored the traditional aesthetics of pictorial photography.

Brownell photographed still-lifes almost exclusively, rarely venturing out of her home for subjects. Drawing upon her training as a sculptor, she paid particular attention to lighting and modeling. Her images were usually sharply focused and high-key, printed on glossy paper. Her favorite camera was a 3¢-by-4¢-inch Graflex, which she held in a picture used to advertise the company in 1938.

Brownell died in Providence on February 2, 1978.

Blosser, Myra H. "Camera Brings Renown to Providence Woman," *Providence Journal*, January 24, 1937, Section IV, p. 3.

Brownell, Rowena. "Esthetics in Photography," *American Annual of Photography, 1946*, pp. 36–47.

Estey, Charlotte M. "Rowena Brownell," *Camera Craft*, July 1940 (Vol. 47), pp. 318–324.

A. D. Chaffee
1870–1933

Chaffee was deeply involved with the Pictorial Photographers of America during the 1920s. He was a master of the bromoil process, frequently photographing in picturesque European villages. A resident of both New York and Connecticut, he made his living as a medical doctor.

Amasa Day Chaffee was born on June 13, 1870, in Moodus, Connecticut. He attended high school in Hartford and graduated from Yale University in 1890. After further schooling in New York, he began practicing medicine around 1895. He often donated his professional services to the needy on New York's Lower East Side and also served as the medical examiner for the New York Life Insurance Company.

Chaffee's interest in photography began at about age seventeen, and by the turn of the century he was making creative pictures and exhibiting in national salons. His work appeared in the Chicago photographic salon in 1900 and 1903 and the traveling American Photographic Salons of 1904 and 1905. He initially printed in carbon and platinum but began making bromoil prints in 1913 after seeing examples of the process on a trip to London. During the 1920s he was a leading exponent of bromoil, writing on the subject and making all his prints by this process. His imagery generally featured quaint village life of the Old World, observed during numerous summer trips to Europe.

Dr. Chaffee associated closely with Clarence H. White, becoming the first vice-president of the Pictorial Photographers of America (PPA), from 1917 to 1920. Two years later, after White stepped down as president, Chaffee assumed the leadership position. Reproductions of his work appeared in four of the PPA's five annuals, *Pictorial Photography in America*, during the 1920s.

Chaffee's work was also widely seen in exhibitions and periodicals. In 1915 he won a silver medal at the Panama-Pacific Exposition in San Francisco. He presented one-person exhibitions of his work in 1919 at the California Camera Club, in 1923 at the Pictorial Photographers of America, and in 1927 at the Cleveland Camera Club. The *American Annual of Photography* reproduced his images as early as 1901, and *American Photography*, *Camera*, *Camera Craft*, and *Photo Era* featured them during the late 1910s and 1920s. In 1923 Chaffee wrote a statement to accompany his pictures in the book *Principles of Pictorial Photography* by John Wallace Gillies.

Chaffee died on February 27, 1933, in West Haven, Connecticut; the cause of death was tuberculosis contracted during his charity work.

Blumann, Sigismund. "Doctor Amasa Day Chaffee," *Camera Craft*, May 1927 (Vol. 34), pp. 209–215.

Chaffee, A. D. "Some Desiderata for Bromoil Papers," *Camera*, July 1922 (Vol. 26), pp. 357–359.

Gillies, John Wallace. "Dr. Amasa Day Chaffee," *American Photography*, October 1922 (Vol. 16), pp. 624–626.

"Obituary: Dr. Amasa Day Chaffee, 1870–1933," *Bulletin of the Pictorial Photographers of America*, April 1933, p. 1.

Arthur D. Chapman
1882–1956

Chapman associated with Clarence H. White during the 1910s and 1920s. He made quiet, softly focused images of New York's Greenwich Village. During World War I he served in the U.S. Signal Corps and later reportedly made his living as a newspaper printer in the New York area.

Arthur Douglas Chapman was born on August 12, 1882, in Bakersfield, California. He was most visible in Clarence H. White's large circle of pictorialists after the demise of the Photo-Secession. In 1910 he began attending the White summer school of photography and may have taught there about a decade later. He was an "associate" for the small journal *Platinum Print* (1913–1917), which reproduced a few of his images. A member of the first executive committee of the Pictorial Photographers of America (PPA), he served as the organization's corresponding secretary in 1918. In the early twenties, his photographs appeared in the annuals of the PPA and in *Camera Pictures*, the publication of the White School's alumni association.

Chapman concentrated on capturing the intimate streets, buildings, and spaces of residential Greenwich Village in the 1910s. He lived there during most of the decade, before moving permanently to New Jersey after World War I. His small platinum prints were always carefully composed and subtlely rendered, the result of using his own custom-made soft-focus lens. In 1915 he published *Greenwich Village: Eight Portraits*, a well-designed brochure featuring his quiet street scenes; fellow pictorialist Edward R. Dickson provided an introduction. A few years later he authored a short article for the *American Annual of Photography* in which he extolled the virtues of photographing subjects near home and familiar to the photographer. Reproduced with the article was *Diagonals*, an image of a Sixth Avenue elevated station Chapman frequently used and his most successful salon print.

In the early 1950s, Chapman gave and sold small selections of his Greenwich Village photographs to the New-York Historical Society and the Museum of the City of New York. These prints are among the few remaining examples of his work. He died in Hackensack, New Jersey, on June 5, 1956.

Chapman, Arthur D. *Greenwich Village: Eight Portraits*, Philip Goodman Co., New York, 1915.

———. "Travel," *American Annual of Photography, 1918*, pp. 235–239.

Nancy Ford Cones
1869–1962

Cones photographed for about forty years, beginning early in the twentieth century. She worked with her husband both professionally and as a pictorialist, based on a farm outside Cincinnati. Her pictorial imagery was romantically traditional.

Nancy Ford was born on September 11, 1869, in Milan, Ohio, and grew up in various small towns in Ohio and Indiana. At age twenty-five she moved to Fostoria to learn retouching and subsequently formed a partnership with a photographer in Mechanicsburg. In 1897 she returned home to South Lebanon, Indiana, where she soon met her future husband, James Cones. After marrying in 1900, the couple worked together in James's photography studio in Xenia and a year later acquired a portrait business in Covington, Kentucky. In 1907 the Coneses closed up shop and purchased a twenty-five-acre farm outside Loveland, Ohio, northeast of Cincinnati. They remained there the rest of their lives, making home portraits and doing commercial work. After moving to Loveland, Nancy performed most of the shooting, and James did most of the printing.

Cones entered competitions and did commissions from 1902 until her husband's death in 1939. She won prizes in contests sponsored by magazines such as *Women's Home Companion* and *Browning's Magazine*, and by photographic manufacturers like Bausch & Lomb and Ansco. In a 1905 Kodak competition, which drew 28,000 entries, her work placed second, higher than that of Alfred Stieglitz. Subsequently, Kodak purchased many of her images for use in their advertisements up until World War I. In 1926 she and her husband were commissioned by Mariemont, Ohio, to document the town, and from the mid-1920s to the mid-1930s they shot an extensive color series of wildflowers for the Film Knowledge Company.

Cones's noncommercial, artistic work was equally successful. She specialized in rural genre scenes and figure studies, softly focused and sentimental. Printed by her husband in a variety of manipulative processes, such as gum-bichromate, her delicate pictures promoted old-world agrarian values. They were included in exhibitions and reproduced in photographic monthlies primarily during the 1920s and 1930s. *Photo Era* ran a few articles by Cones, and *Camera Craft* regularly featured her work. Salons in Buffalo, Pittsburgh, Rochester, San Diego, and London accepted her work during this period. She presented one-person exhibitions in 1916 at the California Camera Club, in 1921 at the Cincinnati Art Museum, and in 1930 at Chicago's Fort Dearborn Camera Club.

When James Cones died in 1939, Nancy ceased photographing. She died at her Loveland home on January 3, 1962.

Nancy Ford Cones: The Lady From Loveland, Walt Burton Galleries, Cincinnati, Ohio, 1981. (Contains bibliography).

Will Connell
1898–1961

Connell was a leading teacher and commercial photographer in Southern California from the 1930s until his death. Based in Los Angeles, he worked for both the Hollywood studios and popular national magazines. For the first fifteen years of his career, he also associated with area camera clubs and exhibited pictorial images in national salons.

Born in the farming community of McPherson, Kansas, Connell moved frequently with his family. In 1914 they arrived in California, where Will began high school and then dropped out to join the U.S. Army Air Service. He trained as a pilot but saw no action during World War I. Subsequently, he worked in a drugstore and obtained certification as a pharmacist.

Connell received his first camera from his grandmother at about age twelve. By 1917 he was a skilled amateur, associated with the Los Angeles Camera Club. Four years later, he joined the Camera Pictorialists of Los Angeles, California's leading pictorial group. He initially created soft focus images that appeared in such monthlies as *American Photography*, but by 1930 his pictorial work was more modernist inspired. In 1931 and 1932 the cover of *The Pictorialist*, the deluxe catalog for the Los Angeles salon, featured his abstract lens design made as a photogram. He continued to be a leading force in the Camera Pictorialists through the end of the decade.

After working in a photographic supply store, Connell launched his professional career in 1925, when he opened his own studio in downtown Los Angeles. Six years later, he established the photography department at the Art Center School, where he taught until his death. Here he influenced a generation of commercial and creative photographers, including Horace Bristol, Wynn Bullock, and Todd Walker. Connell's own professional work spanned a variety of genres, from movie publicity shots to magazine work for *Colliers* and the *Saturday Evening Post* to advertising pictures of iceboxes, motors, and other utilitarian subjects. His use of strong lighting, unique camera positions, and montage effects made his images highly dramatic. In 1957 he received a commendation from the American Society of Magazine Photographers.

Connell provided pictures for three books in the late 1930s and 1940s. *In Pictures: A Hollywood Satire* (1937) was a gritty send-up of the movie industry that poked fun at the fakery of Hollywood and its many players. Four years later, *The Missions of California* included his romantic images of the vestiges of Spanish culture in the state. And in *About Photography* (1949) Connell discussed picture sequences, individual style, lighting, and photographic equipment. Connell also wrote a monthly column, "Counsel by Connell," for *U.S. Camera* from 1938 to 1953.

Connell remained active in both pictorial and professional photography until his death. During the 1950s, he judged salons, including one at the San Diego County Fair, and continued to perform major commercial assignments—for example, providing color illustrations for the Kaiser Steel Corporation.

Connell died in Los Angeles on October 25, 1961. Among the photographers who eulogized him in the 1963 issue of *U.S. Camera International Annual* were Ansel Adams, Philippe Halsman, and Dorothea Lange. The Research Library of the University of California, Los Angeles, holds most of his archives.

Coke, Van Deren. *Photographs by Will Connell, California Photographer and Teacher (1898–1961)*, San Francisco Museum of Modern Art, 1981.

White, Stephen. *Will Connell—Interpreter of Intangibles*, Halsted Gallery, Birmingham, Michigan, and Stephen White Gallery, Los Angeles, 1991.

Edward C. Crossett
c. 1882–1955

Crossett was visible in American pictorial photography during the 1930s and 1940s. He made his living as an executive in the lumber industry, residing in various parts of the country.

Edward C. Crossett was born in Davenport, Iowa, and educated at Amherst College in Massachusetts. He was a successful lumber businessman and president of the Crossett Timber Company. He maintained residences in Massachusetts, Chicago, and California.

For about fifty years, Crossett also was an amateur photographer. His grandmother gave him his first camera when he was a child, and he made pictures in 1900 on a trip to Europe and the Near East. He apparently began making creative photographs in the 1930s, and soon was contributing regularly to pictorial salons. His most prolific season was in 1941–1942, when sixty international salons accepted more than a hundred of his prints. *Cloud Shadows*, which was probably printed through a sharp-soft screen, was one of his most successful photographs.

The pictorial world embraced Crossett throughout the 1940s. His images were reproduced in *American Photography*, *Camera*, and the English annual *Photograms of the Year*. In 1942 he received a coveted fellowship from the Royal Photographic Society (FRPS), and in 1945 he was elected to the board of directors of the Photographic Society of America. He served as a salon judge in numerous American cities and in 1953 donated a complete portrait studio to the Boston Camera Club.

True to his catholic tastes in photography, in 1952 Crossett signed on as a founding sustaining subscriber to *Aperture*, Minor White's decidedly nonpictorialist magazine. He died on July 29, 1955, at his home in Montecito, California, at age seventy-three.

"Edward C. Crossett" (obituary), *New York Times*, August 1, 1955, p. 19.

Wright, Jack, "PSA Officers, 1945–47: Edward C. Crossett, Director," *PSA Journal*, November 1945 (Vol. 9), p. 457.

Imogen Cunningham
1883–1976

Cunningham made pictorial images from about 1905 into the 1930s. She also made straight photographs for half a century, beginning in the mid-1920s. She was, at different times, a member of the Pictorial Photographers of America and Group f.64. Her long career culminated in a series of portraits of people in their nineties.

Imogen Cunningham was born on April 12, 1883, in Portland, Oregon. When she was about sixteen, she moved with her family to Seattle, where in 1907 she graduated from the University of Washington with a degree in chemistry. A few years later, she spent a year in Dresden, studying photographic chemistry on a fellowship.

Cunningham acquired a 4-by-5-inch camera from a mail-order correspondence school and made her first photographs in about 1905. A few years later, after seeing reproductions of the work of Gertrude Käsebier, she decided to pursue a career in photography. Initially, she worked in the portrait studio of Edward S. Curtis, where she learned to retouch negatives and make platinum prints. In 1910, after returning from Germany, she set up her own portrait studio in Seattle. Seven years later, she moved with her husband, printmaker Roi Partridge, to San Francisco, where the couple had twin sons. In 1921, after settling in Oakland, she resumed her portrait business. From the 1930s until her death, she produced situational portraits of friends, artists, and paying customers, made both on the street and in her studio. She moved again in 1943, to Berkeley, and four years later to Green Street in San Francisco.

Cunningham's earliest work was pictorial, depicting nude or classically draped figures in atmospheric landscapes. She joined the Pictorial Photographers of America (PPA), which reproduced her work in three of its annuals during the 1920s, and in 1932 she was part of a PPA-sponsored traveling show, along with Laura Gilpin and Doris Ulmann. As late as 1936, she was still making softy focused nudes and serving as a district executive for the PPA.

Cunningham moved from pictorialism to modernism in the 1930s. In 1932 she became a founding member of Group f.64, a small contingent of California photographers who agitated for creative photographs made with crisp definition, a full range of tones, and nonsentimental subjects. Some of her images of this period, such as her well-known *Triangles*, are in the vanguard in terms of their abstraction, but they retain the pictorial effect of soft focus. By the end of the decade, she was fully committed to the straight approach to photography.

Both schools and museums recognized the importance of Cunningham's work. She taught photography at the California School of Fine Arts in the late 1940s, at the San Francisco Art Institute in the mid-1960s, and shortly thereafter at Humboldt State College. She presented one-person exhibitions at art museums beginning in 1931, with a show at the M. H. de Young Memorial Museum in San Francisco. Large collections of her work were purchased by the George Eastman House in 1960, the Library of Congress in 1964, and the Smithsonian Institution in 1970.

Cunningham remained active in her old age. In 1973, the year she turned ninety, she began a photographic project focused on others also in their nineties. She continued to present one-person exhibitions at museums and galleries, and in 1975 she created a trust to preserve, exhibit, and promote her work. In 1976 she appeared on the *Tonight Show* and matched wits with host Johnny Carson. She died later that year, on June 23, at the age of ninety-three.

Dater, Judy. *Imogen Cunningham: A Portrait*, New York Graphic Society, Boston, 1979.

Lorenz, Richard. *Imogen Cunningham: Ideas without End, A Life in Photographs*, Chronicle Books, San Francisco, 1993.

———. *Imogen Cunningham: The Modernist Years*, Treville Co., Tokyo, 1993.

Mann, Margery. *Imogen Cunningham: Photographs*, University of Washington Press, Seattle, 1970.

———. *Imogen! Imogen Cunningham Photographs, 1910–1973*, University of Washington Press, Seattle, 1974.

Mitchell, Margaretta. *After Ninety: Imogen Cunningham*, University of Washington Press, Seattle, 1977.

Rule, Amy, ed. *Imogen Cunningham: Selected Texts and Bibliography*, G. K. Hall & Co., Boston, 1992. (Contains bibliography.)

Eleanor Parke Custis
1897–1983

Custis was this country's most prominent woman pictorialist during the 1930s and 1940s. She wrote an important book on composition and exhibited extensively. Her photographs generally retained the soft-focus effects of earlier pictorialists.

Eleanor Parke Custis was born in Washington, D.C., on July 28, 1897, an only child and a direct descendant of Martha Custis, the wife of George Washington. She never married and lived most of her life in the nation's capital.

Custis pursued painting for about the first twenty years of her adult life. In 1915 she began studying art, taking classes at the Corcoran School of Art and elsewhere. By the mid-1920s, she was making gouaches and watercolors in the Impressionist-inspired style she would use for the rest of her painting career. She frequently depicted harbor scenes in New England and street scenes in Europe and the Middle East. In 1925 she presented her first one-person show at the Arts Club of Washington, D.C., where she exhibited regularly over the next ten years.

The reason for Custis's shift from painting to photography is unknown, but she pursued her new avocation with zeal. In 1934 she exhibited 5 photographs, the next year 67, and the following year more than 180. Determined to be the world's most prolific salon exhibitor, she achieved that goal by the end of the decade. In 1939–1940 and in four subsequent seasons, Custis showed more photographs in international salons than anyone else in the world, an unprecedented record. Her peak season was 1949–1950, when 257 of her prints were hung in more than 90 salons.

Unlike some American pictorialists working after World War I, Custis created images that were softly focused. She used a "Flou-Net" enlarging diffuser, invented by Belgian pictorialist Léonard Misonne, which produced dark halos along shadow edges. This romantic effect was particularly well suited to the many images she made in Europe and South America, where she continued to travel for subject matter.

Less exotic images, like her *Penguins Three*, also gained atmosphere from the technique.

The 1940s was an active and rewarding decade for Custis. She received fellowship status from the Photographic Society of America (FPSA), presented one-person exhibitions at both the Brooklyn Museum and the Smithsonian Institution, and saw her book, *Composition and Pictures*, published.

Composition and Pictures (1947) was among the last major publication on pictorial photography. In it, Custis dealt with both the principles of composition and their practical application. Central to the book was her examination of dynamic symmetry, a mathematical formula for picture making. "Good" and "bad" images were reproduced, along with a multitude of diagrams. Perhaps the book's most revealing feature was its inclusion of both paintings and photographs by Custis, which, in some cases, strongly suggested she had made the latter first.

In 1960, after the death of her father, with whom she lived in Washington, Custis relocated to Gloucester, Massachusetts, the site of some of her paintings and photographs. She died on July 23, 1983, in East Gloucester.

Custis, Eleanor Parke. *Composition and Pictures*, American Photographic Publishing Co., Boston, 1947.

"Eleanor Park Custis: Washington Pictorialist," *Camera*, April 1944 (Vol. 66), pp. 25–27.

Shellman, Feay. *Eleanor Parke Custis (1897–1983), Retrospective Exhibition*, James R. Bakker Antiques, Inc., Cambridge, Massachusetts, 1986.

Toombs, Alfred. "Prints from Kitchen Hang in 235 Salons," *Popular Photography*, May 1939 (Vol. 4), pp. 28–29, 110–113.

Wenzell, E. V. "Blue Ribbon Portfolio Number 5: Eleanor Parke Custis," *Camera*, June 1952 (Vol. 75), pp. 46–51.

Wright, Jack. "PSA Personalities: Eleanor Parke Custis, FPSA," *PSA Journal*, December 1945 (Vol. 11), pp. 549–550.

William E. Dassonville
1879–1957

Dassonville was a California pictorialist and portrait photographer active during the first third of this century. He also owned a company that manufactured fine photographic paper for discerning amateurs and professionals.

William Edward Dassonville was born on June 20, 1879, in Sacramento. He exhibited his pictorial photographs in the first three San Francisco photographic salons of 1901, 1902, and 1903. At this time, he also served as secretary for the sponsoring California Camera Club; years later he was a juror for the fifth salon. His work appeared both in the First American Photographic Salon, which traveled around the country in 1904–1905, and in the next year's second salon. In 1915 he received an honorable mention for his work in the photography display of San Francisco's Panama-Pacific Exposition.

Dassonville favored a handful of pictorial subjects. He made creative portraits of the known (such as John Muir) and the unknown. He pictured boats, whether small fishing vessels or large ocean liners, in soft focus. And he photographed the California landscape as an idyllic, sun-kissed refuge.

Dassonville's creative work was the subject of one-person exhibitions throughout his career. His own California Camera Club so honored him three times between 1904 and 1935. In 1925 he presented a one-person show at the Dallas Camera Club. Retrospectives of his photographs followed in 1935 at the Smithsonian Institution and in 1948 at San Francisco's Bohemian Club.

Dassonville initially made his living as a professional photographer. He specialized in portraiture in San Francisco until 1906, when the earthquake and fire destroyed his studio. He left the city for a time to photograph the Sierra Nevada mountains but eventually returned and reestablished himself. By the mid-1920s he was an acknowledged authority among California photographers; the text of four of his talks to the state's professional association was printed in 1924 issues of *Camera Craft*, the West Coast's major photographic monthly.

By this time, Dassonville was also busy manufacturing high-quality photographic paper. After experimenting part-time with new papers for about four years, he went into full-time production in 1924, closing his portrait studio for good. The Dassonville Company's famous "Charcoal Black," a specially coated bromide paper, was widely favored by pictorialists for its rich blacks, matte surface, and parchment-like base. In 1944 Dassonville moved himself and his company from San Francisco to Rochester, New York. Magazine ads of a few years later listed the company's home address as Newton, New Jersey.

Dassonville died on July 15, 1957, in San Francisco.

Blumann, Sigismund. "Charcoal Black: A New and Different Photographic Paper," *Camera Craft*, May 1924 (Vol. 31), pp. 217, 220.

Anne Pilger Dewey
1890–1980

Dewey helped administer numerous national and Chicago-area photographic organizations from the 1930s to the 1950s. During the same period, she exhibited still-lifes and portraits in the salons.

Anne Pilger was born on September 1, 1890, in Manitowoc, Wisconsin, where she graduated from the local teachers college. Subsequently, she taught school, married Roy Franklin Dewey, and moved with her husband to Chicago, where she performed social work at Hull House and the Henry Boothe House.

Dewey involved herself in managing camera clubs even before becoming a pictorialist. She initially attended meetings of Chicago's Fort Dearborn Camera Club with her husband, an amateur photographer, and soon found herself running programs and doing other organizational work. She edited its newsletter, the *Spotting Brush*, from 1943 to 1945 and served as the club's first female president. She was a founder and president of the Chicago Historical Society's annual photographic salon and the first woman to become president of the Chicago Area Camera Clubs Association. In addition, she was a founding member of the Photographic Society of America and its secretary from 1945 to 1947.

Dewey was making her own pictorial images by the mid-1930s, when she began exhibiting in photographic salons. The 1945–1946 season was her most prolific, with sixty-five prints accepted at more than thirty-five salons; she continued submitting work until about mid-century. She enjoyed making portraits and night scenes, but her real area of expertise was tabletop photography. She lectured on the topic and made most of her own images as still-lifes, welcoming the challenges inherent in the approach and the control it allowed her.

Dewey was highly honored during and beyond her active years as a pictorialist. Frequently sought as a salon judge, she performed such duties as late as 1964, when she sat on the jury of the Memphis International Exhibition. In 1948 she was honored with a one-person exhibition of her work at the Massachusetts Institute of Technology. From the Photographic Society of America she received the Stuyvesant Peabody Award in 1949, given to an outstanding pictorialist, and in 1972 an honorary fellowship (Hon. FPSA), the organization's highest award.

Dewey died in Woodland Hills, California, on October 31, 1980.

"Obituaries: Anne Pilger Dewey, Hon. FPSA," *PSA Journal*, January 1981 (Vol. 47), p. 32.

Wright, Jack. "PSA Personalities: Anne Pilger Dewey, Hon. PSA, APSA," *PSA Journal*, April 1950 (Vol. 16), p. 166.

Edward R. Dickson
1880–1922

Dickson was closely associated with Clarence H. White and the Pictorial Photographers of America in the 1910s and early 1920s. Deeply devoted to pictorialism, he edited the periodical *Platinum Print* and made photographs of great sensitivity and refinement.

Edward R. Dickson was born in 1880 in Quito, Ecuador. He finished his schooling in London, returned to Ecuador, and then decided to go back to England. In 1903 he came to the United States and began working for what would become the Otis Elevator Company. He retired from business in 1917, in his late thirties, to devote himself full-time to photography.

Dickson was photographing by the early 1910s, when his work was included in group exhibitions, organized by Clarence H. White, that helped identify a new generation of pictorialists. He studied with White early on and was honored with a one-person exhibition at a Boston Camera Club in 1920. He consistently made pictures that were carefully patterned and low in contrast, revealing the influence of White and Japonisme. With an eye sensitive to monochrome design, he usually photographed shadows, trees, and water.

Dickson was prominent in the early years of the Pictorial Photographers of America (PPA), of which he was a founding member. He served as the group's first recording secretary, from 1916 to 1920. The PPA's first annual included both a reproduction of one of his pictures and a lead article he wrote about the organization's mission and responsibilities. In 1920 he was named honorary vice-president.

Dickson began writing exhibition reviews as early as 1911 for *Photo Era* magazine; a few years later, he penned a tribute to Clarence H. White for the same periodical. He contributed articles to the *American Annual of Photography* in 1918, 1920, and 1921, primarily on composition. From 1913 to 1917, he edited and published *Platinum Print*, the period's best-designed and most artistic periodical devoted to photography. In it he included contributions from photographer Paul L. Anderson, typographer Frederic W. Goudy, artist Max Weber, and numerous others. Dickson's last publishing venture was his 1921 book, *Poems of the Dance*, an anthology of poems accompanied by his own rather contrived photographs of dancers frolicking in nature.

In 1919 Dickson was commissioned by the arts council of Newark, New Jersey, his residence, to make a set of artistic photographs of the city's public buildings. He died three years later on March 5, at the age of only forty-two.

Dickson, Edward R. *Poems of the Dance*, Alfred A. Knopf, New York, 1921.

———. "The Picturesque Motive in Photography," *Photo Era*, February 1922 (Vol. 48), pp. 74–79.

"Edward R. Dickson" (obituary), *Photo Era*, May 1922 (Vol. 48), p. 286.

John Paul Edwards
1884–1968

Edwards was a California pictorialist during the late 1910s and 1920s. He turned to straight photography in the early 1930s and was a founding member of Group f.64. He made his living in retail merchandising.

───────────

John Paul Edwards was born on June 5, 1884, in Minnesota. He studied electrical engineering at the University of Minnesota and subsequently worked for his family's mining company. In 1902 he relocated to California and by 1907 had entered the retail business in Sacramento. He moved to San Francisco in 1922 to become a buyer for the Hale Department Store.

Edwards exhibited pictorial work as early as 1915, when eight of his photographs were included in the second Pittsburgh salon. He continued to show in Pittsburgh, when that city hosted the nation's leading salon, for the next decade and a half. One-person exhibitions of his work were presented at camera clubs in Boston and San Francisco in 1918 and a few years later at the Brooklyn Institute of Arts and Sciences. In the 1920s he contributed regularly to the salons of the Pictorial Photographers of America.

Edwards joined numerous organizations of pictorialists—the Oakland Camera Club, the California Camera Club, and the Photographic Society of San Francisco, of which he was a founder. He held board positions with the New York–based Pictorial Photographers of America and served as its vice-president in 1923.

Edwards's favorite subject was the California landscape. He photographed from the mountains to the seashore and wrote an article for the January 1926 issue of *Camera Craft* on working in Yosemite and the high Sierras. In it he emphasized the importance of simplicity and light and shadow, whatever the subject matter. All of his pictorial images were classically composed and softly focused. His photographs and articles regularly appeared in *Photo Era*, as well as in *Camera Craft*. During the 1920s, four of the five annuals of the Pictorial Photographers of America reproduced his work. He also served on the jury of selection for salons in Oakland and San Francisco.

In 1932 Edwards helped found Group f.64. With a membership composed of Ansel Adams, Imogen Cunningham, Edward Weston, and four others (of which Edwards was the oldest), this small contingent of West Coast photographers declared their allegiance to straight photography as an art form. Their pictures were sharply focused, full in tonal range, and void of sentimentality.

In 1967 Edwards and his wife gave his life's work to the Oakland Museum. He died the next year on September 25, in Oakland.

───────────

Novakov, Anna. *John Paul Edwards: From Pictorialist to Purist*, Oakland Museum, Oakland, California, 1987.

Rabe, W. H. "The Work of John Paul Edwards," *Camera Craft*, December 1918 (Vol. 25), pp. 467–469.

Harvey A. Falk
1903–1983

Falk made pictorial photographs during the 1940s. He lived in New York, where he concentrated on architectural subjects.

───────────

Harvey Aaron Falk was born on November 25, 1903, in New York City. He lived there most of his life and in the mid-1930s was employed by the Hayes Duster and Brush Company. He made a hobby of photography as a child and later was encouraged by his wife to resume making pictures. Mrs. Falk bought him a Contax camera and arranged a White Mountain vacation to rekindle his photographic interest.

Falk was a longtime member of the Manhattan Camera Club, which he joined in 1938 and where he quickly rose to leadership positions. In 1941 he served as secretary and three years later was president of the club, an office he also held in 1951.

Falk exhibited his photographs in salons from about 1939 to the mid-1940s. This span of years was modest for a pictorialist, as was his annual total of photographs shown—forty-six at most. But Falk was highly ranked in terms of the percentage of his acceptances to submissions; for the 1939–1940 and 1940–1941 seasons he led all American pictorialists (trailing only Léonard Misonne of Belgium) in this tabulation of the *American Annual of Photography*. Most of the prints he carefully made and submitted to salon juries were accepted for hanging.

During the 1940s *American Photography*, *Camera*, and *Popular Photography* reproduced Falk's work. And Kodak used his most well known, *World of Today*, in a 1947 ad for photographic paper. *World of Today* shows the RCA Building of New York's Rockefeller Center dramatically framed through Lee Lawrie's Atlas sculpture at ground level. The tonal contrasts, sharp focus, and strong diagonals of the image are trademarks of modernist-influenced late pictorialism. Falk never used manipulative printing processes and termed his architectural photographs "pictorial documentaries."

Falk traveled to Europe in 1951 but probably found the old-world subjects incompatible with his modernist outlook. He died in Fort Lauderdale, Florida, in 1983.

───────────

Green, Barbara. "Harvey Falk, Master Pictorialist," *Camera*, May 1942 (Vol. 64), pp. 22–24, 63.

Adolf Fassbender
1884–1980

Fassbender made a substantial contribution to twentieth-century American photography, enjoying a seventy-year career in the field. During the 1930s and 1940s, he was one of the country's leading pictorialists, making successful salon prints and writing an influential book. For most of his career, he taught photography as a livelihood, influencing thousands of committed amateurs and professional photographers.

Adolf Fassbender was born on May 3, 1884, in Grevenbroich, Germany, a small town near Cologne. A boarder in his family's house introduced him to photography, and at age thirteen young Adolf was apprenticed to a professional in Cologne. In 1901 he finished his apprenticeship, passed government exams, and received his diploma for photographic portraiture. A few years later he was drafted and served time in the German infantry.

Fassbender worked in portrait studios in Europe and in this country for nearly the first thirty years of his career. Before entering the military, he initially assisted a photographer in Freiburg, Germany. Subsequently, he worked in Dresden (where he also studied drawing and painting), Vienna (where he began specializing in hand-colored miniature portraits), and Antwerp. In 1911 he emigrated to the United States. He was first employed by the Selby Sisters and in 1921 opened his own New York studio. For the next seven years he produced commercial, illustrative, and portrait photographs, some of which were exhibited at national conventions of the Photographers' Association of America. He closed the business in 1928.

At about this time, Fassbender became interested in pictorialism and began making creative pictures with the camera. He exhibited in pictorial salons for twenty years, beginning in 1925, when his work was first accepted by London's Royal Photographic Society. His work appeared in one-person exhibitions in 1934 at the Camera Club of New York and in 1951 at the Smithsonian Institution. He joined camera clubs in New York, received honorary memberships from groups elsewhere, and was a founding member of the Photographic Society of America.

Fassbender's pictorial photographs are noteworthy for their classic beauty and extensive handwork. True to his European origins, he retained a keen interest in traditional art and handcrafting. Many of his photographs are picturesque interpretations of rural life, village scenes, and the atmosphere of Manhattan. Whatever the subject matter, he invariably manipulated his images. He was a master of numerous control processes—most notably the paper negative, which allowed him to substantially alter the composition, content, and tonal contrast of a picture. He could delete telephone poles, add clouds, and make a single picture from up to four negatives. The high visual drama and manicured look that resulted from such handwork are visible in his 1939 masterpiece, *Dynamic Symbol, New York World's Fair*.

Fassbender shared his techniques and theories by writing for the photographic press. He began in the early 1930s with a short series of articles in *Camera* about various control methods. His article "Why Bother," about the importance of manipulating the negative, was printed over time by three different publications. Most significant was his book *Pictorial Artistry: The Dramatization of the Beautiful in Photography*, published in 1937. Limited to a signed and numbered edition of 1,000 copies, it contains forty exquisite, hand-printed photogravures, each accompanied by text about the picture's subject, composition, and technique. This volume remains today the most lavish pictorial title published after *Camera Work*.

After closing his studio in the late 1920s, Fassbender made his living as a teacher. He taught photography at the Brooklyn Institute of Arts and Sciences from 1930 to 1935 and in the late 1940s at the Central Branch Brooklyn YMCA. He also conducted private and group classes at his Manhattan and New Jersey residences and lectured to camera clubs and professional conventions throughout the country. In the course of his teaching career, from which he retired in 1970, he instructed more than eighteen thousand photographers. In recognition of his long and loyal service to photography, both the Photographic Society of America and the Professional Photographers of America presented him with most of their advanced degrees and awards.

Fassbender and his devoted wife, Franke, moved from Manhattan to Sparta, New Jersey, in 1960. He died twenty years later on January 2, in the Newton (New Jersey) Hospital. The Photographic Society of America, in Oklahoma City, and the Minneapolis Institute of Arts own master sets of his prints.

Fassbender, Adolf. *Pictorial Artistry: The Dramatization of the Beautiful in Photography*, B. Westermann Co., New York, 1937.

Peterson, Christian A. *The Pictorial Artistry of Adolf Fassbender*, Fassbender Foundation, Nutley, New Jersey, 1995. (Contains bibliography.)

Louis Fleckenstein
1866–1943

Fleckenstein was active in pictorial circles for about forty years, beginning early in the twentieth century. He helped found numerous photographic organizations, most notably the Salon Club of America and the Camera Pictorialists of Los Angeles. Based in California most of his life, he frequently photographed dancers and nymph figures in outdoor settings.

Louis Fleckenstein was born on January 2, 1866, in Faribault, Minnesota. As a young man, he worked part-time in his family's brewing company and in the early 1890s moved to Helena, Montana, for a job with the Singer sewing machine company. At about this time, his wife gave him his first camera and he began printing his own pictures.

Fleckenstein first exhibited his pictorial photographs in 1903, when he won a prize in a Bausch & Lomb contest. From then on, he exhibited regularly and was praised by photography critic Sadakichi Hartmann. His work appeared in the first and most subsequent American Photographic Salons, the only national series of pictorial salons presented during the reign of the Photo-Secession. During the late 1910s and early 1920s, one-person exhibitions of his work were presented at camera clubs in San Francisco, Chicago, Boston, and Baltimore. He apparently stopped exhibiting in about 1940, after his work was included in two exhibitions at the New York World's Fair.

Fleckenstein enjoyed organizing pictorial photographers. In 1903, after returning to Minnesota, he joined with Carl Rau of La Crosse, Wisconsin, to establish the Salon Club of America. The club encouraged a popular standard for pictorialism, circulated albums of work among its members, and helped start the American Photographic Salons. Upon moving to California in 1907 he revived a local camera club and, seven years later, helped found the Camera Pictorialists of Los Angeles, which originally included Margrethe

Mather and Edward Weston. Under his direction, the Camera Pictorialists soon became the leading West Coast club and organizer of a prestigious and long-running salon. In 1934 Fleckenstein also became a charter member of the Photographic Society of America.

Reproductions of Fleckenstein's work and occasional articles by him appeared in the photographic press. Every year between 1904 and 1929 one or more of his pictures graced the *American Annual of Photography*. *Camera Craft* and *American Photography* also regularly featured his work. He sometimes wrote exhibition reviews and, in the late 1930s, contributed articles about the state of pictorial photography in the American West to England's annual, *Photograms of the Year*.

Fleckenstein maintained a portrait studio in Los Angeles until his 1924 departure for Long Beach, where he became the city's first arts commissioner. He died there on April 9, 1943.

Fleckenstein, Louis. "Why I Am a Pictorial Photographer," *Photo Era*, January 1929 (Vol. 62), pp. 3–4.

White, Stephen. *Louis Fleckenstein*, Stephen White's Gallery, Los Angeles, 1978.

Christine B. Fletcher
c. 1872–1961

Fletcher embraced pictorial photography late in her life. She resided in San Francisco and photographed primarily still-lifes. Her appealing images were popular in salons, magazines, and competitions in the 1930s and early 1940s.

Christine B. Fletcher was born around 1872, as she claimed she was sixty-six years old in late 1938. Other than the fact that she was married, nothing is known of her personal life.

Although a few isolated reproductions of her work appeared in *American Photography* in 1915 and 1917, Fletcher seems to have taken up photography seriously around 1930, when she was in her late fifties. At this time she studied under photographer P. Douglas Anderson at the University of California extension and began exhibiting. Her work was accepted in up to nineteen salons a year into the early 1940s. In 1933 the California Camera Club gave her a one-person exhibition.

Fletcher frequently entered the monthly competitions of *Camera Craft* and *Photo Art Monthly*, both San Francisco–based publications. Throughout the 1930s these magazines awarded her prizes and reproduced her pictures. Her first-place winner *Muscats* was one of her most widely seen images.

Fletcher produced still-life photographs almost exclusively. Realizing her knack for the subject, she concentrated on classical arrangements of flowers, vases, fruits, and bowls. She preferred a combination of natural and artificial light, used a minimum of equipment, and photographed at f.22 to get sharp negatives. During enlarging, however, she usually drew chiffon over the lens to gently diffuse the image. She also sometimes subtly hand-colored her finished prints, making them even more accessible to the general public.

Fletcher disappeared from the photographic scene after the mid-1940s. In about 1960 her friend and fellow pictorialist Adolf Fassbender reported that she was living in a San Francisco home for elderly women, where she still photographed and hand-colored as a hobby. She died shortly thereafter, on July 13, 1961.

Blumann, Sigismund. "Christine B. Fletcher: A Woman Who Found Her Forte," *Photo Art Monthly*, January 1935 (Vol. 3), pp. 3–10.

Wright, Jack. "Christine B. Fletcher—Pictorialist," *Camera*, December 1938 (Vol. 57), pp. 402–406.

Frank R. Fraprie
1874–1951

Fraprie was the most influential author/publisher of American pictorial photography during the period following the Photo-Secession. From the 1910s to the 1940s, he wrote books and countless articles on all aspects of pictorialism. He edited photographic monthlies and annuals for nearly the entire first half of the century. In addition, he created his own highly successful pictorial photographs and exhibited them extensively.

Frank Roy Fraprie was born in Fall River, Massachusetts, on July 14, 1874. After graduating from Harvard University in 1898, he taught chemistry at the University of Illinois.

Fraprie's editorial career began in 1901, when he relocated to Boston to join the staff of *Photo Era*. He soon became an associate editor of the magazine, a position he held until 1905, when he moved to *American Amateur Photographer*, in which he bought partial interest. Two years later, this monthly merged with a Chicago magazine to become *American Photography*. Based in Boston, *American Photography* soon became the leading and longest-running periodical addressing mainstream pictorialism. By the time it ceased publication in 1953, it had incorporated sixteen other American photographic magazines, including *Camera Notes*, *Camera Craft*, and the original *Popular Photography*.

Fraprie obtained controlling interest in *American Photography* in 1927, the year he also became editor of the *American Annual of Photography*. In this dual position of power, he both guided and observed American pictorialism for nearly twenty-five years. He wrote hundreds of editorials, reviews, commentaries, and articles for the two publications. He was tremendously influential in standardizing salon practices throughout the world by suggesting operational guidelines and by tabulating the exhibition records of photographers from six continents. The extensive listing "Who's Who in Pictorial Photography" earned the *American Annual of Photography* the status of being the "pictorialists' bluebook."

Fraprie wrote a handful of photographically illustrated European travel books in the first decade of the twentieth century. His photography titles began appearing in the 1910s and continued for thirty years. Primarily technical in nature, his monographs covered lenses, printing and enlarging, lantern slides, portraiture, optics, development, lighting, retouching, exposure, and other subjects. Perhaps his most successful volume was *Photographic Amusements*, co-authored by Florence C. O'Connor and in its eleventh edition by 1937. All of Fraprie's books appeared under the imprint of the American Photographic Publishing Company, the field's leading publisher.

Fraprie himself began making photographs when he received a camera for his twelfth birthday. By about 1902, when he started working for *Photo Era*, he was creating and exhibiting artistic pictures. He corresponded with Alfred Stieglitz and knew the work of the Photo-Secession through *Camera Work*, to which he subscribed. Fraprie's early work probably was similar to Secessionist pictures, but by 1910 he and Stieglitz disagreed on aesthetic issues. For the next fifteen years, he exhibited modestly, primarily at camera clubs in Boston and New York.

In the mid-1920s, however, Fraprie's photographic output began to increase. In the 1932–1933 and 1933–1934 seasons he found himself listed at the top of his own ranking of exhibitors in the *American Annual of Photography*. At his peak, he was regularly showing more than three hundred prints a year in nearly seventy-five international salons.

Fraprie's most successful salon photograph was *Warmth of the Winter Sun*. In 1948, just over ten years after he made it, he claimed that 218 photographic juries had accepted it. Made in Italy, the image evokes Fraprie's old-world values and traditional aesthetic; many of the late pictorialists valued its picturesque and accessible characteristics.

Not surprisingly, Fraprie was involved with and honored by the leading photographic organizations of his day. In the 1920s, he headed the Photographic Guild of Boston's Society of Arts and Crafts and was a regional vice-president for the Pictorial Photographers of America. He was a charter member of the Photographic Society of America, which later awarded him a coveted honorary fellowship (Hon. FPSA). He was similarly honored by England's Royal Photographic Society. Upon his retirement, the *PSA Journal* called him, unequivocally, "Mr. Photography."

At the end of 1949, Fraprie stepped down as editor of *American Photography* and the *American Annual of Photography*. The monthly devoted a special issue to him, which included numerous tributes, a portfolio of his work, and a major article on him. By the middle of the next year, he was bedridden and going blind. He died on June 20, 1951, in Brighton, Massachusetts.

"Frank Roy Fraprie, 76, Noted Photographer" (obituary), *New York Times*, June 22, 1951, p. 25.

"The Photographic Art of Frank Roy Fraprie," *American Photography*, December 1949 (Vol. 43), entire issue.

Wright, Jack. "Frank Roy Fraprie, Hon. FPSA, FRPS," *PSA Journal*, November 1945 (Vol. 11), pp. 450–451.

Rowena Fruth
1896–1983

Fruth exhibited her pictorial photographs extensively for a short time during the 1940s. She lived in a small Indiana town, where she photographed primarily still-lifes and children.

———————————

Fruth was born Rowena Rosendale on June 13, 1896, in Fostoria, Ohio. She went to school at what is now Heidelberg College in Tiffon, Ohio, and graduated from Boston's New England Conservatory in 1917. Subsequently, she taught at the Peabody Conservatory of Music in Baltimore. In 1919 she married Dr. Virgil J. Fruth and the next year moved with him to Connorsville, Indiana, about sixty miles east of Indianapolis. Here she taught piano privately and in the school system for much of her adult life.

Fruth became interested in photography after both her husband and son bought cameras. She sought professional instruction in New York, where she studied under Nicholas Ház for a short time in the late 1930s. Upon returning to Indiana, she joined the Indianapolis Camera Club and built a well-appointed studio and darkroom in her house.

Fruth took salon exhibiting seriously. She began submitting her work to juries in 1940, and three years later seventy-one salons accepted more than two hundred of her prints. According to the official tabulation of the *American Annual of Photography*, she was the world's most prolific exhibitor in the 1942–1943 season. By the late 1940s, she had stopped exhibiting altogether.

Fruth was visible among pictorialists in other ways during the 1940s. In 1945 she served on the board of directors of the Photographic Society of America, which awarded her fellowship status (FPSA). She had two one-person exhibitions at the Smithsonian Institution within four years of each other, as well as one in 1943 at the Brooklyn Institute of Arts and Sciences. She also addressed out-of-town camera clubs.

Fruth explored only a couple of broad subjects in her pictorial photographs. One was still-lifes; sometimes she incorporated abstract light patterns and at other times she made straightforward plant studies. She was best known, however, for her child portraits. In particular, she regularly posed a set of local twin girls in situations both trite and visually challenging.

Fruth apparently gave up photography after only a decade or two of intense activity, but she retained her interest in music, skillfully playing the piano in her old age. She died in Connorsville on May 18, 1983.

———————————

"Deaths and Funerals: Mrs. Virgil J. Fruth," *Connorsville News-Examiner*, May 19, 1983, p. 20.

"Rowena Fruth," *Camera*, January 1945 (Vol. 67), pp. 26–27.

Walters, H. Max. "Her Talents, Accomplishments Are Many," *Connorsville News-Examiner*, July 16, 1974, n.p.

Wright, Jack. "PSA Personalities: Rowena Fruth, APSA," *PSA Journal*, April 1944 (Vol. 10), pp. 224–225.

Laura Gilpin
1891–1979

Gilpin made both pictorial and documentary photographs during her sixty-year career. She studied with Clarence H. White and was active in the Pictorial Photographers of America. From the 1930s on, she documented, in sharp focus, the landscape and native peoples of the Southwest. She produced four books and supported herself by making commercial and portrait photographs.

———————————

Laura Gilpin was born on April 22, 1891, in Colorado Springs. She grew up there but attended school in the Northeast. She studied violin and returned to Colorado to run a poultry farm on her family's ranch in the early 1910s.

Gilpin received her first camera at the age of twelve. Subsequently, she photographed at the St. Louis World's Fair and experimented with Lumiere Autochromes, an early color-transparency process. From 1916 to 1918 she attended the Clarence H. White School of Photography in New York, where she learned about artistic photography and photogravure printing. She joined the Pictorial Photographers of America (PPA) shortly after the group formed in 1916 and saw her pictures reproduced in all five of its annuals, published in the 1920s. In 1929 the PPA designated her a regional vice-president and offered a traveling, one-person exhibition of her work. She remained a member of the organization into the early 1940s.

Gilpin made pictorial photographs during the late 1910s and 1920s. Invariably printed on platinum paper, the images were usually landscapes, still-lifes, or portraits. *The Prelude* was perhaps her most successful early image, being exhibited continually from 1917, the year it was made, to the late 1920s. It was also frequently reproduced, appearing in *Photograms of the Year, 1922* and Paul L. Anderson's book *The Fine Art of Photography*.

Gilpin launched her commercial photographic practice in 1918, when she returned to Colorado Springs and opened a studio specializing in portraiture, architecture, and advertising. In the early 1930s, she was the staff photographer for an opera house in Denver, and during World War II she was the chief public-relations photographer for Boeing Aircraft, in Wichita, Kansas. She also taught photography—first at Denver's Chappell School of Art in the late 1920s and later at the Colorado Springs Fine Art Center. In 1948 she moved her studio permanently to Santa Fe, New Mexico.

Gilpin developed a serious interest in the southwestern lifestyle, documenting with a sympathetic eye the people, landscape, and architecture of the area. She wrote and photographically illustrated four books: *The Pueblos: A Camera Chronicle* (1941), *Temples in Yucatan: A Camera Chronicle of Chichen Itza* (1948), *The Rio Grande: River of Destiny* (1949), and *The Enduring Navajo* (1968). In the early 1970s, at the age of eighty, she also began a project on Canyon de Chelly.

Gilpin received many awards and participated in many exhibitions, both group and solo, over her long career. In 1975 she was awarded a Guggenheim Fellowship to resume making hand-coated platinum paper, her favorite printing medium. Three years later, she announced that upon her death her photographic estate would be bequeathed to the Amon Carter Museum in Fort Worth, Texas. She died of heart failure on November 30, 1979.

———————————

The Early Work of Laura Gilpin, 1917–1932, Research Series No. 13 (April 1981), Center for Creative Photography, University of Arizona, Tucson.

Sandweiss, Martha A. *Laura Gilpin: An Enduring Grace*, Amon Carter Museum, Fort Worth, Texas, 1986. (Contains bibliography.)

Arthur Hammond
1880–1962

Hammond was deeply involved in pictorial photography from the 1910s into the 1950s. He helped edit *American Photography* and wrote many articles and an important book on composition. In addition, he made pictorial photographs that were widely exhibited.

———————————

Arthur Hammond was born in London, England, on January 26, 1880. He moved to New York City in 1908 and two years later settled in Boston, where he remained for most of his life. As a professional photographer, he specialized in distinguished home portraiture, usually using soft-focus lenses. In 1927 he went to Chicago for a few years to direct the home-study courses of the American School of Photography.

Hammond contributed substantially to the photographic literature of the time, writing on portraiture, technique, and pictorialism. His long writing career began in 1910, when an article he wrote on night photography appeared in *Camera* magazine. In 1918 he became associate editor of *American Photography*, this country's leading photographic monthly. In 1929, after his stint in Chicago, he resumed his position at the magazine, apparently not returning to his portrait business. During the 1930s and 1940s, he contributed articles to and edited long-running columns for the monthly and also contributed to its sister publication, the *American Annual of Photography*. He retired from the magazine along with its editor, Frank R. Fraprie, in 1949. After this time *American Photography* and the *PSA Journal* carried an occasional article by him.

Hammond also wrote a handful of technical books, sometimes in conjunction with Fraprie. His most important title, however, was his own *Pictorial Composition in Photography*, a basic text on composition, technique, and pictorialism. This enduring volume first appeared in 1920 and remained in print for more than twenty-five years, going through four editions.

Hammond was a practicing pictorialist, creating and exhibiting artistic photographs for at least thirty years. His work was sufficiently accomplished by 1912 to merit a one-person exhibition at the Boston Camera Club. The Smithsonian Institution accorded him a similar show in 1944. He exhibited in salons from as early as 1913, when his work was seen in the Ninth American Photographic Salon, to the late 1940s. His most prolific season was 1934–1935 when more than 50 salons accepted 148 prints.

Semi-Lunar was one of Hammond's most successful salon photographs. Made at the 1939 New York World's Fair, it is as modern as pictorial images got. Its subject—the fair's Perisphere—was the epitome of contemporary, art-deco architecture. Hammond rendered the Perisphere strategically lit, sharply focused, and without visual clutter, making the picture a triumph of photographic minimalism.

Hammond's stature among pictorialists led him to participate in numerous organizations. He was active in camera clubs in Boston and served as treasurer and print director in the New England Council of Camera Clubs in 1941. He was a charter member of the Photographic Society of America, which awarded him with fellowship status in 1946 (FPSA). He was also frequently called upon to judge salons, primarily in the Northeast.

In the mid-1950s, Hammond retired to Texas, where he died in the town of Portland in August 1962.

———————————

Hammond, Arthur. *Pictorial Composition in Photography*, American Photographic Publishing Co., Boston, 1920, 1932, 1939, and 1946 (four editions).

"Miniature Biographies: Arthur Hammond," *PSA Journal*, March 1935 (Vol. 1), p. 7.

Forman G. Hanna
1881–1950

Hanna exhibited his pictorial prints for forty years, beginning in the mid-1910s. Based in Globe, Arizona, he made photographs of Native Americans, the southwestern landscape, and female nudes. His vocation was that of a pharmacist.

According to the "Directory of Pictorial Photographers" in the *American Art Annual 1930*, Forman Gordon Hanna was born in Windsor, Missouri, on December 21, 1881. He grew up on his father's cattle farm near Anson, Texas, and graduated from the Galveston School and University in 1904 with a pharmacy degree. He soon landed a job in Globe, Arizona, at the Palace Pharmacy, which he later bought and ran until retirement.

Hanna acquired his first camera as a child. After seeing reproductions of creative photographs in the press, he began reading monthly photographic magazines to teach himself the technique of pictorial photography. His photographs first appeared as prizewinners in the monthly competitions of *American Photography* from 1913 to 1915.

By the late-1910s, his photographs were being accepted at national exhibitions in San Francisco and Los Angeles. He continued to consistently exhibit in salons until the early 1940s, showing up to fifty prints a year. He was also honored with one-person exhibitions: In both 1923 and 1928, his work was featured at the Camera Club of New York, and New York's Art Center gave him a one-person show at about the same time. His last solo exhibition occurred in 1948 at the Brooklyn Museum, which he traveled east to see.

Hanna was involved with various influential pictorial groups. He was a council member of the Pictorial Photographers of America shortly after its founding and a regional vice-president in the late 1920s. In 1933 he was honored with fellowship status in England's Royal Photographic Society (FRPS). And a year later he became a charter member of the Photographic Society of America.

Hanna's choice of subject matter reflected his lifelong residence in Arizona. He frequently turned his camera on the Native Americans of the Southwest, idealizing the lifestyle of the Apache, Navajo, and Hopi tribes. He was also attracted to female nudes, which he classically posed in the area's natural surroundings; he wrote an article on the subject for the April 1935 issue of *Camera Craft*. In addition, he produced pure Arizona landscapes, repeatedly photographing the state's peaks, deserts, and canyons with an eye toward light and shade rather than topographical documentation.

In 1946 Hanna sold his drugstore and retired. His pictorial output had slowed by this time, and he made his last photographic trip, to the Grand Canyon, in 1949. A year later, after three months of poor health, he went to Los Angeles for medical care and died in a hospital there on April 20, 1950.

Gillies, John Wallace. "Forman G. Hanna," *American Photography*, October 1923 (Vol. 17), pp. 598–601.

Hanna, Forman G. "This Is the Photographic 'Me,' " *Camera Craft*, November 1931 (Vol. 38), pp. 514–520.

Sawyer, Mark. *Forman Hanna: Pictorial Photographer of the Southwest*, University of Arizona and Northland Press, Flagstaff, 1985.

Raymond E. Hanson
(dates unknown)

Hanson was involved in pictorial photography from the mid-1910s to mid-century. He exhibited his landscape pictures in salons throughout the world and wrote extensively for the photographic press. He resided in Massachusetts, where he was a professional photographer.

Raymond E. Hanson was a native of Massachusetts, where he seems to have lived all of his life. He studied chemistry at the Massachusetts Institute of Technology and initially worked in chemical analysis and technical research. In 1925, however, he became a professional photographer, based in Boston. For at least the next twenty-five years, he made publicity, advertising, and illustrative photographs. In 1935 he provided the photographic illustrations for Frederick Howard Dole's book *Sketches of the History of Windham, Maine*.

A friend introduced Hanson to photography in 1914. By three years later he had joined Boston's Society of Arts and Crafts, an important organization of craftsmen (including photographers) with which he was long associated. He was included in two-person exhibitions at the society in 1921 and 1926 and presented solo shows of his photographs in 1923 and 1924. In 1925 he became a medalist of the society, its highest membership level. A few years later, he assumed the position of dean of the society's photography guild, a job held later by fellow Boston pictorialist Frank R. Fraprie.

Hanson mastered the bromoil process, a manipulative technique favored by traditional pictorialists. While most photographers restricted themselves to 8 by 10 inches or smaller when making bromoils, Hanson produced large-format prints by the process. His love for the natural environment is evident in his photographs of the New England landscape. During the 1920s and 1930s these prints were accepted at salons in Pittsburgh, Rochester, Buffalo, Los Angeles, Toronto, London, Tokyo, Australia, and elsewhere.

Hanson wrote prolifically for photographic magazines. From about 1920 to mid-century, he contributed frequently to *American Photography*, *Camera*, and *Photo Era*. In several of his lead articles, he discussed his two areas of expertise, landscape photography and the bromoil process. His last known article, appearing in December 1951, was titled "All-Weather Photography."

Hanson, Raymond E. "Why I Am a Pictorial Photographer," *Photo Era*, December 1929 (Vol. 63), pp. 291–292.

"Meet the Authors: R. E. Hanson," *Camera*, December 1951 (Vol. 74), p. 111.

Nicholas Ház
1883–1953

Ház was widely known as a photographic teacher during the 1930s and 1940s. He also wrote books and articles on pictorial composition, his specialty. His own photographs were usually theatrical figure studies.

Nicholas Ház was born on January 18, 1883, in the Slovakian town of Zvolen, when it was part of Hungary. When he was fourteen, he entered art school in Budapest and spent about a decade and a half studying painting throughout Europe, including five years under Franz von Stuck. In 1913 he sailed for the United States on the *Mauretania*. Over the next few years, he worked as a cartoonist and courtroom artist for New York City newspapers and as a billboard designer.

Ház began his photographic career in 1920 by retouching pictures in the Greenwich Village studio of Nickolas Muray. By the end of the decade, Ház was running his own successful portrait business in New York, maintaining a studio next to Edward Steichen's.

During World War I, Ház taught for a short time at an art school in Los Angeles and in 1930 became a full-time teacher of photography, in both private sessions and group classes. Among his first students were Yousuf Karsh and Valentino Sarra. He taught summer sessions in Gloucester, Massachusetts, and Woodstock, New York, and in 1938 opened the Ház-Sanders Master School of Photography in New York's RCA Building. He traveled extensively to teach, conducting sessions in Havana, Mexico City, Japan, and Hawaii. He frequently spoke to camera-club gatherings, gaining a wide audience and receiving fifteen honorary club memberships by 1943. A few years later, he was also honored with a fellowship in the Photographic Society of America (FPSA).

As an extension of his teaching, Ház wrote two books and numerous articles and columns, emphasizing composition and such formal elements as line, shape, and form. In the late 1930s, for instance, he contributed "Picture Analysis" columns to *Camera* and *Popular Photography*. In 1937 his book *Emphasis in Pictures: A First Aid to Composition* came out, and in 1946 he self-published *Image Management (Composition for Photographers)*. Three years after his death, his widow issued *Image Arrangement*, a book based on his notes.

Ház's photographs were invariably made in the studio, because he sought to control both the subject and the environment. In addition to theatrical portraits, he frequently posed costumed figures in stagelike tableaux; these pictures were consistently reproduced in magazines such as *American Photography* during the 1920s and 1930s. One-person exhibitions of his work were presented at the Brooklyn Institute of Arts and Sciences in 1925, the California Camera Club in 1926, and the Cleveland Camera Club in 1927. In 1939 the Julian Levy Gallery displayed a solo show of his abstract color photographs, which received both critical and popular acclaim.

In 1952 Ház visited England and underwent a successful operation on an eye that had been blind for eight years. Soon thereafter he moved to California and resumed painting. He died in Santa Barbara of a heart attack on April 28, 1953.

Blumann, Sigismund. "Nicholas Ház," *Camera Craft*, January 1928 (Vol. 35), pp. 3–9.

Ház, Nicholas. *Emphasis in Pictures: A First Aid to Composition*, Fomo Publishing Co., Canton, Ohio, 1937.

———. *Image Management (Composition for Photographers)*, Nicholas Ház Books, Cincinnati, 1946.

Wright, Jack. "PSA Personalities: Nicholas Ház, FPSA," *PSA Journal*, June 1943 (Vol. 9), pp. 265–266.

Antoinette B. Hervey
1857–1945

Hervey made pictorial images from the 1910s into the 1930s, focusing on the architecture of New York. She studied with Clarence H. White and was active in the Pictorial Photographers of America.

Antoinette Bryant was born in Gilbertsville, New York, in 1857. In 1887 she married Walter L. Hervey and moved to New York with him.

Hervey's primary subject was the cathedral of St. John the Divine, located near her Morningside Heights residence in Upper Manhattan. According to the *New York Times* she began photographing it in 1906 and continued for about twenty-five years. Wishing to create a complete portrait of the structure, she pictured its exterior during different seasons and at various times of day. Her interior images of the cathedral are reminiscent of the work of Frederick H. Evans, the revered turn-of-the-century English photographer. Like Evans, Hervey made primarily platinum prints, but her work was printed in photogravure when it appeared in a fund-raising portfolio for the cathedral titled *The World in Stone* (c. 1924).

Hervey's subtle prints were exhibited and reproduced beginning in the mid-1910s. The San Francisco and Pittsburgh salons accepted her work, and in the late 1920s she contributed regularly to the members' shows of the department of photography at the Brooklyn Institute of Arts and Sciences. In 1931 she received an honorable mention for a picture in a show of Manhattan subjects presented by the Camera Club of New York. The magazines *Photo Era* and *Camera* featured her work in their pages, as did the *American Annual of Photography*, in 1918, 1924, and 1925.

After studying at the Clarence H. White School during World War I, Hervey became heavily involved with the Pictorial Photographers of America (PPA), founded by White and others in 1916. Early on she was both an executive council member and the organizer of the group's monthly competitions. Her work was reproduced in all five PPA annuals, *Pictorial Photography in America*, published between 1920 and 1929. This was a rare occurrence, and in 1921 she also contributed a brief statement on photographing New York's Municipal Building with a pinhole camera. In the mid-1930s, she was elected honorary vice-president, a position vacated by the death of Gertrude Käsebier. As late as 1938, she spoke and showed her prints at a PPA meeting.

In 1940 Hervey gave all of her work on St. John the Divine to the New-York Historical Society, which exhibited some of it the same year. This collection of about 1,000 prints and more than 2,500 negatives remains her primary archive. The year after she died, in 1945, her husband privately published a memorial booklet on his late wife.

Brown, Robert W. "An Exhibition Tells the Story of Building the Cathedral of St. John the Divine," *New York Times*, October 6, 1940, n.p.

Hervey, Antoinette B. "He Thought She Was Crazy," *Pictorial Photography in America, 1921*, Pictorial Photographers of America, New York, pp. 11–12.

John R. Hogan
1888–1965

Hogan exhibited in pictorial salons and was connected to the Photographic Society of America from the late 1930s into the 1950s. He spent most of his life in Philadelphia, where he worked as a yacht broker. He was widely known for his marine photographs.

John R. Hogan was born in Montclair, New Jersey. He graduated from Cornell University in 1911 and served as a pilot during World War I. After the war, he worked in the steel business but eventually settled in boat sales and service.

Hogan's love for sailing led him to pictorial photography, having acquired his first camera in 1932 to document a sailing race he had entered. He became seriously interested in photography about four years later, after winning a contest and joining the Miniature Camera Club of Philadelphia. In the club darkrooms, he learned how to make exhibition-quality prints of his marine subjects. By the late 1930s, his photographs, such as the action-packed *Crossing the Stream*, were appearing in photographic magazines like *American Photography*, *Camera*, and *Camera Craft*.

Hogan exhibited widely from then on. In the 1944–1945 season, he was the world's leading salon exhibitor, with nearly 50 venues accepting 173 photographs. He was also honored with one-person exhibitions—in 1942 at the Smithsonian Institution and six years later at the Brooklyn Museum.

Hogan was particularly active in the Photographic Society of America (PSA). He joined the organization in 1940 and by the end of the decade was its Pictorial Division chairman. In 1946 he acquired a society fellowship (FPSA) and shortly thereafter received its first Stuyvesant Peabody Award. In 1952, after writing a few articles for the *PSA Journal*, he began editing a monthly column for the periodical. After his death, the PSA designated an annual award in his name for the best marine photograph.

Hogan died in early 1965 in Brielle, New Jersey.

Hogan, John R. "Marine Photography," *American Annual of Photography, 1951*, pp. 37–50.

Wright, Jack. "PSA Personalities: John R. Hogan," *PSA Journal*, March 1947 (Vol. 13), p. 152.

Bernard S. Horne
1867–1933

Horne was closely involved with Clarence H. White and the Pictorial Photographers of America. His well-composed photographs incorporated both modernist and pictorial elements in the transitional period of the late 1910s and early 1920s. He lived a life of leisure in the Northeast.

Bernard Shea Horne was born in Pittsburgh in 1867. He graduated from Princeton University in 1890 and retired when he was in his mid-thirties. Initially, he lived on a farm in Virginia, where he pursued his hobbies of golf and photography. After his wife died in the mid-1910s, he moved to Princeton, New Jersey, with his sons.

In 1916 Horne enrolled in the Clarence H. White School of Photography and two years later began teaching photographic technique, previously the responsibility of Paul L. Anderson. He made friends with the painter Max Weber, who taught the school's art history and design courses. Horne served as president of the school's alumni association in the mid-1920s and was responsible for starting *Camera Pictures*, the association's annual in 1924 and 1925; he was the only alum to have his work reproduced in both issues.

Horne was equally involved in the Pictorial Photographers of America (PPA), the country's leading group of art photographers after World War I. From 1917 to 1920 he served on the PPA's executive committee. Its annuals twice included reproductions of his work, and in 1921 he contributed a short statement on soft-focus lenses. His work was seen in the PPA's initial exhibition of 1917, which traveled to sixteen American art museums, and in its first international salon six years later. In March 1926 he presented one of his few one-person exhibitions, at New York's Art Center, headquarters of the PPA.

Horne organized his photographs in this exhibition into four categories that spanned his life's work: landscape, portrait, still-life, and design. His landscapes pleasantly capture quaint New England summer haunts and his portraits show individuals close to him, like family members and White School participants. His still-life and design photographs are considerably more adventuresome, often incorporating unusual camera angles and other abstract elements influenced by cubist art. Horne's best work combines the forward-looking vision of modernism with the traditional hallmarks of pictorialism. His prints are usually softly focused and printed by manipulative processes such as oil, gum-bichromate, and platinum.

After a brief, ten-year involvement, Horne disappeared from photographic circles in the mid-1920s and died in 1933.

Goldberg, Vicki. *A Catalog of Design Photographs by Bernard Shea Horne*, Keith Douglas de Lellis, New York, 1986.

Horne, Bernard S. "As to Certain Soft Focus Lenses," *Pictorial Photography in America, 1921*, Pictorial Photographers of America, New York, p. 12.

Franklin I. Jordan
1876–1956

Jordan, who was known among pictorialists as Pop, made and exhibited creative photographs from before 1910 to about mid-century. He authored a few popular books on photographic technique and was an editor of both *American Photography* and the *American Annual of Photography*. He worked as a printer in Boston.

Franklin Ingalls Jordan managed the Pilgrim Press, probably in Boston, from the mid-1910s to 1922, when he helped form the Jordan and More Press. He made his first photographs in 1896 and began exhibiting in pictorial salons about a decade later. His work was included in the traveling American Photographic Salons of 1908 and 1912 and in international salons until about 1950. His most prolific season was 1932–1933, when nearly 50 salons accepted 218 of his photographs. He presented one-person exhibitions of his work at camera clubs in Chicago and Los Angeles in the late 1930s and at the Smithsonian Institution in 1951.

Jordan's pictures began appearing in the photographic press in the mid-1910s, when he won monthly competitions in *American Photography* and *Photo Era*. During the 1920s, he developed an interest in photographing animals and continued to create particularly accessible dog and cat pictures for the next few decades. During this time, his images were also seen in *Camera, Camera Craft,* and *Photograms of the Year*. In about 1930 Jordan traveled with Wilmot R. Evans to the Southwest to photograph the Pueblos and Navajos, a project that resulted in a privately printed book of their pictures.

During the 1930s, Jordan associated himself with photographic organizations and began writing about photography. He was a charter member of the Photographic Society of America and served as president of the Boston Camera Club. In 1935 the first of three editions of his book *Photographic Enlarging* was published. Within the next few years, he received fellowship status from the Royal Photographic Society (FRPS) and began contributing articles to *American Photography*. In 1939 he became associate editor of the magazine, forming a strong bond with its editor, Frank R. Fraprie. From late 1949 until the magazine's demise in mid-1953 Jordan wrote the column "Pop Sez." In addition, he helped Fraprie edit the *American Annual of Photography* throughout the 1940s, performing the job alone in 1951 after Fraprie retired.

In 1954 the Photographic Society of America presented Jordan with an honorary fellowship (Hon. FPSA), its highest award. He died two years later, at his daughter's home in Hartford.

Jordan, Franklin I. "Why I Am a Pictorial Photographer," *Photo Era*, November 1929 (Vol. 63), pp. 233–234.

———. *Photographic Enlarging*, Folmer Graflex Corp., Rochester, New York, 1935.

———. "Whence and Whither?" (autobiography), *PSA Journal*, February 1947 (Vol. 13), pp. 89–90.

Hans Kaden
c. 1890–1961

Kaden exhibited his pictorial photographs from the late 1930s to the late 1940s. He then wrote articles for a few years for photographic monthlies. He apparently made his living teaching photography in the New York area.

Hans Kaden was born around 1890 in Germany and received his first camera when he was fourteen. After coming to the United States, he began teaching and by the mid-1940s was on the staff of the School of Modern Photography in New York City. In 1947 he opened a school and studio in his New Jersey home, where he probably taught pictorialists as well as commercial photographers.

Kaden began salon exhibiting in 1938. For the next ten years, his work was accepted by salon juries in the United States and Europe. The 1942–1943 season was his most prolific, with 105 prints shown in more than 30 salons. He was honored with a one-man show in 1944 at the Smithsonian Institution, which retained some of his work for its permanent collection.

Kaden, who always lived near the Atlantic Ocean, photographed primarily seascapes. He considered the water, beaches, boats, and reflections of the sea a pictorialist's paradise, writing an article on the subject for the June 1955 issue of the *PSA Journal*. His full-toned image *Path of Light*, for instance, shows a large expanse of glistening sand under a hazy sky and setting sun and combines accessible pictorial beauty with a strong undercurrent of deep subjectivity.

Kaden was elected to salon memberships at Pittsburgh, Rochester, and Wilmington, and he served as chairman in 1941 of the Philadelphia salon. In 1947 he received fellowships from both the Photographic Society of America (FPSA) and the Royal Photographic Society (FRPS). He occasionally spoke to camera clubs in the Northeast and judged salons as late as 1957, when he was on the jury in Newark, New Jersey.

Kaden wrote for photography magazines for a short time in the early 1950s, after he stopped exhibiting his pictures. In addition to the *PSA Journal*, where a few of his photographs had appeared as covers, he contributed articles to *American Photography*, the country's major monthly. He became a contributing editor for the magazine in early 1952 and wrote regularly for its last year and a half of publication. Among the topics he covered were lighting, pattern, human interest, and skies, sometimes illustrated with "before" and "after" images.

Kaden died on November 20, 1961, at age seventy-one in Paramus, New Jersey.

Carstens, H. H. "Obituaries: Hans Kaden," *PSA Journal*, January 1962 (Vol. 28), p. 40.

"Close-ups: Hans Kaden," *American Photography*, February 1952 (Vol. 46), p. 8.

"Hans Kaden," *Camera*, November 1944 (Vol. 66), pp. 26–27.

Arthur F. Kales
1882–1936

Kales was a leading Southern California pictorialist from the 1910s to the 1930s. He was known internationally for his bromoil and bromoil transfer prints. His favored subjects were dancers, movie stars, and other figure studies.

Arthur F. Kales was born on November 30, 1882, in Phoenix, Arizona. He grew up in Oakland and earned a law degree from the University of California, Berkeley, in 1903. After working for a while in his family's engineering and manufacturing business in New York, he moved to Los Angeles around 1916 to become an advertising manager.

Kales toyed with photography during college and then became seriously interested in the mid-1910s. He first exhibited in 1916, when the London salon accepted some of his work. He continued to exhibit modest numbers of his photographs for the next few decades, always at the most prestigious salons. He was honored with one-person exhibitions at the California Camera Club in 1918 and 1919, the Boston Camera Club in 1919, the Smithsonian Institution in 1928, and the Brooklyn Institute of Arts and Sciences in 1929. On the occasion of his 1927 solo show at the Camera Club of New York, the July issue of *Camera* reproduced more than twenty of his photographs.

Kales's prints were recognizable for both subject matter and printing process. Based in Southern California, he photographed primarily well-known dancers and film stars, such as Ruth Saint Denis and Gloria Swanson, as well as unknown sitters posed for theatrical effect. He printed most of his images in bromoil or bromoil transfer, processes that allowed considerable hand manipulation. He was, in fact, an acknowledged bromoil master, who taught the technique to William Mortensen and others.

Kales participated in pictorial activities in California and beyond. He was an early member of the Camera Pictorialists of Los Angeles, the West's leading photographic society. In 1922 he began writing on West Coast pictorial photography for England's *Photograms of the Year*; his articles and pictures appeared every year until his death. He was honored with a fellowship from the Royal Photographic Society (FRPS) in 1932.

Kales died in Los Angeles in 1936 and shortly thereafter was memorialized with a 300-print retrospective at the Los Angeles Camera Club.

Blumann, Sigismund. "Arthur F. Kales: A Militant Pictorialist Who Really Pictorializes," *Camera Craft*, December 1930 (Vol. 37), pp. 570–578.

———. "Arthur F. Kales, F.R.P.S.," *Photo Art Monthly*, November 1934 (Vol. 2), pp. 514–523.

———. "Arthur F. Kales: An Appreciation of a Departed Artist," *Photo Art Monthly*, September 1936 (Vol. 4), pp. 424–434.

Kales, Arthur F. "Why I Am a Pictorial Photographer," *Photo Era*, December 1928 (Vol. 61), p. 293.

Hiromu Kira
1898–1991

Kira was the most significant Japanese-American pictorialist in the American West during the 1920s and 1930s. Based for most of his adult life in Los Angeles, he exhibited regularly in California and elsewhere during this time. He was best known for his still-life photographs of paper birds.

Hiromu Kira was born in Hawaii on April 5, 1898. He grew up in Japan, spent two years in Canada, and then moved with his family to the United States in 1917. He lived first in Seattle and then, beginning in 1926, in Los Angeles. He worked at several jobs, including clerking at photography stores and retouching at RKO Radio Pictures.

Kira first made amateur snapshots in Seattle at about age twenty. A few years later he saw an exhibition that inspired him to investigate the creative possibilities of the camera. In 1923 he exhibited his first pictorial photographs, at Seattle's Frederick and Nelson salon. Subsequently, juries at such leading salons as Pittsburgh, London, and Sydney accepted his pictures.

Despite his successes, Kira was not a highly prolific or outgoing pictorialist. He apparently choose to work quietly and generally outside of camera-club circles. Although he helped found the Seattle Camera Club in 1924, he did not join the Japanese Camera Pictorialists of California or other photographic organizations in Los Angeles after moving there. He exhibited in salons for only a decade, and his most active season (1928–1929) yielded fewer than one hundred prints in twenty-two salons, modest numbers for pictorialists. Reproductions of his work appeared in a few photographic publications, but only *Camera Craft* gave him significant press.

Kira excelled at still-life pictures during his short pictorial career. His images of paper birds were widely heralded as examples of perfect placement and understated simplicity. To produce them, he would create an origami bird, carefully arrange it on a background of rectangular or circular shapes, and light it for maximum compositional effect. He also produced other Japanese-inspired still-lifes, with glass dishes and other geometrically shaped objects. In 1928 he wrote an article on still-life photography in which he emphasized the importance of arrangement in a picture.

In 1929 Kira was awarded fellowship status in England's Royal Photographic Society (FRPS). He died in Los Angeles on July 19, 1991.

Blumann, Sigismund. "Hiromu Kira, a Japanese Artist Who Has Poetized Paper," *Camera Craft*, August 1928 (Vol. 35), pp. 353–357.

Kira, Hiromu. "Still Life Photography," *Camera Craft*, August 1928 (Vol. 35), pp. 358–360.

———. "Why I Am a Pictorial Photographer," *Photo Era*, May 1930 (Vol. 64), pp. 231–232.

Fred G. Korth
1902–1982

Korth was an industrial photographer in Chicago who moonlighted as a pictorialist. His work was seen in salons and photographic periodicals during the 1930s and 1940s. He wrote a few articles on technique and published a small picture book on Chicago.

Fred G. Korth was born in Germany on October 24, 1902. In 1926 he moved to Chicago, where he made a living doing commercial, illustrative, and, primarily, industrial photography. In 1933 he photographed Chicago's Century of Progress world exposition. Three years later he opened his own studio, which he maintained until retiring in 1963. He produced promotional photographs of tools, food, and other products and worked freelance for both *Commerce* and *Fortune* magazines. *The Chicago Book* (1949) consisted exclusively of his pictures.

Pictorialists admired Korth's commercial work, which was characterized by high contrast, dramatic lighting, and strong diagonals. Pictorial salon juries often accepted photographs Korth initially had made on assignment. His image *Galvanized Sheets*, for instance, was commissioned by Ryerson Steels and turned up in 1948 in the Chicago photographic salon.

Korth was active among American pictorialists for two decades. He was a member of the Fort Dearborn Camera Club, which he addressed at least once. In about 1930 he began exhibiting in salons, showing up to fourteen prints a year in Rochester, London, New York, and elsewhere. He was well known for his bird's-eye views of the Chicago River, and his pictures were reproduced in *Camera Craft*, *Photo Era*, and *Popular Photography* as late as 1950. He also wrote articles for these magazines on equipment, freelancing, and still-life. Among his specialties were photomontage and bas-relief effects, which he used for both Christmas cards and photographic illustration.

Korth died at age seventy-nine on May 2, 1982, in his home in Wilmette, just north of Chicago.

"Deaths, Obituaries: Fred G. Korth," *Chicago Sun-Times*, May 5, 1982, n.p.

Korth, Fred G. *The Chicago Book*, Fred G. Korth, Chicago, 1949.

Smith, Bob. "Korth Shoots the Works," *Camera Craft*, May 1940 (Vol. 47), pp. 213–220.

Sophie L. Lauffer
1876–1970

Lauffer made and exhibited pictorial photographs from the late 1910s through the 1930s. She was a member of the Pictorial Photographers of America and worked in the department of photography at the Brooklyn Institute of Arts and Sciences.

Sophie L. Lauffer was born on April 13, 1876. She studied painting and drawing in college but did not begin pursuing photography until she was in her late thirties. In 1913 she purchased a Kodak Brownie, her first camera, for a trip to Europe. A few years later, she traveled to Yellowstone Park, Yosemite Valley, and the Grand Canyon, still using her snapshot camera.

Lauffer became seriously interested in photography in the late 1910s, when she took a summer class with Clarence H. White and joined the Pictorial Photographers of America. In 1919 she began exhibiting with an acceptance at Pittsburgh, the nation's leading photographic salon. The Brooklyn Institute of Arts and Sciences honored her with no fewer than five one-person exhibitions. In 1924 she presented solo shows at camera clubs in Detroit, Cleveland, Syracuse, and Baltimore. And the June 1925 issue of *Photo Era* featured a lead article she wrote, reviewing the Pittsburgh salon.

Lauffer associated with various photographic organizations. She was the secretary of the department of photography at the Brooklyn Institute of Arts and Sciences from 1919 to 1925, when she became vice-president. She also taught at the institute during most of the 1920s. Britain's Royal Photographic Society awarded her fellowship status (FRPS) in 1928. In the early 1930s, she was an executive committee member of the New York Miniature Camera Club, whose bulletin she also edited. In 1934 she was a charter member of the Photographic Society of America, an organization that also awarded her its fellowship (FPSA).

Lauffer made portraits and night pictures in New York City. Reproductions of her work appeared in four of the five annuals of the Pictorial Photographers of America, published during the 1920s. For the 1921 annual, she also wrote a statement about night photography that indicated she used an 8- by-10-inch camera and printed in gum-palladium. Her pictures also appeared during the 1930s in *Camera*, *Camera Craft*, and *Photo Era*.

In 1932 Lauffer won first prize in a contest sponsored by *American Cinematographer*, indicating competence at filmmaking. Her still-work was exhibited as late as 1939, when examples were included in a women's salon in Philadelphia. She died on Long Island in November 1970.

Lauffer, Sophie L. "Night Pictures in the Streets," *Pictorial Photography in America, 1921*, Pictorial Photographers of America, New York, p. 13.

———. "Why I Am a Pictorial Photographer," *Photo Era*, February 1930 (Vol. 64), pp. 63–64.

Wellington Lee
b. 1918

Lee was extremely active in camera-club circles for half a century, beginning around 1940. His creative work consisted primarily of figure studies, cityscapes, and high-contrast color images. After World War II he worked professionally in New York City.

Wellington Lee was born to U.S. citizens in Kwantung, China, on May 12, 1918. He moved to the United States in 1935 and settled in New York. A few years later, he made his first photographs, with a small camera in Central Park. In 1943 he graduated from what is now the New York School of Art and Design with a degree in photography. During World War II he was a military photographer, receiving a commendation for his work. Following the war, he worked for the Jons Fashion Studio in New York for a few years and in 1950 opened his own portrait studio. Situated in Chinatown, the Wellington Lee Studio operated for twenty-seven years, until the owner retired.

Lee's pictorial involvement began shortly before World War II and continued into the 1990s. During this period he was ranked in the top ten exhibitors of the world more than fifty times, showing a total of nearly 14,000 monochrome prints, color prints, color slides, and stereo slides. His one-person shows were seen at the Smithsonian Institution in 1955 and at hundreds of camera clubs from New York City to Asia. Beginning with an award at the 1939 New York World's Fair, he received more than a thousand trophies, plaques, medals, and other citations for his photographic work at international salons and contests. In 1948 he won *Popular Photography*'s first international competition, subsequently using the $5,000 grand prize to start his portrait business.

Lee involved himself deeply with numerous photographic organizations. He founded and served as president of both the China Photographic Society (New York), in 1948, and the Photographic Society of New York, in 1950. Beginning in 1952 he served for forty years as a member or chairman of various committees for the Photographic Society of America. This national organization and England's Royal Photographic Society both awarded him fellowship status in the mid-1950s. In addition, more than fifty clubs worldwide gave him honorary fellowships or honorary memberships. He judged many of the major salons in this country, including Pittsburgh, Newark, Baltimore, Rochester, Boston, Springfield, and New York.

Lee produced three large bodies of creative work. His cityscapes pictured buildings both existing and under construction in New York City. His high-contrast work, depicting a variety of subjects, usually took the form of "Addacolor" prints, a process he invented that turned black-and-white negatives into color images resembling woodcut prints with bas-relief effects. His figure studies—attractive female subjects surrounded by fantasy environments of painted backdrops, oversize props, and cut paper—were his most inventive pieces. These highly fabricated pictures incorporate strong design elements suggestive of Asian advertising and serve as entertaining period pieces of the 1950s and 1960s.

Lee remained photographically active far beyond the end of late pictorialism in the 1950s. In 1961 he created his own annual Wellington Lee Award to recognize clubs and organizations that promoted creative photography. Later in the decade, he self-published *Artistic Photography*, an intriguing and comprehensive monograph on his own work. And in 1989 he wrote a small handbook on photography in which he explained various techniques, including his own "Addacolor" process. He currently lives with his wife and other family members in Forest Hills, New York.

"Heritage: Wellington Lee, FPSA," *PSA Journal*, June 1980 (Vol. 46), pp. 42–47.

Lee, Wellington. *Artistic Photography*, Wellington Lee, New York, 1968.

————. *Photography*, Wellington Lee, New York, 1989.

Alexander Leventon
1895–1950

Leventon made and exhibited creative photographs from the mid-1920s to the mid-1940s. He was one of the few pictorialists to concentrate on portraits. He spent most of his adult life in Rochester, New York, where he was a noted musician in numerous orchestras.

Alexander Leventon was born on November 11, 1895, in Rostov-on-Don, Russia. He began studying violin at the age of seven and was performing four years later. After receiving a law degree from the University of Moscow, he went to Vienna in 1914 to continue his musical studies. At the outbreak of World War I he was jailed there as a civilian. Fours years later he escaped and returned to Rostov, where he taught music and joined the White Russian Army. In 1921 Leventon left Russia for Turkey and the next year emigrated to the United States. He initially lived with his aunt in New York City but in 1923 was hired by the Eastman Theater Orchestra in Rochester. For the next seventeen years, he was first violinist or concertmaster with a number of Rochester orchestras. He retired around 1940 but returned briefly to the Rochester Philharmonic in the late 1940s.

Leventon made snapshots as a child, but his serious interest in photography began in the mid-1920s, when his wife gave him a camera for Christmas. In 1928 the young professional musician opened a portrait studio with Byron Morgan in Rochester. The enterprise was short-lived, but he continued making pictorial portraits after it closed. His subjects included famous musicians who performed in Rochester, such as Leonard Bernstein and Sergei Rachmaninoff, and local business and social leaders, like George Eastman. Leventon was capable of rendering his sitters in poses that were confrontive and modernist as well as gentle and traditional. With his son, Boris, he used the latter approach, producing his most popular portrait. Titled *Russian Boy*, the picture was widely reproduced and exhibited; in 1931 it appeared as a photogravure in the portfolio *Pictures from the Tyng Collection*, issued by the Royal Photographic Society, of which he was a member.

Leventon participated in numerous pictorial activities, primarily during the 1930s. He joined the Pictorial Photographers of America and in 1934 was a charter member of the Photographic Society of America. In 1930 he summered in Europe, visiting such leading photographers as Léonard Misonne, Frantisek Drtikol, Hugo Erfurth, and J. Dudley Johnston. Upon returning to the States, he spoke to camera clubs about his odyssey and wrote articles about some of the photographers he had encountered.

Leventon's work was reproduced in photographic monthlies and exhibited in pictorial salons. *American Photography*, *Camera Craft*, and *Photo Era* regularly featured his accomplished portraits. From the mid-1920s to the mid-1930s, up to thirty-four of his prints per season were seen at such salons as Rochester (where he sometimes judged), Buffalo, and Pittsburgh.

On October 12, 1950, Leventon died in Rochester, after suffering a heart attack.

"Alexander Leventon Dies; Retired Concert Master," unidentified Rochester, New York, newspaper, October 13, 1950, n.p.

Blumann, Sigismund, "Alexander Leventon: Artist, Photographer and Musician," *Camera Craft*, October 1930 (Vol. 37), pp. 468–475.

Leventon, Alexander, "Why I Am a Pictorial Photographer," *Photo Era*, January 1930 (Vol. 64), pp. 3–4.

Thomas Limborg
1894–1992

Limborg made pictorial photographs, in both black and white and color, from the 1930s through the 1950s. Based in Minneapolis and St. Paul, he specialized in character studies, often posing himself for the pictures.

Thomas Limborg was born on May 27, 1894, in Oslo, Norway, and moved to the United States at age seventeen. After studying art here and abroad, he won awards for his drawings and paintings.

In the mid-1920s Limborg picked up photography as a hobby, eventually establishing a prosperous home-portraiture business in Minneapolis. He began sending his creative pictures to the Minneapolis photographic salon in 1934, but he did not take up serious international exhibiting until about 1947. His most prolific season was 1949–1950, when nearly fifty of his prints were accepted at twenty-two salons. Around this time, he also had one-person exhibitions in Minneapolis, Pittsburgh, Boston, and New Zealand.

Limborg was active in local and national photographic organizations. He joined camera clubs in the Twin Cities, where he judged prints and gave lectures and demonstrations, and in 1953 he served on the jury of the Minneapolis salon. In 1950 he received a trophy from the Photographic Society of America for outstanding color work. Four years later he spoke at the society's national convention and shortly thereafter received fellowship status (FPSA) in the organization.

Limborg primarily made figure studies of models transformed by makeup and homespun costumes. He even let his own hair and whiskers grow long so he could photograph himself as a sailor, hillbilly, and tattoo artist. Using paper negatives and William Mortensen's abrasion-tone process, which allowed extensive handwork on the image, Limborg produced highly crafted pictorial images. Reproductions of his work appeared in *Camera*, *Popular Photography*, and the *PSA Journal* in the late 1940s and early 1950s. His *Water Nymph* graced the cover of the 1950 publication *Pictorial Figure Photography*.

In 1959 Limborg moved from Minnesota to the Northwest, where he reportedly stopped making photographs. He supported himself by designing and painting billboards and died on April 30, 1992, in Seattle.

Wenzell, E. V., "Blue Ribbon Portfolios, No. 2: Thomas Limborg," *Camera*, November 1951 (Vol. 74), pp. 44–50.

William E. Macnaughtan
(dates unknown)

Macnaughtan made quiet landscapes from the first decade of the century to the mid-1920s. During much of this time, he taught photography in Brooklyn, where he resided.

William Elbert Macnaughtan was known exclusively for his pictorial landscape photographs. He loved nature and worked largely in rural New England, where he was drawn to the picturesque qualities of trees, rivers, and hillsides. He rendered these in classical pictorial compositions, often under twilight conditions. Using enlarged negatives from his 4-by-5-inch camera, he produced exquisite prints on hand-coated platinum paper. Fellow pictorialist Paul L. Anderson claimed that Macnaughtan was so particular that he produced fewer than thirty-five exhibition-quality prints in his entire lifetime.

Macnaughtan exhibited modestly for many years. His work was included in the First American Photographic Salon of 1904–1905, which traveled around the country, and in many subsequent salons in this series. Most consistent were his regular contributions to the annual exhibitions of the department of photography at the Brooklyn Institute of Arts and Sciences, primarily during the 1910s and 1920s. In 1924 he presented one-person exhibitions at both the Newark Camera Club and the Brooklyn Institute, perhaps his only solo shows.

The older traditional pictorialists most admired Macnaughtan's work. Clarence H. White, for instance, included his work in two early post-Secession exhibitions of pictorial photography in 1911 and 1912, held at the Newark Public Library and New York's Montross Galleries, respectively. And Paul L. Anderson, who championed him and collected his work, included pictures by Macnaughtan in two books he authored on pictorial photography.

Macnaughtan participated in the Pictorial Photographers of America, the country's leading organization of pictorialists. His pictures were reproduced in two of its annuals, and in 1921 he wrote a short article on manipulating negatives. In 1923 he contributed work to the group's first annual salon, seen at the Art Center in New York.

Macnaughtan was long associated with the Brooklyn Institute of Arts and Sciences. He exhibited regularly at the institute and served as president of the department of photography for more than ten years before stepping down in 1925. He continued teaching there, however, for at least another two years. It's not known if Macnaughtan made his living at this job or was otherwise employed full-time.

Evidence of Macnaughtan's photographic activities faded from the photographic press after 1930. His last known appearance was in 1940, when four of his early platinum photographs appeared in the fiftieth annual exhibition of the Brooklyn Institute.

Anderson, Paul L., "The Work of William E. Macnaughtan," *Photo Era*, March 1915 (Vol. 34), pp. 107–112.

Macnaughtan, William E., "How to 'Work Up' a Negative," *Pictorial Photography in America, 1921*, Pictorial Photographers of America, New York, 1921, p. 13.

Ira W. Martin
1886–1960

Martin was an important leader in the Pictorial Photographers of America from the 1920s through the 1940s. Despite this association, he produced photographs that were modernist as well as pictorial during his long career. He made his living as the photographer at the Frick Art Reference Library in New York.

Ira Wright Martin was born and spent his youth on a farm near Lennon, Michigan. At the age of fourteen, he began working during vacations in a camera store and making photographs. Later he went to work in the oil business in California, where he also studied art. During World War I he served as an aerial photographer in the U.S. Signal Corps; afterward he spent two years in advertising photography in New York. In 1923 he began as the photographer at the Frick Art Reference Library, a job he held until his death. Martin lived in New York until about 1933, when he moved his family north of the city to Rye.

Martin devoted much time to the Pictorial Photographers of America (PPA), this country's leading group of pictorialists during the 1920s. He initially studied photography with Clarence H. White, the figurehead of the PPA, and joined the group in 1921. In 1927, shortly after White's death, Martin became the PPA's president, a position he held for a full decade. In the early 1930s, he wrote articles for the PPA's publications, and in the late 1930s he gave monthly photographic demonstrations to the group. After serving as president, Martin ran the PPA's annual salons for a number of years and in 1946 was designated honorary salon director. When he died in 1960, he was still on the advisory board of the PPA, nearly forty years after joining the organization.

Martin was also active outside of the Pictorial Photographers of America. He taught a class titled "Advanced Pictorialism" at the Brooklyn Institute of Arts and Sciences from 1935 to 1937. In 1936 Edward Steichen invited him to serve on a panel of editors for *U.S. Camera Annual.* A few years later he presented a forty-year retrospective of his work at the Camera Club of New York. And he was a frequent salon judge throughout the Northeast.

Martin created two bodies of artistic photographs. Initially, during the early 1920s, he made quiet, soft pictures that confirmed his association with Clarence H. White. Among these is a group of platinum prints made in Charleston, South Carolina, where he focused on the effects of light and shade. By the late 1920s, he was making bolder photographs influenced by modernism and advertising, such as his *Design: Bee's Knees,* which appeared in *Pictorial Photography in America, 1926.* Beginning in 1937 he served on the jury for the modern section of the PPA's annual salons, the section into which his own photographs best fit. He is known to have spoken out in favor of purist photography and to have owned work by Edward Weston.

Martin died of heart failure in New York on November 12, 1960.

Martin, Ira W. "Why Should Style in Pictures Change," *Camera Craft,* October 1930 (Vol. 37), pp. 480–488.

"Obituaries: Ira W. Martin," *PSA Journal,* March 1961 (Vol. 27), p. 34.

"Progress Keynote of His Pictures: Martin Specializes in Prints of Country Life," *New York Sun,* March 22, 1941, n.p.

Taylor, Herbert G., ed. "Ira W. Martin," *My Best Photograph—And Why,* Dodge Publishing Co., New York, 1937, pp. 60–61.

Edward P. McMurtry
1883–1969

McMurtry was a leading California pictorialist during the 1930s. He favored coastal scenes, usually making small carbro prints. He was mechanically minded and an amateur inventor.

Edward Painter McMurtry was born on February 13, 1883, in Allegheny, Pennsylvania. He graduated from Harvard in 1909 and then worked for a short time in a Massachusetts textile mill. In about 1913 he moved for health reasons to California, where he spent the rest of his life. During World War I he volunteered for the American Field Service, maintaining and driving ambulances in France; during World War II he performed machine work for a defense contractor in San Francisco. Independently wealthy, he occupied himself with photography and mechanical inventions, securing several patents.

McMurtry's mechanical interests led him to photography. By the late 1920s, however, he was using the camera creatively. He began exhibiting in 1928, when Will Connell encouraged him to send work to the Los Angeles salon, which accepted all four of his submitted prints. He continued to exhibit for about a decade, with the 1932–1933 season being his most prolific: 279 prints in more than 45 international salons. His work was particularly successful in Europe; the back of one print listed nineteen exhibitions in the United Kingdom alone.

McMurtry's favorite subjects were seaports, harbors, boats, and other sites and subjects of the waterfront. He photographed on the West Coast, where he lived, and in Maine, where he summered. *On the Elbe,* his widely exhibited and reproduced signature piece, is an atmospheric image that contrasts a small tugboat in the foreground with larger vessels in the background in a tightly framed composition created from a larger negative. McMurtry printed this and most of his images in carbro, a process that rendered a standard bromide silver print more permanent by the use of carbon tissue.

McMurtry associated with other pictorialists and saw his work reproduced in the monthly magazines. In 1930 he wrote a short article about himself for *Photo Era,* and his pictures were subsequently seen in *American Photography, Camera,* and *Camera Craft.* He was a member of the Pictorial Photographers of America, as well as the Camera Pictorialists of Los Angeles, and was awarded a fellowship by the Royal Photographic Society (FRPS). In 1940 he spoke to the combined camera clubs of San Jose, and he reportedly continued to make pictures throughout the decade.

McMurtry moved to the Monterey Peninsula in 1945 after living for many years in Pasadena. He died on September 5, 1969 in Carmel, California.

McMurtry, Edward P. "Why I Am a Pictorial Photographer," *Photo Era,* October 1930 (Vol. 65), pp. 189–190.

William Mortensen
1897–1965

Mortensen was the most widely known American pictorialist during the 1930s and 1940s. This was a result of his flamboyant images, his prolific writing, and his influential teaching. He lived most of his creative life in Southern California, where he staged female nudes and other figures in uniquely provocative and/or historically based settings.

William Herbert Mortensen was born on January 27, 1897, in Park City, Utah. He grew up in Salt Lake City and studied at the Art Students League in New York from 1918 to 1920. After serving in the U.S. Army, he went to Greece and then returned to Salt Lake City to teach art at East Side High School, from which he had graduated. In 1921 he moved to Hollywood, where he initially designed sets and made masks for the Western Costume Company.

Mortensen received a Kodak camera when he was about ten years old and was photographing for money by the time he moved to California. In 1925 he opened a portrait studio on Hollywood Boulevard, and the next year Cecil B. DeMille hired him to make still pictures on the set of *The King of Kings*. Unlike other photographers, Mortensen used a miniature camera on the set—reportedly a first—and shot his pictures while the film was being made. The results were included in an elaborate, limited-edition, oversize book made up of original photographic prints.

In 1930 he left Hollywood for Laguna Beach, where he opened the William Mortensen School of Photography two years later. Over the next thirty years, the school preached good technique and manipulative processes to approximately three thousand students.

Mortensen enhanced the school's influence and supplemented his own income with his prolific writing on photography. In 1934 his first book, *Projection Control*, was published. In conjunction with George Dunham, he wrote eight more books within the next decade, delving into aesthetics as well as explaining technique. In *Monsters and Madonnas* (1936), his most important title, he pitted universal beauty against the mere mechanics of photography and also reproduced his most challenging images. In *The Command to Look: A Formula for Picture Success* (1937), he analyzed composition and challenged amateurs to use their eyes creatively. And in *The Model: A Book on the Problems of Posing* (1937), he dissected female anatomy in terms of artistic picture making.

Mortensen wrote hundreds of magazine articles as well. His primary forum was the San Francisco–based monthly *Camera Craft*, to which he began contributing lead articles in 1933. For a time, the magazine also printed articles by Ansel Adams promoting the straight aesthetic of photography; the result was a lively debate between the two authors. After the 1942 demise of *Camera Craft*, Mortensen continued to write regularly for *Popular Photography* and to reach an even wider audience; he instructed readers on costuming, composition, the paper negative, and numerous other topics still of interest to pictorialists. In 1950 he introduced a regular column in *American Photography*.

Mortensen's distinctive pictorial images were highly orchestrated and heavily manipulated, always melodramatic and sometimes shocking, intensely seen and beautifully rendered. He made character studies, where figures were given universal attributes; idealized nudes; and so-called grotesques, which pictured the darker side of humanity—a rarity for pictorialists. These pictures were seen on the international salon circuit from the mid-1920s through the 1930s. Mortensen also presented one-person exhibitions at the Camera Club of New York in 1927, the California Camera Club in 1928, 1929, and 1934, and the Smithsonian Institution in 1948. Beginning in the mid-1930s, he issued small, inexpensive portfolios of his work, usually made up of copy prints that don't compare to his exhibition prints.

Dissatisfied with the straight photographic image, Mortensen invariably hand-altered his pictures with texture screens, abrasion-tone techniques, and other means that made every image his own. In the mid-1930s he developed the Metalchrome process, which allowed him to turn monochrome images into color pictures. As a teacher, he shared most of these processes and techniques in his classes and writings.

In the early 1960s Mortensen returned to painting. He died of leukemia on August 12, 1965, in Laguna Beach. The Photographic Society of America, in Oklahoma City, owns the best group of his exhibition prints.

Irmas, Deborah. *The Photographic Magic of William Mortensen*, Los Angeles Center for Photographic Studies, 1979. (Contains bibliography.)

Mortensen, Myrdith. "The Mortensen Collection of the Photographic Society of America," *PSA Journal*, June 1971 (Vol. 37), pp. 21–36.

Mortensen, William. *Monsters and Madonnas*, Camera Craft Publishing Co., San Francisco, 1936.

Kentaro Nakamura
(dates unknown)

Nakamura was a Japanese-American pictorialist active in Los Angeles during the late 1920s and early 1930s. Few details of his life are known.

Kentaro Nakamura seems to have burst on the scene in 1927 with his remarkable photograph *Evening Wave*. This image, shot from an elevated position, shows a breaking wave that fills the frame diagonally from corner to corner. It incorporates visual elements common to traditional Japanese ukiyo-e woodblock prints: flattened space, lack of horizon, and strong pattern. *Evening Wave* was widely exhibited, published, and praised. It was reproduced in *Photograms of the Year, 1927*, the *American Annual of Photography, 1929*, and the 1929 issue of *Pictorial Photography in America*. The 1931 issue of *Modern Photography* used it to illustrate the Japanese photographers' "gift of decorative placing."

Nakamura was a member of the Japanese Camera Pictorialists of California; this Los Angeles-based group, founded in 1926, was the country's most important organization of creative Japanese photographers, most of whom didn't make a living in the field. The Japanese Camera Pictorialists didn't sponsor a major salon, but they did hold annual members' exhibitions until about 1940. They also associated with Edward Weston after he rejected pictorialism, exhibiting and purchasing his straight photographs.

Nakamura exhibited in international salons from the mid-1920s to about 1931. His work was accepted in Chicago, Pittsburgh, and at other venues. The 1928–1929 season was his most prolific, with twenty-seven prints in nearly a dozen salons. Around this time, the monthly magazines *Camera*, *Camera Craft*, and *Photo Era* included reproductions of his work.

Very few of Nakamura's original photographic prints remain; most of his work was undoubtedly lost during the internment of Japanese Americans during World War II.

Reed, Dennis. *Japanese Photography in America, 1920–1940*, Japanese American Cultural and Community Center, Los Angeles, 1985.

P. H. Oelman
1880–1957

Oelman created and exhibited pictorial photographs during the 1930s and 1940s. He resided in Cincinnati, where he taught and was active in camera clubs. He was widely known for his photographic nudes.

Paul H. Oelman was born on July 7, 1880, in Dayton, Ohio, where he grew up and eventually worked as a mechanic for the Wright Brothers. After learning how to fly from one of the Wrights' assistants, he moved to Denver, where he constructed and test-piloted planes. He returned to Ohio by the early 1930s and spent the rest of his life in Cincinnati.

Oelman probably first took photographs to make postcards of the Wrights' flights. He began exhibiting pictorial photographs in 1932, continuing to show in salons until about mid-century. The 1943–1944 exhibition season was his most prolific, with 118 prints accepted at more than 35 salons. In 1945 he presented an invitational one-person exhibition at the Smithsonian Institution.

Oelman shared his enthusiasm for pictorialism with others through his involvement in photographic organizations and his teaching. He was a lecturer for ten years, beginning in 1933, at the University of Cincinnati. He spoke frequently to camera clubs and in 1948 inaugurated a national lecture program for the Photographic Society of America; stopping in eight midwestern and West Coast cities, he logged six thousand miles in fourteen days. In later years, when he was unable to travel, his recorded talks were distributed to clubs throughout the country.

Oelman devotedly served the Photographic Society of America (PSA), which he joined in 1941. He held numerous positions in the organization, including executive vice-president and chairman of the honors committee. In 1948, when the PSA's national convention was held in Cincinnati, he headed the committee that organized it. At this time he also reviewed portfolios for PSA members, offering constructive advice to hundreds of aspiring pictorialists. The society honored him with both the Stuyvesant Peabody Award in 1949 and, later, its fellowship (FPSA).

Oelman photographed female nudes almost exclusively. Presented in high-key and against blank backgrounds, the images are escapist and stereotyped. He always worked in his unique downtown studio/residence, where the parents of his young models (and probably his wife) supervised the sessions. In addition to making exhibition-size prints of his nudes, he issued two portfolios of smaller prints, probably in the 1940s. His lectures usually concerned the nude figure, and his three articles on the subject appeared in the *PSA Journal* in March 1942 and December 1950 and in the *American Annual of Photography, 1947*.

Oelman's sight began to deteriorate in the late 1940s. As a consequence, he made fewer photographs, but he remained active in organizations such as the PSA and his hometown Queen City Pictorialists. He died on August 7, 1957, in Cincinnati.

"A Memorial Portfolio of Photographs of the Nude by P. H. Oelman," *PSA Journal*, April 1958 (Vol. 24), pp. 33–40.

"P. H. Oelman Passes Away," *PSA Journal*, September 1957 (Vol. 23), pp. 17–18.

Wright, Jack. "PSA Personalities: P. H. Oelman, APSA," *PSA Journal*, March 1944 (Vol. 10), pp. 164–165.

Fred P. Peel
c. 1884 – c. 1959

Peel simultaneously pursued professional and pictorial photography from the late 1920s to about mid-century. During most of this time he lived in Chester, Pennsylvania. He consistently used a ring light, which obliterated the shadows of his figure subjects.

Fred P. Peel graduated in engineering from the University of Michigan and subsequently served in both the U.S. Army and U.S. Navy. From 1909 to about 1925, he worked as a mechanical engineer and operator at a large cold-storage plant in Chester. He briefly returned to both engineering and the navy during World War II, apparently working in Detroit.

Peel acquired his first camera at the age of nine. Around 1925, when he was about forty, he left engineering to devote himself to photography. He opened a studio in his home and produced both portrait and commercial work. Within a few years his experiments led to the development of the ring light, a device that circled the camera's lens with lightbulbs. The resulting illumination largely eliminated shadows and made human flesh look marble-like. He called these pictures "shadowless" photographs and wrote a book on the subject in 1936.

Peel enjoyed sharing his knowledge of things photographic with others. He intentionally did not patent his ring light and kept others from making money off the idea. In the mid-1930s, in addition to his book, he wrote articles on shadowless lighting for *Camera Craft*. In the early 1940s, he offered a home instruction course based on ten booklets covering composition, portraiture, and various darkroom techniques. At about the same time, he wrote a related series of articles for *Camera* magazine.

Peel regularly showed work with both commercial and pictorial photographers. In the late 1930s his work-for-hire was seen in annual members' exhibitions of the Commercial Photographers Society of Philadelphia. His creative work graced the walls of many photographic salons, including Buffalo, Los Angeles, Pittsburgh, nearby Philadelphia, and several cities in Europe. In 1934 he contributed work to the First Salon of Pure Photography, held in San Francisco and made up of "straight" photographic art. His most prolific season was 1933–1934, when 227 of his photographs were accepted at more than 50 salons. According to Peel, his best-known salon print, *Lady in White*, was never turned down by a salon jury, and it was reproduced in photographic monthlies for more than twenty years, beginning shortly after he made it in 1930.

Peel was active in numerous photographic organizations. In 1927 he was president of the Photographic Society of Philadelphia, the country's oldest group of devoted amateurs. Five years later he headed the committee that organized the first Philadelphia salon, and he judged exhibitions throughout the Northeast. He was also a charter member of the Photographic Society of America, which later awarded him their fellowship status (FPSA). By 1936 he was also a fellow of the Royal Photographic Society (FRPS) in England.

By the late 1940s, Peel was living in Louisville, Kentucky, where he judged a salon as late as 1951. In March 1959 the *PSA Journal* reported that Peel had recently died of a heart attack, after suffering several years from Parkinson's disease.

"Fred Peel, Pictorialist and Professional Photographer," *Camera*, July 1931 (Vol. 43), pp. 18–24.

Peel, Fred P. *Shadowless Figure Portraiture*, Galleon Press, New York, 1936.

Wright, Jack. "PSA Personalities: Fred P. Peel, FPSA," *PSA Journal*, October 1945 (Vol. 11), pp. 357–358.

Joseph Petrocelli

? – 1928

Petrocelli was a successful pictorial photographer during the 1920s. He resided in Brooklyn, but made most of his pastoral images in Italy and North Africa. As a professional importer, he traveled extensively.

Joseph Petrocelli was born in a small town near Naples, Italy. He came to this country as a young man and first worked in international banking. Later he established Joseph Petrocelli and Company, importers of Italian goods.

Petrocelli became seriously interested in photography in about 1920. Throughout the next decade, his pictorial work was reproduced in *American Photography*, *Photo Era*, and *Camera*; the September 1927 issue of *Camera* featured a cover and twenty halftones by Petrocelli. His images were also seen in *Camera Pictures*, the publication of the Clarence H. White Alumni Association, and the annuals of the Pictorial Photographers of America.

Pastorale Arabe was his most popular picture; for three years after it was made, it was seen in more than fifty international salons and it won awards in New York, England, Austria, Spain, Hungary, and elsewhere. Probably made in North Africa, where he traveled in 1926, it typifies his work in both style and technique. Petrocelli photographed old-world subjects almost exclusively, composing them classically and tapping their accessible sentiment. He printed primarily in bromoil, a process that allowed manipulation of the image.

Petrocelli was particularly interested in such hand-wrought methods in photography. He was known as a master of the bromoil process, which he happily demonstrated to camera clubs. He also used a related process called resinopigmentipia (or resinotipia), which he learned from its developer in Italy and about which he wrote in the *American Annual of Photography, 1925*.

Petrocelli was closely associated during the 1920s with the department of photography of the Brooklyn Institute of Arts and Sciences, serving on its executive committee. He participated in many of the department's annual exhibitions and was memorialized in an exhibition of his work there in early 1929. He also joined the Camera Club of New York. One-person exhibitions of his work were seen in 1924 at New York's Art Center and at camera clubs in Chicago and New York.

Petrocelli died on December 30, 1928, in Lake Placid, Florida, where he was visiting for the holidays. He had recently retired and was headed for Morocco, probably on another photographic journey. Following his death, his widow, Mary O. Petrocelli, briefly exhibited under her own name pictorial work similar to her husband's. In 1933 she gave a large group of Petrocelli's prints to the Smithsonian Institution, where they were exhibited the same year. The Brooklyn Museum also has substantial holdings of his work.

Anghiltree, J. W. "Joseph Petrocelli—Pictorial Photographer" (obituary), *Photo Era*, February 1929 (Vol. 62), p. 110.

Catalogue of Pictorial Photographs Made by Joseph Petrocelli of Brooklyn, N.Y., 1921–1928, United States National Museum, Smithsonian Institution, Washington, D.C., 1933.

Petrocelli, Joseph. "The Resin Process or Resinotipia-Namias," *American Annual of Photography, 1925*, pp. 120–123.

Piper, Jean. "Petrocelli's Last One-Man Show," *Photo Era*, May 1929 (Vol. 62), p. 240.

Charles B. Phelps, Jr.

1891–1949

Phelps was active in pictorial circles from the mid-1930s through the 1940s. He served as a top officer of the Photographic Society of America for many years. Based in Detroit, he spent most of his professional life as an executive in the automobile industry.

Charles B. Phelps, Jr., was born on May 24, 1891, in Detroit. He graduated from Williams College and served in the U.S. Navy during World War I. By the 1920s he was working in the auto industry; he spent five years as secretary and director of Dodge in England and then returned to Detroit. After thirteen years in the industry, he was briefly involved in the securities business. He retired at an early age to pursue photography, a childhood hobby.

In 1935 Phelps joined the Detroit Camera Club and began sending his work to salons. His most prolific exhibition season came six years later, when 191 of his prints were accepted at more than 65 international salons. The Smithsonian Institution honored him with a one-person exhibition in 1945. His work appeared in numerous photographic monthlies, including *Camera*, *Camera Craft*, and the *PSA Journal*. Kodak also used it during the 1940s in an ad for photographic paper and the *Detroit Free Press* put one of his images on the first page of its Sunday photogravure picture section.

Phelps's *Curves and Angles* illustrates the influence of modernist subject matter on pictorialism. It captures an architectural detail from the 1933 Century of Progress exposition, held in Chicago. Except for the inclusion of some lettering and a diminutive human figure at the bottom of the image, the picture is abstract and disorienting. Phelps's main interest here, as reflected in his title, was visual design.

Phelps devoted himself to serving the Photographic Society of America (PSA), a national organization, and the camera clubs of his area. Over time, he served as president of the Detroit Camera Club, the Photographic Salon Society of Detroit, and the Scarab Photographic Society (Detroit). In 1938 he chaired the committee that organized the Detroit salon, in which he frequently exhibited. His service to the PSA was even more impressive. After joining in 1937, he became chairman of the honors committee and treasurer and in 1943 was made a fellow (FPSA). He was elected to two terms as president, holding office from 1945 to 1949, the year he died. During his tenure, the membership of the society doubled and numerous organizational improvements were made.

Phelps passed away in Grosse Pointe, Michigan, on January 19, 1949.

"Charles B. Phelps, Jr.," *Camera*, February 1944 (Vol. 66), pp. 22–25.

"In Memoriam: Charles B. Phelps, Jr., FPSA, 1891–1949," *PSA Journal*, February 1949 (Vol. 15), p. 99.

Edward Quigley
1898–1977

Quigley made modernist-inspired images that were seen in pictorial salons during the 1930s. He was active in photographic organizations in Philadelphia, where he lived. He was a professional photographer who made advertising and editorial pictures.

———————————————

Edward Quigley was born on January 3, 1898, in Philadelphia. He acquired his first camera at age twelve, and began working as a professional in 1918. After opening his own studio in 1930, he produced dramatic commercial work for such firms as Philadelphia's S.K.F. Industries, manufacturers of ball bearings for aircraft. His pictures were used for advertising, promotion, and editorial purposes, frequently being published in trade and popular magazines. In 1953 he made the last of his life's work of 13,000 negatives. During the 1960s, however, he continued to use this stock to generate an income by selling photographs to religious periodicals and greeting-card companies.

Quigley wrote about commercial concerns, primarily during the 1940s, for monthly magazines such as *Camera* and *Good Photography*. In 1943 he wrote a two-part article, "My Specialty Is Everything," in which he explained the economic necessity of being a multi-talented professional and illustrated his point with references to his own contributions to architectural, illustrative, and industrial photography. His last article, on photographic interiors, appeared in the February 1952 issue of *Camera*.

Quigley was also highly visible among pictorialists at this time. He joined the Photographic Society of Philadelphia in 1929 and began exhibiting in salons the next year. His work was seen in Chicago, London, Los Angeles, Philadelphia, Pittsburgh, Rochester, Toronto, and elsewhere; in the 1937–1938 season, eighteen salons accepted his photographs. In 1932 a one-person exhibition of his work was presented at the Philadelphia Art Alliance, where he later headed the committee that ran its photographic salon. In November 1934 thirty of his photographs made up the exhibition "Designs with Light"

at the Delphic Studios in New York. The amateur monthlies *American Photography*, *Camera Craft*, and *Popular Photography* frequently ran reproductions of his work during the 1930s and 1940s.

Quigley encouraged openness between the pictorialists and the modernists. In 1938 he organized one-person exhibitions of work by Edward Weston and Moholy-Nagy for the somewhat conservative Photographic Society of Philadelphia. His own most creative photographs were abstract light patterns, which were seen at both pictorial salons and such venues as the 1934 First Salon of Pure Photography, juried by Weston, Ansel Adams, and Willard Van Dyke. He made virtually all of his light abstractions in 1931, using a system, which he never fully explained, of refracted and interrupted light rays. Traditional pictorialists did not always accept such challenging work, but his important image *Crescendo* was featured in the first Philadelphia salon of 1932. In 1937 *Sam* was published, a book featuring Quigley's affectionate pictures of his cat.

In the early 1970s Quigley wrote to Ansel Adams, hoping to drum up interest in his work, and he sold a quantity of prints to collector Sam Wagstaff. He died in Haddonfield, New Jersey, on April 6, 1977.

———————————————

Friedman, Barry, and Robert A. Sobieszek. *Edward Quigley: American Modernist*, Houk Friedman, New York, 1991. (Contains bibliography.)

Quigley, Edward, and John Crawford. *Sam*, Stackpole Sons, New York, 1937.

Rabinovitch
1884–1964

Rabinovitch taught photography in his New York studio during the 1920s and 1930s. His nudes and other personal work found favor among pictorialists at this time.

———————————————

Ben Magid Rabinovitch was born on December 1, 1884. According to one of his students, he was short, had a deep, rich voice, and hailed from Odessa, Ukraine. He enrolled in New York's Columbia University to study experimental zoology under Dr. Thomas Hunt Morgan; although he didn't pursue a career in this field, he later used in his own school the research and teaching methods he learned from Morgan.

Rabinovitch, who became known professionally by his last name only, began to make photographs at about age twenty. He established a studio in New York and in 1920 expanded it into the Rabinovitch School and Workshop of Art Photography, which occupied various locations in Manhattan. Fifteen years after its founding, he stated that "the school is not an institution but a personal relationship between my pupils and myself." His few students paid high tuition and enjoyed the atmosphere of an artist's atelier. Among those who studied with him were Dmitri Kessel, Ben Schnall, and the Grand Duchess Marie.

Rabinovitch taught the importance of good technique in photography but emphasized artistic training for professionals. The school's catalogs and its newsletter, *The Photo Observer*, stressed the importance of both pictorial and graphic effects. In these self-promotional publications, Rabinovitch praised the accomplishments of former students and reprinted complimentary press reviews. The school also maintained a gallery, which showed both student work and photographs by established professionals such as Grancel Fitz, Paul Outerbridge, Jr., and Edward Steichen.

Rabinovitch's personal work included nudes, flower studies, and portraits. His somewhat academic *Nude Torso* of around 1929 was his most heralded piece. One person exhibitions of his work were seen at the Newark Camera Club in 1922 and, a few years later, at the Baltimore Camera Club. His pictures were also included, in relatively modest numbers, in international salons during the 1920s and 1930s. He was a member of the Pictorial Photographers of America, which included his work in its annuals of 1922 and 1929. Reproductions of his pictures were also seen around this time in the English annual *Photograms of the Year*.

Rabinovitch was a master printer and photographic technician. He issued many of his images in portfolios as photogravures, which he signed and designated "Ravgravures." In 1949 he presented an entire exhibition of fifty-four different prints of the same modernist image of a calla lily, printed in various processes and altered by darkroom techniques such as solarization.

Rabinovitch reportedly ordered that all his negatives be destroyed upon his death, which occurred in New York in April 1964.

———————————————

Photography: Pictorial and Graphic, Rabinovitch School and Workshop of Art Photography, New York, c. 1935.

Rabinovitch School and Workshop of Art Photography, Rabinovitch School and Workshop of Art Photography, New York, c. 1938.

Jane Reece
1868–1961

Reece was based in Dayton, Ohio, where she made both pictorial images and professional portraits from before 1910 to around 1940. Her sensitive, understated artistic work typified early pictorialism. Her professional portraits of many of Dayton's first families were equally successful.

Jane Reece was born in a log house near West Jefferson, Ohio, on June 19, 1868. Growing up in Zanesville, she showed interest in opera, piano, and painting and was encouraged by local artist Howard Chandler Christy. She first used a camera in 1903, when recuperating in North Carolina from a near-fatal case of spinal meningitis.

Reece worked as a professional portrait photographer for forty years, beginning in 1904, when she established the first of five studios she would have in Dayton. In 1907 she won a portrait award at the national convention of the Photographers' Association of America, and she subsequently became known for her portraits of prominent Daytonians. Around 1920 she developed a popular method of making silhouette portraits, which she revived in the late 1930s as "Camera Cameos." From 1924 on, she lived in, and worked out of, a renovated brick firehouse across the river from downtown Dayton.

Reece was also respected in pictorial circles during her years as a professional. Aware of the Photo-Secession movement, she went to New York in 1909 to study with Clarence H. White at Columbia University. Upon returning to Dayton, she made creative use of the Autochrome color process, as well as the subtle platinum print, then the standard paper preferred by pictorialists. In 1918 she was elected a fellow in the Pittsburgh Salon of Photographic Art. The next year she traveled to California, where she met then-pictorialist Edward Weston, whom she photographed and whose work she acquired.

Reece exhibited regularly during the 1910s through early 1930s, receiving awards from around the world. Her pictorial work was seen as early as 1911 in Hamburg, Germany, and in the 1929–1930 exhibition season more than ninety of her prints were accepted in twenty-two international salons. One-person exhibitions of her creative photographs were presented at the Cleveland Camera Club in 1927 and the Chicago Camera Club in 1934.

Although her home was in the Midwest, Reece was active in the New York-based Pictorial Photographers of America (PPA). She served as the Ohio representative for the organization from 1918 to 1920 and saw her work reproduced in four of the PPA's annuals, published in the 1920s. In 1930, to celebrate the opening of the Dayton Art Institute, she hung a PPA traveling exhibition in her studio and wrote her only known article for the June issue of the group's newsletter, *Light and Shade*.

Reece's work is closely associated with her city art museum, where she had numerous one-person exhibitions. She showed there first in 1921 and again in 1947. In 1952 she gave her life's photographic work to the institute and was honored with a retrospective of more than four hundred pieces. In 1963, shortly after her death, a memorial exhibition was presented, and another major retrospective is scheduled at the museum for 1997.

Reece gave up photographing in 1944 due to dimming eyesight and hearing loss. She died in Dayton on June 10, 1961, at age ninety-two.

Brannick, John A. "Jane Reece and Her Autochromes," *History of Photography*, January–March 1989 (Vol. 13), pp. 1–4.

Martin, Mabel Brown. "Jane Reece, of the Rembrandt Studio," *Photographic Journal of America*, January 1915 (Vol. 51), pp. 36–44.

Pinkney, Helen L. "Jane Reece Memorial Exhibition: The Wonderful World of Photography," *Dayton Art Institute Bulletin*, March–April 1963 (Vol. 21), entire issue.

Seaver, Esther I. *"The Camera, the Paper, and I": A Collection of Photographs by Jane Reece*, Dayton Art Institute, Dayton, Ohio, 1952.

O. C. Reiter
1861–1935

Reiter was active as a pictorialist from the turn of the century until shortly before his death. He was largely responsible for organizing and running the Pittsburgh salon for its first twelve years, and he judged many other pictorial exhibitions. His own pictures reflected old-world sensibilities.

Oscar C. Reiter was born in Pennsylvania on February 7, 1861, and spent most of his adult life in Pittsburgh. He bought his first camera in 1895 and began organizing pictorialists shortly thereafter. He served as a board member of the American Lantern Slide Interchange for fifteen years and in 1907 helped form a print-interchange system among major camera clubs in the Northeast. In 1903 he joined the Camera Club of Pittsburgh and the next year helped arrange a major Photo-Secession exhibition at the Carnegie Institute.

Reiter's most important organizational work was with the Photographic Section of the Academy of Science and Art of Pittsburgh, established in 1900. In 1914 he was a founder and the first president of the Photographic Section's Pittsburgh Salon of Photographic Art, which became this country's leading annual exhibition of pictorial photography. Reiter served as president of the salon for more than a decade, prompting fellow pictorialist William A. Alcock to claim that the names "Reiter" and "Pittsburgh salon" were synonymous. He frequently wrote brief, encouraging comments on the backs of prints rejected by the salon's jury.

Reiter both exhibited at and judged pictorial salons. His work appeared regularly from the mid-1910s until the early 1930s, when he stopped submitting to salons. At the time of his death, he and professional photographer Pirie MacDonald reportedly had judged more salons than any other Americans.

Reiter also associated himself with the Pictorial Photographers of America (PPA) and the Photographic Society of America, becoming a charter member of the latter. He was a regional vice-president for the PPA in the late 1920s, wrote an article for the April 1929 issue of its journal, *Light and Shade*, and saw his work reproduced in other PPA publications.

Reiter's work was traditional and sentimental, a reflection of his early initiation into pictorialism. He used soft-focus effects and painterly subject matter. His image *The Husbandman*, which pictures a farmer tilling the soil, was widely known among pictorialists in the 1920s; it appeared in numerous magazines, as well as in the annual *Pictorial Photography in America, 1920* and the book *Principles of Pictorial Photography* by John Wallace Gillies. Reiter also was one of seven photographers to provide statements on pictorialism for Gillies's book.

Reiter remained active in civic groups late in life. He became an avid bird-watcher and was president of Pittsburgh's chapter of the Audubon Society. He also served as treasurer for the Carnegie Institute. He died on August 18, 1935, at age seventy-four and was eulogized by Sigismund Blumann, Byron H. Chatto, and Max Thorek.

Alcock, William A. "Oscar C. Reiter," *Photo Art Monthly*, January 1936 (Vol. 4), pp. 29–30.

Blumann, Sigismund. "O. C. Reiter: Suggesting Pittsburgh," *Camera Craft*, April 1925 (Vol. 32), pp. 163–165.

Gillies, John Wallace. "O. C. Reiter, President of the Pittsburgh Salon," *American Photography*, August 1922 (Vol. 16), pp. 500–501.

Thorek, Max. "Oscar Reiter—An Appreciation," *PSA Journal*, September 1935 (Vol. 1), p. 7.

William Rittase
1887–1968

Rittase was a commercial photographer who worked in Philadelphia from the late 1920s into the 1960s. Pictorial salons included photographs he made on assignment up until about World War II. His major subjects included such machine age phenomena as locomotives and skyscrapers.

According to Social Security records, William Maurice Rittase was born in Baltimore on January 16, 1887. He studied both art and engineering and worked for a while as an engineer. In the late 1920s he turned his boyhood hobby of photography into a profession. By then a resident of Philadelphia, he listed himself as an "illustrative photographer" and made commercial, advertising, and industrial photographs, frequently traveling on assignment. He produced dramatic and forceful professional work for the American Railroad Association, *Fortune*, and numerous architectural magazines.

Pictorial photographers appreciated the work Rittase made for his commercial clients. From the mid-1920s to the late 1930s this work was accepted and highly praised at international salons in Pittsburgh, Los Angeles, and elsewhere. Reproductions of his photographs appeared in annuals of the Pictorial Photographers of America and in both issues of the *Pictorialist*, issued by the Camera Pictorialists of Los Angeles in 1931 and 1932. In 1938 he presented a one-person exhibition at the Smithsonian Institution.

His interest in salons extended to judging and reviewing them. He served on the jury for the 1931 Rochester salon and did the same as late as 1954 for the Baltimore salon. Both his articles on salon exhibiting and his pictures appeared in *Camera Craft* and the *PSA Journal*.

Rittase enjoyed sharing his photographic knowledge with creative photographers. In 1926 he demonstrated the carbro process to the Photographic Society of Philadelphia, of which he was a member. He also joined the Pictorial Photographers of America, to whom he spoke and showed his portfolio several times. And he lectured at the Brooklyn Institute of Arts and Sciences, the Photographic Guild of Philadelphia, and the Glenwood Camera Club (Philadelphia). In addition, he taught photography at Temple University in Philadelphia, beginning in 1934.

Throughout his involvement with pictorial photography, Rittase remained connected with his professional colleagues. In 1941 he spoke to the national convention of the Professional Photographers of America on industrial photography. According to his old friend Richard Roane Frame, he was still working in 1963, the year the two began sharing a studio. Rittase died on October 28, 1968.

Carey, Marty. *William Rittase* (Catalogue 5), Howard Greenberg/Photofind Gallery, New York, 1986.

Frame, Richard Roane. "The Rittase Touch," *Professional Photographer*, March 1970 (Vol. 97), pp. 52–55, 132–133.

Rittase, William. "Why I Am a Pictorial Photographer," *Photo Era*, December 1930 (Vol. 65), pp. 301–302.

D. J. Ruzicka
1870–1960

Ruzicka practiced and preached pictorial photography for four decades, from the mid-1910s past mid-century. He photographed primarily the architecture of New York, where he resided most of his life, as well as scenes in his native Czechoslovakia. He practiced medicine and was known among pictorialists as Dr. D. J. Ruzicka.

Drahomir Joseph Ruzicka was born on February 8, 1870, in Trhová Kamenice, Bohemia. At age six, he moved with his family to a farm near Wahoo, Nebraska. In 1884 the young Ruzicka went to New York to finish high school and subsequently to Vienna for college. He graduated from New York University with a medical degree in 1891. A few years later, he set up a private practice in obstetrics and pediatrics on Manhattan's Upper East Side and became one of the earliest doctors to use X rays. In 1921, when he was in his early fifties, he retired from medicine.

Ruzicka 's knowledge of X rays fostered an interest in photography, and he purchased his first camera in 1904. At first he was unhappy with his amateur results, but in 1909 he became aware of the creative possibilities of the medium. Within a few years his pictorial images were appearing in magazines such as *Photo Era*, for which he also wrote an early article on photographing in the city. During the 1910s Ruzicka made largely sentimental, softly focused images in the parks of New York. He printed on platinum paper, producing images that were subtly toned and full of traditional pictorial beauty.

Ruzicka is best known for his images of Pennsylvania Station, which he began photographing around 1915. Always set in the station's cavernous interior, the pictures are flooded with light and largely inhabited by determined New York businessmen. At this time, he began making straight prints, more sharply focused and with greater tonal contrast. Influenced by modernist attitudes and subject matter, he also photographed on Wall Street, Fifth Avenue, and 42nd Street, exploring what he called the "canyons" of New York.

Ruzicka's straight pictorialism helped nurture the entire movement of mod ern photography in his native Czechoslovakia. In 1921 he returned for an extended stay to Prague, where he showed his work to local camera clubs and spoke about the aesthetics of photography. Czech photographers were still basing much of their imagery and technique on paintings and other established arts, but Ruzicka's example showed the path of modernism to such individuals as Josef Sudek and Jaromír Funke, who went on to make major contributions to avant-garde photography in their country.

Ruzicka committed himself to assisting photographers in this country as well. In 1916 he helped found the Pictorial Photographers of America (PPA). He served on the PPA's first executive committee, spoke at many meetings, judged some of its salons, and was designated honorary president in 1940. He was also active in the New York Camera Club, where he presented one-person exhibitions of his work as late as 1952.

Ruzicka's photographs were exhibited at numerous other venues and even were acquired by museums during his lifetime. His work was prominent in salons up until about 1940, with the 1935–1936 season being his most prolific—more than a hundred prints shown in thirty-three salons. Invitational one-person exhibitions of his work were seen at the Smithsonian Institution in 1930 and at the Brooklyn Museum in 1947; both museums also solicited gifts of his photographs for their permanent collections.

Numerous organizations honored the elderly Ruzicka. England's Royal Photographic Society presented him with an honorary fellowship (Hon. FRPS) in 1949. A year later the Photographic Society of America bestowed upon him a similar honor. And the year before his death, a small monograph on his photographs was published in Prague. He died in Jackson Heights, New York, on September 30, 1960.

Jeniček, Jiři. *D. J. Růžička*, Státni Nakladatelství Krásné Literatury, Hukdy a Uměni, Prague, 1959.

Peterson, Christian A., and Daniela Mrázková. *The Modern Pictorialism of D. J. Růžička*, Minneapolis Institute of Arts and Galerie Hlavního Města Prahy, Prague, 1990. (Contains bibliography.)

Thomas O. Sheckell
1883–1943

Sheckell photographed from the 1910s until his death. He specialized in pictorial images of trees and published a book on the subject. He lived in the New York City area, working much of the time in finance.

According to the *American Art Annual, 1930*, Thomas O. Sheckell was born in Tekamah, Nebraska, in 1883. He graduated from the University of Indiana and then practiced law in Salt Lake City. He later moved to New York and, in 1928, to East Orange, New Jersey. While living in the Northeast, he was an executive at the New York Credit Men's Association.

Sheckell was making accomplished pictorial photographs by 1919, when his work was included in salons in Montreal and Pittsburgh. He continued to submit to international salons for the rest of his life, with the 1941–1942 season being his most prolific—113 prints accepted at more than 40 sites. One-person exhibitions of his work were presented in 1922 at the California Camera Club and in 1929 at the Newark Camera Club.

Sheckell was particularly active in the Pictorial Photographers of America (PPA). He was a council member in 1920 and shortly thereafter saw his pictures reproduced in two of the group's annuals. During the 1930s he regularly spoke at PPA meetings and served as president of the organization for two terms, in 1937 and 1938.

Sheckell assisted other groups, as both a teacher and a mentor. From 1936 to 1938, he was president of the Orange Camera Club. At about this time, he also led a photographic tour of Europe and taught classes at the Ridgewood Camera Club, the Metropolitan Camera Club Council, and the Brooklyn Institute of Arts and Sciences. He was appointed dean of faculty at the New York Institute of Photography in 1940. In addition, he wrote articles on portraiture for *Camera* (February 1941) and on the manipulative process mediabrome for *Camera Craft* (January 1942).

Sheckell favored tree subjects for his pictorial photographs. These images were frequently reproduced, especially in the monthly *American Photography*. In 1933 the American Forestry Association awarded him first prize for an image it considered the year's most beautiful tree photograph. He often pictured trees in silhouette against a brooding sky or prominently placed in the foreground against a tapestry of nature. In 1936 his book, *Trees: A Pictorial Volume for Lovers of Nature*, was published and favorably reviewed by the *New York Times* and numerous photographic magazines. His only other publishing venture was editing the *1941 Universal Photo Almanac*.

Sheckell died of a heart attack in his East Orange studio on March 2, 1943.

Sheckell, Thomas O. *Trees: A Pictorial Volume for Lovers of Nature*, Frederick A. Stokes, New York, 1936.

"Thomas O. Sheckell, Landscape Artist, 58" (obituary), *New York Times*, March 4, 1943, p. 20.

William Gordon Shields
1883–1947

Shields made and exhibited pictorial photographs during the 1910s and 1920s. He lived in New York, where he was involved with the Pictorial Photographers of America. He spent his entire career in the steel industry.

William Gordon Shields was born in Hamilton, Ontario, on February 4, 1883. He moved to New York early in the twentieth century and began working for the American Smelting and Refining Company, where he eventually rose to the position of assistant secretary. In 1915 John Wallace Gillies wrote a brief profile on Shields for *American Photography*, characterizing him as quiet and deliberate.

Shields began photographing casually probably before he left Canada. After arriving in New York around 1910, he bought a Smith soft-focus lens, and his interest became more serious. He was exhibiting by 1914, and for at least the next decade his work was seen in salons in London, Buffalo, Pittsburgh, and San Francisco. Camera clubs in Toronto and Montreal awarded him medals during this time. In 1922 the Brooklyn Institute of Arts and Sciences presented a one-person exhibition of his work.

Shields was active in the Pictorial Photographers of America (PPA). He acquainted himself with Clarence H. White but apparently didn't study formally with him. Shields's work was included in numerous exhibitions organized by the PPA. In 1919 his pictures were part of a seven-person show at the White School. The next year his work was included in a PPA-organized exhibition that traveled to Copenhagen. And in 1923 he was listed in the catalog for the PPA's first salon, held at the Art Center in New York. Shields was on the executive committee of the organization in 1920. In addition, the PPA's annuals, *Pictorial Photography in America*, reproduced his work three times. In 1921 he wrote a brief statement for the annual about using the bathroom as a darkroom.

Shields photographed numerous subjects—the architecture of Manhattan (such as St. Patrick's Cathedral), boating and harbor scenes, and rural landscapes—and printed in various media. He is known to have made prints in platinum, gum-bichromate, kallitype, bromoil, and bromide, sometimes printing the same image by more than one process. In 1925 he wrote an article on making small-sized gum prints.

Shields was still working and living with his wife on Staten Island when he died on March 13, 1947.

Bell, Michael. *Pictorial Incidents: The Photography of William Gordon Shields*, Agnes Etherington Art Centre, Queen's University, Kingston, Ontario, 1989.

Gillies, John Wallace. "Amateurs I Have Known: William Gordon Shields," *American Photography*, August 1915 (Vol. 9), pp. 482–484.

Shields, William Gordon. "Miniature Prints by the Gum-Bichromate Process," *American Annual of Photography, 1925*, pp. 178–186.

Harry K. Shigeta
1887–1963

Shigeta made inventive pictorialist prints from the 1920s through the 1940s in Chicago. He was active in both local and national amateur organizations, freely sharing his expertise and enthusiasm. He was also an accomplished professional photographer, working in portraiture, advertising, and illustration.

———————————

Harry K. Shigeta was born in Japan on July 5, 1887, and came alone to this country when he was sixteen years old. He lived first in Seattle, where he attended art classes and bought his first camera.

Shigeta's professional career began when he landed a job in a portrait studio in St. Paul, Minnesota. Here he learned the technique of portraiture and studied painting on the side. In 1911 he moved to Los Angeles, where he became an expert retoucher. He opened a portrait studio in 1918 and shortly thereafter served as staff photographer for a Hollywood motion-picture magazine. By 1924 he had relocated to Chicago to work as a retoucher at Moffett's, a large portrait studio, but he soon became a full-fledged photographer and took over the company's neglected commercial department. Influenced by the avant-garde work of Moholy-Nagy, Shigeta began making dynamic, combination-printed commercial work. In 1930 he and George Wright opened the Shigeta-Wright Studio, which specialized in experimental photographic illustration. He continued to work professionally for about thirty years and was honored with the master of photography degree from the Photographers' Association of America in 1949. That same year a Chicago church commissioned him to make a 16-mm color film of its production of the Passion Play.

Shigeta was a pictorial leader in Chicago and beyond during the time he worked there as a professional. He was a long-term member of the Fort Dearborn Camera Club, where he conducted monthly print criticisms during the 1930s. He gave demonstrations and talks to other local camera clubs, and his prints appeared regularly in the Chicago photographic salons. He exhibited at international salons throughout the 1930s and 1940s and presented one-person exhibitions at the Camera Club of New York in 1935 and the Smithsonian Institution in 1951. In the late 1940s, he wrote a regular column for the *PSA Journal* and in 1949 was awarded an honorary fellowship by the Photographic Society of America (Hon. FPSA).

Shigeta frequently embraced the nude as a subject in his pictorial images. He photographed unclothed figures on sand dunes and in the studio, sometimes making modernist-inspired images. Some of these pictures may have begun as illustrative assignments, given their dramatic lighting, stylization, and professional finish. His piece *Curves: A Photographer's Nightmare*, for instance, appeared both at a Chicago salon as Shigeta's own and in a 1937 magazine as the product of the Shigeta-Wright firm. Such an example illustrates how the boundaries between pictorialism and commercialism blurred after World War I.

Shigeta retired to California in about 1960. Three years later, on April 21, he died of a heart attack in Los Angeles.

———————————

Arnold, Rus. "This Is Shigeta," *Popular Photography*, May 1947 (Vol. 20), pp. 60–74, 86, 90, 92, 94, 96.

"Obituaries: Harry K. Shigeta," *PSA Journal*, June 1963 (Vol. 29), p. 45.

Shigeta, Harry K. "Still Life Photography," *The Complete Photographer*, Vol. 9, Issue 51 (1943), pp. 3322–3326.

Wright, Jack. "PSA Personalities— Harry Shigeta, FPSA," *PSA Journal*, October 1947 (Vol. 13), p. 626.

Clara E. Sipprell
1885–1975

Sipprell made pictorialist prints from the 1910s into the 1930s. She earned her living producing softly focused portraits in New York and New England. Her pictorial subjects included landscapes and still-lifes.

———————————

Clara Estelle Sipprell was born on October 31, 1885, in Tillsonburg, Ontario, the youngest of six children. She grew up fatherless and moved with her mother in the 1890s to Buffalo, New York, to join some of her siblings.

Sipprell learned photography from her brother Frank, in whose portrait studio she worked for a decade, beginning in 1905. In 1915, at the age of thirty, she moved to New York City, where she took an apartment on Morningside Drive with a friend and established her own portrait business. Among her early sitters were faculty members of Columbia University's Teachers College and the Ethical Culture School, as well as Russian expatriots like Ilya Tolstoy. In the 1920s her interpretive portraits appeared in *Vanity Fair* and other periodicals. Sipprell supported herself by making portraits; to supplement her income, she also accepted commissions, such as a 1929 excursion along the Canadian Pacific Railway. In 1938 she traveled to Sweden, where she photographed the country's leading personalities, including its royalty. Her professional career spanned seventy years, virtually until her death at age ninety.

Sipprell began making creative, personal photographs shortly after taking up the medium. She first exhibited in the 1910 annual exhibition of the Buffalo Camera Club, though she was not a member, and three years later won more prizes than any other participant. By 1915 she was presenting one-person exhibitions of her work at the Newark Museum and at Teachers College. About this time, she studied with Clarence H. White, and her pictures were included in White School alumni exhibitions. She joined the Pictorial Photographers of America, whose annuals reproduced her images three times in the 1920s. Her work was accepted at international salons in San Francisco, Toronto, Pittsburgh, Buffalo, New York, and elsewhere until the mid-1930s. After this time and into the 1960s, she had solo shows at libraries, shops, art galleries, and other venues.

Sipprell restricted her pictorial subjects to portraits, landscapes, and still-lifes. She was a traditional pictorialist, interested in simple beauty and soft-focus effects. She preferred platinum paper as long as it was available and later made her silver prints as subtle as possible, sometimes using tissue stock.

Sipprell cultivated foreign friends and enjoyed traveling. In 1924 she first ventured to Europe, visiting Italy, France, and Yugoslavia. A few years later, she returned to Yugoslavia, where she made many successful pictorial images, guided by her married roommates Irina Khrabroff and Feodor Cekich, a native of the country. Later in the decade, she worked in Canada. Then in 1931 she and Khrabroff drove across the United States—quite an adventure for unaccompanied women of the time—to Mexico, where she made romantic pictures of the country.

Sipprell moved to Manchester, Vermont, in the late 1930s. Forty years later, she received the Vermont Governor's Award for Excellence in the Arts. She died in April 1975.

———————————

McCabe, Mary Kennedy. *Clara Sipprell: Pictorial Photographer*, Amon Carter Museum, Fort Worth, Texas, 1990. (Contains bibliography.)

Sipprell, Clara. *Moment of Light*, John Day Co., New York, 1966.

Karl F. Struss

1886–1981

Struss was one of the few Photo-Secessionists to continue making pictorial photographs after World War I. His work from the 1910s focused on the distinctive light and new structures of Manhattan, while his later images featured the personalities of Hollywood and the landscape of California. He worked as a cameraman for films and television for half a century, from about 1920 through the sixties.

Karl Fischer Struss was born on November 30, 1886, in New York and made his first photographs at about age ten. He took extension classes at Teachers College of Columbia University under Clarence H. White and in 1910, twelve of his prints were included in the International Exhibition of Pictorial Photography, held at Buffalo's Albright Art Gallery. Though this exhibition signaled the effective end of Stieglitz's Photo-Secession, Struss "joined" the group two years later and saw eight of his images appear as photogravures in the April 1912 issue of *Camera Work*.

Struss soon became closely associated with Clarence H. White and Edward R. Dickson and supported their efforts to continue the tradition of pictorial photography. In 1913 he contributed an article on multiple-gum printing to Dickson's short-lived but noteworthy periodical, *Platinum Print*. The next year he was listed as an "associate" of the magazine, and a few of his photographs were subsequently reproduced on its cover and in its pages. In 1912, the year he completed his classes with White, he himself taught a summer class on photography at Teachers College. Four years later he joined White and a handful of others to found the Pictorial Photographers of America.

During this time Struss made his living as a professional photographer. In 1914 he took over White's former studio, where he made portrait, advertising, and commercial photographs for three years. After years of manufacturing it privately, he offered his Struss Pictorial Lens for sale at this point. During his military service, from 1917 to 1919, Struss experimented with infrared photography.

After World War I Struss headed directly to Hollywood, determined to get into the motion-picture industry. He was initially hired by Cecil B. DeMille to make still shots and three months later was working behind a film camera on the set. His long career as a cinematographer began when he signed a two-year contract with DeMille. In 1924–1925 he was one of the cameramen for *Ben-Hur*, and a few years later he and Charles Rosher shared the first-ever Academy Award for cinematography—for their camera work on *Sunrise*, directed by F. W. Murnau. Struss subsequently filmed more than a hundred pictures for United Artists, Paramount, and other studios. His credits include *The Great Dictator* and *Dr. Jekyll and Mr. Hyde*; among the stars he shot were Charlie Chaplin, Bing Crosby, Mary Pickford, and Mae West.

Struss resumed salon exhibiting in 1921, associating with the second generation of pictorialists of California. He joined the Camera Pictorialists of Los Angeles and presented a one-person exhibition of his work at San Francisco's California Camera Club in 1929. His pictures also were seen at salons in Buffalo, London, New York, Oakland, San Antonio, San Diego, Seattle, Tokyo, and his own Los Angeles, where he sometimes served on the jury. In 1926 and 1929 reproductions of his pictures graced the pages of *Pictorial Photography in America*, the annual of the Pictorial Photographers of America.

During the 1950s and 1960s, Struss did cinematography for television programs and commercials. At the same time he made color slides which he submitted to exhibitions. In 1970 he retired.

Struss died on December 15, 1981, in Los Angeles. A few years later, the Amon Carter Museum in Fort Worth, Texas, acquired the majority of his prints, negatives, and other archival material.

Harvith, Susan and John. *Karl Struss: Man with a Camera*, Cranbrook Academy of Art Museum, Bloomfield Hills, Michigan, 1976. (Contains bibliography.)

McCandless, Barbara, Bonnie Yochelson, and Richard Koszarski. *New York to Hollywood: The Photography of Karl Struss*, Amon Carter Museum, Fort Worth, Texas, and University of New Mexico Press, Albuquerque, 1995.

Max Thorek

1880–1960

Thorek was a leading American pictorialist during the 1930s and 1940s. He exhibited, wrote, and lectured extensively and excelled at making figure studies with the paper negative process. Professionally, he was a world-renowned surgeon who practiced in Chicago.

Max Thorek was born in a Hungarian village on March 10, 1880. He attended school in Budapest and then emigrated with his parents to the United States at about age twenty. In 1904 he obtained U.S. citizenship, as well as his medical degree from Rush Medical College of the University of Chicago. As a general practitioner, he opened an office in the Chicago slum where he and his parents had originally lived. Four years later, he co-founded the American Hospital (now the Thorek Hospital and Medical Center), pledging to serve patients according to their need, not their ability to pay. Over time he wrote more than three hundred articles and five books, significantly expanding knowledge in the field of surgery. For his various achievements, he was made an officer of the French Foreign Legion and was awarded the Distinguished Citizen's Medal of the Veterans of Foreign Wars.

In about 1925 Thorek somehow found the time to begin making pictorial photographs. He considered the photographic salon the high court of pictorialism and soon was exhibiting extensively. For the seasons of 1937–1938 and 1938–1939, the *American Annual of Photography* listed him as the world's most prolific salon exhibitor. By mid-century—near the end of his career—he had exhibited nearly 4,000 prints in 1,087 salons.

Thorek was indefatigable, involving himself deeply with numerous photographic organizations. In 1930 he was elected president of Chicago's Fort Dearborn Camera Club, a position he held for three consecutive terms. Four years later he was instrumental in founding the Photographic Society of America (PSA), the country's only national organization of amateurs, and served as its first president. Early in his career, he was awarded fellowship status in England's Royal Photographic Society (FRPS). In 1930 he helped promote the important Chicago International Photographic Salon by sponsoring gold, silver, and bronze medals.

Thorek was an acknowledged master of the paper negative process, the most widely used manipulative technique between the world wars. He considered the camera-generated negative mere raw material in the making of creative photographs, and he freely used pencil, crayons, and even stove polish to hand-alter his imagery. Rarely venturing outdoors with his camera, he preferred working in the studio, where he could direct his models and fabricate his scenes. In this setting, he photographed primarily figure studies and portraits, both generic and specific. He made flamboyant use of the female form in creating tableaux and allegories, often with such spare titles as *Despair*.

Thorek enjoyed collecting, and he acquired large holdings of both autographs and photographs. While his autograph collection included such notables as Louis Jacques Mandé Daguerre, the French inventor of photography, his print collection focused on the work of living photographers. Among the pictorialists whose work he acquired were Anne W. Brigman, Louis Fleckenstein, and Alexander Leventon. In addition, he owned at least four photographs by the Belgian modernist Pierre Dubreuil and five prints by the Chicago illustrative photographer Harry K. Shigeta. In 1935 Thorek presented this collection of about 150 pictures to what is now the Museum of Science and Industry. Five years later the Brooklyn Museum acquired his own creative photographs for its permanent collection.

Pictorialists around the country felt Thorek's influence. He lectured, demonstrated, and critiqued at camera clubs and judged international photographic salons. In addition, he wrote articles for the photographic press covering such topics as the nude, salons, and the paper negative, and he explored all these subjects in depth in his two books, *Creative Camera Art* (1937) and *Camera Art as a Means of Self-Expression* (1947), a rehash of the first title. The first chapter of *Creative Camera Art* clarified his crusading attitude about photography as an art form. In the same book, he ranted against purist photography and modernist art, despite the fact that the volume's cover design clearly reflected machine age thinking. Ironically, in his 1943 autobiography, *A Surgeon's World*, Thorek alluded only briefly to his photographic exploits.

Thorek died of a heart attack on January 25, 1960, in Chicago.

Peterson, Christian A. *The Creative Camera Art of Max Thorek*, Thorek Memorial Foundation, Chicago, 1984. (Contains bibliography.)

Thorek, Max. *Creative Camera Art*, Fomo Publishing Co., Canton, Ohio, 1937.

Doris Ulmann
1882–1934

Ulmann photographed from the 1910s until her death. Independently wealthy, she joined the Pictorial Photographers of America and concentrated on portrait work. Her images of both well-known Americans and rural southern blacks were published in numerous books during her lifetime.

Doris Ulmann was born into an affluent New York City family on May 29, 1882. She studied teacher training with photographer Lewis W. Hine at the Ethical Culture School from 1900 to 1903 and subsequently took classes in psychology and law at Columbia University. In about 1915 she married Dr. Charles H. Jaeger, whose name she used until their divorce ten years later.

Around 1910 Ulmann began studying photography with Clarence H. White, the guiding light of pictorialism at the time. She apparently took classes with him both at Columbia's Teachers College and at the White School of Photography. When the White School moved to a new location in 1920, a one-person exhibition of her work inaugurated its gallery. By this time, she was a member of the Pictorial Photographers of America, which included reproductions of her work in four of its five annuals during the 1920s. In 1929 she provided a cover image for the group's bulletin, *Light and Shade*. Three years later, the PPA sponsored a traveling show of work by Imogen Cunningham, Laura Gilpin, and Ulmann.

Ulmann devoted herself to professional photography in 1918. She began making softly focused portraits in her living room of famous individuals in literature and the arts. Within the next decade, three deluxe, gravure-printed books of her portraits appeared: *Twenty-four Portraits of the Faculty of Physicians and Surgeons of Columbia University* (1919), *A Book of Portraits of the Medical Faculty of the Johns Hopkins University* (1922), and *A Portrait Gallery of American Editors* (1925).

In about 1925, after divorcing her husband, Ulmann began to photograph rural folk along the East Coast. Initially, she worked in New England, concentrating on the Amish, Mennonite, and Shaker communities. After 1927 she traveled with folklorist John Jacobs Niles to remote areas of the Appalachian Mountains, producing her best-known work there over the next several years. She also made portraits of the black residents of a South Carolina plantation; these were used to illustrate Julia Peterkin's book *Roll, Jordan, Roll* (1933).

Ulmann died at her New York City home on August 28, 1934. The University of Oregon, Eugene, owns a large collection of her negatives.

The Appalachian Photographs of Doris Ulmann, Jargon Society, Penland, North Carolina, 1971.

The Darkness and the Light: Photographs by Doris Ulmann, Aperture, Millerton, New York, 1974.

Featherstone, David. *Doris Ulmann: American Portraits*, University of New Mexico Press, Albuquerque, 1985.

Shigemi Uyeda
1902–1980

Uyeda was a Japanese pictorialist active during the 1920s in the Los Angeles area.

Shigemi Uyeda was born in Hiroshima, Japan, on January 1, 1902. He came to the United States at age eighteen and spent most of his life farming in Lancaster, California. Uyeda didn't join the Japanese Camera Pictorialists of California, but he did associate with his fellow Japanese pictorialists. In the mid-1920s, he visited his native land, photographing along the way.

Reflections on the Oil Ditch was Uyeda's most successful print. Made near Los Angeles in around 1925, it is a decorative pattern of receding circles, with little tonal contrast. Like most Japanese-American pictorial images, it features a simple composition and strong design. *Oil Ditch* was printed from part of a larger, sharply focused negative. In 1927, when a print of it was included in the prestigious Pittsburgh Salon of Photographic Art, a reviewer in *Photo Era* heralded it for its pleasing arrangement and its unusual subject matter. Reproductions of this image were also seen in the *American Annual of Photography* and in annuals in England, Germany, and Russia. Years later it was still considered striking enough for avant-garde teacher and photographer Moholy-Nagy to include it in his 1938 book, *The New Vision*.

During World War II Uyeda and his family were held at the Poston Relocation Center. He died on his birthday in 1980 in Westminster, California.

Reed, Dennis. *Japanese Photography in America, 1920–1940*, Japanese American Cultural and Community Center, Los Angeles, 1985.

Margaret Watkins
1884–1969

Watkins associated closely with Clarence H. White and the Pictorial Photographers of America in the 1910s and 1920s. She made advertising photographs for a living and contributed modernist images to pictorial salons.

Meta Gladys Watkins was born on November 8, 1884, in Hamilton, Ontario, to parents who had recently arrived from Scotland. Known as Margaret, she began photographing around the turn of the century and later opened a professional studio in New York's Greenwich Village. During the 1920s she made photographs for Macy's department store and the J. Walter Thompson advertising agency.

Watkins made herself visible among the devotees of Clarence H. White, the leading Photo-Secessionist who continued to promote pictorial photography after the group disbanded. She studied with White in 1914 and a few years later was teaching at his school, where her students reportedly included Laura Gilpin, Doris Ulmann, and Paul Outerbridge, Jr. In 1926, shortly after White died, Watkins organized a memorial exhibition of his work, drawn entirely from her own collection. She was also very involved with the Pictorial Photographers of America (PPA); early on, she was the group's corresponding secretary, and in 1926 she served as resident vice-president. She was also instrumental in issuing the group's annual, *Pictorial Photography in America, Volume 4*, serving on both its jury of selection and editorial board. One of her own images was reproduced in this 1926 publication and she contributed an article on advertising photography.

Watkins made primarily portrait, nude, and still-life photographs, the latter of which were most adventuresome. In these she usually incorporated simple designs, strong shadows, and truncated subjects that made them abstract and modernist. Her most famous image, *Domestic Symphony*, was reproduced in *Vanity Fair* and other magazines, causing a controversy over its mundane subject matter and its unorthodox composition. During the 1920s her work was accepted at pictorial salons in the United States, Britain, Europe, and Japan. She presented one-person exhibitions of her work at New York's Art Center in 1923 and at the Newark Camera Club in 1926.

In 1928 Watkins visited Scotland, Europe, and Russia, making documentary photographs along the way. A few years later, she returned to Scotland to take care of several of her aunts. She eventually established a foundation to help the needy and apparently spent her last decades in semi-seclusion, never marrying. She died in 1969, at age eighty-four.

Bolhoff, Halla, Joseph Mulholland, and Lori Pauli. *Margaret Watkins, 1884–1969: Photographs*, Street Level Gallery, Glasgow, 1994.

Margaret Watkins: Photographs, 1917–1930, Third Eye Centre, Glasgow, 1981.

Bertrand H. Wentworth
1868–1955

Wentworth was active as a pictorialist during the 1910s and 1920s. A native and longtime resident of Maine, he specialized in pictures of the Atlantic coastline and winter landscapes.

Bertrand H. Wentworth was born in Gardiner, Maine, on February 3, 1868. He grew up there and worked from 1886 to 1888 as a clerk at the Merchant's National Bank. Over the next two decades, he clerked at banks in Chicago and Denver, prospected in Arizona and California, worked at Wentworth Brothers retail store in Los Angeles, and was an engineer at a quarry in Grand Rapids, Michigan. From 1911 to 1913, he was publicity manager for the Detroit Publishing Company.

Wentworth was making photographs by about age fourteen, when he ventured with a friend to a neighboring county to depict the landscape. After moving to the West, he reportedly associated with the renowned landscape photographer William Henry Jackson, accompanying him to the Mountain of the Holy Cross in Colorado. In 1913 he decided to devote himself full-time to photography. He returned to Gardiner and established a studio on Monhegan Island, where he concentrated on shooting marine pictures and winter landscapes. Hoping to appeal to collectors, he produced limited-edition carbon prints, priced between ten and fifty dollars each.

Wentworth associated closely with Boston's Society of Arts and Crafts, which maintained a photographic guild. He joined around 1914 and the next year presented the society's first one-person exhibition of photographs. During the next decade, there were five additional solo shows of his work, more than any other photographer. In 1918 the society made him a medalist, its highest honor.

Wentworth was active outside Boston as well. In 1918 he served as a council member of the Pictorial Photographers of America. He presented one-person exhibitions of his work at Washington's Corcoran Gallery of Art in 1919 and at the Camera Club of New York in 1924. In 1926 the Smithsonian Institution invited him to contribute examples of his work to its permanent collection of photographs.

The photographic press recognized Wentworth as one of the country's leading marine photographers. He wrote an article titled "Photography as a Means of Expression" for the July 1915 issue of *Photo Era*. Paul L. Anderson's 1919 book, *The Fine Art of Photography*, praised him, reproduced his work, and included a lengthy letter from Wentworth that comprised most of the chapter on marine photography.

Wentworth died on January 29, 1955, in Bangor, Maine. Shortly thereafter, his daughter gave a major collection of his photographs to the Farnsworth Library and Art Museum in Rockland, Maine.

McNamara, Virginia M. "Marine Man, After 40 Years Spent in West, Chooses Native State to Study Marine and Landscape Photography," *Portland Sunday Telegram*, January 18, 1931, pp. 1D, 6D.

"Mr. Wentworth's Pictorial Photographs," *American Magazine of Art*, October 1919 (Vol. 10), pp. 473–474.

Edward Weston
1886–1958

Weston is well known for the pure, formal photographs of nudes, shells, vegetables, and landscapes he made primarily from the mid-1920s to about mid-century. His softly focused early work was well received on the salon circuit. Throughout most of his life, he supported himself by making portraits.

Edward Henry Weston was born in Highland Park, Illinois, on March 24, 1886. He grew up in the Chicago area and at age sixteen received his first camera as a gift from his father. In 1906 he visited California, decided to stay, and committed himself to becoming a professional portrait photographer.

Weston maintained a string of small portrait studios. After attending the Illinois College of Photography and working as a printer for other California photographers, he opened his first studio in what is now Glendale in 1911. Within a few years, professional organizations were awarding him prizes and having him demonstrate his methods at their conventions. He had a portrait studio in Mexico while living there in the mid-1920s, and he also ran one in Carmel, California, beginning in 1929. His early portraits were evocative and pictorial, but those he made after returning to the United States were unretouched contact prints.

Weston was a confirmed pictorialist throughout the 1910s and up until his 1923 trip to Mexico. During this time he made softly focused portraits and figure studies, which were successful in competitions and photographic salons. Reproductions of his work appeared regularly in *American Photography, Camera, Camera Craft,* and *Photo Era*, as well as in annuals like England's *Photograms of the Year*. To these same periodicals he contributed occasional articles on such subjects as artistic interiors and high-key portraiture. He presented numerous one-person exhibitions at American camera clubs and in 1917 was the first California pictorialist elected to the London salon. In 1922 he traveled to New York to meet Alfred Stieglitz.

During a three-year stay in Mexico, Weston shed the pictorial style in lieu of a sharper view of the world. In the mid-1920s he began depicting his subjects in a simple, straightforward manner that led him to become a major proponent of purist photography. This aesthetic preached previsualization, sharp focus, a full range of photographic tones, and avoidance of all sentimentality. Its ultimate manifestation was Group f.64, formed in 1932 by Weston, Ansel Adams, Imogen Cunningham, Willard Van Dyke, and three other West Coast photographers. Weston remained committed to this purist approach for the rest of his active life, photographing primarily in California and the West. His last negatives were made in the late 1940s on Point Lobos.

In 1937 Weston received the first Guggenheim Fellowship awarded to a photographer. This grant, which was extended the next year, allowed him to concentrate on personal work for the first time and to photograph extensively in the West. At about this time, he moved into a house on Wildcat Hill outside of Carmel, where he lived the rest of his life. In 1947 Weston experimented with color photography and was the subject of Willard Van Dyke's film *The Photographer*. A few years later, Parkinson's disease prevented him from making new negatives. In 1952 he published the *Fiftieth Anniversary Portfolio*, consisting of twelve representative pictures printed with the assistance of his son Brett. Brett Weston went on to become a creative photographer in his own right, and another son, Cole, was largely responsible for printing his father's negatives after his death.

Weston died at his home on Wildcat Hill on January 1, 1958. His archive resides at the University of Arizona's Center for Creative Photography in Tucson.

Armitage, Merle, ed. *The Art of Edward Weston*, E. Weyhe, New York, 1932.

———. *Fifty Photographs: Edward Weston*, Duell, Sloan and Pearce, New York, 1947.

Conger, Amy. *Edward Weston in Mexico, 1923–1926*, University of New Mexico Press, Albuquerque, 1983.

———. *Edward Weston: Photographs from the Collection of the Center for Creative Photography*, Center for Creative Photography, Tucson, 1992.

Enyeart, James L. *Edward Weston's California Landscapes*, New York Graphic Society, Boston, 1984.

Madow, Ben. *Edward Weston: Fifty Years*, Aperture, Millerton, New York, 1973.

Newhall, Beaumont. *Supreme Instants: The Photographs of Edward Weston*, New York Graphic Society, Boston, 1986.

Newhall, Nancy, ed. *The Daybooks of Edward Weston*, 2 vols., George Eastman House, Rochester, New York, and Horizon Press, New York, 1961.

———. *Edward Weston: The Flame of Recognition*, Aperture, Millerton, New York, 1971.

Weston, Edward. *My Camera on Point Lobos*, Houghton Mifflin Co., Boston, 1950.

Wilson, Charis. *Edward Weston Nudes*, Aperture, Millerton, New York, 1977.

Wilson, Charis, and Edward Weston. *California and the West*, Duell, Sloan and Pearce, New York, 1940.

———. *The Cats of Wildcat Hill*, Duell, Sloan and Pearce, New York, 1947.

Clarence H. White
1871–1925

White played leading roles in pictorial photography both during and after the heyday of the Photo-Secession. Stieglitz made his work highly visible in Secession exhibitions and publications. White also became widely known as a photographic instructor, teaching at both the school he established and elsewhere. He frequently photographed figures in the traditional soft-focus style.

Clarence Hudson White was born in West Carlisle, Ohio, on April 8, 1871. Four years later his family moved to nearby Newark, where he grew up. After finishing high school, White became a bookkeeper at a local wholesale grocer and worked there until 1904.

White made his first photographs in 1893 and by four years later was receiving awards for his artistry. In 1898 he achieved national prominence with pictures in the Philadelphia salon and a photogravure in *Camera Notes*. The same year, he organized the Newark Camera Club and traveled east to meet Alfred Stieglitz and other pictorialists. In 1899 he presented one-person exhibitions at both the Camera Club of New York and the Boston Camera Club and began exhibiting in the prestigious London salon. Over the next few years, his star continued to rise. He juried salons in Philadelphia and Chicago, joined the Linked Ring, and had his work included in the New School of American Photography exhibition, seen in London and Paris.

Stieglitz designated White as one of the founding members of the Photo-Secession in 1902. Subsequently, his work was seen in all the major Secession exhibitions, including the 1910 show at Buffalo's Albright Art Gallery, where he was the best-represented American. In 1906 he shared a two-person exhibition at the Little Galleries of the Photo-Secession with Gertrude Käsebier. His work was also regularly presented in *Camera Work*, where twenty-seven of his photogravures appeared.

White produced largely figure studies of family members, sensitively posed both indoors and out, with simple props like books, mirrors, and glass balls. The subject matter and the subtle tones of his platinum prints reflected the photographer's gentle, midwestern nature. White's photographic output was tempered by his teaching responsibilities, but his later pictures, made after World War I, show an awakening to cubist ideas.

White attempted to make his living as a photographer after quitting his bookkeeping job in 1904. Still based in Ohio, he became a traveling portrait photographer, but he was lured to New York after only a few years of mixed success. Unable to adequately support himself and his family as a professional photographer, he soon found himself teaching—first as a lecturer in photography at Teachers College of Columbia University in 1907 and shortly thereafter at the Brooklyn Institute of Arts and Sciences. While maintaining both jobs, he established his own summer school of photography in 1910 on an island in Maine and four years later opened the Clarence H. White School of Photography in New York. White promoted the integration of professional methods and pictorial aesthetics, inspiring such students as Paul Outerbridge, Jr., Ralph Steiner, and Margaret Watkins to produce creative commercial work.

After the disintegration of the Photo-Secession in about 1910, White carried the banner of pictorialism for the next decade and a half. He severed his relationship with Stieglitz and in 1916 organized the Pictorial Photographers of America (PPA), for which he served as first president. The PPA promoted inclusiveness and education, circulating popular exhibitions and publishing five volumes of its annual, *Pictorial Photography in America*, during the 1920s. In 1920 White also became a founder and director of the Art Center, a group of New York–based arts organizations (including the PPA) that worked toward combining art and industry.

White died at age fifty-four on July 7, 1925, in Mexico City, while on a photographic trip with students from his school. His archive resides at the Art Museum, Princeton University.

Bunnell, Peter C. *Clarence H. White: The Reverence for Beauty*, Ohio State University Gallery of Fine Art, Athens, 1986.

Homer, William Innes, ed. *Symbolism of Light: The Photographs of Clarence H. White*, Delaware Art Museum, Wilmington, 1977.

Maddox, Jerald. *Photographs of Clarence H. White*, University of Nebraska Art Galleries, Lincoln, 1968.

White, Maynard P. *Clarence H. White*, Aperture, Inc., Millerton, New York, 1979.

Wood Whitesell
1876–1958

Whitesell was an appealing eccentric who made his living as a portrait photographer in the French Quarter of New Orleans. He also made a name for himself on the salon circuit during the 1940s, exhibiting primarily genre scenes.

Joseph Woodson Whitesell, later known as Pops, was born on a farm near Libertyville, Indiana, in 1876. He became interested in photography at age seventeen, and began taking pictures of the rural life and residents around him. He learned retouching from a professional photographer in Terre Haute and subsequently held numerous photographic jobs in Indiana and Illinois. In 1918 he was hired by Hitcher's studio in New Orleans, the city where he lived the rest of his life.

Whitesell's solo career as a professional began in about 1920, when, after trying several locations, he settled into a courtyard studio in the Vieux Carré. Located behind what is now the jazz spot Preservation Hall, the studio filled up with the colorful photographer's homemade equipment and domestic devices. For thirty years he photographed the locals, especially around Mardi Gras time, and the continuous stream of celebrity visitors to New Orleans, among them Sinclair Lewis and Sherwood Anderson. Late in life, he was honored by the profession when the Photographers' Association of American awarded him the degree of master photographer.

Confident of his standing as a professional, Whitesell ventured into pictorial photography in the early 1940s, when he was past retirement age. By 1942–1943 he was exhibiting in excess of a hundred prints in more than forty salons per season, a record he maintained for six years. He joined the Delta Camera Club, judged salons in the South, and presented one-person exhibitions of his photographs at the Smithsonian Institution in both 1946 and 1951. During this time, the Photographic Society of America embraced him, designating him a fellow (FPSA); he was the featured speaker at the association's 1949 national convention and subsequently went on a PSA-sponsored lecture tour of twenty-three cities.

Whitesell's salon photographs revealed the atmosphere of the French Quarter, both on the street and in his studio. The rustic comfort of his studio provided an ideal environment for posing friends conversing and otherwise interacting. Whitesell frequently included himself in these humorous genre scenes and made no effort at hiding the telltale cable release that made possible the exposure. He long acknowledged the influence of Dutch master paintings on his group pictures, having first seen a replica of Rembrandt's *Night Watch* at the 1904 St. Louis World's Fair.

In the 1950s Whitesell, who never married, experienced physical problems and became increasingly eccentric. He died in a New Orleans hospital on February 18, 1958, and was buried in Clinton, Indiana.

Bodine, A. Aubrey. "'Pops' Whitesell—Salon Sensation at Sixty-eight," *Camera*, September 1944 (Vol. 66), pp. 14–18.

Peterson, Anne E. "Pops Whitesell: A Hoosier in the Vieux Carré," *Traces* (Indiana Historical Society), Spring 1991 (Vol. 3), pp. 4–13.

"Pops Whitesell Succumbs at 82," *Times Picayune* (New Orleans), February 20, 1958, pp. 1, 7.

Index

Page numbers in italics indicate illustrations.

Book design and composition in Futura by Katy Homans and Gina Webster

Printing and manufacturing by Arnoldo Mondadori Editore, Verona, Italy